A History of Art Education

Intellectual and Social Currents
in Teaching the Visual Arts

A History of Art Education

*Intellectual and Social Currents
in Teaching the Visual Arts*

ARTHUR D. EFLAND

TEACHERS
COLLEGE
PRESS

Teachers College, Columbia University
New York and London

Published by Teachers College Press, 1234 Amsterdam Avenue
New York. NY 10027

Library of Congress Cataloging-in-Publication Data

Efland, Arthur, 1929–

 A history of art education : intellectual and social currents in
teaching the visual arts / Arthur D. Efland.
 p. cm.
 Includes bibliographical references.
 ISBN 0-8077-2978-7. — ISBN 0-8077-2977-9 (pbk.)
 1. Art — Study and teaching — United States — History. 2. Art — Study
and teaching — History. I. Title.
N105.E35 1989 89-35255
707'.073 — dc20 CIP

ISBN 0-8077-2978-7
ISBN 0-8077-2977-9 (pbk.)

Printed on acid-free paper
Manufactured in the United States of America

14 13 12 11 10 11 12 13 14 15

Contents

Preface

In 1961, while a graduate student at Stanford University, I discovered that art education had a history. On the shelf of the Cubberley Library were Fred Logan's *Growth of Art in American Schools* and Harry Beck Green's doctoral dissertation. I concluded then that the history of art education was an accomplished fact, that there were few new discoveries to be made, and that the task of future histories would consist in amending the record of progress that had been chronicled by Logan, Green, and others.

Since 1955, when Logan's book appeared, much has happened to change the character of art education. From his vantage he could see a straight line of progress from the rigid, mechanical exercises of the nineteenth century to the freer forms of expression then advocated by Ziegfeld, Lowenfeld, and D'Amico. Since that time, art educators have returned to forms of content and practice that had once been abandoned. The current interest in the teaching of art appreciation is a notable example.

Does history move in a straight line, or is it cyclical — with some trends dominating at one time only to yield to alternate trends at another? If so, what accounts for these transformations? Are they grounded in the social realities of the times in which they occur, or are they simply the result of changes in pedagogical fashion? Logan and Green did not raise these questions; they were concerned with establishing the record of the past, while my interest has moved toward the development of a more adequate interpretive perspective.

When Green and Logan wrote their histories, they did not have at their disposal the fruits of explorations that have been under way in the last 10 to 20 years. My history owes much to persons like Robert Saunders, who shed light on the nineteenth-century labors of Horace Mann and Elizabeth Peabody. He also brought to light new information on the Owatonna Project. Diana Korzenik, who shares my love for the Walter Smith episode, has greatly expanded our awareness of the social impact of the industrial drawing movement and done much to give us a fuller picture of Smith's life and

career. Paul Bolin investigated the legislative intricacies of industrial drawing in Massachusetts, while Mary Ann Stankiewicz has worked to expand our knowledge of schoolroom decoration, picture study, and unsung heroines at the turn of the century. Foster Wygant and Peter Marzio have increased our awareness of the drawing manuals of the nineteenth century. Wygant also was helpful in enlarging my understanding of Dow's work at Teachers College, Columbia. David Baker's study of the romantic tendency and Peter Purdue's work on the arts-and-crafts movement helped me to recognize the presence of conflicting tendencies at work in art education.

I am also indebted to Stuart Macdonald and Clive Ashwin for their work on English and continental art education, which influenced developments in this country. I need also to acknowledge my intellectual debt to Raymond Callahan for his *Education and the Cult of Efficiency*, which was an important source for my sixth chapter, and to Lawrence Cremin, whose *Transformation of the School* was of central importance in shaping my understanding of the educational scene during the interwar era. Michael Katz's *Class Bureaucracy and Schools* clarified the politics of the Boston School Committee in that crucial decade when drawing was introduced into Boston's schools.

A number of people were helpful in lending scarce resource materials. Ben Hopkins at the Massachusetts College of Art sent me an original copy of the Dean history of the college. While I was giving a paper at the University of Illinois on Froebel's gifts and occupations, someone whose name I cannot recall sent me copies of the Milton Bradley Co. catalogues. Margery Cohn of the Fogg Art Museum was kind enough to lend me notes on correspondence among Prang, Perkins, and Smith from the time of their textbook controversy. Jean Shields, librarian for the Boston School Committee Administration Library, was very helpful in locating the proceedings of the committee for the 1870–1880 time period. Don Soucy regularly sent me copies of dissertations and papers and made numerous suggestions. He also checked several long quotations against the primary sources. I feel a special debt of gratitude to the late Jacqueline Sisson, fine arts librarian at the Ohio State University, who saved everything, and to her successor, Susan Wyngard, who finds everything. The two travel grants awarded me by the College of the Arts Research Committee to work at other libraries helped make this book possible. I also need to thank the students in my graduate seminar on the history of art education who taught me far more than I could teach them. I am also grateful to the editorial staff of Teachers College Press, who greatly facilitated this publication.

I want to acknowledge my gratitude for the warm encouragement and intellectual insights into the artistic and political climate of their native Vienna that I received from the late Hermine Floch, who helped me under-

stand the contributions of Franz Cizek, her teacher, and Viktor Lowenfeld, her friend and classmate. I am also grateful for the support of the late Frederick Fraenkl and for the continued support of Liselott Fraenkl. Lastly I should mention my son, David, who had to endure my work trances and whose sense of humor helped me when the going got rough, and my wife, Jenny, who reminded me of the art in art education.

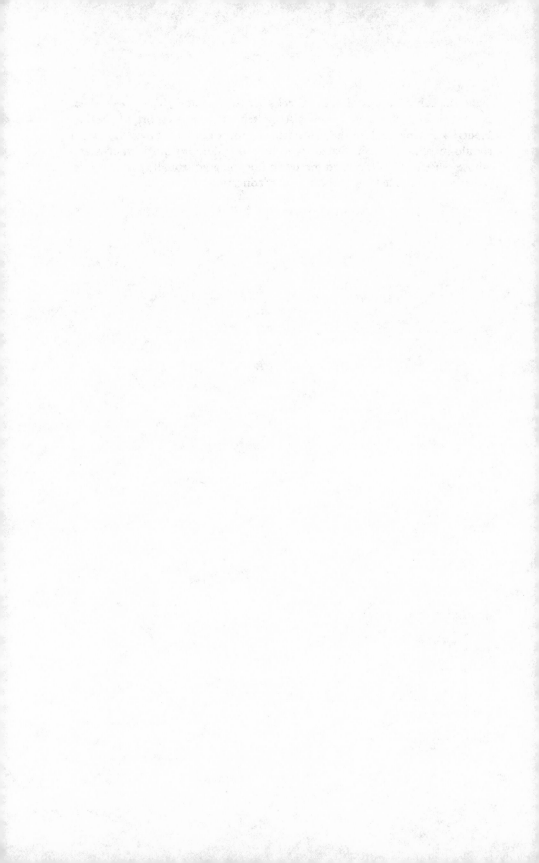

A History of Art Education

Intellectual and Social Currents
in Teaching the Visual Arts

CHAPTER ONE

Art Education: Its Social Context

As long as the arts have existed, artists, performers, and audience members have been educated for their roles. Every culture has devised ways to select and prepare individuals to engage in these roles. This book is about the teaching of the visual arts throughout the history of education, both before and after public education came upon the scene. These background developments enable us to understand the social currents that eventually led to the introduction of the arts as standard subjects within the school. Though the focus is on art in American education, developments in Europe and England that relate to the United States are discussed.

The ways the visual arts are taught today were conditioned by the beliefs and values regarding art held by those who advocated its teaching in the past. Many of these early supporters were socially powerful individuals who influenced the educational policies of their day. For them, the teaching of art was neither capricious nor accidental; but rather it was done to further social, moral, and economic aims.

A sense of elitism clings to the teaching of the visual arts. Many schools regard the arts as special subjects to be pursued by a privileged or talented few. To understand how these attitudes arose, we must look back to the beginnings of education in Western culture. Only after we have studied the teaching of art in earlier times can we understand its role in education today.

A central issue in art education, as in general education, is access to instruction. In very early times the arts were either learned through group rituals that were an integral part of worship or taught to a selected few through arduous apprenticeship. While some societies regarded knowledge of the arts as the privilege of a social elite, others thought that the visual arts were subjects fit only for slaves and the children of artisans. In the nineteenth century working-class women in Europe could study the decorative arts, while study of the fine arts, except under highly unusual circumstances, was for men. Thus all through the history of art education, access

1

to instruction was affected by class, gender, and the general social status of the visual arts as a subject for study.

With the rise of universal literacy in the nineteenth century, the first tentative efforts to introduce art and music into public education began in spite of objections from segments of the public. The introduction of these arts was often described as educational reform, as a privilege bestowed by the school on the young as part of a free public education; but having a privileged status exacts its social costs. It removed the arts from the realm of necessities. To find out why the arts are vulnerable, even today, is one of the functions of this book.

As this history unfolds, it will become clear that the teaching of the arts was organized within a series of institutional settings. In the Middle Ages it was controlled by the higher clergy, who served as the patrons, educators, and sometimes the artists themselves. By the high Middle Ages, art education was regulated by the craft guilds. In the sixteenth and seventeenth centuries it was the secular court that sponsored the academies of art and music then taking form. In our own time, instruction in the arts is transmitted through a complex network of formal and informal institutions: professional art schools, museums and museum schools, liberal arts colleges, publications, the mass media, and compulsory schooling. Instruction is available for the amateur and the professional, in private classes with one student and in group classes of all sizes. Great diversity characterizes access to the arts today, but this was not always the case.

SYSTEMS OF CONTROL

Powerful elements in each society determined the purposes to be served by the arts and created appropriate institutions to carry out these tasks. What resources were available for the production and performance of artworks, who could be recruited for training, who could serve as teacher, and what could be taught were determined by these institutions. In short, the arts were controlled by three means: patronage, education, and censorship (Kavolis, 1974).[1]

Patronage refers to the organization of human and material resources for the production of art. In a patronage system there are relations between performers and audiences or between artists and consumers. Education refers to the theoretical and practical training received by prospective artists and audience members. In educational systems there are social relations between teachers and students or masters and apprentices. These systems define who is to be taught and who is not. Censorship affects what is expressed in works of art and who is permitted access to them. In censorship

systems social authorities act as a screen between the art object and society as a whole.

These three systems for controlling the arts are often interrelated. For example, the Medici of Florence were not only active in commissioning works of art but were also instrumental in sponsoring academies of art that promoted art theories favoring the type of expression they sought in commissioned works. In seventeenth-century France the academy of art established during the reign of Louis XIV administered all three functions. Currently the National Endowment for the Arts, initially conceived to facilitate patronage, is also deeply involved in an artist-in-the-schools program designed to deliver the arts to schoolchildren.

In all societies patronage, education, and censorship are systems controlled by the socially powerful. This is obvious in the examples of the medieval Church and Louis XIV, but it is equally the case in contemporary society, though it is more difficult to identify the channels of power today because the institutions and institutional networks are more complex. This increasing complexity is reflected in the changed meaning of the word *patron* since the Renaissance. Then it designated those persons who sponsored, commissioned, protected, or supported the artist. Now it refers to anyone who functions as an audience member for the arts.

Patronage may be in the hands of a single institution, such as the church or state, or it may come from a great range of sources. When the latter situation prevails, there is likely to be greater variety in the methods used to teach the arts. Painting, for example, may be taught in different ways in different places; thus stylistic differences emerge. Diverse patronage creates conditions that foster a degree of competition among artists, which, in turn, encourages each artist to emphasize his or her own individual style. When an experimental climate prevails, artists attempt to discover the expressive possibilities and limits of their media. As artists pass on these discoveries to their students, different instructional traditions develop.

During the Renaissance patronage became more diverse than it had been in the Middle Ages. Patrons often had to compete with one another to obtain the services of renowned artists. In addition, artists experimented with their methods to a greater extent than they had during the Middle Ages or in the centuries following the Renaissance, and their discoveries were disseminated by the first academies of art. Similarly, the nineteenth and twentieth centuries saw a rise in the patronage of the middle class, which accompanied the rise of personal fortunes and private philanthropy. In this period, art instruction also became more accessible. Educational opportunities for the amateur as well as the professional expanded dramatically (Wittkower & Wittkower, 1963).[2]

In other places and times, such as seventeenth-century France, all pat-

ronage came from the state, and art had to conform to state standards. Methods of teaching art also became standardized, and the once-fresh discoveries of the Renaissance became the basis of a formal system of rules for the making of art. Moreover, access to art instruction was restricted by the academy (Pevsner, 1973).[3]

SOCIAL CONTEXT OF THE ARTS

These preliminary observations suggest that patronage systems differ in their degree of diversity and control and that greater diversity is accompanied by increased educational opportunities and artistic variety. The arts themselves reflect the society in which they arise, but so does the art education system that teaches the arts. Whether the system narrows access to the arts or makes the arts broadly available tells us something of the character of the society. Ancient Sparta was a militaristic state that limited all artistic activity to that which glorified war. Athens, by contrast, was a sea-faring state that carried on trade with other peoples living on the shores of the Aegean and Mediterranean. The Athenians were open to ideas from all corners of the known world, and they were equally open to the arts.

The arts are not autonomous realms of activity, uninfluenced by the social context. They are supported by patronage, controlled by censorship, and disseminated by education; and the character of these systems reveals a great deal about the society of which they are a part. This book deals primarily with the systems of education in the visual arts.

As we look for connections between the past and present, we will consider such elements as the social structure of a society, the ideas of reality that are shared within a culture, the cultural policies that inform its educational system, the institutional systems that implement policy (e.g., guilds, academies, public schools), and the instructional methods used in teaching (e.g., copying the masters, self-expression).

The *social structure* of a society is a network of social roles. A social role is a way of behaving in relation to other persons who have their own roles to perform. Each role is a kind of behavioral norm. Within the realm of the arts, such terms as *masters, apprentices, novices, artists, geniuses, artisans, patrons, consumers, amateurs, professionals, critics, collectors, philanthropists,* and *audience members* identify social roles. Within a specific social structure these roles acquire social status. Social status is linked to social power. Depending on the social setting, patrons might have higher or lower status than the artists they support, or the two roles might be equal in importance. For example, a typical medieval patron, a bishop or cardinal, would have played an active role in determining the form, content, and

aesthetic features of a work being commissioned. The artist's role was limited to solving the technical problems associated with making the object. By Renaissance times, patrons had begun to leave the artistic decisions to the artist, though the artist chosen by a patron was usually one who shared a similar set of beliefs. In our own time the artist is frequently part of a social and intellectual elite that often excludes the patron. Such patrons buy art as tokens of status, which wealth and social power alone fail to grant them (Wolfe, 1975).

Also entering into any discussion of the arts are various *ideas of reality*, by which we mean a general system of beliefs or a kind of consciousness that characterizes a particular epoch. Sometimes this consciousness is embodied in the philosophical writings of a single individual or in the great works of art of the time. For example, in his *Gothic Art and Scholasticism* Panofsky (1957) notes parallels between the writings of Thomas Aquinas and the cathedral architecture of the period. Aquinas argued that faith can be found in both reason and divine revelation. Panofsky shows how this idea is reflected in architectural features of Gothic cathedrals. Similarly, the Renaissance was influenced by the humanists and their renewal of classical learning. Cartesian rationalism captured the spirit of French culture in the seventeenth century. Sometimes the ideas of reality that prevail in a society are the property of ruling elites; at other times they are widely shared by all segments of society, providing a framework for both patron and artist. They are the foundation for the cultural policies and social philosophy affecting the arts and education. These ideas of reality create the social climate that makes the artforms of an era possible.

The term *cultural policy* refers to the ways the arts are used to promote the values of a society. Examples of such policies are the use of art to promote religious faith in the Middle Ages, or the building of Versailles to enhance the prestige of Louis XIV, or, in our own time, the use of art as political propaganda or advertising. Cultural policy may coincide with economic policy, as when industrial societies use art to promote tourism or to make manufactured goods more competitive in the marketplace through better design. The term also applies to the ways in which social beliefs enhance or inhibit artistic expression, such as the prohibition against figurative art in Islamic cultures or the bans against nudity at the time of the Counter Reformation.

Societies create specific *institutional systems* to carry out mandated cultural policies. Institutions that affect education in the arts include the guild system of the Middle Ages, the system of art academies that arose in the seventeenth and eighteenth centuries, and, more recently, trade schools for artisans, museums, and public and private schools. Each of these institutions embraces certain pedagogies for teaching the arts. Imitating nature and

copying as teaching methods tended to be universal in ancient times. In later periods this method was more common when institutional control of the arts was especially strong. Individual expression, on the other hand, was fostered in societies where the artist enjoyed a higher degree of social status—during the Renaissance and the romantic era of the nineteenth century, for example. But emphasis on individual expression can also be a sign that there is little interest in the arts, resulting in artists' being left to their own devices. Thus the methods of teaching that are in favor in a given time can reveal as much about the society as can the artworks themselves.

PLAN OF THIS BOOK

Chapter 2 surveys educational practices from classical times to the eighteenth century. We will see that the political, cultural, scientific, and economic events that shaped the outlook of a society also affected its arts. We will see how differing cultural policies affected teaching practices in the arts and the creation of institutions for teaching the arts. We will also look at the teaching methods themselves to see how these reflect the character of the society and the nature of the artform being taught.

Chapters 3, 4, and 5 are devoted to developments in the nineteenth century. In this period major social transformations in Europe and America brought into being systems of public education. Political revolutions in many European countries brought an end to absolutist monarchies and initiated systems of parliamentary rule. The Industrial Revolution changed the nature of work and transformed rural, handicraft-based societies into urban, industrial ones. Finally, the romantic movement gave rise to the belief that artistic expression contributes to the moral evolution of society. Each of these revolutions affected education and the position of the arts within it, and each developed a separate educational theme. Chapter 3 explores the organization of art education in academies for artists, the development of specialized trade schools for industrial workers, and the scholarly study of art by laymen in colleges and universities. Chapter 4 deals with rise of the common school in response to the Industrial Revolution and the forms of art education within its curriculum that led to the industrial drawing movement of the 1870s. Chapter 5 draws together the influence of the romantic movement in such manifestations as the kindergarten movement, the role of women in education, and the picture study and school decoration movements.

The remaining chapters cover art education throughout the twentieth century. Chapter 6 describes the period prior to World War I and discusses the impact of the child study movement and the effects of social Darwinism on art education. It also deals with the impact of the arts-and-crafts move-

ment on teaching practices. Chapter 7 covers the period between the First and Second World Wars, providing a history of creative self-expression and reconstructionism in art education. Art education is explored in the context of the progressive education movement. Chapter 8 summarizes the developments from the end of World War II to the present and describes art education as it responded to a series of educational movements, including the life-adjustment movement, the curriculum reforms based on the disciplines, and the accountability movement of the 1970s. The survey is brought up to the present with a review of the status of art during the 1980s. The chapter concludes with the development of an interpretive perspective based upon the idea that several streams of influence have influenced art education and that these continue to play themselves out as rival movements, often in sharp contention with each other. The dominance of these streams, in turn, is related to the existence of various social movements and groups and their interests and aspirations.

Each chapter develops themes that in some instances span a century or more of time. For example, the invention of common school art (Chapter 4) opens at the outset of the nineteenth century and traces the teaching of various systems of geometric drawing to the industrial drawing that became influential during the 1870s. The next chapter takes up the romantic impulse in art education. Once again the story returns to the opening of the century and follows it through to the present century. The reader should bear in mind that the impulse toward industrial art education and romantic idealism were concurrent and contrasting developments. Throughout the three chapters covering the twentieth century, these contending streams of influence emerge in different forms as they flow through each of the three time periods into which the century is divided. It is my hope that this form of organization will enable today's reader to focus on the arguments that were waged throughout this century and continue to form the background of issues and events that affect the teaching of art today.

CHAPTER TWO

Western Origins of Art Education

Throughout most of the history of Western civilization, education was limited to the children of families with wealth or social power. And yet for nearly 2,500 years now, educational matters have been subjects for earnest discussion by philosophers and statesmen. Western culture dawned in Greece, and her great philosophers, Plato and Aristotle, wrote not only about education but also about the place of the arts within it; thus the story of art education begins here.

In the intervening time span we shall witness the rise and fall of Rome, Europe during the Middle Ages, the Italian Renaissance, the discovery and conquest of the New World, and the founding of the United States.

ART EDUCATION IN THE CLASSICAL ERA

Other civilizations have also discussed the arts and education, but the discussions of the Greeks have a direct bearing on our story, because their attitudes toward the arts themselves and toward their place in education continue to influence us even today. Plato's and Aristotle's commentaries on art and education occurred in their political writings, for these were serious matters, affecting the survival of the community. In these discussions the arts were valued not for their aesthetic qualities but for their didactic impact as instruments of cultural maintenance.

Though the arts were esteemed, sometimes highly so, only scant information has survived about the actual methods of instruction used for training prospective musicians, sculptors, architects, and craftsmen. This is because the arts were thought of as unworthy professions for the children of the high born to pursue. Painting and sculpture were deemed inferior trades, akin to common labor, and hence played only a minor role in the formal

education of aristocratic offspring. Those who pursued their livelihood as potters, weavers, painters, or stonecarvers learned these crafts in family workshops, with the father passing on his skills to his sons. On occasion outsiders were taken into the family as apprentices. In late Roman times the emperor encouraged the study of architecture by granting stipends to talented students; it then came to acquire a somewhat higher status as a career (*Encyclopedia of World Art* [*E WA*], 1959–1968, Vol. 4, cols. 557–571; Vol. 8, cols. 141–143).

In spite of the fact that patronage in the classical world often reached a grand scale, artists did not enjoy the kind of recognition and esteem that was accorded their counterparts in Renaissance times. Pericles, who ruled Athens when the Acropolis was built, has sometimes been compared with Lorenzo de Medici, a great patron of Renaissance art. Such comparisons are only partially adequate, for Lorenzo did more than commission works; he also encouraged youthful artists to develop their talents (Wittkower & Wittkower, 1963). Intimately connected with the founding of academies and libraries, he was interested in learning the principles of art as well. A comparable interest in the education of artists or curiosity about the principles of art was probably not displayed by Pericles or his aristocratic contemporaries. An artist such as Phidias was a skilled craftsman, with little social status. His work was championed by Pericles, who also functioned as his protector and advocate at times when this sculptor's work offended his contemporaries (Wells, 1922).

In Hellenistic times, when Alexander the Great and Ptolemy were patrons of poets, philosophers, and court artists, the idea of collecting esteemed works of art and manuscripts became an established practice (Taylor, 1948). Hellenistic culture became highly fashionable in Rome around 200 B.C., and the possession of art objects of high quality began to characterize their owners as men of refinement and culture; but the maker of these objects remained a mere artisan.

With music and poetry the story differed. To understand why the Greeks regarded these arts differently from the visual arts, we shall review early educational practices in ancient Sparta and Athens.

Education in Sparta

In 800 B.C. Sparta was a primitive village on the Laconian plain, but a century later, it had become the center of an elaborate culture. According to Castle,[1] "her citizens were acknowledged as the leaders of Greece, to whom artists, poets, and musicians were attracted from distant parts of Hellas, sure of appreciation and success" (1961, p. 14). But by 550 B.C. Sparta had

reversed its cultural course and no longer patronized the arts. Only the art of war was cultivated.

Castle suggests that the change in Spartan cultural policy occurred after two wars in which this city-state was locked in a life-and-death struggle with the Messenians. When Sparta emerged victorious, its ruling class became a land-owning military aristocracy while the people under its rule were reduced to the status of landed serfs on whose toil the Spartans depended for their material existence. Sparta had become a garrison state run by professional citizen-soldiers, and this ruling caste was outnumbered ten to one by those in servitude and often in a state of rebellion as well. Everything that maintained their wartime footing was valued, while the arts and everything else that might embellish life were cast aside. Castle describes the Spartans as being "violently conservative, hating the stranger at their gates, rejecting trade with the foreigner, whether in goods that made life more comfortable, in arts that made existence more graceful or in ideas that might disturb settled minds" (1961, p. 17).

Though the Spartans had numerous slaves, theirs was not a life of ease. Indeed, softness was held in contempt; their self-imposed stringency was deemed a virtue. Education was a long process of conditioning that began at birth. The newborn child was displayed before experienced judges of fitness and if found puny or badly shaped was condemned to exposure in the mountains. By this means Spartan society eliminated its potentially weakest members. At the age of 7 a form of state training, or *agogé*, began, lasting for 13 years. From ages 7 to 11 the young boys lived at home and attended classes for games and physical training. From ages 12 to 15 they left home to attend what was in effect a Spartan boarding school, where even tougher treatment was imposed, and following that they received four years of formal military training. The newly trained soldier then began serving the state, a responsibility that continued until the age of 53 (Castle, 1961).

The training concentrated on physical and military readiness, with such subjects as military drill, hunting, swimming, riding, scout-craft, and spying, but some reading and writing was also provided, as well as the poems of Tyrtaeus, the national songs, and such music and dancing as would induce a martial spirit. Mathematics was ignored because it was linked to commerce, and the teaching of rhetoric was forbidden. Art was not unknown in education, but it was used as a means to an end. Love of the beautiful would have been unthinkable.

Spartan educational practice was a topic treated by both Plato and Aristotle, who praised it for its virtues yet recognized its shortcomings. In Plato's view, its weakness was that the child was "schooled not by gentle influences but by force," for the Spartans neglected reason and philosophy

and "honored gymnastic more than music" (*Republic* VII:548).[2] For Aristotle, Spartan education was faulty because it was based upon one virtue. He was critical of "parents who devote their children to gymnastics while they neglect their necessary education, [for they] in reality vulgarize them," making them useful in one quality only (Castle, 1961, p. 26).

Athens in Contrast to Sparta

Unlike the Spartans, the Athenians looked beyond the confines of their city. As early as 800 B.C. the sailors and traders of Athens had reached the far corners of the Mediterranean. Travelers and foreigners were welcome in their midst. They developed a form of government by the rule of the people, or *demos*, in combination with a hereditary aristocracy who had special responsibilities of a religious nature. From the time of Solon, most Athenians earned their livelihood in the crafts and trades, and in spite of differences in wealth and prestige, they stood as equals before the law. In the period between Solon and Pericles, Athenian society was bonded together by a common ethical spirit, the community of the *polis*, which had its origins in Greek religion. They believed that a man's wealth was not for his use alone but was a potential resource for the good of the community. Those with lesser means contributed what talents and labor they could, with equal willingness, to the building of the monuments that adorned the Acropolis.

In 480 B.C. the Athenians defeated their longstanding enemies, the Persians; but in the process their city was reduced to ashes. With Pericles as leader, they rebuilt the city, centering their efforts upon the Acropolis, which was both their civic and religious center. Plutarch's biography of Pericles describes how the craftsmen of that time strove to surpass the quality of the materials and the design with the beauty of their workmanship. Indeed, this was appropriate, because on the crown of the Acropolis stood the Parthenon, the temple to the goddess Athena. More than the goddess of wisdom and the protectress of Athens, she was guardian of the arts as well. As Castle (1961) remarks, there was "nothing vulgar or flamboyant or merely clever in any of these works; but there is always reverence—for the polis, for the law, and for the gods" (p. 35). Thus we find that the religion, the constitution that formed the basis of a government of laws, the festivals, the drama, and the works of Athenian artists, each in its own way, reinforced the same cultural outlook and values; each contributed to the pattern of communal life, the polis.

SCHOOLING IN ATHENS. In the period between Solon and Pericles, the old aristocratic values emphasized duty and obligation. By 450 B.C. rule of

the Athenian state began to shift to its merchants, craftsmen, and profes-
sionals. They were not natural heirs to the ancient traditions that for centu-
ries had been accepted by the Greeks. With the rise to power of this new and
wealthy class, there was a general feeling that democracy would degenerate
to mob rule if the state could not find new leaders whose intellectual and
moral excellence could supplant the old aristocracy. A conception of educa-
tion arose whose aim was "the good life," which was based upon the devel-
opment of the whole personality, including its physical, intellectual, aesthet-
ic, and moral aspects. The educational pattern was carefully balanced
between gymnastics and music. Gymnastics was training in bodily strength
and grace, while music was for the soul. The state did not provide schools as
in Sparta, but it stipulated the conditions for running private schools, in-
cluding the hours of opening and closing and provision for moral supervi-
sion and safety.

The Greek term for music, *mousike*, had a wider meaning than the
modern word *music* now carries. Then it meant any of the arts and sciences
that came under the patronage of the muses. It also was used to refer to a
unity consisting of sung text and instrumental accompaniment that was
considered one of the accomplishments of all free-born men. Much of Greek
education revolved around learning the works of the great poets, and the
music that accompanied the text provided mood and rhythm to convey a
sense of character. It also carried the prevalent tone or sentiment of the
community, what was called ethos. Thus music was an integral part of
Greek educational experience, what they called *paideia*, that is, the individ-
ual's sense of identity with the culture (Castle, 1961).

DRAWING IN HELLENISTIC GREECE. According to Marrou (1956),[3]
the visual arts were also present in the form of drawing and began to enjoy
esteem during Hellenistic times. Drawing classes first made their appearance
in Sicyon in the fourth century B.C. under the influence of Pamphilus, one of
the teachers of Appelles, and from there it spread to the whole of Greece.
Aristotle listed it as an extra subject that pupils took in addition to the
normal curriculum of literature, gymnastics, and music, but a century later
the drawing teacher was listed as a regular member of the teaching staff.
During the second century B.C. drawing was listed as one of the subjects in
school examinations in Teos and Magnesia ad Meandrum.

Marrou notes that little is known about the ways drawing was taught,
but he believes that children were taught to draw with charcoal and to paint
on a board made of boxwood and that the chief activity consisted in drawing
from live models. According to Aristotle (Lord, 1982), the chief object of
drawing instruction was to make the students judges of the beauty of the
human form.

Art Education in Plato's *Republic*

In the era after Pericles, Athens was further troubled by wars and by the disintegration of its society into rival groups beset with mistrust and conflict. A class of teachers appeared, called Sophists, who attempted to prepare youth for roles as political leaders through the use of such subjects as rhetoric, the art of persuasion. The acquisition of linguistic skill took precedence over the study of the ancient poets, while the goal of seeking "the good life," with its emphasis upon the *polis* and *ethos*, weakened. It was supplanted by a goal similar to our current notion of material success. The neglect of direct training for citizenship troubled Socrates and Plato.

It was this deficiency that prompted Plato to write the *Republic*, which was a proposal for the reform of society through the education of the guardians of the republic. What Plato sought was a state that would be ruled only by the most able. The best would be found among neither the hereditary aristocracy nor the wealthy; rather they would come from an educated elite who had demonstrated their fitness to rule by their complete integrity, who had themselves seen the Good and taken it as a pattern for the right ordering of the state and of the individual (*Republic* VII:540).

Plato discussed the arts as an integral part of the proper education of these guardians, but before we can interpret his views on art education, we should understand the basis for his limited regard for the arts. Not only will this enable us to see how he came to value music more than poetry and the visual arts, but it will also help us understand the high place he gave to the role of reason in the affairs of the state.

For Plato, ultimate reality was to be found in "ideal forms," which are eternal and can only be apprehended by training the power of reason. In the tenth book of the *Republic* he illustrates this belief, using the example of the three beds. The *idea* of the bed is eternal and is made by God and hence is most true; the bed of the carpenter we see in the world of appearances; and finally, there is the bed as it appears in a painting. The bed of the carpenter has actuality but is an imitation of the ideal, which we cannot see. Images of beds that appear in pictures, then, are "imitations of imitations," and being two removes from the ideal, they are less reliable as knowledge. The painting presents the bed as it *appears*, not as it is in actuality, and such appearances are deceiving because the picture lacks many attributes of the archetype it imitates. Hence all pictures are unreliable sources of knowledge because they do not tell the whole truth, and by extension, all art is prone to error, even the art of the great poets such as Homer. Thus the arts are metaphysically suspect as modes of knowing (*Republic* X:597).[4]

Why did it matter to Plato that art should tell the truth, and why was it necessary for him to demonstrate that it did not? The answer stems from the

fact that during his lifetime there were important transitions occurring in Greek culture. For hundreds of years before Plato's time, the great poets such as Homer were deemed the principal sources of wisdom and truth. From Homer one learned how to live the good life and govern justly. The learned man was the one who could recite long passages of the *Iliad* and *Odyssey* from memory, skills that the Sophists could perfect in their students for a fee. Though old aristocratic values appeared to be secure in this tradition, Plato and Socrates recognized that these skills could be used by ambitious politicians to wrap themselves in a false cloak of virtue, much as today's politicians might be said to wrap themselves in the flag by uttering platitudes. Plato was intent upon reestablishing the state on a new footing, through the art of rational inquiry, with the guardians trained to use reason as the basis for the just conduct of the state.

Throughout the *Republic* Plato maintained that the supreme art is that of statecraft, and the statesman is conceived of as both an educator and a legislator. Among the matters that should concern the statesman is the impact of the arts upon the *polis*. Plato observed that hearing poetry and seeing beautiful architecture and statuary are among the higher pleasures open to the citizen, but such pleasure is not a sufficient test for the efficacy of art. Plato was disturbed by the fact that many works of tragic drama portray people in highly aroused emotional states that, in turn, evoke an emotional response in the audience. Plays about wise and serene personalities did not garner much interest in ancient Greece, any more than they would from a television audience today. But dramas about a mother driven by a jealous rage to slay her children (Medea), or a wife plotting the murder of her husband (Clytemnestra), would not please the rational part of the soul. Hence Plato concluded that "we shall be justified in refusing to admit such dramatists into the well ordered state" (*Republic* X:605).

To review, the arts were under suspicion because they were imitations of imitations. This was as true of statues and pictures as it was of poetry. A second concern was the danger to social decorum. Only one art, music, escaped this sanction; because it imitated not nature but the virtues themselves, it was thought to be closer to the "ideal forms." Music thus warranted and received a higher place in education than did the other arts.

In spite of their potential for harm, Plato did not advocate elimination of the arts from education, for he was no Spartan. Arts of the right sort could serve as an indispensable resource in the child's development. He realized that children's rational powers are not sufficiently strong to permit them to deal with the forms themselves. The arts that imitate these forms can thus serve a useful function, since they can enter the soul through the senses long before the power of reason has matured. Because the impressions formed in childhood are indelible and lasting, moral education could begin

by exposing the child to good works of art. Thus he proclaimed: "Let our artists be those who are gifted to discern the true nature of the beautiful and the graceful; then will our youth dwell in the land of health, amid fair sights and sounds, and receive the good in everything" (*Republic* III: 400–01).

Art and Education in Aristotle's *Politics*

Aristotle's view of art had its basis in a conception of reality that differed from Plato's, and consequently he arrived at different attitudes toward art and education. For Aristotle there was no separate world of the forms. All things in nature embody certain "universals," which one can approach directly in perception. Universal attributes are those qualities a thing shares in common with other members of its species. Aristotle also believed that all objects have certain "accidental" attributes as well. For human beings, these accidental qualities provide for the individuality of each person. One can have a nose longer than average, or darker skin, or curlier hair and still be recognized as a member of the human species. Aristotle refuted Plato's charge that poetry and other arts are inferior as sources of knowledge, for by presenting the universals of experience the poet focuses upon the knowledge that really matters (Schaper, 1968).

For Plato, the artistic process meant copying something that had prior existence, with the copy never fully replicating the model. The artist's work is doomed to fall short in its overall truthfulness; "inspired" artists are merely the instrument of the muses and have no true knowledge of their own actions. For Aristotle the artist was one who is skillful at the making of imitations. A drama might present imitations of people who did not exist in actual life, although they might have existed and might yet exist in the future. Though the work imitates nature, it is wholly unique. Art is not an imitation of an imitation, as Plato saw it; it is, rather, the one place where true representations can occur. To make art is to know the dynamics of nature and the psychology of human affairs. Artistic training involves more than mastery of a medium; artists must also know about cause and effect in nature and motive and consequence in human actions. Otherwise they would fail to produce convincing representations.

Aristotle was also concerned with the effects of art. He noted that audiences obviously derive pleasure from dramas in spite of their presentation of fearful and pitiable events and that somehow the violent emotions felt by the beholder are discharged, thus yielding a pleasurable sense of relief. Indeed this may be the purpose of the drama—to purge one of destructive emotions and thus to restore order to the *polis*.

Aristotle regarded music and poetry as essentially educative in a moral sense; moreover, he did not confine their educative role to the training of the

young but extended it to the culture of mature citizens as well. The cathartic tragedy was designed to reinforce moral virtue and prudence. According to Lord (1982), Aristotle viewed culture, which involves drama, literature, and music, both as a vehicle for civic education and as the central component of a kind of leisure that is essential in any kind of political order precisely because it serves to moderate the claims of politics.

In short, Aristotle's *Poetics* defended the cognitive status of the drama and by inference the other arts as well; social and moral effects were judged beneficial when the work provided both the pleasure of a convincing imitation and the impetus to learning. It was in his *Politics*, however, that he explained the educative importance of the arts in detail, the eighth book being one of the oldest extant rationales for the inclusion of the arts in education.

In the *Politics* Aristotle identified four branches of instruction, these being reading and writing, gymnastic exercises, music, and sometimes drawing. Reading, writing, and drawing are justified by their usefulness to life; gymnastic training, by its ability to infuse courage. But, Aristotle asked, why did our forefathers also include the study of music? In answer he drew upon a distinction that may be difficult for a twentieth-century mind to grasp, for in our own time we divide human endeavor into two categories—work and play. Work includes all necessary toil, while play encompasses our recreational activities. To these categories Aristotle added a third, namely leisure. Leisure is neither the absence of toil nor the recreational activity involved in play. Instead, leisure is that which we do for the intrinsic satisfaction it gives, that which can give the greatest happiness. Music is such a pursuit because it is an intellectual activity to be valued for its own sake. As he put it, "There remains, then, the use of music for intellectual enjoyment in leisure; which is in fact evidently the reason for its introduction, this being one of the ways it is thought a freeman should pass his leisure. . . . It is evident, then, that there is a sort of education in which parents should train their sons, not as being useful or necessary, but because it is liberal and noble" (1952, pp. 209–210).

In concluding that music is worthy of pursuit "for the sake of pleasure" as an intellectual enjoyment, Aristotle was agreeing with most of his contemporaries. But enjoyment and pleasure as reasons for music education were vulnerable to attack, especially in the education of the young. A stronger defense required something more meaningful than pleasure. He then proceeded to list the powers of music, the first being play and relaxation and the second being leisure associated with a pastime. He eliminated these as sufficient reasons for music education and finally proposed that the true goal of such education is virtue. Enjoyment and judgment at one level

can be limited to the aesthetics of the music itself, but at a higher level it is the enjoyment and judgment of "the decent characters and noble actions which music is able to represent" (quoted in Lord, 1982, p. 75) that make it educationally important.

Decline of Music and Gymnastics in Hellenistic Times

Both Aristotle's *Politics* and Plato's *Republic* were conservative educational treatises that attempted to stem the gradual erosion of traditional values in Greek life. In their views, this loss weakened the social order. They sought to return to the simpler virtues of Homeric times that were sustained by traditional music and gymnastics. Aristotle was vehement in his objection to the increasing professionalization of musical training for the young by private music teachers. Gymnastic training had also been subjected to a similar kind of professionalization; athletics was becoming a spectator sport, thus losing much of its original significance as training to infuse the soul with courage (Marrou, 1956). It was not that music and gymnastics had declined as values in Greek life but that they had lost status as media for the education of the young; thus by the time Hellenistic education passed to Rome, they had ceased being important areas in the curriculum.

This might explain why there was relatively little discussion of either the visual arts or music in Roman writings concerned with education. According to Gwynn (1926), Roman educational discourse employs the words *ars* or *artes*, which can be assigned to any professional practice. He notes that Varro included nine such arts in his *Disciplinae*, including grammar, dialectics, rhetoric, geometry, arithmetic, astronomy, music, medicine, and architecture. Galen, writing on medical education in the second century A.D., listed the arts of medicine, rhetoric, music, geometry, arithmetic, dialectics, astronomy, literature, and law; he listed sculpture and drawing as optional studies. Seneca listed the same arts, exclusive of sculpture and drawing, and it was his list that came to be thought of as the *artes liberales*, or liberal arts. The visual arts were listed by Seneca as belonging to a class of "frivolous arts" that also included dancing and singing. Vitruvius,[5] writing on the education of architects, listed literature, drawing, geometry, optics, arithmetic, history, philosophy, music, and even medicine, law, and astronomy as requisite studies.

The Arts in Roman Education

By the time of Cicero, the well-educated Roman was one who was educated by the Greeks. As early as 267 B.C., cultured Greeks were brought

to Rome as slaves. Livius Andronicus was one such Greek, who, after obtaining his freedom, became a teacher of the Greek language to Roman youths. He also translated Homer into Latin, thus making the *Iliad* and *Odyssey* available to Roman students. In succeeding generations it was not uncommon for Romans to travel to such centers of Greek learning as Athens, Alexandria, and Rhodes to study rhetoric and philosophy.

In Castle's (1961) view, Cicero's *De Oratore* (The Orator) is historically significant because it represents the triumph of Greek influence on Roman educational practice. In Cicero's view the purpose of education is to produce a good man skilled in speaking and thus able to be of practical service to the state. The true orator has to possess a good moral character, wide culture, and the ability to speak convincingly. Rhetoric as preparation for civic service was paramount in Cicero's treatise, but in later times the concept weakened and rhetorical training was pursued as mere affectation for personal display. A rigorous educational program degenerated into any empty formalism.

The aristocratic tradition of collecting artworks, which we mentioned as existing among the Greeks in Hellenistic times, entered Roman society as well. Indeed, Rome had many sculptors whose livelihood consisted of making copies of Greek statuary. There are reports from the latter days of the empire describing emperors who had learned to draw and paint but not to labor at sculpture (Dill, 1919). Plutarch's biographical account of the Roman general Aemilius Paulus states that he employed Greeks to teach his sons modeling and painting, among numerous other subjects.

By late Roman times Aristotelian ideas were out of fashion. Those of Plato were known, especially those aspects of his teachings inviting mysticism. In the third century A.D., Plotinus, the founder of the Neoplatonic tradition, developed a philosophy of beauty based upon Plato's view of inspiration. He believed that the inspired artist is one who can embody the Platonic forms in the materials of this world by a power given him through the activity of his soul. Such an artist does not merely represent natural objects as they are but also may add where nature is lacking. A tree in a picture and a tree in nature share the same "form," but the inspired artist's version is capable of capturing it more fully. Thus for Plotinus art is not merely imitation, as with Plato; it is revelation as well.

The embodiment of the ideal forms became a definition of beauty, but beauty was seen as more than a source of pleasure; it was also seen as a form of intellectual apprehension, for art makes the forms accessible to the senses. Although this suggests that the place of the arts would have been secure in education, such does not appear to have been the case in the latter years of the empire. The visual arts are notably absent in Roman discussions of education.

TEACHING THE ARTS DURING THE MIDDLE AGES

The city of Rome was abandoned by the Emperor Honorius as the capital of the Western Roman Empire in A.D. 402; after repeated invasions and sackings by the Visigoths and Vandals, it fell in A.D. 476. This is the date many historians use to mark the end of the Roman Empire and the beginning of the Middle Ages.

After the fall of Rome, secular activity in the visual arts came to a virtual standstill, as did trade and travel. Agriculture remained the principal economic activity. The patronage of the artist, musician, and poet was virtually at an end. With the spread of economic chaos, the workshops of craftsmen gradually disappeared. The towns, which relied upon trade, withered and fell into ruin. With the rise of the feudal system, Europe became a patchwork of landed estates, each a self-sufficient economic entity, including the monastic communities in the fold of the Church. The feudal economy was one that operated without money, trade for profit, or borrowing. To seek riches was to commit the sin of avarice, while lending at interest (usury) was regarded as a sin by the Church. Each estate had workshops for making the implements for daily living.[6]

The Church actively suppressed all remnants of pagan culture. Along with the arts, learning itself entered a period of decline. Yet some elements of pagan culture were preserved by monks and scribes, many of whom were educated in the classical tradition. Writers like Augustine were familiar with Stoicism, as well as the philosophies of Plato, Aristotle, and Plotinus, and they saw much in these doctrines that was in accord with the revelations of Scripture. In Augustine's view one does not achieve understanding exclusively by the exercise of reason. Rather, one must have faith in order that one can have understanding. Every aspect of life stood in direct relationship to faith and the truths of the Gospel. The arts and sciences as well as all thought and action emanated from the same religious conception of the world, in which the meaning of all things was expressed and explained in terms of the world to come (Hauser, 1951).

The key to the understanding of medieval society is land. Land was given to man by God to enable him to work toward eternal salvation. Labor was directly or indirectly tied to working the land, and the object of labor was not to grow wealthy but to maintain oneself in the position to which one was born until one passed over to the world to come. The clergy's function was to teach about the next world and to administer the sacraments, through which all persons may obtain grace. The function of the feudal hierarchy was to defend the land against heathens and spoilers so that both serfs and nobles could work out their destiny to enter the world to come. Labor was both a form of penance and a way to ennoble life. The monks in

the monasteries were primarily recruited from the aristocratic classes, and it was not uncommon for the son of a nobleman, as Hauser explains, who would "otherwise probably never handle a paint brush, a chisel, or a trowel, [to come] into direct contact with the crafts" (p. 168).

Monastic Schools, Scriptoria, and Workshops

With the decline in the level of literacy, there was need to make greater use of the arts to guide the faithful to God. By the time of Pope Gregory the Great, some two centuries after Augustine, pictures and statues could be used to illustrate the teachings of the faith, though Gregory cautioned that pictures in themselves should not be worshiped but should be used to lead the mind to God. Near the end of the eighth century (A.D. 787) the Council of Nicaea removed Gregory's stipulation by suggesting that the honor paid by the faithful to the image passes onto the subject represented in it. This made way for an expanded use of the arts as means for propagating the faith (Beardsley, 1966).

The aim of the early monastic schools was the same as the ultimate aim of monastic life—the salvation of souls. Benedict (480–543) formulated a series of rules for the conduct of the affairs of the monastery known as the Rule of Benedict. The 43rd rule declared that "idleness is the great enemy of the soul, therefore the monks shall always be occupied, either in manual labor or in holy reading" (quoted in Wilds & Lottich, 1962, p. 119). The rule went on to specify that seven hours of the day were to be spent in manual labor, while the sacred literature should be read for two hours. The monks became skilled artisans in wood, leather, precious metals, and glass. They became farmers and provided the peasants with information on agriculture. The convents for women also had similar requirements for manual labor, and the weaving of vestments and the embroidery of altar cloths were among the arts that were practiced. The reading requirement led both to collections of manuscripts in the monastery libraries and to the copying of manuscripts for exchange with other monasteries. Work in the scriptorium was done by those who were incapable of the harder forms of manual labor.

In the early monastic schools the educational content was very rudimentary, designed solely to prepare the monks for the essential duties of monastic life. Novices were required to learn to read to permit the study of the sacred texts, to write in order to copy the manuscripts, to sing in order to take part in the daily devotional activities, and to be able to do enough arithmetic to reckon the time of church festivals. At a later time the curriculum consisted of the seven liberal arts.

Grammar was also emphasized in monastic education as an introduction to literature. The study of rhetoric largely consisted of written composi-

tion, but it also included some church history and canon law. Dialectic played a small part in the monastic schools but became the major subject of concern in the Scholastic movement in the high Middle Ages. The monastic school was the only educational institution that operated in the early Middle Ages, and though it was primarily operated to train the monks, it also admitted boys who were in most cases the sons of nobles.

Work on books was carried out in the scriptorium, which was a large hall with numerous desks. Sometimes scriptoria were divided into cells, called "carrels," large enough for the writer, his desk, and a shelf for his inks and colors. Scriptorium work was considered equal to labor in the fields. To support this view, Addison notes the sixth-century Rule of St. Fereol, which contains the clause, "He who doth not turn up the earth with his plough, ought to write the parchment with his fingers" (Addison, 1908, p. 328).

Many different artisans were involved in the making of a book. The first was the scribe, who made the black letters of the text. Then came the painter, who was not only an adept draftsman but also needed to know how to prepare the mordants and to both lay gold leaf and burnish it. Then came the bookbinder. At first illuminations were confined only to the capital letters, and red was the color selected to enliven the written page. The red pigment was known as *minium*, and hence the artist who applied it was called a *miniatore*. Today's word *miniature* is derived from the pictures that were executed in later centuries, when the art of the book had developed more fully.

Participation was based upon level of knowledge and skill. The master was at the top of the hierarchy by virtue of his superior abilities, followed by his assistants. In addition, the monks in the scriptorium acquired their skills "on the job" under the guidance of the master, who might well have been the abbot himself. The quality of achievement was judged by the faithfulness of the copy. Since manuscript copying was done to pass on the Holy Writ, originality of execution was seen as no more important an attribute than would have been a reinterpretation of the word itself. Yet the quality of illuminated books improved steadily as new means were discovered and as the standards of skill became more exacting.

Because the Benedictine Rule prescribed manual as well as intellectual work, great importance was attached to the manual occupations in the early development of the Benedictine Order. These activities were consecrated to the greater glory of God, not practiced as a form of individual expression or for personal gain. The Rule also stipulated that "if there be artists in the monastery, let them exercise their crafts with all humility and reverence, provided the abbot shall have ordered them. But if any of them be proud of the skill he hath in his craft, because he seemeth to gain something for the

monastery, let him be removed from it and not exercise it again" (quoted in Addison, 1908, p. 4).

Yet several monasteries had begun to develop elaborate workshops that warrant description as monastic art schools. England's Alfred the Great imported talented artist-monks from the continent to establish such a school at Athelney. The king is described by Asser as being active in craftwork himself, and in spite of frequent wars, he continued to teach his workers in gold and artificers of all kinds. Hauser comments upon the extent to which many monastic workshops were renowned for the quality of their work.

> In many monasteries—as for example, in Fulda and Hildesheim—handicraft workshops were set up which served primarily educational purposes and guaranteed the monasteries and cathedrals as well as the secular manorial estates and courts with a constant supply of young artists. The monastery of Solignac which was founded by St. Eligius, the famous gold-smith of the seventh century, achieved a particularly high standard in its education work. (1951, pp. 171–172)

According to Addison (1908), the German city of Hildesheim owed its reputation as a Romanesque center of art education to Saint Bernward, who served as its bishop from 992 to 1012. Bernward was a student of art all his life and in times of war served as commander-in-chief for Hildesheim. Having traveled to Paris and Rome, he was consequently a man of wide culture for his time. He founded and directed a school for goldsmiths that was famous throughout Europe. He is described as an excellent penman, a good painter, and one who excelled in the mechanical no less than the liberal arts. He was also a collector who established a museum for the instruction of students who came in touch with him. He was canonized in 1194 by Pope Celestine III.

By the end of the eleventh century, the social forces that had favored the development of monasticism began to change. Amidst the feudal estates and monasteries, towns and cities began to rise and flourish. Travel became easier and safer: Pilgrims were on the roads to the sites of holy shrines, students traveled to seats of learning (the cathedral schools and universities), and knights were en route to fight in the Crusades. But more important than any other factor in bringing about a new social order and new situations for the artist was the development of trade.

Art Education in the Guilds

By the high Middle Ages new occupational classes had made their appearance, resulting in the development of new institutions. Among these were the craft guilds for the various artisans, which became a significant

part of the educational picture. Guilds brought together persons working in the same trade and established their rights with regard to each other and their obligations to their patrons. They would intervene on behalf of crafts-men involved in legal disputes and give assistance to the family of a member in time of sickness and need. Guilds also functioned to equalize the distribu-tion of commissions. These organizations operated under charters obtained from civil or ecclesiastic authorities; in exchange for such recognition, they undertook to instill rigorous self-discipline in and maintain control over their members (Perrine, 1937).

THE APPRENTICESHIP SYSTEM. The latent function of the guild was to control the labor supply by drastically limiting the number of apprentices who could be taught and those who could do the teaching, for taking on apprentices was a privilege that belonged only to the master. Apprentices usually began their period of training at the age of 13 or 14. In some cases the family had to pay the master for the training received, though in other situations apprentices received wages. A talented apprentice was more than likely to be paid for his services in Italy than in the northern Europe (Bleeke-Byrne, 1984). After a period of five or six years an apprentice usually received a certificate, and after an official test that often included the prepa-ration of a suitable "masterpiece," he could be appointed to the rank of master. A master could set up his own workshop and take on apprentices. The process of becoming a master was long and arduous, and few achieved this status.

In his treatise on painting, Cennino Cennini (1360–1437) advised that the apprentice should spend six years in "working up the colors; and to learn to boil the sizes and grind the gessos; and to get experience in painting, embellishing with mordants, making cloths of gold and getting practice in working on the wall" (1933, pp. 64–65). Through this period of intense technical training the young apprentice had to comply with the strict rules of the local guild. These rules had to do with the preservation of the secrets of the craft; they also limited the right of the apprentice to sell objects of his own making (Bleeke-Byrne, 1984).

The workshop was organized in an instructional hierarchy, with the master overseeing his assistants, who, in turn, supervised the apprentices. Training was by imitation of the master or assistants, with successful perfor-mance judged in terms of the accuracy of the imitation. As mentioned before, the system was not one designed to encourage artistic originality but rather to assure the transmission of a high degree of workmanship, and in this respect the system fulfilled its function very well.

Theodor Galle's engraving *The Invention of Oil Painting* (Figure 2.1) illustrates an artist's workshop at the end of the sixteenth century (ca.

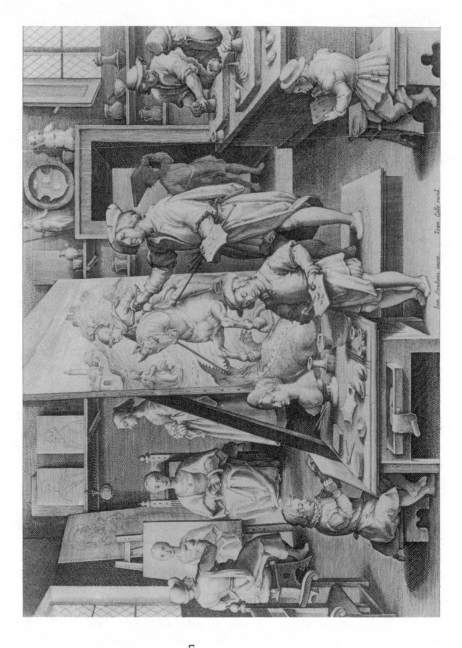

FIGURE 2.1.
Theodor Galle,
*The Invention of
Oil Painting
[Nova Reperta]*,
engraving after
Jan van der Straet
(Stradanus). The
Fine Arts Museum
of San Francisco,
Achenbach Foun-
dation for the
Graphic Arts,
purchase, 1966.
(1966.80.73).
Reproduced by
permission.

1580). Though portraying a Renaissance situation, it includes certain socio-logical features that were present in medieval workshops as well. For example, the figures at the right are coarsely dressed, in contrast to the more refined clothing of the master artist and the apprentices. Pointing to this detail, Bleeke-Byrne suggested that poor boys coming from families unable to pay instructional fees probably ended up spending their lives as drudges, while capable apprentices could advance to the role of workshop assistant or master.

WORKSHOP TREATISES. During the Middle Ages a number of treatises were prepared by craftsmen dealing with the problems that would be en-countered in the production of objects. Though most art instruction in the Middle Ages was by oral instruction or by copying, these were supplemented by written collections of knowledge. This literature consisted either of pre-scriptions for "making" such works or of models to be followed (Barasch, 1985). Much of this writing came about because the production of many goods had grown more complex and differentiated, demanding more spe-cialization and increased skills. The workshop thus became a place where this type of information was collected and codified to make it professionally available.

One of the earliest of the treatises, *Heraclius on the Colors and the Arts of the Romans*, is described by Barasch as a text written in several places and times and patched together at a later time. The writer urges the reader to try some of the techniques, asserting that testing the suggestions would show them to be true. This suggests that craftsmen not only copied from models established in the past but also experimented with new techniques. The treatise primarily discusses the preparation of colors for the writing and illuminating of manuscripts, the handling of glass, the cutting of semipre-cious stones, and techniques for treating gold.

One of the most important treatises was called *The Various Arts (De Diversis Artibus)* by Theophilus Presbyter. One of the best sources on the technology of the medieval period, it was composed in the first half of the twelfth century by a monk, probably of the Benedictine Order. It contains one of the first references to paper in Western Europe, but it also describes bell founding and organ building. The technical processes in casting, ham-mering, and soldering gold and silver it describes document the state of knowledge and practice as it existed in the eleventh century.

Theophilus described the proper arrangement of the workrooms, the benches at which the smiths were to sit, and the procedures that were to be followed to make the tools for sculpting, scraping, and hammering. All the implements of the craft had to be made by the craftsman. With *The Various Arts*, the fruits of the monastic tradition were passed on to the workshops of a later time (Barasch, 1985).

TEACHING THE VISUAL ARTS
DURING THE RENAISSANCE

The Italian Renaissance was one of the crucial turning points in Western cultural history, for it laid the groundwork for modern conception of the arts. The separation of the fine arts from the crafts was to have profound consequences for the teaching of art. When the artist rose to the position of genius, new educational questions presented themselves, for how does one instruct a genius? Is it appropriate to train the potential genius like a lowly apprentice?

Renaissance Humanism

A group of scholars known as humanists secured a respected place for the work of art by stressing its similarity to literature and history. Humanism was not so much an organized system of belief as a philosophy of education favoring the pursuit of classical studies. It centered around the study of the literature of antiquity, including its history, philosophy, and poetry. The humanists developed the practice of going back to original documents in classical and scriptural sources. They read Plato in the original Greek rather than in second- and third-hand translations. Above all, the humanists spread the ideal that general education, in and of itself, was inherently valuable for everyone, that it should not be limited to the clergyman or physician.

Humanistic education triumphed through the establishment of new schools that showed more promise to youths than the monastic or cathedral schools of previous ages. These focused on the recovery of the classical intellectual inheritance by Italian scholars. What emerged was a model for a new type of secondary school, one that was to dominate European education for several centuries to come. These first classical secondary schools were the court schools in Italy, on which the German gymnasium, the French lycée, and the Latin grammar schools of England were modeled. They were founded by the ruling princes and dukes in the city-states. Famous schools were located in Florence, Venice, Padua, and Verona, but among the most influential was the school at Mantua directed by Vittorino Da Feltre. A renowned classical scholar, he was able to develop a curriculum and methods for imparting the new learning (Kristeller, 1961; Wilds & Lottich, 1962).

The schools of the humanists differed from their medieval predecessors in making greater use of printed texts as opposed to the lectures of the earlier schools. Written themes replaced the oral disputation so common in medieval education. Of great importance for the arts was the fact that the expo-

nents of humanism studied the literary and artistic aspects of the classical heritage as well. Students were taught to appreciate the beauty of the literature, architecture, poetry, and drama of the past. Aesthetic education, wholly absent from medieval education, was stressed for the first time (Wilds & Lottich, 1962).

These scholars were especially successful in establishing the importance of *studia humanitatis* in the minds of the well-to-do laity, especially the claim that such study has a special moral and civic importance, since the humanities contain all the broad truths of human experience. In addition, they succeeded in developing a strong sense of cultural identity—the feeling that one should become conscious of one's own time and culture in relation to one's own past traditions and those of other people. This attitude can be seen in such phrases as Petrarch's description of the Middle Ages as the "dark ages" and his own age as a "renaissance" to be attained through the rekindling of the learning, the recovery of aesthetic forms, and the political values of the past.

> The last four decades of the Quattrocento saw humanism thoroughly established in court and literary circles in all parts of Italy—not only in Medicean Florence, the papal curia, and court of Alphonso V. at Naples, in Sforza Milan, and at Venice but in the minor princely courts of the Gonzaga at Mantua, the Estes and Ferra. . . . Humanists were active as private tutors, as teachers in the schools and universities; as secretaries, orators, and diplomats; as consultants on classical mythology, tombs, inscriptions, and architecture; as court poets, and historians. They were active in the service of the states and of powerful individuals. (*EWA*, 1959–1968, Vol. 8, cols. 715–716)

Neoplatonic Theory and Its Impact on the Arts

In the last third of the fifteenth century a small circle of humanist scholars came together in Florence under the sponsorship of Cosimo and later Lorenzo de Medici. Heading this group was the philosopher Marsilio Ficino, who translated into Latin many of Plato's dialogues—in particular the *Timeas*, the *Ion*, and the *Symposium*—and provided extensive commentaries on these works. Highly allegorical, as were all his classical commentaries, his original interpretation of the Platonic doctrines of love and beauty would particularly influence the theory of the arts and their value in human experience (Kristeller, 1961).

Teachers like Ficino helped pave the way for the acceptance of the artist as a member of a cultural elite as opposed to the medieval idea that the artist was merely a skilled craftsman. Now the artist was seen as a uniquely endowed individual participating in godlike creative endeavors.

Renaissance Art Theory

The ideas of the humanists were reflected in a new architecture based upon the study of monuments from classical antiquity. The centrality of man is abundantly evident in such paintings as Raphael's *School of Athens* and enunciated in treatises such as Alberti's 1435 work, *Della Pictura*. Three of Alberti's principles clearly reflect the teachings of the humanist scholars:

1. A painting should evoke a sense of spatial and historical actuality by using a combination of perspective and a system of proportion and scale based on the human figure.
2. A painting should have an *istoria*, or theme, a dramatic situation or historical episode from classical literature or the Bible.
3. The particular theme should be elaborated through the appropriate use of color, light, proportion, and composition so as to communicate a living, visual drama that would edify, terrify, please, or instruct the viewer.

Alberti's principles exemplified the humanist's preference for literary or historical content. His insistence upon the use of appropriate technical means can be equated with the humanist's concern for eloquent rhetoric that states important truths with care and artistry. Finally, the purpose of the work is achieved when it moves the viewer to an appropriate moral or religious insight. Works that achieve this end embody a truly humanist conception of art (Blunt, 1963).

Renaissance Art Education

The ideas of such theorists as Alberti and Leonardo led to a questioning of the adequacy of an art education supervised exclusively by the guilds. Though there was no question that such practical training was necessary to produce high levels of craftsmanship, the workshop could not provide prospective masters with the humanistic learning that Alberti insisted was necessary to the overall education of the artist.

The new social status of the artist in centers such as Florence led many to question their association with the guilds as a prerequisite for the practice of their art. With the successes of such personalities as Leonardo and Michelangelo, artists became more intent upon realizing the expression of their internal vision and wanted the freedom to seek patrons in the same manner as the humanist scholars, who could move from city to city and from court to court. The traditional regulations of the guild restricted such peripatetic activities. Fortunately for Leonardo and later Michelangelo, they lived at a

time when their art was so greatly admired that it gave them a status that lessened their dependence upon the guild. The fact that the artist had come to occupy a position of respect in the courts of princes and popes accentuated the demand for a broader conception of art education than the medieval system of instruction could provide.

Both Leonardo and Michelangelo were involved with the leading ideas of their time and were associated with the intellectual circles where such ideas were in daily commerce. Both exhibited an active scientific curiosity, and each succeeded in leaving the stamp of his unique personality upon his works. They were recognized not merely as masters with superlative skills but as geniuses whose talents were divine in origin. Once artistry was viewed in this light, the entire educational program of the guilds, with its servile submission to a local master, was in jeopardy. The guild master could only transmit skills that he himself possessed; he could not nurture another's genius.

As a consequence, art education in the Renaissance called for an educational approach more in keeping with the notion of genius. This took the form of academies—places where knowledge of the theory and philosophy of artistic practice, based on the search for universal knowledge of the science of art, could be developed and shared by teachers and students working in concert.

> Leonardo was the first to question the typical routine of the workshop which placed practice above the work of free interpretation. "Study knowledge first, and then follow the practice dictated by this knowledge." This view was echoed by Michelangelo, according to whom, "one paints with the mind not the hand," and who considered sculpture to be a "scienza studiosa" (a learned science, not a mechanical or servile art). In this concept of art the link between master and pupil can only be an academy, a place of pure speculative study where the relation between members is that formed by free research without an ever present authority. (*EWA*, 1959–1968, Vol. 8, col. 151)

The first academies were not art schools in the modern sense, where there are formal curricula directed by teachers. Rather, these Renaissance academies consisted of groups of artists of various ages, some neophytes and some accomplished masters, who would gather together to draw, or to watch others demonstrate new techniques or principles, or to discuss theories of art and other developments of a general cultural nature. They were informal philosophical circles brought together under the auspices of a noteworthy sponsor, such as a Cosimo or Lorenzo de Medici, or perhaps a prince of the Church. The curriculum, if it could be called that, consisted of the theories being developed by the contemporary artists themselves, who dealt with the mathematical basis of the arts, anatomy, or humanist inquiry

into the antique. Pevsner (1973) places Leonardo at the beginning of the movement, since his theoretical ruminations lay at the basis of all subsequent systems of academic art education.

Leonardo's treatise on painting contains his ideas about art instruction. This treatise is more in the nature of a collection of precepts written down at various times without any special order. It was his intention to organize these into a more comprehensive doctrine at a later point in his life, a task he never lived to carry out. He indicated the sequence of instruction that was to become the central core of academy practice in later generations:

> First of all copy drawing by a good master made by his art from nature and not as exercises; then from a relief keeping by you a drawing done from the same relief; then from a good model; and of this you ought to make a practice. (Da Vinci, 1958, p. 899)

In an engraving by Pierfrancesco Alberti (Figure 2.2) several aspects of Renaissance art education are aptly illustrated. In the lower left-hand corner a student is being instructed in copying schemata of the various parts of the body, in this case the eye. In the upper left a group of students draw from a plaster cast of a leg. The art of architecture is depicted in the back of the atelier, while in the lower center a group is being instructed in the geometry of perspective drawing. In the lower right a group draws from the skeleton, while to their right can be seen students at work in sculpture. Behind them a group is dissecting a cadaver. On the wall the major genres of painting are represented with landscapes, portraits, and religious subject matters. The training sequence appears to follow Leonardo's sequence, with work from three-dimensional models following the mastery of two-dimensional drawings.

For this purpose a master usually had a collection of drawings and casts to aid students in their training. The etching of eyes shown in Figure 2.3 is from one of the first drawing manuals for artists and their students, published by Odoardo Fialetti in 1608. The manual illustrates parts of the human body such as eyes, ears, torsos, and legs.

Another depiction of Renaissance art education can be found in Agostino Veneziano's portrayal of the academy sponsored by Baccio Bandinelli in Rome (Figure 2.4). According to Roman (1984), both Alberti and Leonardo urged that students draw sculpture by candlelight because it defined the planes in such a way that the student could become proficient at rendering relief. Roman also discusses the underlying symbolic meaning of Veneziano's engraving, suggesting that the samll sculpture located at the left of the candle is probably an Apollo, which, being located closest to the light source, is therefore the source of inspiration. The candle is also the symbol of nocturnal study, signifying the studious nature of artistic inquiry.

The first formal academy of art, the Accademia del Disegno, was established by Georgio Vasari in 1562. Some 36 distinguished artists were select-

FIGURE 2.2.
Pierfrancesco Alberti, *A Painter's Academy in Rome*, engraving. The Metropolitan Museum of Art, The Elisha Whittelsey Collection, The Elisha Whittelsey Fund, 1949. (49.95.181). All rights reserved, The Metropolitan Museum of Art. Reproduced by permission.

FIGURE 2.3. Odoardo Fialetti, "Eyes," from *Il vero modo et ordine per dissegnar tutte le parti et membra del corpo humano*, Venice, 1608, folio 4. Print Collection, Miriam and Ira D. Wallach Division of Art, Prints and Photographs, New York Public Library, Astor, Lennox and Tilden Foundations. Reproduced by permission.

ed as members, of whom 32 were residents of Florence. The move to create the academy was spurred by the feeling that the age of greatness was passing, that the period of great masters and great discoveries had come and gone. Leonardo and Raphael were dead, and Michelangelo was an old man whose major accomplishments were behind him. Vasari attempted to develop the rules for art, basing them on the discoveries of these giants. These rules thus came from art itself rather than from nature, as before, making art its own discipline with established methods of inquiry and teaching.

When Vasari used the term *de maniera*, he literally meant working in the manner of the masters of the high Renaissance. He could boast that in the past it took Michelangelo six years to finish one work, while with his system of rules, it was possible to do six works in a single year (Fleming, 1968). As Blunt put the matter, painting had ceased to be the intensely serious pursuit it had been for Leonardo and Michelangelo; it had become instead "a game of skill appealing to a love of ingenuity and leaving the rational faculties undisturbed" (1963, p. 91).

In 1593 the Accademia di S. Luca, founded by Frederico Zuccari under the auspices of Cardinal Borromeo, opened in Rome. At approximately the same time, an academy was established by the Caracci brothers in Bologna. Their institution differed in that it was a private establishment, sponsored by neither prince nor clergy. Private academies became common in Italy by the late sixteenth and early seventeenth centuries. Their existence can be taken as evidence that the vocation of the artist had become respectable since the days of the early Renaissance. The Caraccis were consciously eclectic in their teaching theory. They were also conscious of the decline in the quality of Italian painting since the days of Pope Leo X and hoped to put a stop to this trend "not by new discoveries but by the intelligent imitation of the works which the masters of the Renaissance had created. For them . . . painting was a science

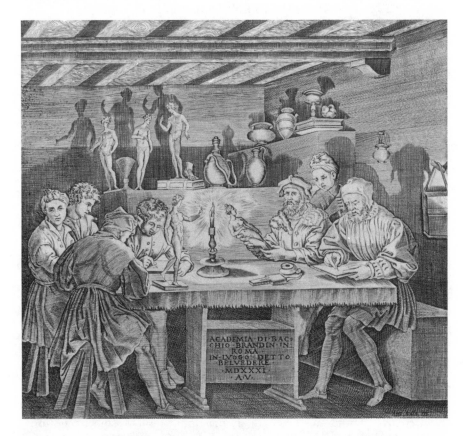

FIGURE 2.4. Agostino Veneziano, *The Academy of Baccio Bandinelli*, 1531, engraving after Baccio Bandinelli. Davison Art Center, Wesleyan University, Middletown, CT. Reproduced by permission.

which could be taught according to fixed rules, and these rules could be discovered by studying the example of good masters" (Blunt, 1963, p. 137).

By the end of the sixteenth century academies had ceased being the circles of intellectual enthusiasm they had been in the latter decades of the fifteenth century, places where new artistic discoveries were discussed, debated, demonstrated, and disseminated to artists and patrons alike. In later generations the model of art education chosen for France was provided by the academies of Rome and Bologna. Teaching had reduced art to a set of absolute rules grounded in the undisputed authority of the past genius of high Renaissance art.

THE AGE OF ABSOLUTISM
AND THE FRENCH ACADEMY

The mood of self-confidence so characteristic of the Renaissance, when humanity measured all creation against its own image, had given way to doubt and questioning. The schism in the Church, wars, and social upheavals marked the end of the Renaissance. Yet it was no longer possible to return to the spiritual outlook of the Middle Ages. Assailed with doubt, society turned instead to political absolutism, reason, and science. A new consciousness took form in the seventeenth century that would influence the teaching of the arts until the end of the nineteenth century.

The Arts and Sciences in the Age of Reason

By the seventeenth century the Aristotelian system of learning had been swept aside by the rise of the empirical sciences. The accompanying reduction in the status of the arts can be seen in the writings of such philosophers as Roger Bacon and John Locke, who insisted upon precise forms of speech to convey the objectivity of science. The poetic allusions of the classical humanists, once the very model of scholarly erudition, were now viewed as mere forms to indulge the fancy, inappropriate for the communication of propositional knowledge. The language of science was distinguished both from ordinary language and from that of literature and art, something that would have been incomprehensible to Leonardo.

The Ideology of Absolutism

Descartes found his absolute in his doubt. But absolutist notions seemed to be confirmed by science as well. The laws of the universe were

ones that had no exceptions, and Copernicus proclaimed that "the sun, as if sitting in a royal throne, governs the family of stars which move around it." In like manner, the king was the center of the French state, ruling his subjects by the light of his majesty. It was thus no accident that Louis XIV was the *roi du soleil*, or sun king. The sun as his symbol appeared on coinage, in the decorations of Versailles, on emblems, and on inscriptions in official documents (Fleming, 1968).

For the arts the principle of absolutism meant that their primary purpose was to assert the power and prestige of the state. In the case of Louis XIV, he *was* the state: "L'etat, c'est moi." To this end France established a series of academies for the various arts, sciences, and literature. The Academy of Language and Literature was formed in the previous reign in 1635; the Academy of Painting and Sculpture was formed in 1648; the Academy of Architecture came into being in 1671 (Pevsner, 1973).

The Position of the Arts in the Absolutist State

Addressing the French Academy in 1663, Louis XIV said: "You can judge, messieurs, the very esteem that I have for you since I confide in you the matter in the world that is most dear to me, which is my glory" (quoted in Isherwood, 1973, p. 158). Architecture, music, painting, and sculpture were not created to indulge the king's fancy or to beautify his surroundings; they were used systematically to build an image of glory and grandeur. Grandeur was the strategy employed for asserting the divine right of kings and at the same time placing France in a position of leadership among the nations of Europe. This leadership was to be in the arts and commerce as well as on the battlefield. Art in France was political propaganda in the same way that the art of the Counter Reformation was propaganda for the Church.

The idea that art was a powerful instrument for influencing minds and hearts had been implicit in the proceedings of the Council of Trent in the sixteenth century, which saw a role for art in strengthening the allegiance of the faithful to the Roman Catholic Church. What was new in Louis's reign was the extent to which the policy was institutionalized in the apparatus of government-sponsored academies to oversee patronage, censorship, and education.

Changes in General Education

The Protestant Reformation of the sixteenth century had spread the idea of the humanistic classical school through the Protestant German states. Philipp Melanchthon, a close associate of Martin Luther, was respon-

sible for setting up the schools of Saxony, the first state-controlled school system in history. He devised a three-tiered system made up of the vernacular primary school, classical secondary school, and the university for the training of leaders and professionals. This educational pattern is still to be found in many European countries today.

By the end of the sixteenth century, however, the methods of the schoolmasters had begun to degenerate into a type of linguistic formalism, with exercises stressing the routine pronunciation of words and rote memorization. Secondary education had become a matter of learning the rules, declensions, and conjugations of Latin grammar and memorizing long passages from the classics (Wilds & Lottich, 1962). The broadly based humanism that had come to the fore during the Renaissance, which was to be the fertile soil for kindling lay interest in the arts, failed to live up to this promise.

Art Education in the French Academy

The French Academy of Painting and Sculpture was founded in 1648. It arose as a result of a rebellion of French artists against the guild restrictions that had governed painters and sculptors in Paris since the thirteenth century. As early as the reign of Henry IV (1589–1610) the monarchy had recognized that the guilds were obstructing the establishment of new industries and plans for the embellishment of Paris, but in 1622, during the reign of Louis XIII, the guilds succeeded in obtaining reconfirmation of their privileges. They were able to forbid imports of art objects and to keep out foreign artists as well. At the time these guilds were intent upon keeping Italian art and artists out of Paris.

Court artists who were not members of the guild devised a plan that would circumvent the guild, namely the formation of an academy. They petitioned the crown for such an establishment. Their petition contained an outline of the program of art education that would be carried on by the academy, which included the teaching of architecture, geometry, perspective, arithmetic, anatomy, astronomy, and history.

The foundation meeting for the new academy was held in February of 1648, at which time the rules were established. The academy was charged with conveying the principles of art to its members by means of lectures and with imparting instruction to students by means of the life drawing courses. As in the academies of the previous century in Florence and Rome, a different teacher, who was responsible for posing the model, was appointed each month. Two hours a day were reserved for the life drawing class. The most important event in assuring the ascendency of the institution was its securing a monopoly on the life drawing course. Nowhere, outside the academy, was

the teaching of life drawing permitted. Private life drawing circles were forbidden in the studios of all artists who were not members of the academy (Pevsner, 1973).

The painter Charles Le Brun was appointed *premier peinture du roi* and chancellor of the academy. By 1663 all court painters were obliged to join the academy, and failure to join meant a loss of patronage privileges; but the prestige that was accorded to members of the academy was enormous, and membership was deemed more a privilege than an obligation. Since its rules were law and all members were expected to observe these principles in their art education activities, the academy was able to dictate aesthetic canons to the artist in a way that would have amazed and shocked Leonardo and Michelangelo. Now artists were part of the apparatus of the state, and the details of their art were supervised by the king's ministers.

The professors in the academy had to pose the model, supply drawings to be copied by beginners, and correct the efforts of the students. They served in rotation, with a different instructor appointed for each month, thus diffusing the influence of any individual artist's style on the students.

The course of the academy was divided into a lower and a higher class. The lower class of students had to copy from the drawings of the professors, while the upper class drew directly from the live model. An intermediate stage consisted of having students draw from plaster casts, but it is not clear whether this was part of the lower or upper course. The sequence of drawing from drawings, drawing from casts, and drawing from the model was viewed as the heart and core of the method from the latter years of the seventeenth century to the latter years of the nineteenth century.

The academy concentrated on providing students with theoretical knowledge through the academy lectures, while the technical training was provided in the ateliers of the academicians. Thus the educational scheme retained some elements of apprenticeship from the past. The crown secured its monopoly in art education by controlling access to the theory of art—it was less interested in limiting control over the technical aspects of the medium. It took an interest only in those aspects that would assure the maintenance of the "official" style and ideology of the realm. Academic instruction also provided the art student with a stock of motifs, myths, and allegories that could be drawn upon to develop appropriate imagery to support the official legend and hence be found acceptable to the crown.

THE ACADEMY LECTURES. Naturally, the lectures on perspective, geometry, anatomy, and especially the analyses of paintings through which the rules of the method had been formulated were of great importance. These rules, or *préceptes positifs*, were to be laid down in writing for the benefit of aspiring artists. According to Pevsner (1973), no epoch in the

history of art has had so unswerving a faith in clear, mathematically prov-
able rules and in arguments accessible to reason as that of the golden age of
absolutism.

The academy lectures were designed to acquaint students with art prin-
ciples. A picture from the royal collection would be analyzed according to
the various categories of judgment identified by Fréart DeChambray in his
1662 treatise, *L'Idée de la perfection de la peinture*. The categories were
invention, proportion, color, expression, and composition. Le Brun had
devised a similar set of categories, which he used with great success in his
analysis of the paintings of Poussin. Two additional treatises had an influ-
ence upon the academy in later years. The first was André Félibien's 1666
treatise, *Conversations on the Lives and Works of the Most Eminent Paint-
ers*, which established the hierarchy among the various genres of painting.
Still lifes were placed at the bottom, landscapes above still lifes, followed by
pictures of animal life. Then moving over into the human realm, people were
more important than animals; nobles were more important than peasants,
and so forth. At the top of the scale was the portrayal of important historical
events. The second influential treatise was Roger de Piles's 1708 *Balance des
Pientures*, which evaluated the most famous painters according to the degree
to which they conformed to the academy's rules, using a system of points on
a scale from 0 to 80. Not surprisingly, Le Brun scored high on the list, being
placed immediately under Raphael and Rubens, while Michelangelo and
Dürer were rated lower.

One of the topics most resistant to rational inquiry was that of expres-
sion. After his retirement as the academy's director, Le Brun developed a
theory of expression based upon Cartesian psychology. He produced his
Expression des Passions in 1698. If a student wanted to portray a person in a
state of anger or remorse, he would observe such faces in the Le Brun essay,
noting the creases in the forehead, the flaring of the nostrils, and the dishev-
eled hair. Formulas for the depiction of each of the soul's passions were thus
stipulated (Rogerson, 1953). A drawing of the proper expression of these
passions (Figure 2.5) was included in an English translation of the Le Brun
treatise that was published in 1703.

THE ROYAL MANUFACTURIES. The academy not only determined the
rules for art and the basis for patronage; it was also responsible for the
supervision of the royal manufactures, where the objects for the decoration
of the king's residence and public buildings were made. Sèvres, located
outside of Paris, was the location of the royal porcelain factory, while Gobe-
lins was a center for weaving, tapestry, and textile production. Le Brun and
other academicians provided the designs for objects to be made by crafts-
men working in these manufactures. Le Brun was also responsible for

DRAWING. The Pafsions. Plate IV.

Attention.

Admiration. Veneration.

Admiration with Astonishment.

Rapture. Joy with Tranquillity.

Desire.

Laughter. Simple Bodily Pain.

Acute Pain.

FIGURE 2.5. "Drawing the Passions," from *The Elements of Drawing in All Its Branches*, Plate IV, etching with engraving after Charles LeBrun. Yale Center for British Art, Paul Mellon Collection. Reproduced by permission.

the art education of the workmen, and with these craftsmen he used essentially the same system as that for training artists. Thus the academy was more than an art school; it was also an extension of the plans for the economic development of France through the arts. At this time the country became one of the leading exporters of luxury goods to the rest of Europe. But France's use of the painting academy to further national industry established a pattern of education that secured for the French a dominant economic position in succeeding centuries, a pattern that became apparent with the onset of the Industrial Revolution at the end of the eighteenth century.

Art Education for Amateurs

In the early decades of the seventeenth century the courtly ideals of Castiglione were taken as the model for the well-rounded gentleman. *The Book of the Courtier* was widely read on the continent and was translated into English by Hoby in 1561. Though a knowledge of the visual arts was deemed a gentlemanly trait, much like the dance, it was not regarded as a serious leisure pursuit. In *Some Thoughts Concerning Education*, John Locke recommended that a knowledge of drawing was desirable for the gentleman traveler but was quick to add that he would not favor "hav[ing] your son a perfect Painter," for that would take time away "from his other Improvements of greater Moment." The passage on drawing is provided below:

> When he can write well, and quick, I think it may be convenient, not only to continue the exercise of his hand in writing, but also to improve the use of it farther in drawing, a thing very useful to a gentleman in several occasions, but especially if he travel, as that which helps a man often to express, in a few lines well put together, what a whole sheet of paper in writing would not be able to represent and make intelligible. How many buildings may a man see, how many machines and habits meet with, the ideas whereof would be easily retained and communicated by a little skill in drawing; which, being committed to words, are in danger to be lost, or at best but ill retain'd in the most exacting descriptions? I do not mean that I would have your son a perfect Painter; to be that to any tolerable degree, will require more time than a young gentleman can spare from his other improvements of greater moment. (Locke, 1693/1964, p. 118)

Locke believed that the mind's ideas could be communicated more precisely by images than by language, which necessarily contains a degree of imprecision. Thus he could justify the teaching of drawing on cognitive grounds. His refusal to consider painting a suitable career suggests that he considered artistic pursuits to be of relatively low value.

ART EDUCATION DURING THE ENLIGHTENMENT

By the 1700s the scientific spirit that had arisen in the previous century was beginning to introduce new changes in European civilization, for science brought about improvements in technological capabilities, which in turn led to the Industrial Revolution. In addition, science generated new attitudes concerning the supernatural. If God was truly the creator of the universe and its laws, was He not obliged to honor them? The notion of a divine prerogative that could suspend the laws of nature — as in "miracles" — strained the credulity of enlightened thinkers. Moreover, human beings were given minds whereby they could discern these laws for themselves. Such attitudes concerning the nature of the divine ultimately led to the questioning of such premises as the divine right of kings. In time political revolutions affected the major nations of Europe, and near the end of the century, France brought an end to the reign of its Bourbon kings.

Absolutism was replaced by systems of parliamentary governance. Sometimes these changes occurred peacefully, as in England and Holland. In France, the violence of revolution was required to bring about change. During the new century the fruits of scientific investigation brought about improvements in technology that laid the foundation for the Industrial Revolution. Indeed, technical progress and the increase of constitutionally guaranteed liberties marked this as an age of progress.

Ideas of Reality in the Eighteenth Century

Though Newton's *Principia* was written in the seventeenth century, it was in the eighteenth that its cultural implications began to be understood. Indeed, Newton's ordered view of the universe was to the eighteenth century what Thomas Aquinas's *Summa Theologica* was to the thirteenth and what Aristotle's philosophy was to Hellenistic times. During the eighteenth century, the universe was likened to a gigantic clock, with God as its maker. God was the creator of the system of stars and planets and the laws that governed their motion. Eighteenth-century religion was one that had to be founded upon principles of reason accessible to educated persons, as opposed to divine revelation given to a few or to systems of institutional dogma.

Because God created nature and its laws, it was good, and humanity in its natural state was good also — obeying nature's laws is obeying God's laws, since they are the same. Human actions in accord with these laws are also intrinsically moral. People become corrupt by following the artificial laws of society instead of the laws of nature. The institutions created by man seemed arbitrary, corrupt, and cruel — in a word, irrational. Nature was seen as

providing the possibility of boundless good, while humanity's troubles were perceived as rooted in the artificiality of social institutions (Schneider, 1965).

This idea was expressed with vehemence by Jean Jacques Rousseau near the end of the Enlightenment, especially in his novel *Emile*, which is a critique of the corruption of civilized society. In its time *Emile* was also read as a pedagogical treatise; indeed, it was the catalyst for a series of educational reforms based upon learning through the senses that would culminate in the work of Pestalozzi and Froebel in the century to come (Baker, 1982).

New economic policies came into being to allow for the expansion of trade and the accumulation of private wealth. Adam Smith, for example, theorized that among individuals there arise natural divisions of labor, not because some are better endowed but because they can develop their talents to a high level by dint of their education and experience. Some naturally become better producers of goods than others, and the wise society is one that allows its members to develop their talents to the fullest and to compete in a free-market situation wherein those with the better goods would prosper while the poorer producers would not. In such a society, then, everyone benefits by the development of the best tendencies. Laissez-faire economic policies began to replace the more conservative mercantilist policies of the previous century.

The belief in progress, in laissez-faire economics, in the democratic ethic, in individuals' capacity to secure their own happiness—all these came into prominence during the eighteenth century. They were important in shaping American ideas of education. Of great importance, also, was the idea that society should provide for the education of all its members. This notion was stressed not only within the more liberal societies but within absolutist states as well. Frederick the Great said in 1772 that "the true well being, and glory of a state require that a people be as well educated and as enlightened as possible" (quoted in Wilds & Lottich, 1962, pp. 263–264). It was in this spirit that the rulers of the German states became pioneers in the organization of *Realschulen, Burgherschulen*, and new academies for the teaching of art to satisfy the needs of industries. In the Protestant north, opportunities for education had greatly expanded, although compulsory education did not make its appearance until the beginning of the nineteenth century.

Schooling in Colonial America

The first New World settlements by the English were founded early in the seventeenth century. Jamestown, Virginia, was settled in 1607; Ply-

mouth, Massachusetts, in 1620; and Boston, ten years later. The first Latin grammar school was founded in Boston in April 1635. This was the Boston Latin School, which is still in operation today and has the distinction of being the oldest "free" public, nonendowed, nonsectarian secondary school in the United States (Holmes, 1935).

The early settlers in Boston were Puritans who had left England in search of religious freedom. Most of them had been well educated in the grammar schools of England, and Boston Latin was their attempt to replicate an educational pattern with which they were familiar. It was their opinion that classical learning, with its emphasis upon ancient languages, was the foundation of their church and state. The object of instruction was to secure a body of learned scholars and ministers who, through acquaintance with Latin, Greek, and Hebrew, could study the Scriptures in their original languages. In 1642 the General Court of the Massachusetts Bay Company passed a law to insure that in all towns provision would be made to enable all children to read, write and understand the principles of religion and the laws of the country. It also provided for the levying of fines for failure to comply with the act. The law was the first in the English-speaking world ordering that all children should be taught to read. These school laws represented the first attempt to establish a universal, tax-supported, and state-controlled school system in colonial America.

The Latin school tradition was not without its critics, including Milton and Locke, whose writings influenced Benjamin Franklin when he wrote his proposal for an academy in Philadelphia in 1749. In *The Tractate of Education*, Milton had attacked the dull instruction in the classical grammar schools in seventeenth-century England and then gone on to describe the form of an academy that would serve both "practical" and scholarly purposes served by the traditional grammar schools. Milton envisioned the properly structured academy as more than a school for linguistic training, which the grammar schools had become. Among other proposals, he wanted academies to provide for education in the health of the body, an idea that went back to the Greeks (Sizer, 1964).

In his proposal for an academy in Philadelphia, Franklin recommended the teaching of practical subjects such as English, modern languages, arithmetic, navigation, and drawing. Of interest to us is the surprising extent that the subject of drawing was discussed.

Franklin was successful in winning the economic support of prominent Philadelphians but was markedly less successful in garnering support for the practical aspects of his proposal, and shortly after the school was founded its curriculum reverted to classical studies. His proposal will be described in detail later in this chapter.

The Position of the Arts in the Eighteenth Century

The idea that art was a commodity that could be bought and sold in the marketplace came to be widely accepted. In France, private salons and concerts became the events that attracted attention in the journals, events that increasingly became identified with the middle class rather than with the court or the aristocracy. In marked contrast to France, England never had an elaborate policy of state patronage, nor was this patronage consciously pursued for the kind of political purposes it served in France. Most English patronage was private in nature and tended to treat the arts as luxury commodities that, as a rule, were imported from continental sources. Gentlemen rounded off their education with the taking of the "grand tour" to acquire culture, and collecting souvenirs in the form of antiques or works of art was part of the process.

Like the English, the Americans of the colonial period had no conscious policy with regard to the arts. Puritanism was strong in New England; Calvinism, in New Amsterdam; and Quakerism, in Philadelphia. Common to all these traditions was a disdain of artistic embellishment in places of worship.

By midcentury, however, Americans were more receptive to fashions in architecture, furnishings, dress, music, and dance originating in Europe. Objects of high fashion were acquired through import rather than through local manufacture, and it was not until the end of the century that the first academy of art made its appearance in the United States with the opening of the Pennsylvania Academy of Fine Arts in 1791. For the most part American art students throughout the eighteenth century went abroad for their professional training, and some, such as Benjamin West, remained there because the patronage prospects were brighter.

Eighteenth-Century Professional Art Education

Throughout the eighteenth century the French Academy was used as the prototype for art schools throughout the continent. By Pevsner's reckoning, there were nineteen academies throughout Europe by 1720, including those in Florence, Rome, Bologna, Milan, and Vienna. By 1740, six additional academies had opened, including those in St. Petersburg (1724), Toulouse (1726), and Edinburgh (1729). Finally, the first academies of art in the Americas were established in Mexico in 1785 and in Philadelphia in 1791 (Pevsner, 1973).

For the most part these new academies and art schools were founded not for the political purposes behind the French institution but rather for economic reasons. Throughout Europe there was a growing demand for

drawing and design skills on the part of workers and craftsmen in the new industries that were beginning to appear during the latter half of the eighteenth century. For example, in 1779 the municipal authorities at the Hague pressed for the reorganization of the academy "in order to make factories flourish, and increase the prosperity of the citizens." For this, "it is necessary to promote the art of drawing as the foundation of all art." In Dublin a drawing school was established "for improving manufactures and the useful arts and sciences." That drawing was "so useful in manufactures" is found in the opening announcement of the academy at Glasgow, while in France, the idea that the fine arts are separate from the crafts was so firmly implanted that Louis XVI declared that art should contribute to the perfection of the arts of industry and the promotion of commerce. The Geneva drawing school was justified as a trade school "to improve the work of manufactures most usual in commerce and everyday life" (Pevsner, 1973, pp. 140–145).

Art Within General Education

Earlier we noted that Franklin put forth his idea of an academy that would provide students with both a classical education and practical studies such as English, navigation, and drawing. Franklin advocated drawing for all the reasons that Locke had put forth in the previous century.

> As to their studies, it would be well if they could be taught everything that is useful, and everything that is ornamental; but art is long, and their time is short. It is therefore proposed that they learn those things that are likely to be most useful and most ornamental. Regard being had to the several professions for which they are intended.
>
> All should be taught to write a fair hand, and swift, as that is useful to all. And with it may be learnt something of drawing, by imitation of prints, and some of the first principles of perspective. (Franklin, 1749/1931, p. 158)

This short passage was appended with two additional footnotes in addition to the passage from Locke quoted earlier. The first describes the universality of drawing as a language. Franklin's argument is quite remarkable in that he recognized the nearly universal tendency that children have toward drawing, a tendency that is thwarted by neglect. In the other note Franklin went beyond Locke in stating that drawing is not merely for the gentleman but for the mechanic as well. Unlike Locke, whose educational proposals were limited to ones for the upper classes, the ideas that Franklin advanced were egalitarian in their reach.

> Drawing is a kind of universal language, understood by all nations. A man may often express his ideas, even to his own countrymen, more clearly with a lead

pencil, or bit of chalk, than with his tongue. And many can understand a figure, that do not comprehend a description in words, though ever so properly chosen. All boys have an early inclination to this improvement, and begin to make figures of animals, ships, machines, etc. as soon as they can use a pen, but for want of a little instruction at that time generally are discouraged, and quit the pursuit.

Drawing is no less useful to a mechanic than to a gentleman. Several handicrafts seem to require it; as the carpenter, ship-wright's, engraver's, painter's, carver's, cabinet-maker's, gardener's, and other businesses. By a little skill of this kind, the workman may perfect his own idea of the thing to be done, before he begins to work; and show a draft for the encouragement and satisfaction of his employer. (pp. 158–59)

The innovative side of Franklin's proposal was never implemented, and his general ideas about the practical focus of education did not take root until the following century. In the first half of the nineteenth century private academies became the most prominent form of secondary education, and the teaching of drawing was offered in a number of such schools.

CONCLUSIONS

We initiated our inquiry into the history of art education by looking at its roots in Western culture and surveying the teaching of the visual arts up to the colonial period in the United States. We went back to ancient Greece to investigate the origin of the attitude that the visual arts should not be a regular part of general education. We saw that the visual arts in American education had an inauspicious beginning with Franklin's abortive proposal to include drawing in the curriculum.

We saw that many of the attitudes toward the visual arts originated with the specific social circumstances of Greek society, which do not obtain today. There the profession of artist was held in low repute because Athenian society was based upon a slave economy, with artisans and craftsmen ranked only slightly higher in the social pyramid. For this reason the children of the high born were never encouraged to become artists, although some instruction in drawing had begun to appear by the time of Aristotle. Even so, drawing was only mentioned in passing; music, on the other hand, was staunchly advocated.

The visual arts were also suspect because of their cognitive status as forms of knowing, a problem brought to light by Plato. But even though Plato advocated exposure to beautiful art of the right sort, by the time Greek learning passed to the Romans, general education had become dominated by literary studies. The Romans, in turn, emphasized the *artes liberales*, or

liberal arts, which specifically excluded the visual arts. They were not regarded as part of the body of theoretical knowledge expected of all well-educated citizens.

The Roman exclusion of the visual arts from liberal studies then passed to the Middle Ages. Though practice in the visual arts was viewed as mere labor, labor itself came to be viewed as both ennobling and as a form of penance under the Benedictine Rule; consequently many monks of noble birth worked at the visual arts.

In the high Middle Ages the liberal arts, which continued to exclude the visual arts, were still the mainstay of general education. Thus Greek slavery, the initial source of the lack of esteem for the professional artist, continued to influence educational patterns nearly 1,500 years after Pericles.

During the high Middle Ages the increased technological sophistication involved in the visual arts was reflected in the long apprenticeship required to master the requisite skills. Written documents also began to appear, facilitating the production of art and training of artists.

With the coming of the Renaissance a fundamentally new idea of the artist took hold as the notion of genius asserted itself, and new forms of art education more in accord with this new status of artists made their appearance. The idea of an academy where artists could study the theoretical aspects of their field was born. Art was seen as a theoretical discipline in its own right, equal in many respects to literature. Throughout the Renaissance most artists continued to receive their practical training in the workshop, with the theoretical training provided by the academy. In general, artists in the Renaissance possessed a higher level of classical learning than in the Middle Ages.

As the fine arts began to separate from crafts, amateur art education for social elites also became socially acceptable. Because art requires knowledge of a literary and scientific sort, wealthy gentlemen could find the study of such subjects as drawing to be suitably dignified.

Unlike the Renaissance academies, the French Academy attempted to organize the discoveries of the past into a rational doctrine made up of "rules" for the practice and teaching of the fine arts. The French system was widely imitated throughout Europe.

Though drawing did not become a regular part of general education in the seventeenth century, it came to be regarded as a requisite part of the education of gentlemen, provided that it was not viewed as training for an artistic profession.

The first public institutions for general education in colonial America were patterned after the Latin grammar schools of England. Franklin's proposal to introduce drawing into general education was based on Locke's suggestion, made more than a half-century earlier, but American attitudes

toward drawing were shaped by a general disavowal of the arts rooted in the Protestant Reformation. In addition, art education for all but professional artists came to be viewed as a luxury pursuit, having no useful purpose.

Throughout the history of education in these centuries, the visual arts either were considered too menial to be worthy of the socially prominent or were viewed as idle pursuits for the leisured wealthy. The fundamental change in the status of art that had occurred during the Renaissance had little or no effect in bringing the study of art within the reach of most children. It merely changed the reasons that they were not introduced to the visual arts. With the coming of the Industrial Revolution the circumstances that led to this exclusion began to change. It is to these that we now turn.

CHAPTER THREE

The Visual Arts and the
Industrial Revolution

Though the nineteenth century is sometimes described as an era of confidence and progress, it was also one of contradictions. It was a time of scientific materialism, atheism, and greed, but also one of religious reawakening and social reform. It was a time when nature was viewed as a machine moving toward a predetermined future, wholly without purpose, but also as a transcendental mystery and refuge. It was the century when the poet Shelley proclaimed the artist to be the unacknowledged legislator of the race, though many an artist languished and starved. Schiller and Goethe identified the progress of human spirituality with progress in the arts, but the arts were marked by a vulgarization of taste in the forms of popular entertainment and mass manufacturing. It was an era of international trade, yet one marked by nationalism and colonial exploitation. The century saw living standards raised to new heights, with more persons educated than in any previous era, yet it was marked by the ruthless exploitation of the working poor.

This chapter deals with the differentiation between the education of professional artists and that of artisan designers. In addition, it describes the introduction of art as a subject for lay study in colleges and universities.

THE ORIGINS OF NINETEENTH-CENTURY
TRANSFORMATIONS

As the eighteenth century drew to a close, three revolutions radically transformed the character of the Western world. The first was the Industrial Revolution. The second was the political struggle against the autocratic rule of monarchs that expressed itself in the violence of the American and French revolutions. The third was the cultural revolution known as romanticism. Each began in the latter decades of the eighteenth century, but it was in the nineteenth that their consequences affected general education.

Industrialization

By the opening of the nineteenth century the factory had supplanted the craft workshop. Skilled artisans of the past were gradually replaced by machines that could be operated by untrained workers. As long as the guilds had controlled production and the training of new craftsmen, there was a sufficient supply of trained artisans, since design education was an integral part of training in a craft. But the workshop master of medieval times was replaced by the entrepreneur who could hire unskilled workers to operate machinery without the necessity of long apprenticeships. And as older craftsmen died off, there were no ready replacements. For all its greater efficiency, the factory system failed to provide needed designers (Mumford, 1952).

The lack of trained designers had been evident in the last half of the eighteenth century, as we saw in the reasons given for the founding of academies of art (Pevsner, 1973). The most obvious symptom was the decline in the artistic quality of manufactured goods. In Britain the design crisis was noted as early as 1836, when the first government-sponsored school of design was established, and it became painfully evident during the Great Crystal Palace Exposition of 1851 (Pevsner, 1960). Though Britain led the world in manufacturing technology, its industrial output was judged artistically inferior to that of its rivals on the continent. The House of Commons worried about the relation of the arts to manufacturing, for at stake was Britain's ability to compete effectively in the international marketplace.

Each nation approached its problem of industrial art education in a different way, with each solution reflecting ideas concerning the nature of art and its role in society. France established a series of provincial academies of art geared to the needs of local industries. Germany relied on the founding of polytechnics (*Gewerbeschulen*) and, later, schools for arts and crafts (*Kunstgewerbeschulen*). After surveying the French and German options, Britain chose a path of its own (Bell, 1963; Sutton, 1967).[1]

With the exception of France, most nations found it expedient to separate the education of fine artists from that of artisans. Romantic attitudes about the cultural role of the artist in securing the progress of civilization interfered with efforts to make art education relevant to industry.

Ideas of Reality

The optimism of the Enlightenment came to an abrupt end with the French Revolution. This political event swept away the absolute authority of the monarchy as an institution. The revolution was grounded in the premises

of the Enlightenment, in the idea that rational beings could create a happy and just society using the knowledge of science and the process of reason without any recourse to divine intervention or dependence upon authority. But the revolution produced a reign of terror that in many ways exceeded the worst extremes of the Bourbon kings.

The Rise of Romanticism

After nearly two centuries of dominance by the scientific understanding of reality, the arts began once again to be proclaimed as important sources of spiritual insight necessary for the welfare of society. The artist was now seen as the creator of unifying symbols in an otherwise fragmented civilization. "Beauty alone can confer upon him a social character. Taste alone brings harmony into society, because it fosters harmony in the individual" (Schiller, 1795/1967, p. 215). If the role of artists was to provide new insights and perceptions, it made little or no sense to constrain them by imposing rules to govern their creative activity. If artists were to be guided by rules, then these must originate in the creative process itself!

As this view gained acceptance it raised questions about the purpose of teaching, for if artists found the rules for art in themselves, why would they need academies to impose such rules through their teaching? Kant had asserted a generation earlier that "genius is a talent for producing that for which no definite rule can be given" (Kant, 1790/1964, p. 314).

Originality became the primary value in art. This new value gave rise to the new style known as romanticism, which brought an end to the neoclassicism of the eighteenth century. Artists came to be seen as persons whose imaginative power was a faculty of immediate insight, superior to science; hence art was seen as a culturally relevant form of knowledge.

Position of the Arts

In previous centuries it was possible to discuss patronage for the arts in terms of a few powerful individuals. Middle-class patronage had become important throughout the eighteenth century, while in the nineteenth century, with the onset of industrialism, new audiences of art consumers began to appear. Not only was there a great expansion in the number of private collectors, but a mass market evolved for humbler artifacts, such as factory-made furnishings, textile designs, sheet music, musical instruments, lithographs, and steel engravings. The era of state-controlled, or official, patronage gave way to a market system of patronage. Art had become a commodity.

PROFESSIONAL ART INSTRUCTION

What distinguished nineteenth- from eighteenth-century professional art education was the realization that an academy education in fine arts could not provide designers for industry, in spite of the fact that they were in many instances founded for this purpose. The education of the artisan designer was recognized as a separate concern requiring its own type of educational institution. The nations of Europe each experimented with various systems to provide for industry, and it was not until the twentieth century that the problem was satisfactorily resolved with the founding of the Bauhaus in Germany (Pevsner, 1960).

As the nineteenth century opened, the academies of art still maintained the traditions of teaching devised when aristocratic and court patronage were their principal *raison d'etre*. Court patronage had virtually disappeared after the French Revolution; furthermore, the academy was troubled by the rising demand for artistic freedom that came on the heels of the romantic movement. With art and beauty identified with the self-activity of artists rather than with a process guided by rules, it was inevitable that the ancient traditions of the academy would be challenged. In Paris, where the legacy of Le Brun, Felibian, and DePiles had deep roots, the changes in educational teaching doctrines were very slight. Academic reforms consisted of liberalized admission procedures to the official salons and the elimination of inequities that favored certain students over others. Nevertheless, academy instruction did undergo change.

The Ateliers

Traditionally the term *atelier* referred to the workshop or studio of an artist. Then, when certain ateliers became noted for the excellence of their teaching, it also began to refer to the followers or pupils of a particular academician who headed the atelier. This academician was called the *patron* in the root sense of the term, meaning father. The student would be attracted to a particular atelier by the fame of the patron and his teaching.

The great ateliers at the end of the eighteenth century were those established by David and Gros, which promoted the neoclassical style of art that was also the style of the French Academy. Later ateliers, such as Gleyre's in the 1860s, provided the setting for the impressionist painters, such as Monet, Renoir, and Sisley, while the postimpressionist painters Van Gogh and Toulouse Lautrec studied at the atelier of Cormon. The fauve painters Matisse and Roualt studied with Gustav Moreau.

The first ateliers worked within the confines of the traditional style of

the academy. Then, gradually, certain ateliers tended to become somewhat more experimental. The laborious process of building up the darks and lights in a drawing by cross-hatching gave way gradually to the quicker techniques of charcoal and conte crayon, with tones rendered by the use of the stump. Art students were also required to keep notebooks in which they made quick impressions of nature and people. This was done to supplement the traditional drawing or painting from the model, which was done in the studio. Classical poses gave way to the casual scenes of daily living (Boime, 1971).

A prospective student attempting to gain admission to an atelier would present a portfolio to the master and, if approved, would proceed to draw or paint from the model. The middle ground between approval and outright rejection was the requirement to draw from casts for a period of time. The selection process also involved the *anciens* (established students) of the atelier, who could ban a prospective neophyte.

The typical atelier had a set routine. Early on Monday mornings the *massier* (a student monitor) would set the pose of the model, and the students would arrive as early as possible to obtain a good place in the room for the week. Drawing or painting would take place in the morning hours, followed by afternoon visits to the Louvre to copy masterpieces. Once a week the patron would visit the atelier to offer critiques, stopping at each easel to make and explain corrections. Observers of the nineteenth-century ateliers have commented frequently that possibly the only times the atelier was quiet were the times when the master was present. At other times it was a place of comraderie and intense discussions about art.

Master Classes in German Academies

In Germany, where the academy tradition was not as old, writers began to complain as early as 1819 that the existing academies did not allow beginning artists to "trust the spirit of their own activity." Instruction had become impersonal. Lacking was "a true school with one great master and an intimate personal relation between him and his pupils . . . after the manner of the old masters" (Pevsner, 1973, p. 209), a situation characterized by fatherly care as opposed to academic routine. In 1808 Schelling urged art teachers not to impose "any uniform mechanisms [rules], but leave to the pupil as much freedom as possible to show his particular talent and the special qualities of his manner of looking at objects and imitating them" (p. 211). In response to these urgings academies, such as the one at Dusseldorf under the direction of Wilhelm Schadow, established what were termed "master classes." In this arrangement, the student, upon completing prelimi-

nary studies, would choose a professor to oversee the advanced studies; this professor would continue as mentor until the student's training was completed.

What Schadow had in mind as a master teacher was the model not of Le Brun or David but of the masters of the medieval workshops. By the nineteenth century the life of medieval apprentices was viewed in a highly romanticized light that pictured the master-apprentice relationship as a collaborative one, with the master and apprentices making art in the spirit of a communal enterprise. Lacking was the awareness that the medieval apprentice was little more than an indentured servant (Pevsner, 1973).

The difficulty with Schadow's ideas was that centuries of academy influence had succeeded in raising the artist to the social level of the scholar and poet; thus no one could seriously entertain the notion of a return to the subservience of the medieval artisan. This fact combined with the nineteenth-century passion for artistic freedom ruled out a return to the teaching methods of the Middle Ages. The romantic artist was too individualistic to become the mere servant of the church, prince, or the industrial entrepreneurs then appearing. The curriculum of the German academies, which was imported from France, had not been in place very long before it began to be questioned. The spirit of rationalism that imbued French doctrine was at odds with the idealism appearing in the writings of Kant, Schiller, and Goethe. The individualistic spirit of the nineteenth century could already be anticipated in 1794, when the German artist Carstens expressed his new outlook to his patron:

> I must tell your excellency that I do not belong to the Berlin Academy, but to mankind, which has a right to demand the highest possible development of my capabilities . . . my capabilities have been entrusted to me by God. I must be a conscientious steward, so that when I am asked, "Give an account of thy stewardship," I do not have to say, Lord, "the talent that you gave me I have buried in Berlin." (quoted in Vaughn, 1980, p. 35)

French Schools for the Decorative Arts

For a variety of reasons going back to the seventeenth century, the split between the education of the fine artist and that of the artisan did not become problematic in France. The French liquidated their craft guilds during seventeenth century under Louis XIV, and workers in the royal manufacturies were specifically trained under the supervision and methods of the academy. Throughout the eighteenth century provincial academies were established at important centers of industrial activity. After 1789 and throughout the reign of Napoleon, additional art schools were established to provide

a ready supply of trained artisans. As modes of production changed with the Industrial Revolution, the French had also adapted their system of training to prevent acute shortages of artisan designers. In fact, by the 1830s France had more than 80 such schools operating. This policy succeeded in making France the envy of other industrial nations.

Throughout this process of adaptation, which started with guild apprenticeships and ended with schools of decorative art, France continued to place heavy emphasis upon life drawing as the heart of its instructional program. Though the expressed purpose of a given school might have been to further the manufactures of local industries, specialized studies were built upon an existing core of academic drawing. This policy was described with particular clarity by Bowring, a parliament member who testified before the Select Committee on Arts and Manufacture of the British House of Commons. The French school that had greatly impressed him was the Académie des Beaux Arts at Lyon, which he described in the following manner:

> Its object was to give elementary instruction in art with a view to the improvement of the silk manufactures of France. But its field of usefulness had widened from time to time and it is now divided into six principal departments, that of I. Painting; II. Architecture; III. Ornament, and mise en carte (which is the means of communicating to a fabric or to a manufacture any model or drawing upon paper). There is also IV. a botanical department; V. a Sculpture department; and lastly a department which has been added in the last year or two, that of Engraving. (British Sessional Papers, 1836, pp. 2–4)

Bowring went on to describe these departments in detail, with the telling feature found in his description of the painting department. This was subdivided into three sections, one of which was devoted to drawing from the living subject. The second involved drawing from the cast or from nature, while the third included the principles of painting. Thus the art school at Lyon based its program upon figure drawing. In the early stages of the training there was only minimal difference in the studies pursued by the fine arts student as opposed to one entering textile design. In effect, then, the French response to the problem of furnishing industry with artisan designers was to adapt the traditional academy program to such purposes, with the core of such studies rooted in life drawing. This policy had been in place since the days of Le Brun, and in the first half of the nineteenth century it was vigorously defended in a report by Felix Ravaisson (1857)[2] addressed to the French Ministry of Public Instruction. The report was cosigned by such renowned artists as Delacroix and Ingres. Ravaisson asserted that through drawing the human figure one learns the skills of representation because errors are so much more discernible in the depiction of that form than any other. He went on to say that there is nothing better to propose as the first

object for study than the human figure, for both its spiritual and instruction-
al significance, since the student who could draw the human figure would be
able to draw anything else as well. French industry, he argued, maintained
its position of superiority precisely because France was first among the
nations in its artistic accomplishments; because its artisans were trained like
artists, French industry drew inspiration from art itself (Efland, 1983b).[3]

Trade Schools in the German States

For reasons that had to do with the inflated status of the artist in the
romantic era, German states such as Prussia and Bavaria found that it was to
their advantage to prepare artisans in craft schools (*Gewerbeschulen*), or
polytechnics, quite separate from academies of art. In testimony given before
the Select Committee on Arts and Manufactures, Dr. Waagen, the director
of the Gewerbe Institut in Berlin, described trade school education as it
existed in the 1830s. His school in Berlin admitted students from all over the
country without charge. In their first year of instruction pupils studied
drawing, modeling, and other areas of specialization. The same testimony
also made it clear that drawing from the live model was not a part of the
regular curriculum, although students could elect to pursue this interest in
the Berlin Academy; but this institute taught drawing almost wholly outside
the traditions of instruction that had been in place since the first art acade-
mies were founded (British Sessional Papers, 1836).

Working-class students who came to the trade schools had previously
been educated in the *Volkschule* and *Mittleschule*, while the typical student
from the middle or upper classes continued his or her education at the
Realschule, or gymnasium. Many of the trade schools provided part-time
instruction in the evening so that students could work in industry during the
day. There were trade schools located in Breslau, Königsberg, Danzig, and
Cologne, with a central school at Berlin available for advanced training.
Curricula at these trade schools had a strong technical focus that included
free-hand drawing based upon copy exercises and study in mathematics and
physics. Trade schools also existed in Bavaria (Macdonald, 1970).

In the 1860s a new type of art school appeared, known as the *Kunstge-
werbeschule*. These were more than trade schools, although they also fo-
cused on the industrial application of the arts. They attempted to redress the
excessive preoccupation with technical processes by showing a greater con-
cern for design and artistic culture. One way this was achieved was through
establishing links to museums of decorative art, which usually contained
examples of works from other cultures and from earlier periods. In Berlin,
for example, the Gewerbe-Museum opened in association with the Ge-

werbe-Institut; in Vienna the Austrian Museum for Art and Industry, founded in 1864, was linked to the Vienna Kunstgewerbeschule, which was founded in 1867. Similar practices of bonding museums with art and crafts schools also occurred in the Netherlands, while in England the most notable example was the linkage of the South Kensington Design School with the Victoria and Albert Museum (Macdonald, 1970).

Schools of Design in England

In 1835 and 1836 the House of Commons organized a select committee to investigate the feasibility of founding schools of design for the training of British workers. Though Britain was the world's leader in terms of industrial technology and output, it trailed behind its European rivals in the quality of product design, especially in the area of textiles. Not only had Britain's goods fallen below the artistic standards of continental goods; they were also of noticeably lower quality than those produced in the Britain of previous generations. The age of Chippendale and Hepplewhyte in furniture and Wedgewood in pottery had passed. This decline was ascribed to the fact that Britain was the only industrial country that had *not* established a system of schools to prepare artisan designers for the industrial trades. The French, as we noted, had some 80 schools for the applied arts, while German polytechnics had been in operation for nearly 20 years.

In the course of their proceedings the select committee surveyed the academies of fine art, including Britain's Royal Academy, which had come into being in the latter half of the eighteenth century. It had among its listed purposes improvements in the arts of design, but its principal activities focused on the promotion of fine art rather than the applied or decorative arts (Pevsner, 1973). In the 1836 select committee's report, the academy system was scrutinized, with special attention given to the Royal Academy as a potential resource for solving the problem of training artisan designers. But their conclusion militated against this solution.

> Academies appear to have been originally designed to prevent or retard the supposed decline of elevated art. Political economists have denied the advantages of such institutions, and artists themselves, of later years have more than doubted them. It appears on the evidence on some of the witnesses, that M. H. Vernet, the celebrated Director of the French Academy at Rome, has recommended the suppression of that establishment. It is maintained by Dr. Waagen, that what is called the academic system gives an artificial elevation to mediocrity, and that the restriction of academic rules prevents the artist from catching the feeling and spirit of the great master he studies. . . . When academies go

beyond their province, they degenerate into mannerism and fetter genius; and when they assume too exclusive and oligarchical a character, they damp the moral independence of the artist and narrow the proper basis of all intellectual excellence and mental freedom.

It seems probable that the principle of free competition in art (as in commerce) will ultimately triumph over all artificial institutions. (British Sessional Papers, 1836, p. viii)

Thus academies were criticized by two kinds of arguments. The first was the romantic view that academy rules stifled the moral independence of the artist. Among some German artists, this meant that they demanded to be left to their own devices, devoid of any obligation to engage in the mundane affairs of business or commerce. The British did not draw this particular conclusion but, in fact, were critical of academies for their tendency to cultivate elitist snobbishness. Writing some years later, Richard Redgrave complained that the rigorous admission process of the Royal Academy had the effect of making its students "consider themselves to take rank as artists, and since none can study but those who have gone through the above named long probationary trial with success, the students cultivate exclusiveness, and look down upon outsiders who are not partakers of their own advantages" (1857, p. 158).

A second criticism of academies was that they restricted the freedom of the artist in an economic sense by stifling competition among artists through having them conform to established rules and conventions. What was remarkable about the select committee's report was that it drew upon the free-trade economics of the British system as an argument for artistic freedom as well. Following upon the select committee's survey of both the French and German solutions to the problem of training artisans, Britain embarked upon its own solution with the founding of the first government-sponsored school of design in 1837. The council governing the school borrowed some elements of its curriculum from German trade school practice and others from the French art schools, such as the one at Lyon championed by Bowring. Unlike the latter school, which placed figure drawing first and the study of decoration as a subsequent study, the British school made decoration its first priority, with almost no study of the human figure included.

The individual who determined and guided the curriculum was William Dyce, who had made a survey of the various systems of instruction in use on the continent. Among the systems he reviewed were the French, Prussian, and Bavarian ones, and though France was clearly the leader in the decorative arts, it was not the French educational system he admired but the trade schools in the German states. Dyce felt that the course on decoration was more important than figure drawing and that in many areas of the applied

arts the study of the figure was a waste of time. Drawing on a practice he had observed in Prussian craft schools, he attempted to make the school of design more practical by teaching students to make working models and patterns so that they would understand the industrial processes in which the designs were to be applied. Though Dyce was not successful in getting this latter innovation accepted, he did succeed in moving the school away from the academy approach to drawing, making design education more suitable for a working-class populace than the fine arts training that served the upper classes (Bell, 1963).

Dyce's tenure as director was confounded by the pressure of rival views about the approach to design taken within the school, which lessened the overall effectiveness of the program. In addition, his attempt to emulate German teaching practices did not take into account the fact that a system of drawing instruction was in place in German primary schools, so that a student entering a craft school was already quite proficient in drawing and thus ready for more advanced work. Before the system could reap similar results in Britain, drawing would have to be introduced into British primary schools as well, a process which began in 1857.

In 1849 a second select committee was organized to determine why the schools of design were failing in their mission to provide training for artisans. Among those testifying was the noted artist Benjamin Haydon, who decried the lack of figure study in the curriculum. Supporters of Dyce argued for the retention of his approach, which minimized figure study. Two years later, at the Great Crystal Palace Exposition of 1851, Britain's industrial products were ranked among the lowest. One result of this embarrassment was the reorganization of the schools of design under the leadership of Henry Cole (Bell, 1963).

Cole not only reformed their curriculum but was instrumental in establishing a national drawing course for the primary schools of England and a program for the training of drawing masters. What emerged was a new school known as the South Kensington School of Design, now the Royal College of Art. It included a Department of Science and Art, which was involved in preparing teachers of drawing for the British schools. It was his plan that all children in British schools should learn to draw as part of their regular studies. When some of these pupils later entered the schools of design, they would then be ready for a more advanced level of instruction than was possible before. South Kensington was to be the central training school that would prepare the faculty of the provincial schools of art and design; it was also to be the place where drawing masters would be trained for work as drawing inspectors in the schools.

In line with Cole's plan, a national course in drawing was prepared by Richard Redgrave for use in British schools. Implemented in 1857, it was intended to give pupils "a power of close and refined imitation from the flat,

knowledge of the elements of practical geometry, and the power of drawing the objects themselves" (Macdonald, 1970, p. 160). One of the exercises in the drawing syllabus for elementary schools is shown in Figure 3.1. The national course remained in effect throughout the remainder of the nineteenth century.

Britain solved the problem of training artisan designers by devising a two-tiered system of professional art education. The fine artist was trained in the academy, where the life drawing course still provided the core of instructional content. The artisan designer, by contrast, was trained in a school of design, where the course was built around the study of decorative form. In a sense these two tracks imposed Britain's social-class structure upon its system of art education. The problem of class distinctions and their detrimental effects upon the training of artisans was recognized as an acute problem by Redgrave when he compared the Royal Academy in London with the École des Beaux Arts in Paris:

> The real purpose in view in drawing comparison between the two academies of fine art is to show how greatly the Parisian system tends to a union between the student of fine art and the ornamentist, through its students in the various schools of design in Paris . . . can freely enter and study in the evenings side by side with those specially following the fine arts. . . . Thus class distinctions prevalent in our own schools are avoided, and the youths feel no loss of caste to work indifferently as ornamentists and artists. (Redgrave, 1857, p. 159)

Redgrave may have exaggerated the extent to which class distinctions were absent in Paris. He ascribed the source of the problem to be one of access to instruction, failing to recognize that social-class differences were reflected in the content as well. Leaving the study of the human figure out of the British schools of design had the effect of imposing a social-class structure onto the curricula of art education. Dyce did not recognize that the practice of giving students a common artistic grounding would raise the decorative arts to the status of the fine arts rather than the reverse, for the human figure was no neutral object, but the principal object on which the art styles of Europe had focused since the early Renaissance. Ravaisson's report, which we discussed earlier, typified the French attitude toward the subject of the figure:

> Made among all bodies to serve for the habitation and instrument of the Soul, to obey its will and to express its affections, the Human Body is of all that which, in its movements, in its forms, in all their proportions, presents at once the greatest variety and the greatest unity. (Ravaisson, 1857, p. 419)

FIGURE 3.1.
Exercises from the 1895 *Syllabus of Drawing in Elementary Schools*, Standards I, IV, and V (Department of Science and Art, South Kensington School of Design, London, England).

It would be a mistake to conclude that the French advocated figure drawing for its spiritual significance, for, as we saw, Ravaisson also noted that it was among the most difficult forms to master and that the student who succeeded in so doing was also prepared to deal with the simpler forms of ornamental subjects, such as flowers. His report attacked methods of teaching drawing based upon geometry, though conceding that geometric drawing might answer sufficiently well for the instruction of artisans. Yet he maintained that the interests of industry were better served by individuals who could meet the standard of the fine arts, for it was from art that industry received inspiration, and that the superiority of French manufactured goods owed much to the superiority of French art. Similar arguments, voiced in Britain by the artist Benjamin Haydon, went unheeded. Instead Britain organized the curriculum in the schools of design around courses of decoration (Bell, 1963).

Art Academies in the United States

As early as 1794 an academy of art was formed in Philadelphia by a group of artists and patrons. Its one successful venture appears to have been the arrangement of the first showing by American artists, an event that took place in Independence Hall in 1795 and was intended to be an annual event. In addition, it organized studio classes that met to draw from casts and from the model and formulated plans for an art school. Internal dissension, however, brought the academy to an early end. In 1807, the first successful American academy, known as the Pennsylvania Academy of Fine Arts, was formed. A building was erected and a collection of casts was secured. By 1811 annual exhibits were being held, and the academy became the site of the first national society of artists.

A second academy of art was founded in New York in 1802 but was not chartered until 1808. Though headed by the artist Jonathan Trumbull, it was largely run by a lay board rather than by its artist members. In 1825 a group of dissident students broke away from the New York Academy to form a group known as the Society for the Improvement of Drawing. By 1826 it had become known as the National Academy of Design. The new academy was headed by Samuel F. B. Morse, who patterned its governance after Britain's Royal Academy (Fink & Taylor, 1975).

In 1875 a group of students dissatisfied with the conservative policies of the National Academy of Design met with Professor Wilmarth in his studio and founded a group known as the Art Students League. Within a month a statement of purposes was issued to the students of the National Academy. They had among their objectives "the attainment of a higher development in Art studies; the encouragement of a spirit of unselfishness among its members; the imparting of valuable information pertaining to Art, as acquired by

any of its members" (Landgren, 1940, p. 17). Dissatisfaction with the National Academy was not the only reason for the founding of the Art Students League. In a temporary economy move, the National Academy had closed its life drawing school and had decided not to reemploy Wilmarth, its professor of life drawing. But the students were also angry with the fact that they were denied access to books on art and collections of artworks. In the milieu of the post–Civil War era, they sought greater freedom, and thus the first independent art school in the country was founded (Landgren, 1940).

These first institutions imitated the European art academies, and like their European counterparts, they did not provide training for application of the arts to industry. In the latter part of the century other professional art schools were established that both accommodated industrial development and offered training in the fine arts. Among these were the Cooper Union, the Pratt Institute, and the Rhode Island School of Design.

THE VISUAL ARTS IN THE UNIVERSITY

From the inception of universities in the Middle Ages, the visual arts had never been included in courses of study. Not until the latter third of the nineteenth century did this change. In 1868 three chairs were established by the will of Felix Slade for professorships in the fine arts at Oxford, Cambridge, and London universities. This was the first attempt to introduce the study of the fine arts into the university setting in the English-speaking world. The history of art had become an established area of study in German universities in the late eighteenth and early nineteenth centuries, a discipline that grew out of antiquarian and archeological studies, but German universities shied away from teaching the practice of art.

The first occupant of the Oxford chair was John Ruskin, who lectured there on the fine arts and also established a drawing mastership for an institution known as the Ruskin Drawing School. In spite of Ruskin's efforts, the study of the fine arts never became well established in British universities. However, Ruskin's efforts bore fruit in American universities. Today, for example, most major American universities have art departments offering courses in studio practices and art history, either as part of their general educational requirements or as study in the humanities.

Introduction of Art Instruction in American Universities

The idea that study in the visual arts could be included as an integral part of the liberal arts began to be established in the United States following the Civil War. Ruskin's general influence upon American art education will be discussed more fully in Chapter 5, while the beginnings of art instruction

in American universities will here focus on art education at Harvard, Yale, and Princeton. Each approached art in a different way, providing models for other institutions to emulate.

HARVARD. Art education at Harvard began with the appointment of Charles Eliot Norton in 1874 (Vanderbilt, 1959). Norton was born in Cambridge, Massachusetts, in 1827, the descendant of a long line of New England clergymen. His father was Andrews Norton, a conservative Unitarian member of the faculty of the Harvard Divinity School. Charles graduated from Harvard in 1846 and began a literary career as an editor and writer for the *North Atlantic Review, The Atlantic Monthly*, and *The Nation*. Illness forced him to abandon his journalistic career for a long period of convalescence in Europe. It was during this time that he came into contact with both John Ruskin and European culture. He studied Italian art and architecture, and over a period of 40 years he carried on an extensive correspondence with Ruskin. He returned to Boston in 1873 and later that year received an invitation from his cousin Charles William Eliot, the president of Harvard, to join that university's faculty. He did so the following year, at the age of 46. In a letter to Ruskin he said that "I want to be made a professor in the University here that I may have hard work forced on me, and may be brought into close relations with youths whom I can try to inspire with love of things that make life beautiful, and generous" (Norton, 1913, p. 29).

His academic title initially was that of Annual Lecturer in the "History of the Arts of Construction and Design, and their Relation to Literature"; in 1874 his academic title was changed to Professor of Fine Arts.

Norton's ideas about the role of the fine arts in education were derived to a considerable extent from his friends in England, especially Ruskin and John Stuart Mill. Mill's inaugural address at the University of St. Andrews, in particular, asserted the belief that the cultivation of feelings and imagination was central to the school's aim, and for Norton this was important in America's schools as well. Ruskin had written to Norton about his plans for instruction at Oxford (a letter that has not come to light), and Norton's reply to Ruskin praised his scheme for making art an integral part of the Oxford curriculum (Vanderbilt, 1959). Norton, in turn, described his own purpose in this letter to Ruskin:

> My plan is to give my class at first a brief sketch of the place of the arts in the history of culture, of their early developments, and then to take them to the Acropolis at Athens and make them study it in detail, till they shall have some notion, however faint, of its unique glories, and shall illustrate their Aeschylus and their Demosthenes and all their Greek books with some images of the

abodes and figures of the gods and men by whom the Acropolis was inhabited. I have it much at heart to make them understand that the same principles underlie all the forms of human expression, — and that there cannot be good poetry, or good painting or sculpture, or architecture, unless men have something to express which is the result of long training of soul and sense in the ways of high living and true thought. (Norton, 1913, pp. 34–35)

According to Vanderbilt, Norton's program of fine arts at Harvard had a triple purpose: "to show the significance of the fine arts as an expression of the moral and intellectual conditions of the past"; to contrast this with "the barrenness of the American experience which, up to that time, had starved the creative spirit"; and finally, "to refine the sensibilities of the young men at Harvard" (1959, pp. 124–125). The plan Norton described to Ruskin was one that he followed for the next 23 years. He lectured on the aesthetic and moral dimensions of art much after the manner of Ruskin at Oxford, and like Ruskin his efforts were assisted by the appointment of an instructor in free-hand drawing and watercolor. This instructor, Charles H. Moore, taught a course titled "Principles of Design in Painting, Sculpture and Architecture." Moore and Norton had known each other for many years before they worked together, having corresponded with each other as early as 1866 (Mather, 1957).

Norton centered his teaching upon the golden ages of art history — classical Athens, the Italian Gothic style of Venetian architecture, and the Florence of the early Renaissance. In fact, the Renaissance was the terminal point in his art history survey, for he felt that no great art had been created after 1600 (Vanderbilt, 1959). In this view he differed from Ruskin, who in the early part of his career had championed the works of Turner and his Pre-Raphaelite contemporaries. Like the Ruskin of the *Stones of Venice*, however, Norton would draw contrasts between ancient and modern American civilization. In his view the difference could be seen in the loss of a sense of personal elegance as expressed in the articles of common use, the lack of discrimination between the beautiful and the ugly.

Norton's course was immensely popular, with many undergraduates electing it, but it was Norton's intention that the study of art history should be balanced with instruction in the practice of art as well. However, most students did not take work in the studio. Moore's courses in drawing and painting did not draw in the numbers that flocked to Norton. In 1895 Harvard acquired the Fogg Museum, with Moore becoming its first director. Under his leadership a program of studio courses began to take shape, although Harvard avoided becoming a professional art school. Commenting upon Harvard's progress in 1928, Duffus noted that:

Just as Norton's one-man school of fine arts was expanded in ways never dreamed of, so the studio courses at Harvard mark the annexation of another large area of educational territory. Not . . . that Harvard endeavors to turn out finished artists. The art faculty would be almost horrified at the thought of doing this in an undergraduate curriculum. The student performs his required exercises in drawing and painting just as he does his paragraphs and themes in English composition. He is not encouraged to think himself a genius. . . . If the student does not like this system the fact merely goes to prove that he belongs, not at Harvard but possibly in a professional art school. (Duffus, 1928, pp. 33–34)

YALE. Interest in the visual arts at Yale was in evidence as early as 1831, when it acquired a collection of paintings on historical subjects by the American artist Jonathan Trumbull. Though drawing was taught at Yale's Sheffield Scientific School as a technical subject, the active pursuit of the fine arts began in 1863 when Yale received a gift of $200,000 from an alumnus named Augustus Russell Street for the purpose of erecting a school of the fine arts. Construction of the school was begun with the laying of the cornerstone in 1864. According to Duffus, the object of this school was:

First to provide a school for the technical training for those proposing to follow art professionally as painters, sculptors or architects; second, to provide courses of lectures in the history and criticism of art in all its branches, adapted to the need of professional students and undergraduates; and third to provide for the community at large, including the university and the city, such familiarity with works of art as may be derived from loan-exhibitions and permanent collections. (1928, pp. 44–45)

The Street gift was predicated upon the notion that the study of the fine arts fell within the province of the university, an idea that was not generally established either in European institutions or in America. The building was completed in 1867, and additional gifts amounting to $85,000 went to endow chairs of instruction, which included a directorship, a professorship in painting and design, and a professorship in the history and criticism of art. In 1871 additional funding was received to establish a professorship in drawing. The Trumbull collection of paintings was augmented by the acquisition of James Jackson Jarves's private collection of early Italian masters. At the time that Yale purchased the collection, it was the largest collection of Italian paintings in the United States.

The school's first director was John Ferguson Weir, who stressed the practical aspect of art instruction, including the education of practical artists. Though the principles of art history and criticism were offered as part of Yale's liberal arts studies, this course did not have the impact that Nor-

ton's lectures had at Harvard. The art school was unusual in that it was open to women, unlike the rest of the college; in fact, women students outnumbered men until the turn of the century. As Duffus put it, young ladies in New Haven studied art for a year or two "while preparing themselves for the responsibilities of matrimony by learning to paint china" (1928, p. 38). The identification of the fine arts as a feminine interest placed constraints upon the participation of men. Yet in spite of these social pressures, the art school at Yale was recognized as being second only to the National Academy of Design in the quality of its instruction.

PRINCETON. Though formal art instruction at Yale and Harvard antedated Princeton's entrance into this field, a course in Roman antiquities had been given there as early as 1831, and archeology had been taught as a supplement to courses in classics from 1843 to 1868. In addition, a series of lectures in the history of architecture had been offered between 1832 and 1855 (Duffus, 1928). Thus art education at Princeton developed under the aegis of other departments. The creation of a department of fine arts did not take place until 1882, when the trustees of the university adopted suggestions made by William C. Prime for the founding of a department of art history. In the same year the president of the university invited Allan Marquand to share with Prime the lectures of the department and to give a course on the philosophy of art. Marquand had taught at Yale, and his father had played a leading role in the founding of the Metropolitan Museum of Art in New York. Although he shared his father's tastes, his personal interests leaned more toward archeology, and thus in 1882 he found himself in charge of these subjects at Princeton.

Marquand guided the fledgling department through a time when archeology and art history had begun to detach themselves from the study of the classics. Unlike Norton, who was able to appeal directly to undergraduates, Marquand's appeal was to graduate students, who were already committed to scholarship. These students became the missionaries carrying the idea of conscientious scholarship to other universities. Thus under Marquand the fine arts developed as part of the humanities. Duffus described the emphasis of the Princeton program in the following way:

> The Princeton student does not learn to draw or paint unless he teaches himself to do so, or unless he takes some of the professional courses in architecture. What he learns is the drawing, painting, carving, and building that has been done by others — the cultural hand-me-downs of the past. He does not learn "appreciation" for that, as Princeton looks at it, cannot be taught. "Appreciation" is an expression of something inside the appreciator, the result of such

thought and experience as he may have undergone, the reflection of the kind of person he is. It can be imitated, like table manners. But it is not art. What can be taught is facts. (1928, p. 62)

If we compare the initial programs of Harvard, Yale, and Princeton we see that three distinctive patterns of instruction took shape. Harvard attempted to combine the practice of art with art history. Yale, by contrast, emphasized studio studies, while Princeton focused on art history. Other universities adopted the patterns of art instruction first developed at these three schools. For example, Syracuse University's department of fine arts appears to have followed the Yale program; indeed, a number of reports on the fine arts in higher education discussed Yale and Syracuse together. According to Green (1948), in 1915 the U.S. Commissioner of Education noted that both Yale and Syracuse had stated that the purpose of their fine arts programs "is that of a regular school of fine arts" (p. 371), while as early as 1874 Clarke (1875) had referred to the special art departments at Yale and Syracuse.

Growth of American University Art Departments

By the end of the century Harvard, Yale, and Princeton were among some 47 colleges and universities in the United States offering some form of courses in the fine arts. A special survey was conducted by Frederick for the National Education Association of all the colleges and universities operating in the United States. This survey specifically excluded professional art schools but listed those institutions whose mission was anchored in the tradition of the liberal arts. He noted that art teaching in these colleges was characterized by a wide diversity of practices, but generally he noted two main emphases:

> It is the aim of students in the first class to know *about* fine art, and to know it systematically and fully, without thought of its immediate application. And it is the aim of these universities to encourage in the student this high form of thinking—this study of pure fine art, if we may use the term as in speaking of pure mathematics—as far removed as possible from the affairs of practical life.
>
> The aim of the student in the second class, in which the study of the practical side of art is the central idea, is to gain as wide a knowledge of the technical side of art as possible, that he may use it to aid him directly in his studies and to equip himself more fully for his professional career. (1901, pp. 696–697)

Frederick went on to note that 5,146 students were enrolled in art courses, with 1,206 nonmatriculating students permitted to enter the colleges to take courses in art alone, as we noted in the example of the women

studying art at Yale. He estimated that in the 47 institutions surveyed, at least one student in three would come into contact with a professor of fine art, and that this influence would be great and far-reaching (1901, p. 696). By the turn of the century, only two universities granted degrees in the fine arts, these being Yale and Stanford. Yale was singled out for special mention in that it was unique in providing a curriculum that was essentially identical with professional art schools.

The infusion of the visual arts into the liberal arts colleges was one of the consequences of the romanticism, which, more than any other cultural movement, affected the status of the artist in cultural affairs. The artist had become a giver of new values, and the study of the art of the past had itself become an occupation from which moral lessons could be drawn. The art criticism of Ruskin and others, as we shall see, played a significant role in bringing this new conception of art to social consciousness. Ruskin did not succeed in establishing the study of art at Oxford, though his American disciples were to experience greater success. Fledgling departments of art had begun to appear in several American universities, emphasizing a liberal arts rather than professional approach to the study of art.

In their studies of art in nineteenth-century institutions of higher education, neither Frederick nor Duffus discussed the teaching of art that began to appear in the normal schools for the training of teachers, a topic we shall take up in the next chapter. Neither did they survey those institutions that were beginning to provide for the education of professional artists and industrial designers. Fortunately, Clarke's third volume of *Art and Industry* appeared in 1897, describing professional art studies available in the country by the 1880s.

Introduction of Art History from German Universities

In his essay on art history in the United States, Panofsky recalled the remark made by the son of Charles Eliot Norton describing his father's teaching as a series of "lectures on modern morals illustrated by the arts of the ancients" (1955, p. 324). Norton's teaching of art history, the introductory phase of art education in American universities, followed in the tradition of Ruskin. By contrast, the pattern of studies established at Princeton resembled the evolution of the history of art as a discipline in late eighteenth-century Germany. And it was this earlier German tradition that was to supplant the Norton approach. Panofsky describes this German historiographic tradition as follows:

> Though rooted in a tradition that can be traced back to the Italian Renaissance and, beyond that, to classical antiquity, the history of art—that is to say, the historical analysis and interpretation of man-made objects to which we assign a

more than utilitarian value, as opposed to aesthetics, criticism, connoisseurship and "appreciation" on the one hand, and to purely antiquarian studies on the other—is a comparatively recent addition to the family of academic disciplines. And it so happens that, as an American scholar expressed it, "its native tongue is German." (1955, p. 322)

Art history began to take shape as a discipline in the late eighteenth and early nineteenth centuries, when, in the intellectual fashion of the period, ideas, objects, and events became amenable to understanding through a knowledge of their history. It was only about 150 years ago that the historical approach became a form of thought in its own right. Lukacs notes that:

> During the nineteenth century the ideas of history as science replaced gradually the previous practice of history as literature. This was to some extent, the consequence of the way in which Germanic thinking was beginning to replace France's pre-eminence in the cultural history of Europe during the beginning of the romantic revolution. (Lukacs, 1968, p. 19)

Art history in the modern sense appears for the first time in the work of Johann Joachim Winckelmann. His *Geschichte der Kunst des Alterums* was the first to use the phrase *history of art* (Panofsky, 1955, p. 323). History in previous periods tended to be a history of artists, as with Vasari during the Renaissance, but Winckelmann's history of ancient art was a history of the beautiful, one that stressed the evolution of form. This was imposed upon him by the anonymity of ancient art as a subject, but the important point is that he "focused on the monument itself, which for him becomes the object of history and is interpreted on the basis not only of content but also of form" (*EWA*, 1959–1968, vol. 8, cols. 519–520). Winckelmann regarded the object of his inquiry the revelation of underlying principles that would describe the organic development of styles from one era to another, or, in other words, the formal evolution of art as an expression of culture.

Winckelmann described what appeared to him to be unifying principles for the study and development of artistic styles. He divided Greek art into four divisions: an archaic period covering the time prior to Phidias; the period of the sublime, which included Phidias and his contemporaries; followed by the period of the beautiful, which included such artists as Praxiteles; and finally a period of imitation, leading to the death of Greek art. In identifying a similar pattern in the development of Renaissance art, he inaugurated the tendency toward abstract historical constructions that was to become typical of German art history.

Among the notables concerned with the broader issues of culture and the position of the arts within the fabric of civilization was Jacob Burckhardt, whose *Civilization of the Renaissance in Italy* was deemed essential

reading for virtually all well-educated students in the German-speaking world. It provided a broad framework for placing artworks in the context of the politics, religion, and philosophy of their period.

The first professorship devoted exclusively to the history of art was established at Göttingen in 1813, a chair that was held by Johann Dominic Fiorillo. His *Geschichte der Ziechenden Kunste* compiled the history of art in Europe from widely scattered literary sources. The first chair in the history of art in Berlin was held by Gustav Friedrich Waagen, whose book *Treasures of Art in Great Britain* was distinguished in its time by the fact that he based his study upon direct experience with the objects themselves rather than with the literary sources describing the works. Chairs in the history of art were also established in Basel, Switzerland, and Vienna, Austria.

Romantic historiography included the notion of art as an expression of the spiritual evolution of culture, but in the later decades of the nineteenth century positivists like Hippolyte Taine tended to focus on the work of art in terms of its immediate context as opposed to viewing it as an exemplar of a stage in a larger unfolding. He considered the work of art not merely as an artistic phenomenon but as an expression of the particular race, climate, and period in which the work had its origin. The character of the work was determined by these factors rather than by the freedom of the artist. Art was explained in terms of material causes rather than in terms of artistic creativity. Though positivist scholarship removed the romantic mystique from works of art, it did much to establish a scientific basis for classifying works on an empirical basis, especially works whose authorship is unknown. In addition, the positivists contributed to the classification of documentary evidence used to establish the time of origin or attribution of the work in question.

The history of art as we know it today in American universities largely came into being in the twentieth century; we will discuss this in Chapter 7.

CONCLUSIONS

In Europe throughout the nineteenth century, a series of polytechnics, trade schools, and schools of design were created to prepare artisans for industry since academies of fine art were found wanting in this regard. The academies of art in Europe also began to develop different teaching traditions, with pronounced differences between the German and French institutions. This came about in response to romantic conceptions of artistry calling for freer forms of expression.

Unlike the study of art in Europe and Great Britain, in which there was a marked separation between the visual and liberal arts, American institu-

tions tended to experiment with a variety of curricular patterns. Some, such as the National Academy of Design, maintained a single-minded focus on the traditional fine arts, using European academies as their models.

Others, such as Harvard, experimented with the visual arts as a form of liberal arts study involving a mixture of studio instruction and lectures on art history. Harvard put into practice a program of art instruction that was based on Ruskin's principles, a program that Ruskin had intended for Oxford but that failed to materialize there.

Still other colleges, such as Yale and Syracuse, developed programs that were professional art schools, turning out students capable of practicing either as fine artists or as industrial artists. Somewhat later, independent professional art schools, such as the Pratt Institute and the Rhode Island School of Design, came on the scene to provide training for industrial designers and illustrators.

All told, the development of new institutions in Europe and the United States reflected an increasing degree of diversification, reflecting the specialized needs of industrial societies.

CHAPTER FOUR

The Invention of Common
School Art

In the early decades of the nineteenth century the trend to establish state-supported schooling is referred to as the common school movement. In an emerging industrial era the ability to read and write had become practical necessities. Industry required a workforce that could follow written instructions and maintain records, and this literacy also embraced aspects of the arts. Carpenters and builders had to be able to read the plans of clients, and, as we saw in the last chapter, designers were needed in factories.

This chapter concentrates on the development of the teaching of drawing. Drawing had become an essential skill, and yet its acceptance as a requisite part of the school's curriculum was slow in coming. Horace Mann, one of the early advocates for drawing, used three arguments to convince his New England contemporaries of its merits: (1) it would improve handwriting, (2) it was an essential industrial skill, and (3) it was a moral force. Later in the chapter, we will look at these arguments in detail.

THE COMMON SCHOOL MOVEMENT
IN THE UNITED STATES

Aside from meeting the needs of an industrial society, common schooling came about to offset the seamier consequences of the Industrial Revolution. Working poor in increasing numbers were concentrated in the slums of industrial cities. Crime, prostitution, and drunkenness became serious urban problems. In Britain, this newly recognized misery was often ascribed to the low morals and ignorance of the poor. British educators such as James Kay-Shuttleworth saw education as the remedy to both poverty and criminal behavior (Kay-Shuttleworth, 1862; Tholfsen, 1974).

In the United States Horace Mann and Henry Barnard also viewed schooling as a moral agency that would assure the orderly conduct of society. They argued that an ignorant and dissatisfied populace was easy prey

for demagogues. By the 1840s education of the moral faculties was among the principal rationales for common schooling. This concern for moral education intensified as increasing numbers of immigrants came to the United States, bringing with them different standards of behavior and exacerbating the social problems of cities in the throes of an urban explosion (Kaestle, 1983; Spring, 1986).

Vocal music and drawing were prescribed as ways of elevating moral standards. Mann declared: "Drawing may well go hand in hand with music; so may the cultivation of libraries and the cultivation of a taste for reading, etc. Every pure taste implanted in the youthful mind becomes a barrier to resist the allurements of sensuality" (Mann, 1841, p. 186).

The account that follows describes the introduction of drawing into the Boston school system. Though other cities had introduced drawing earlier, Boston's status as the heart of the common school movement gave its actions special significance. Practices meeting with acceptance there were soon emulated in other cities. In fact, Boston was somewhat late in adopting a drawing program for its schools. Baltimore, Philadelphia, Cleveland, and Cincinnati had been experimenting with the subject some 20 years prior to its full-scale implementation in Boston, beginning in 1871 while New Haven and Hartford had introduced it in the late 1860s. But throughout the nineteenth century Boston was not only the cultural and literary capital of America but the trendsetter in educational matters as well. In 1838 it had begun to introduce vocal music into the school curriculum, an example that was soon emulated by other cities (Rich, 1946).[1]

By the 1830s the city had a well-developed school system consisting of a series of one- and two-room primary schools for boys and girls between the ages of 4 and 8. Boys who showed academic promise would then attend the English grammar schools, which provided terminal schooling for most of them. A few boys went on to the college-preparatory school, Boston Latin, and from there to college, which in Boston usually meant Harvard. The English grammar school was the heart of the system, since few students went on to the Latin school (Wightman, 1860).

The early story of drawing in Boston involves the careers of William Bentley Fowle and Horace Mann. It is to these that we now turn.

William Bentley Fowle

Fowle[2] was born in Boston on October 17, 1795. In the tradition of the time, he entered school before the age of 3 (probably a dame school). A brilliant scholar throughout his schooling years, he graduated from Boston Latin with the intention of entering college; he was precluded from this course, however, by family financial difficulties. He therefore apprenticed himself to Caleb Bingham, a bookseller. Bingham was a former teacher, and

his bookstore had become a center for educational discussion, where the theory and practices of educational innovators such as Joseph Lancaster and Johann Heinrich Pestalozzi were avidly discussed.

Fowle was greatly influenced by this environment, and in 1821 he was elected to the Primary School Committee of Boston. At that time this school committee had planned to establish a school for 200 poor pupils, using the monitorial method of Lancaster. In this system the teacher provided instruction to a small group of able students — "monitors" — who in turn provided the same lesson to a group of less advanced students. The services of a single teacher could thus be stretched to instruct a much larger group than possible by ordinary methods, with a concomitant savings in salaries.

A specially trained teacher was recruited for this purpose, but he failed to appear at the appointed time. Fowle volunteered to undertake the work on a temporary basis, using the monitorial method. What was to have been a temporary assignment lasted for the full year, and by all accounts his teaching was a great success. Fowle had discovered his true vocation.

In the following year a private group of citizens asked him to take a position in a "school of a higher class," to be called the Female Monitorial School. Fowle's reputation as an educator continued to grow as he made one innovation after another. These included the use of blackboards, geography lessons involving the drawing of maps on the blackboard, linear drawing, printing, physical exercise, needlework, and music. In addition, he eliminated corporal punishment. In 1842 he resigned from the school because of ill health and became the editor of the *Common School Journal* until it ceased publication in 1851.

In the course of his life he wrote more than 50 textbooks for various school subjects, including one on linear drawing (Fowle, 1825) that was a translation from Louis Benjamin Francoeur's manual prepared in 1822 for use in the monitorial schools of Paris. This book was quite a success, going through three successive editions. In the introduction Fowle clearly highlighted the difference between the systematic type of drawing presented by Francoeur's manual and what he termed the "fancy" drawing of the private schools, which he held in low esteem.

> It is a lamentable fact that it [drawing] is seldom or never taught in the public schools, although a very large proportion of our children have no other education than these schools afford. Even in the private schools where drawing is taught it is too generally the case that no regard is paid to the geometrical principles on which it depends. (Fowle, 1825, unpaginated Introduction)

The statement reveals that as early as 1825 class distinctions between public and private schools were quite sharp. Private schools taught drawing, which suggests that it was regarded as an educational luxury, though not by

a method grounded in geometrical principles. In the introduction to the 1866 edition of his manual (published posthumously), he referred to this kind of art teaching as "fancy drawing, which is hardly subject to any fixed rules." As a luxury item, fancy drawing was accepted as a female accomplishment (Sigourney, 1837). His own preference was clearly for teaching drawing by an intellectually rigorous method, and he believed that girls should be taught it exactly as were boys. In this respect Fowle was ahead of his time.

Horace Mann

Like Fowle, Horace Mann did not begin his career as an educator. He was a practicing lawyer, a college graduate, a prominent member of the Whig Party, and a member of the Unitarian church. With the exception of the fact that he attended Brown instead of Harvard, he was in every respect a member of Boston's elite, educated in the old system (Mann, 1867). Like Mann, most men of upper-class Boston society prepared for higher education by attending either Boston Latin or a private academy. Like Mann, some had questioned the value of this traditional form of education.

When Mann accepted the position of secretary for the Massachusetts Board of Education in 1837, he felt that the common school was the mediating link between himself, as a member of the small, privileged minority that ran Boston, and the unlearned masses. He felt that the school, operating under the authority of the state, was an instrument of universal enlightenment. Mann was often described as a crusader working to create a nation of literate and well-behaved citizens.[3] With his wife, Mary, Mann traveled throughout Europe to learn first-hand of the methods used to advance common schooling, methods quite at variance with the traditional means of the grammar and Latin schools. State-supported schools and the advanced methods coming from Pestalozzi and from Prussian normal schools, he felt, could succeed in achieving a literate, moral, pious, industrious society. Mann did not teach or originate a system of drawing, but he was a strong advocate for the subject as we shall see later in this chapter (Massachusetts Board of Education, 1845; Spring, 1986).

EUROPEAN ORIGINS OF THE
COMMON SCHOOL PEDAGOGY

Johann Heinrich Pestalozzi

As the eighteenth century closed, Napoleon became ruler of France, and soon France was at war with the rest of Europe. The Napleonic Wars left in their wake a large number of orphans. Johann Heinrich Pestalozzi

responded to this crisis by establishing a boy's school for orphans at Burgdorf and later at Yverdun in Switzerland. In his youth Pestalozzi had read Rousseau's *Emile* and was sufficiently inspired to make education his life's work. His early career was marked by a number of abortive attempts to establish schools to advance the educational ideals espoused by Rousseau. In his novel *Leonard and Gertrude* (1785/1977) he established his educational philosophy through the character of Gertrude, who was a poor mother attempting to educate her young. His successes in educational practice at Burgdorf first began to bring him international recognition as the leading educational reformer of the early nineteenth century.

Pestalozzi sought methods of teaching that would develop the potential of all children. Believing with Rousseau that nature was the best teacher, he thought that the foundation of all human learning is based upon sense impressions, *Anschauungen*, received by the mind from nature. Nature is the source of truth, and truth is obtained through the senses. In addition, there is a natural progression by which the learning process enables the mind to engage the objects of the world. Thus in the first stages one receives sense impressions that are vague, disorganized, and confused. Later, one is able to find order and clarity in these impressions. With clear impressions as the foundation, the mind can then develop clear and distinct ideas; but if these impressions are confused, the resulting understanding will be flawed (Pestalozzi, 1801/1898).

Ordinarily nature is sufficient to guide the growth of the mind, but for most children, the accident of their birth, or the destruction and misery then afflicting Europe in the wake of revolution and war, removed all hope that learning by natural means could occur. Nature needed the help of "art" by which Pestalozzi meant "the art of teaching" (Silber, 1960).

Basis for Pestalozzian Method

Pestalozzi believed that people learn by hearing *sounds*, both spoken and sung; by the study of *form*, which includes measurement and drawing; and finally by the study of *number*. Within each area there is a natural progression from simple sense impressions to abstraction. Measurement plays a crucial role in making sense impressions clear in all three areas. From the measurement of sound one is led to the study of rhythm in music, while from the measurement of form we are led into geometry and drawing. Later we will compare Pestalozzi's system of drawing with the natural method fostered by Rousseau a generation earlier. In general the principles of his system may be summarized as follows:

To bring all things essentially related to each other together
To subordinate all unessential things

To arrange all objects according to their likenesses

To strengthen sense impressions of important objects by allowing them to be experienced through different senses

To arrange knowledge in graduated steps so that differences in new ideas shall be small and almost imperceptible

To make the simple perfect before going on to the complex

Dissemination of Pestalozzian Pedagogy in Prussia

As long as education had been a privileged affair and the number of students remained small, the efficacy of methods was not of great concern, but when classes of poor and unruly pupils would reach numbers as high as 60, the need for an effective pedagogy became urgent. Pestalozzi found himself in just such circumstances after the Napoleonic Wars. He was forced to find ways of teaching that were efficient, inexpensive, reliable, and easily implemented by teachers who could be trained in a short time. As each nation began to establish its system of public schools, it found itself facing similar circumstances to those confronted by Pestalozzi and his associates.

In 1809, following its humiliating defeat by Napoleon, Prussia began the task of rebuilding its social fabric. Central to this process was the institution of public education. In establishing common schools for all individuals, Prussia became the first modern nation to tie its future to the power of education. Wilhelm von Humboldt was appointed Minister of Public Instruction, entrusted with the task of establishing a national system of education. For a number of years Prussia sent its most promising students of pedagogy to Pestalozzi to study his methods, and upon their return they established normal schools for the preparation of teachers. By 1825 Pestalozzian methods had been incorporated throughout Prussia.

Noting that the subject was generally very badly taught, Humboldt sought advice at the Berlin Academy on the teaching of drawing. He sought a method that would give children "the necessary practice of the faculty of observation and representation, a correct knowledge of relationships, especially those of the human body, the ability to translate objects from nature directly onto paper, and hence to use drawing as a kind of language" (quoted in Ashwin, 1981, p. 56). He lamented the widely accepted view that drawing was a luxury, for he believed that it had a role to play in the cultivation of aesthetic receptivity and judgment. The art historian Alois Hirt answered Humboldt's inquiry in 1809, suggesting that German children everywhere should follow the same drawing syllabus "proceeding from Pestalozzian fundamentals in the form of geometric exercises and observation practice onto man-made forms, then onto natural forms such as plants and animals,

concluding with the human form" (quoted in Ashwin, 1981, p. 56). Ashwin (1981) suggests that Hirt was probably influenced by Pestalozzi's *A B C der Anschauung* (1803), published six years earlier.

THE BEGINNINGS OF PUBLIC SCHOOL DRAWING INSTRUCTION

Almost all the systems of drawing instruction for children that developed in the first years of the nineteenth century were made up of a series of exercises starting with simple geometric figures—straight and curved lines, angles, plane and solid shapes, and simple ornaments. Instruction usually was limited to outline drawing. Exercises involving shading were minimized, and the quality of the student's work was judged by its accuracy and neatness. The exercises proceeded in a strict simple-to-complex sequence. Little provision was made for original composition or personal expression. Fowle's drawing manual, which was used in Boston, was similarly grounded in geometry.

Pestalozzi's Drawing Method

An account of one of the first of these methods appears in the third chapter of *How Gertrude Teaches Her Children* (Pestalozzi, 1801/1898), where the struggles of Pestalozzi's assistant, Johannes Christoff Buss, are recounted. Pestalozzi had assigned to Buss the task of devising a systematic method of drawing instruction that would avoid the pitfalls of trial-and-error methods, which had heretofore been the only way one could learn to draw. Pestalozzi described the usual faltering course by which art education began as a prelude to the introduction of this new method.

> The usual course of our art education is to begin with inaccurate observation and crooked structures; then to pull down and build up again crookedly ten times over, until at last and late, the feeling of proportion has matured. Then we come, at last, to that with which we should have begun, measurement. (Pestalozzi, 1801/1898, pp. 186–187)

Prior to the utilization of geometric lines and figures, students taught themselves to draw by copying other drawings. This was the basic means used by academies of art, but in Pestalozzi's opinion, this was too slow and unpredictable a method for use with children. In addition, art academies began with the most difficult subject of all, the human figure. Pestalozzi sought a method that would begin with simple forms and then move gradu-

ally to the complex. Though he had no knowledge of drawing, he suggested that "lines, angles, and curves are the foundation of the art of drawing" (1801/1898, pp. 116–119). These were the simplest elements in the vocabulary of visual forms.

At first Buss was unsure of the way to proceed. Although the idea of basing pedagogy upon sense impressions suggested that students should begin their studies with objects, Pestalozzi suggested, to the contrary, that the process could begin with the study of lines and that these lines could be used to describe and judge objects in perception. Though objects can be perceived directly in nature, he felt that this drawing method would facilitate the process of perception by intervening with lines. In this way natural learning would be facilitated by the art of teaching. Pestalozzi believed that the lines, curves, and angles that make up the forms of objects, could be read like an alphabet of sense impressions, what he termed an "A B C of *Anschauung*." Later, he summarized the drawing method in the following way:

> This should be presented to the child in the following way: We show him the properties of straight lines, unconnected each by itself, under many conditions and in different arbitrary directions, and make him clearly conscious of the different appearances, without considering their further uses. Then we begin to name the straight lines as horizontal, vertical and oblique; describing the oblique lines as rising or falling, then as rising or falling to the right or left. Then we name the different parallels as horizontal, vertical or oblique parallel lines; then we name the principal angles formed by joining these lines, as right, acute, and obtuse. In the same way we teach them to know and name the prototype of all measure—forms, the square which rises from joining together two angles and its division into half, quarters, sixths and so on; then the circle and its variations in elongated forms, and their different parts. (1801/1898, p. 191)

The statement then went on to describe the geometry of the circle and to suggest three methods by which children learn to use these forms, such as by naming the various proportions, by applying these forms in independent work, and by drawing them (1801/1898, p. 192).

The drawing method was published in 1803 under the title of *A B C der Anschauung* and included three copperplate engravings illustrating a system for dividing lines and squares into smaller units. The first of these illustrations (see Figure 4.1) shows the various subdivisions of the straight line.

Students were required to estimate the division of these lines without the help of rulers. According to Ashwin (1981), the system devised by Buss was not widely used at Pestalozzi's institute. In 1804 Buss left Pestalozzi's circle and the method devised by him was superseded in 1809 by another drawing manual by Joseph Schmid.[4]

FIGURE 4.1.
"Elementary Lines"
(Figure 1), from Johann
Heinrich Pestalozzi, *A B
C der Anschauung*
(Zurich: H. Gessner
Publisher, 1803).
Reproduced by permis-
sion of Interwood Press.

Efforts of Pestalozzi's Associates

Records indicate that drawing was also advocated (if not actually taught) by Pestalozzi's associate Hermann Krusi. Krusi worked with Pestalozzi from 1800 unti 1817, when he resigned from the institute as a result of a dispute with Joseph Schmid. In 1818 he published an account of a new educational institution for boys to be located in Yverdun, the site of Pestalozzi's school. He outlined a plan of education based upon Pestalozzian principles. Though the outline is quite brief, it gives indications of the

position of drawing within the curriculum as a whole. The curriculum was divided into three departments: number, form, and language. Form was called the second means of development and was subdivided into "exercises in form with reference to truth. (Geometry)" and "exercises in form with reference to beauty. (Drawing)" The drawing curriculum consisted of "Linear drawing, to form the eye and the hand, and to practice invention, under rules and in forms agreeable to the sight." It also dealt with the study of perspective "as a result of observation" and "as the result of geometrical and optical laws." A third section of the drawing program dealt with the imitation of light and shade, while a fourth consisted of "progressive exercises in drawing from nature" (Barnard, 1906, p. 351).

In the next section we discuss a drawing course devised by Krusi's son, which was published in the United States in 1872. But long before, another account of Pestalozzian drawing reached these shores in Joseph Neef's *Sketch of a Plan and Method of Education* (1808; Gutek, 1978). Neef left Pestalozzi's institute in 1804 for Paris and eventually emigrated to Philadelphia. Portions of his drawing course are described below:

> In compliance with their [the students'] wishes, I shall present each of them with a fine slate, and an excellent pencil; and now we shall strive to outdo one another in drawing horizontal lines. But we shall not confine ourselves to draw very fine and straight lines, but we shall also try to divide them first into two, then into four, and at last into eight equal parts. (Neef, 1808/1969, p. 44)

Like the *A B C der Anschauung*, Neef's method began with drawing straight lines and subsequently subdividing them into smaller units. These drawing exercises were designed to train the mental faculties by sharpening sense impressions through measurement. Neef also described a procedure called "dictation" drawing:

> We shall, each of us in our turn, loudly and distinctly, and accurately, express and describe, whatever we do or construct on our slate. Thus when our dictator for instance says, "I draw my third horizontal line . . . " we shall all of us draw our third line, and give it the like dimensions. (Neef, 1808/1969, p. 44)

He then concluded by saying:

> Nature, good models, and common sense, shall be our drawing-masters. But neither in cultivating this art nor in any point else, shall we deviate from our beloved maxim, or lose sight of our immutable rule. We shall therefore begin by the most simple, and thence we shall proceed to the easy, by slow degrees we shall approach the difficult, and by slower degrees proceed to the most difficult.

> Thus, for instance, our first efforts shall be directed toward the simplest objects, a ladder, table, chair, house. . . . We shall soon become aware of the effects of light and shade, and of course try to produce them. Nor shall the laws of perspective escape our observation. The dimensions of the human body as well as other objects shall be most carefully determined and ascertained. But this much will, I suppose, be enough on the subject at present. (Neef, 1808/ 1969, pp. 46–47)

What is curious about Neef's account is that although he claims to teach drawing through the imitation of nature, the student is presented with nonnatural exercises in geometry. Neef's method was based on the Pestalozzian idea that "nature needed the help of the art of teaching," and since Pestalozzi got the idea of basing education on nature from Rousseau, it might be instructive to see how Rousseau (1761/1976) himself would have taught drawing.

> All children in the course of their endless imitation try to draw; and I would have Emile cultivate this art; not so much for art's sake, as to give him exactness of and flexibility of hand. . . . So I shall take good care not to provide him with a drawing master, who would only set him to copy copies and draw from drawings. Nature should be his only teacher, and things his only models. He should have the real thing before his eyes, not its copy on paper. Let him draw a house from a house, a tree from a tree, a man from a man; so that he may train himself to observe objects and their appearance accurately and not to take false and conventional copies for truth. (p. 108)

Pestalozzi would have agreed with Rousseau that drawing was not to be taught "for art's sake." Both agreed that it was an essential way to train the mind's faculties and hence was directly linked to the pedagogical task of furthering cognitive development. It was unrelated to the methods used to develop artistic culture—the methods of the academy. What Rousseau described was how he would *not* teach Emile, by *not* providing drawing masters. Pestalozzi also did not provide drawing masters, providing instead a method that could be used by a regular teacher in a common school. Pestalozzi used geometry to teach the truth about nature, not nature herself, which was where Rousseau and Pestalozzi parted company.

Krusi's Inventive Drawing

Previously, it was noted that Hermann Krusi had advocated an educational program that described an approach to drawing; it is not clear whether he had actually devised the method described. However, in succeeding years Krusi's son did devise a drawing method based on Pestalozzian princi-

ples. Hermann Krusi, Jr., was educated by his father, who was the director of a private normal school in the town of Gais in the Appenzell canton of Switzerland.

> In the long winter evenings, and during leisure hours, I generally employed myself with literary exercises, which appealed to my originality and inventive power. I sketched—for the first time—a course in Inventive Drawing, which, however, I modified afterwards, by reducing it still more to the real elements. (Krusi, 1907, p. 62)

The younger Krusi prepared this course while a young man serving on the faculty of his father's normal school. After his father's death in 1846, Krusi emigrated to England, where he taught in the Home and Colonial School, a private institution based upon Pestalozzian principles. It was here that he met a number of visitors from America, including William Whitaker and the Boston music educator Lowell Mason. The former in particular urged him to prepare the course on inventive drawing as a manual for publication. Since Whitaker subsequently published such a manual—*A Progressive Course in Inventive Drawing on the Principles of Pestalozzi* (Whitaker, 1851, 1853)—in the United States under his own name, it is likely that he plagiarized Krusi. Krusi refers to Whitaker in his *Recollections* (1907); though he never accused Whitaker of plagiarism, Krusi does seem to have had some reservations about him:

> This young man Whitacre [*sic*] . . . was greatly pleased with my course of Inventive Drawing and admonished me to have it published at the expense—as he suggested—of one of his patrons. If I had known at that time as much of his sanguine visionary temperament as I did afterwards, I would have not trusted his proposition. It had, however, the effect of causing me to construct a carefully graduated course, which afterwards was published by a bookseller of my acquaintance, in which shape I suppose it met the eyes of a few men interested in art education. (p. 92)

Whitaker was instrumental in paving the way for Krusi's emigration to the United States, an event which occurred in 1853. Krusi was invited by Edward A. Sheldon, principal of the Oswego Normal School, to join the faculty there, where he taught courses in the philosophy of education, mathematics, and drawing. He was highly revered as a teacher and retired in his 70th year (Dearborn, 1925; Hollis, 1898).[5]

The first part of Krusi's drawing system was called the synthetic series and was designed for use in the primary grades. It dealt with the outlines of forms only and was described as being "specially calculated to stimulate the observing powers, give freedom of movement, and cultivate taste" (Krusi, 1872, Introduction). A second series, called the analytic series, was for the

intermediate schools and for those who had acquired skill in imitating forms. Although these exercises also dealt with outlined forms, they placed greater emphasis upon proportion and accuracy of division. Parts three and four dealt with the laws of perspective and the principles of geometric drawing and shading. Examples of some of the exercises in the Krusi manual are shown in Figure 4.2.

Graduates of Oswego settled in many parts of the country, disseminating the method. In addition, drawing by these step-by-step procedures had influenced art courses in many normal schools by the turn of the century. For example, Stark (1985) notes that there were many similarities between the drawing syllabus prepared by the New York Department of Public Instruction in 1896 and those in Krusi's manuals.

IMPACT OF PESTALOZZIAN DRAWING
IN THE UNITED STATES

Pestalozzian drawing found its way to the United States by a number of routes. The first and most direct link, as we saw, was through Joseph Neef, who introduced the subject of Pestalozzian pedagogy in 1808. However, Neef had very little influence upon American pedagogy. Soon after he emigrated to Philadelphia he moved to a remote settlement on the American frontier—New Harmony, Indiana—where the resulting isolation limited the spread of his ideas. Much later, Krusi's methods were widely disseminated by the graduates of the Oswego Normal School, but his method represented a late flowering of Pestalozzianism, which by the 1870s had become a highly ritualized formal procedure, with teachers asking questions and students parroting ready-made answers. Lost was the innovative spirit that had given Pestalozzi's teaching its initial vitality.

Reports of Prussian Schools

During the interim between Neef and Krusi, Pestalozzian influence in this country came via a series of reports on the Prussian schools by such travelers to the continent as William Woodbridge, Henry Barnard, Horace Mann, and Calvin Stowe. These writers disseminated their glowing reports of Prussian schools through the medium of educational journals. Woodbridge, for example, served as editor of the *Annals of Education*, while Mann was the founding editor of the *Common School Journal* from 1837 until 1842. Barnard founded both the *Connecticut Common School Journal* and his renowned *Barnard's American Journal of Education*. These publications also provided their readers with translations of reports by European

FIGURE 4.2.
Drawing exercises
(Figures 32–37) from
Hermann Krusi, *Krusi's
Drawing Manual for
Teachers, Inventive
Course.* New York: D.
Appleton Co., 1872.

writers. In this way ideas about drawing as practiced in continental schools entered into educational discussions throughout the United States.

These observers reported what they had found, including the drawing methods used in the schools of Prussia. Ashwin's (1981) study of the drawing methods in nineteenth-century German-speaking Europe provides a detailed description of what Barnard, Mann, and Stowe would have seen on their visits to Berlin, and what they saw was not always from Pestalozzi. When Horace Mann visited Berlin in 1843, the current method in favor had been devised by Peter Schmid.

PETER SCHMID'S SYSTEM OF DRAWING. Mann (1844b) described Schmid's system in the *Common School Journal* and presented 24 of the lessons from Schmid's manual. The illustration pictured in Figure 4.3 appeared with these lessons. He also provided a biography of Schmid and described the method's invention. The method itself made use of a series of cubes and rectangular blocks, which were coded by letters identifying each block. With each lesson he provided an engraving showing a particular

FIGURE 4.3.
Copperplate engraving
of a drawing exercise
from Peter Schmid's
manual, as it appeared
in the *Common School
Journal* (1844), Vol. VI,
following p. 354.

arrangement of the blocks for a given lesson. The step-by-step instructions asked the student to assemble the blocks in the arrangement pictured in the engraving. The lesson showed how to reproduce this image by placing a series of points on a slate or paper. The points corresponded to the corners of the blocks, while the letters identified the particular plane of the block being drawn. After the points were in place, the student connected these with thin lines. In this way the pupil learned to draw various geometric shapes. Plane geometric shapes were mastered first, followed by solid shapes (Mann, 1843).

Unlike the *A B C der Anschauung*, which emphasized flat outline forms, students were involved with solid shapes from the very outset of instruction; that is, they were involved with the problem of representing three-dimensional forms on a two-dimensional surface. Schmid's method also differed from other Pestalozzian methods in that his was a system of individualized instruction. Each student could proceed at his or her own pace by reading the directions and following them. The teacher provided criticism and encouragement, but instruction per se came from Schmid's manual.

By contrast the methods devised by Pestalozzi's associates were designed for group instruction. We saw this in Neef's example. Mann apparently believed that Schmid's system was an improved version of Pestalozzian drawing, as can be seen from the following:

> Pestalozzi, and his friend Joseph Schmidt [*sic*], had done much toward suggesting the method, but Professor Peter Schmidt [*sic*] first perfected the system. We afterward saw it in operation in one of the finest normal seminaries of Prussia, where his latest improvement of the more simple sets of blocks was adopted. In all other schools where the pupils were of an age to commence drawing from nature, (and eight or ten years of age is not too early even to begin perspective drawing if taught thus practically, not theoretically) this mode was universally employed. (Mann, 1844a, p. 199)

The Joseph Schmid referred to by Mann had devised a method of drawing in Pestalozzi's institute that was published in 1809 (Ashwin, 1981), but it was not related to the method devised by Peter Schmid, as Mann had supposed. Yet he observed Peter's methods in one of the more advanced normal schools in Prussia, known for its advocacy of Pestalozzianism, which suggests that by 1843 new innovations were being incorporated into the method. Henry Barnard, who visited Prussia in 1836, listed Peter Schmid's methods as being among the principal advantages of the Pestalozzian method (Barnard, 1906).

Barnard also became acquainted with Peter Schmid's method before Mann, which is revealed in a passage in the *Connecticut Common School*

Journal describing a method that is unmistakably Schmid's, though he is not identified by name (Barnard, 1839). Barnard observed this method at the Royal Realschule of Berlin in 1835, which suggests that Mann was greatly mistaken in assuming that the method could be used to teach perspective to 8- and ten-year-olds.

SUCCESS IN TEACHING THE ARTS. A third writer on the subject of Prussian education was Calvin Stowe, whose report on it was first prepared for the Ohio legislature in 1838. It was later reprinted in both the *Common School Journal* and the *Connecticut Common School Journal*. The excerpt which follows comes from the latter publication.

> The universal success also and beneficial results with which the arts of Drawing and Designing, Vocal and Instrumental Music, have been introduced into schools, was another fact peculiarly interesting to me. I asked all the teachers with whom I conversed, whether they did not sometimes find children actually incapable of learning to draw and sing. I have had but one reply, and that was, that they found the same diversity of natural talent in regard to these, as in regard to reading, writing, and other branches of education; but they had never seen a child that was capable of learning to read and write who could not be taught to sing well and draw neatly, and that too without taking any time which would at all interfere with, indeed which would not actually promote his progress in other studies. (Stowe, 1838, p. 23)

Mann's Advocacy of the Introduction of Drawing

By 1844 Mann was making a concerted effort to promote instruction in drawing with arguments stressing both its practical and moral advantages.

> No artisan, in any department of mechanical labor, would fail to reap the advantage of knowing how to draw accurately. Cabinet-makers constantly import patterns for new furniture at considerable expense, and even the silversmith and calico-printer are dependent upon drawings for their improvements in fashions. In Europe, and in some places in this country persons gain their whole livelihood by making designs for calico printing for which large salaries are paid. If the subject of drawing were made an item of public instruction, young people would go forth from the schools partly prepared for entering into the various mechanical trades. (Mann, 1842, pp. 209–210)

In his *Seventh Annual Report* to the Massachusetts Board of Education he stressed drawing's link to handwriting.

> Such excellent handwriting as I saw in the Prussian schools, I never saw before. I can hardly express myself too strongly on this point. In Great Britain, France, or in our own country, I have never seen any schools worthy to be compared

with theirs in this respect. I have before said that I found all children provided with a slate and a pencil. They write or print letters, and begin with the elements of drawing either immediately, or very soon after they enter school. This furnishes the greater part of the explanation of their excellent handwriting. . . . This excellence must be referred in a great degree to the universal practice of learning to draw, contemporaneously with learning to write. I believe a child will learn both to draw and to write sooner and with more ease, than he will learn writing alone. (1844c, p. 132)

While Mann was unsuccessful in seeing drawing added to the schools of Massachusetts during his tenure as board secretary, his efforts bore fruit many years later. John Philbrick, Boston's second school superintendent, recalled that, "as one of the results of Mr. Mann's report on foreign education [the *Seventh Annual Report*] the school committee of Boston in 1848 placed the word 'Drawing' on the list of grammar school studies." Philbrick also noted that "the teachers were almost universally ignorant of this branch," and no provision was made for teaching it (Boston School Committee, 1874b, p. 256).

Influence of German Immigration

A less direct route by which drawing came to these shores was through the immigration of large numbers of Germans. Wygant (1983) notes that drawing was introduced into the schools of Cincinnati as early as 1842, where it was described as "the very useful art of Design in its various departments, in which many evidences of successful experiment were observed in some of the Districts during the past year" (p. 42). In 1847 the drawing department in the Central School proposed to offer a 4-year program of study. Wygant indicates that the Central School would be equivalent to a high school. Its drawing department was one teacher, William B. Shattuck. However, his position was terminated and the program was never fully implemented. Wygant also discusses early efforts to teach drawing in the schools of Cleveland, where a "Professor Jehu Brainerd began to help the teachers in their classrooms without demanding pay" (p. 41). His efforts, though short-lived, met with success.

Wygant notes that drawing was taught on a regular basis in Cincinnati's primary grades years before it met with public acceptance in cities along the eastern seaboard. The fact that the subject met with acceptance in Cleveland as well leads us to ask what these inland cities had in common that might account for this receptivity. Both Cincinnati and Cleveland were centers of heavy German immigration, especially after the Revolution of 1848. These new settlers came from a background where the teaching of drawing had been an accepted practice. The fact that the Cincinnati school reports were

liberally sprinkled with quotations from Stowe and Mann, extolling the virtues of Prussian education, suggests that the Cincinnati public was generally receptive to the idea that drawing should be taught.

By contrast, cities like Boston and Philadelphia had been settled for more than 200 years and had well-established schooling traditions based upon English schooling practices. Practices like drawing instruction, which had originated in the German-speaking world, would have had to surmount a Puritan or Quaker tradition, both which regarded the arts with suspicion.

The Art Crusaders of the Antebellum Era

A final source of Pestalozzian influence came from a group of artists who had begun to establish themselves as a developing aspect of American culture. A number of these were active as teachers of art or as writers of drawing manuals that could be used by the general public as self-help books. Peter Marzio describes these individuals as "art crusaders" because they were intent upon establishing a democratic form of art for a democratic society. Both in their drawing manuals and in their teaching they asserted that learning to draw was a skill well within the reach of all willing to apply themselves to the exercises with a respectable degree of diligence. One of the most influential manuals was *The American Drawing Book*, by John Gadsby Chapman (1847/1858). This book opened with the proclamation that "ANYONE WHO CAN LEARN TO WRITE CAN LEARN TO DRAW" (see Figure 4.4). Having studied more than 120 drawing manuals published between 1820 and 1860, Marzio notes that they were informed by two instructional doctrines. One was the *Discourses on Art* by Sir Joshua Reynolds; the other was Pestalozzian drawing.

> The art crusaders borrowed heavily from Reynolds and Pestalozzi, but both men often contradicted one another. The naturalism of the Swiss educator sneered at the formal, time-honored commandments of the English academic. Their major disagreement occurred over the meaning of beauty. Pestalozzi defined beauty as an activity of the mind; it was a function of perceiving or a process of perceptualization. Beauty was not a set of passive precepts of predetermined forms, but a tool to be used in constructing a "world view." (Marzio, 1976, p. 26)

The art crusaders reasoned that a democratic art needed rules that everyone could understand, which they found in the "grand style" of Reynolds, while in Pestalozzi they found practical methods for teaching it. By following Pestalozzian drawing and learning proportion through the division of geometric forms, the student gradually began to acquire the ability to draw Reynold's ideal forms. A drawing exercise for heads, for example, was

FIGURE 4.4.
Opening page of *The American Drawing Book*, by John Gadsby Chapman (New York: J. S. Redfield, 1847/ 1858).

derived from exercises academicians used with their beginning students for practicing the drawing of schemata of individual body parts (see Figure 4.5).

Many of these artists attempted to introduce drawing directly into the common schools. For example, William Bartholomew, an art teacher in the Girls' High School of Boston, published a series of textbooks for use in the Boston schools. Though these artists did much to dispel the notion that only the talented few could benefit from instruction, they did not succeed in establishing drawing in the public schools. It was still deemed a luxury for those who could afford lessons, not a subject worthy of public expense.

THE INDUSTRIAL DRAWING MOVEMENT

Public reluctance to support drawing began to change in the years following the Civil War. In 1870 the subject of drawing was mandated by

FIGURE 4.5.
"The Human Head,"
illustrating the drawing
of faces, from John
Gadsby Chapman, *The
American Drawing
Book* (New York: J. S.
Redfield, 1847/1858,
p. 41).

law in Massachusetts, some 37 years after Mann urged his fellow citizens to consider the merits of drawing as a branch of common school instruction.

In the intervening years since Mann's *Seventh Annual Report*, Massachusetts had gone from an agricultural economy to a burgeoning industrial one, with thriving textile and shoe manufacturing enterprises. Railroads now connected its major cities, and by 1870 Boston was a city of 250,000 in the throes of an urban explosion. Though the times had brought change, education continued to be viewed as that instrument which could correct the defects of society (M. Green, 1966; Handlin, 1969). The introduction of drawing was an attempt to enable the populace to capitalize upon the advantages of the Industrial Revolution, much as Europe had done generations before.

Economic Factors Leading to Industrial Drawing

The Civil War years were ones of economic recession in the textile industries of Massachusetts, owing to the cutoff of the cotton supply from the South. Wartime prices for goods were high, but profits were limited by

the lack of raw material. After the war these industries were hampered in their recovery by deflated textile prices and a lack of investment capital. The business pages of Boston's *Daily Advertiser* and *Evening Transcript* were filled with advertisements for investment opportunities in the railroads and western lands, suggesting that these prospects were draining funds that might otherwise have been used to capitalize local industries. New England industries were in competition not only with new ones in the American heartland but with European ones as well.

The 1867 Paris Exposition had a sobering effect on America. It became clear that New England's textiles could in no way compete for a share of the international market; in fact, European textiles were successfully competing with American products in our own domestic markets, in much the same way that Japanese automobiles were in the 1980s. Something had to be done if local textile industries were to survive; and as with other social crises of the nineteenth century, the schools were asked to supply the remedy.

By 1867 the quality of Britain's textiles was markedly improved over those seen at the Crystal Palace Exposition in 1851. American goods, by contrast, remained in the cellar. Boston's industrialists were anxious to learn the secret of Britain's success.

Key Persons in the Movement

The story of America's response to this situation began with the actions of three individuals: a wealthy Bostonian, Charles Callahan Perkins; the superintendent of schools for Boston, John Dudley Philbrick; and an English drawing master, Walter Smith. Perkins was the central figure, since he was able to influence his Boston contemporaries on the need for drawing in the schools.

CHARLES CALLAHAN PERKINS. An extensive biography on Perkins can be found in Diana Korzenik's *Drawn to Art* (1985).[6] Perkins had spent a great deal of time abroad, at which time he became acquainted with the system of education being developed in Britain by Cole. In 1869 he returned to Boston, and in the following year, when the Boston School Committee wanted advice on instruction in drawing, they consulted with him. A portion of his reply appears below:

> I am much flattered by your request that I would give my opinion upon the best way of rendering instruction efficient in the public schools. . . . It is as easy to teach children to draw as it is to teach them to write, provided they are taught in the right way, upon a system whose excellence has been fully tested. . . . The first object, then, is to have the teachers taught by a thoroughly well educated

master, so that having learned his system they may become competant to instruct in it. You naturally ask where is such a person to be found—this which question I answer, among the graduates of the Normal School at South Kensington. (Boston School Committee, 1871, pp. 323-327)

Perkins had also taken the liberty of writing to Henry Cole, superintendent of South Kensington, to make inquiries about salary level and to receive advice on potential candidates. He noted that a suitable drawing master could be had for about £500. The drawing committee's report continued with the following:

This letter of Mr. Perkins suggests a radical change in our normal instruction, but one which seems absolutely necessary if we wish to take any high stand in the movement now making itself felt throughout the land. We have had no system; our teachers have not been instructed, and the work must now be commenced: shall we have a plan, or shall all be done at random? Will it not be better to invite such a teacher as we have not had in this country to open here a school at which all our regular teachers shall have gratuitous instruction, and other teachers may become pupils at some fixed rate? The labor of instructing our large corps of teachers is no light one. It is harder in some respects than the instruction of the children, but when once accomplished in the right way, its influence pervades all our schools. The State requires us to give instruction in drawing; let it be the best that our country can afford. We are learning a new language in the United States, and we must learn it well, beginning with our primary schools. (Boston School Committee, 1871, p. 328)

JOHN DUDLEY PHILBRICK. In 1856 Philbrick became the second superintendent of the Boston schools, a position he held for 18 years (Clarke, 1892; Dunton, 1888). In 1874 he wrote a retrospective account of the history of drawing in his annual report to the school committee (Boston School Committee, 1874a). He mentioned that he had procured, at his own expense, a set of models and copies from England for the teaching of drawing. Later he appointed William Bartholomew, the drawing master of the Girls' High School, to serve as special drawing instructor for the primary and grammar schools. Bartholomew prepared the "Boston Primary Drawing Tablets and Slates" for this purpose. In 1867 he urged Bartholomew to prepare a series of drawing textbooks for the grammar schools. Philbrick claimed to have taken these initiatives "simply because there was at that time, absolutely no apparatus to be had, at all suitable for the purpose of instruction in drawing in the Primary Schools, where the foundations ought to be laid" (Boston School Committee, 1874b, p. 257).

By 1868, Boston had a graded course of instruction in drawing that began in the primary grades with slates and tablets, continued through the

grammar school grades, and ended with classes in the high and normal schools from special drawing instructors.

Though a system was in place, few if any classroom teachers were prepared to offer drawing instruction. Philbrick described the situation in the following way: "As the teachers were almost universally ignorant of this branch, and not the slightest provision was made for teaching it, either in the way of a programme, text-books, or special teachers, next to nothing came of this action" (Boston School Committee, 1874b, p. 256). At Philbrick's urging, the Boston School Committee appointed a standing committee on drawing to coordinate instruction. It was also formed in anticipation of the pending legislation that would make the teaching of drawing mandatory. In its first report this committee noted that "of all the studies of our public schools, drawing exhibited the most feeble results" (Boston School Committee, 1871, p. 323). The 1870 report of the drawing committee ended with two resolutions to the school committee as a whole. One was to open evening drawing schools for artisans; the other was to proceed with the procurement of a normal art instructor from South Kensington.

WALTER SMITH. The third key person in the story of industrial drawing was a professional drawing master named Walter Smith. Earlier we saw that Perkins had made inquiries to Henry Cole on the subject of an art master who could bring a first-hand knowledge of Britain's systems of art instruction to Boston. Cole, in turn, recommended Smith, and in the spring of 1871 Smith interviewed for the position and accepted. In the autumn of the same year, he emigrated to the United States to become the first art supervisor for Boston. At the same time he served as the first art education supervisor for the state of Massachusetts. While retaining these positions, he became a founder and first head of the Massachusetts Normal Art School, now The Massachusetts College of Art. Through these three offices Smith profoundly affected the teaching of what he called, "Industrial drawing." Not only did he devise a system of drawing instruction, but a system for the in-service training of classroom teachers. He also established the first training program for professional art teachers in the nation.

By the time the first volume of Isaac Edwards Clarke's monumental study *Art and Industry* appeared in 1885, Smith had returned to his native England, a defeated man. Though Clarke may not have so intended it, his book was for many years the chief work used by scholars to document Smith's work. *Art and Industry* was commissioned by a resolution of the U.S. Senate asking that the Secretary of the Interior furnish "a statement containing all the information in his possession relative to the development of instruction in drawing as applied to the industrial or fine arts" (Congressional Record, 1880, p. 647). At the time of the resolution Clarke

worked in the U.S. Bureau of Education and collected the documents, compiled the statistical data, and wrote the report. Its purpose was to disseminate information on art teaching throughout the country. In Clarke's view Smith's work in Massachusetts was most exemplary, and the appendices in the volume contain several hundreds of pages of documents by Smith and the Massachusetts drawing experiment.

By 1966 Harry Green could refer to Smith as "the forgotten man." His article is based on his doctoral dissertation of 1948, and at the time of that writing the biographical data on Smith was limited to Clarke's commemorative eulogy in the preface to Volume 2 of *Art and Industry*. Diana Korzenik's *Drawn to Art* (1985), which used the family records of Smith's descendants and noted his early career in England, brought new facts to light. The full story of Smith's accomplishments is presented later in this chapter.

Legislative Developments Preceding the Drawing Act

The *Thirty-Fourth Annual Report* of the Massachusetts State Board of Education (1871) offers the most complete public account of the background developments leading to the Drawing Act of 1870. Prepared by Joseph White, secretary of the board, the report notes that a group of 14 prominent citizens, mostly from the Boston area, delivered a petition to the legislature requesting a law that would make the provision of free drawing instruction to men, women, and children mandatory in all communities of the commonwealth with a population exceeding 5,000. The report also indicates that Francis Cabot Lowell, Jr., and Edward Everett Hale probably instigated the petition process.

Lowell and Hale were more than public-spirited citizens. Each was intimately connected with the textile industry. Lowell was a descendant of the original Francis Cabot Lowell, who reinvented the first power loom in America, based on crude drawings made of such machines that he had seen in England. Hale was a prominent Unitarian minister, the son of Nathan Hale, editor and publisher of the *Boston Daily Advertiser*. Hale was also a popular writer, best remembered today for his novel *The Man Without a Country*.

Hale's father was a friend of Dr. Jacob Bigelow (Holloway, 1956), another signer of the petition. Bigelow's son, Erastus Brigham Bigelow, was the founder and owner of the Bigelow mills, which produced brocades, lace, and carpets. He also signed the petition.

A study was made by Bolin (1986) of the connections between these 14 signatories. He found that most of them were bound to the textile industry, that they were mainly graduates of Harvard University, that their predominant religious affiliation was Unitarian, and that in their politics they were

supporters of the old "Whig" ideals. Though the Whig Party had ceased to be active after the 1850s, these men supported a strong central government active in the pursuit of trade policies that would protect American industries from international competition. For example, Erastus Bigelow was an active pamphleteer on behalf of protective tariffs for the textile industry (Bigelow, 1877). Thus in every respect they represented the industrial power structure of Massachusetts and New England.

The text of their petition requesting that free drawing instruction be made available throughout the state was reprinted in the Massachusetts Board of Education (1871) *Thirty-Fourth Annual Report,* as follows:

> To the Honorable General Court of the State of Massachusetts.
>
> Your petitioners respectfully represent that every branch of manufactures in which the citizens of Massachusetts are engaged, requires in the details of the process connected with it, some knowledge of drawing and other arts of design on the part of skilled workmen engaged.
>
> At the present time no wide provision is made for instruction in drawing in the public schools.
>
> Our manufacturers therefore compete under disadvantages with the manufacturers of Europe; for in all the manufacturing countries of Europe free provision is made for instructing workmen of all classes in drawing. At this time, almost all the best draughtsmen in our shops are thus trained abroad.
>
> In England, within the last ten years, very large additions have been made to the provisions, which were before very generous, for free public instruction of workmen in drawing. Your petitioners are assured that boys and girls, by the time they are sixteen years of age, acquire great proficiency in mechanical drawing and in other arts of design.
>
> We are also assured that men and women who have been long engaged in the processes of manufacture, learn readily and with pleasure, enough of the arts of design to assist them materially in their work.
>
> For such reasons we ask that the Board of Education may be directed to report, in detail, to the next general court, some definite plan for introducing schools for drawing, or instruction in drawing, free to all men, women and children, in all towns of the Commonwealth of more than five thousand inhabitants.
>
> And your petitioners will ever pray.

Jacob Bigelow	John Amory Lowell
J. Thos. Stevenson	E. B. Bigelow
William A. Burke	Francis C. Lowell
James Lawrence	John H. Clifford
Edw. E. Hale	Wm. Gray
Theodore Lyman	F. H. Peabody
Jordan, Marsh & Co.	A. A. Lawrence & Co.

Boston, June, 1869 (pp. 163–164)

On June 12, 1869, the legislature, obviously impressed by the status of the signatories, passed a resolution instructing the state Board of Education to consider the expediency of "making provision by law for giving free instruction to men, women, and children in mechanical drawing, either in existing schools, or in those to be established for that purpose" (p. 163), with instructions to report back to the legislature with a definite plan by the next session. On receipt of the resolve the state board organized a study committee consisting of John Philbrick, D. H. Mason, G. G. Hubbard, and Joseph White.

On December 27, 1869, this study committee issued a circular asking for the opinions of those knowledgeable of the mechanical industries. The text of the circular stated: "It is presumed that the term 'mechanical drawing' as used in the Resolve, is intended to comprise all those branches which are applicable to the productive or industrial arts" (p. 164). The circular asked for information pertaining to the advantages "which might be expected to result from contemplated instruction in mechanical or industrial drawing, . . . the course and methods of instruction appropriate for the objects in view, . . . the models, casts, patterns, and other apparatus necessary to be supplied, . . . the organization and supervision of the proposed Drawing Schools, . . . [and] the best means of promoting among the people an interest in the subject of art education" (pp. 164–165).

The circular produced numerous replies from such notables as C. O. Thompson, principal of the Worcester Technical School; William Ware, professor of architecture at the Massachusetts Institute of Technology; Professor Louis Bail of the Sheffield Scientific School of Yale College; and William Bartholomew, teacher of drawing from Boston. Perhaps the most impressive testimonial came from Henry Barnard, who had recently retired as U.S. Commissioner of Education. These letters were published in the appendix to the annual report of state Board of Education secretary Joseph White.

The study committee held interviews with Edward Everett Hale and Francis Lowell on March 9, 1870, and in its report to the legislature recommended "an enactment requiring elementary free hand drawing in all of the Public Schools in the Commonwealth." On May 16, 1870, the legislature enacted the first law in the nation making the teaching of drawing compulsory. The text of the law appears below:

An Act relating to Free Instruction in Drawing. Be it enacted . . . as follows:
 Section 1. The first section of chapter thirty-eight of the General Statutes is hereby amended so as to include drawing among the branches of learning which are by said section required to be taught in the public schools.
 Section 2. Any city or town may, and every city and town having more than ten thousand inhabitants shall, annually make provisions for giving free instruc-

tion in industrial and mechanical drawing to persons over fifteen years of age, either in day or evening schools, under the direction of the school committee.

 Section 3. This act shall take effect upon its passage. [Approved May 16, 1870] (Massachusetts Board of Education, 1871, p. 134)

The Drawing Act fell short of the petitioners' wishes by applying only to towns of 10,000, instead of 5,000 as requested. It did not contain provisions to facilitate or enforce the legislation. Nor did it provide funds to hire drawing teachers or buy textbooks, casts, slates, and other supplies; in the following year, however, funding for a state supervisor of drawing was provided.

 Joseph White took obvious satisfaction in the great response to the legislation that ensued around the state. Though noting crowded classrooms and a lack of qualified teachers, he minimized these problems. He also was able to report that public response was extremely favorable. Evening drawing classes were crowded throughout the state, as many workers sought to improve their skills (Massachusetts Board of Education, 1871).

 The Drawing Act obviously struck a responsive chord throughout the state, where 23 cities and towns were now required to provide free drawing instruction. In her introduction to *Drawn to Art*, Korzenik recounts that in the latter decades of the century Americans felt themselves to be a people without any art, and yet there was a "passion for learning to draw. This single activity took on the intensity of a dream, capturing and compressing the needs and wishes that encompassed the whole culture" (1985, p. 2).

Smith's Definition of Industrial Drawing

 When Walter Smith took up his duties in Boston, there was little agreement as to the type of drawing that satisfied the definition of "industrial drawing." The legislation itself specified "industrial or mechanical drawing." For some, these terms meant the kind of technical drawing done with instruments. For others, it meant the free-hand drawing of designs or decorative motifs to be applied to objects undergoing manufacture. Even White's committee, which recommended the legislation, was uncertain as to the exact definition. In their December 1869 circular they presumed the term *mechanical drawing* was "intended to comprise all those branches of drawing which are applicable to the productive or industrial arts" (Massachusetts Board of Education, 1871, p. 164).

 Thus throughout 1872 Smith gave 12 lectures before the Lowell Institute defining industrial drawing and describing a program of instruction to establish it. Later in that year the lectures appeared in book form under the title *Art Education Scholastic and Industrial* (Smith, 1872a). It was dedicat-

ed to John Armory Lowell, one of the signatories of the 1869 petition and the first trustee of the Lowell Institute. Smith described industrial drawing in the following way:

> The kind of drawing which the State of Massachusetts requires that its citizens shall have the opportunity of studying, is called "Industrial Drawing;" and wisely so called for in that lies the justification of its public action in the matter.
>
> It is so described, I apprehend, to distinguish it from the more ornamental or professional branches of art which people study rather as an amusement or gratification, or as a lucrative profession than as an important element in the trades and manufactures. (1872a, p. 42)

Near the end of his tenure in Boston, Smith took pains to emphasize the degree to which drawing is an intellectual discipline:

> The true function of drawing in general education is to develop accuracy of perception and to exercise the imagination, thereby tending to produce a love of order and to nourish originality.
>
> Educationally drawing should be regarded as a means for the study of other subjects, such as geography, history, mechanics, design. In general education it is to be considered as an implement, not an ornament.
>
> The practice of drawing is necessary to the possession of taste and skill in industry, and is therefore the common element of education for creating an enjoyment of the beautiful, and for a profitable practical life.
>
> Good industrial art includes the scientific as well as the artistic element; science securing the necessity of true and permanent workmanship, art contributing the quality of attractiveness and beauty. The study of practical art by drawing should therefore comprehend the exactness of science by the use of instruments, as in geometrical drawing and designing, and the acquisition of knowledge of the beautiful, and manual skill in expression, by free-hand drawing of historical masterpieces of art and choice natural forms. (quoted in Clarke, 1885, p. 264)

In 1881 he reiterated the importance of drawing in education in a lecture to grammar school teachers held at the Girls' High School. Here drawing is characterized as a mental discipline:

> What we are trying to do in our lessons is to make the children know how to draw, not how to make drawings; and I hope you see the distinction. And the great reason for them to draw is, that the process of drawing makes ignorance visible; it is a criticism made by ourselves on our perceptions, and gives physical evidence that we either think rightly or wrongly, or even do not think at all. For a bad or incorrect drawing is never an accident; it is an uncomfortably accurate mirror for our thoughts, and fixes the stage of mental development and civiliza-

tion we have arrived at. Good or bad pictures are never produced unintentionally; they have existed in the brain in all their beauty and deformity before they passed through the nerves and fingers on to the paper or canvas. So with drawings; if a child draws in a diabolical manner, don't trouble to alter the drawing in his book as to change the mental process in his skull. (quoted in Clarke, 1885, pp. 564–565)

For Smith, the term *industrial* was not to be narrowly construed with work in factories. Rather, it was bound up with the virtue of industriousness. Ordinary drawing became industrial when the emphasis turned to science, which is seen in its "accuracy of perception," its neatness and precision.

Moreover, industrial drawing was not blind to beauty. In Smith's writing *the beautiful* was a term used in connection with the art of classical antiquity, and in his instructional practice the student was exposed to the beautiful in the form of casts, though more usually through flat copies (Smith, 1872b). Copying these forms was a way to acquire the faculty of good taste. What also made his drawing industrial was the use of outline drawing. Figure 4.6 shows one of the flat copies that Smith provided advanced students who had completed the formal exercises in his drawing program.

Smith's Vision of Art Education

Smith's plan for art education was one that embraced all levels from the primary grades to the high school. And it reached beyond public schools and the evening drawing schools, for it was concerned with the elevation of public taste as well.

There are three sections of the public to be educated, — children, adult artisans, and the public generally, who come under neither of the first two divisions. How this has been provided for in most of the European States I may here shortly describe. For children, elementary drawing is taught as a part of general education in most of the public schools; for adult artisans, night schools and classes have been established in almost all towns or populous villages; and for the general public, museums, galleries of art, and courses of public lectures on art subjects, are becoming general. Upon the comparative value of these several means there may be and is much difference of opinion; but on one point there is a general agreement, viz., that to make national art education possible, it must commence with children in public schools. . . . To establish schools of art and art galleries before the mass of the *community* were taught to draw was like opening a university before people knew the alphabet; but to provide both of these agencies in conjunction with, or as a continuation of, the instruction of drawing in public schools, was like a logical sequence, going in rational order

FIGURE 4.6.
Illustration (Plate 184)
from Walter Smith, *The Standard Book of Graphic Reproductions and Designs* (Boston: James Osgood & Co., 1872).

from strength to strength of an unbroken chain; from bud to branch, and from branch to flower of natural educational growth. (1872a, p. 43)

Smith had two main objectives: to create a plan of instruction in drawing that would be distinctly industrial, and to instruct the regular teachers to give instruction without the aid of special instructors, as part of their regular school work.

Prior to Smith's arrival, the drawing committee decided that drawing should be taught by regular teachers, as with any other regular subject. They justified this policy by citing the excessive cost of using special drawing teachers, not to mention their lack of availability; practices in other countries; and the success with which music had been introduced a generation earlier. Smith expressed a similar view in the following passage:

Who is to teach drawing in public schools? . . . To this there can be but one reply; which is, There can be no special teaching of drawing as a special subject, any more than of writing or arithmetic as separate subjects; but the general

teachers themselves must learn and teach elementary drawing to the children in the same way they learn to teach other subjects. It will only be by having a teacher of drawing in every classroom in every school in the country, that all the children can be taught to draw; and this can only be accomplished by making general teachers include drawing among their subjects of instruction. (1872a, pp. 44–45)

Smith developed a graded plan of instruction that began in the primary grades, continued through the grammar school grades, and culminated in the high schools. During 1872 he introduced free-hand, model, and memory drawing in the primary grades.

In free-hand outline drawing, the teacher made a prescribed drawing on the blackboard in front of the children. These first drawings consisted of vertical, oblique, or horizontal lines in various combinations, such as angles, squares, and triangles. The younger pupils reproduced these drawings on their slates and were required to devote four 30-minute lessons to drawing each week. Older pupils were permitted to draw on paper. An example of a typical free-hand exercise is shown in Figure 4.7.

Model drawing was introduced to the older pupils in the primary grades. The models to be drawn consisted of objects that are the same on all sides, such as a cylinder, a cone, or a vase without a handle. Because these first objects are symmetrical, the teacher could use a central line in drawing them. As in the free-hand drawing lessons described above, the teacher introduced the lesson by drawing the model on the blackboard. In *Art Education Scholastic and Industrial* (1872a), Smith showed how model drawing was being taught in studios at the Cooper Union (see Figure 4.8). Memory Drawing was also taught in the primary grades. In this exercise the children reproduced from memory some object that they had already drawn. "The chief cornerstone of our whole fabric was the use of the blackboard," which "is to teaching what steam is to transportation" (quoted in Clarke, 1885, p. 558).

Drawing cards were also used to supplement the demonstration work of the teacher. These contained copies of the blackboard demonstrations printed on 3″ × 5″ cards in white lines against a black background, simulating the blackboard. Each child received a small envelope containing a set of 12 cards.

The grammar school program was built on the foundation established in the primary grades. Model drawing was treated once again, but in a more complex fashion that introduced the elementary rules of perspective. Groups of objects would be placed together, as in a still-life arrangement, to introduce students to the problems of compositional arrangement.

FIGURE 4.7.
"Free-Hand Drawing"
exercise, from Walter
Smith, *The Teacher's
Companion to the
American Drawing-
Slates* (Boston: James
Osgood & Co., 1872, p.
26).

S. — Greek Anthemion.

Draw the vertical line, and divide it into two equal parts. Make 1–2 equal to two thirds of the vertical line, and 3–4 equal to one third, at a distance of one third the vertical line from its lower extremity.

Draw the dotted curved lines inclosing the leaflets or sepals of the anthemion, and terminating in the upper and lower extremities of the central line. The points on this curved outer line, where the members of the anthemion touch it, should then be marked on either side, and the forms be drawn ; afterwards the spiral lines, which are at its base, should be sketched by judgment of the eye. This ornament is a conventionalization of the honeysuckle, or columbine, or woodbine, and is among the most refined of the beautiful forms we derive from Greek art.

A horizontal moulding may be made of this example by continuing the two lines forming the spiral upwards to inclose the whole figure, parallel with the dotted lines, which pass through 1–2, and meeting above in the central vertical line. The oblong in which the figure is inclosed may then be repeated horizontally as many times as desired, and the same figure drawn in each.

The first in-service art classes for teachers were held at the Appleton Primary School, where a temporary drawing school was set up on the upper floors of the building. There a collection of casts (some donated by Perkins) were assembled. Smith then proceeded to instruct a small cadre of teachers made up of special drawing instructors. These individuals taught drawing in high schools prior to the arrival of Smith in 1871, but now they were placed under Smith's direction and proceeded to work in the in-service program. The drawing committee report for 1871 identified them as Mr. Charles Furneaux, B. F. Nutting, Henry Hitchings, Mr. Barry, and Miss Mercy Bailey (Boston School Committee, 1872, p. 305). In 1874 they were joined by two additional instructors, raising the number to seven. These specialists

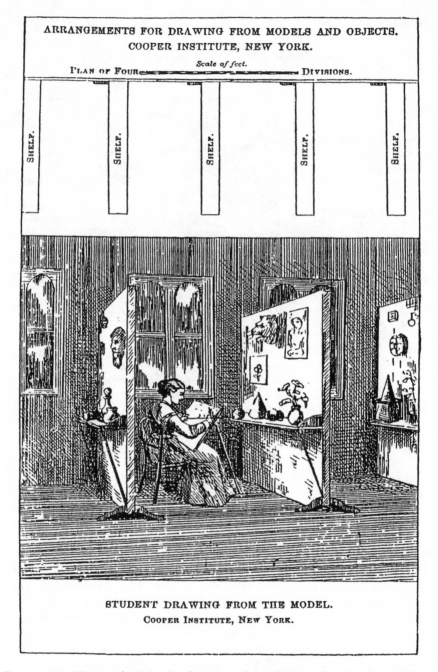

ARRANGEMENTS FOR DRAWING FROM MODELS AND OBJECTS.
COOPER INSTITUTE, NEW YORK.

Scale of feet.

PLAN OF FOUR━━━━━━━━━━━━━ DIVISIONS.

SHELF. SHELF. SHELF. SHELF. SHELF.

STUDENT DRAWING FROM THE MODEL.
COOPER INSTITUTE, NEW YORK.

FIGURE 4.8. "Fittings for Schools of Art," model and object drawing, from Walter Smith's *Art Education Scholastic and Industrial* (Boston: James Osgood & Co., 1872, following p. 116).

in turn taught Smith's lesson to the regular teachers in the primary and grammar schools. Participation in these lessons was on a voluntary basis. By 1880 Smith was able to report that out of 1,045 teachers then employed in the public schools, more than 1,040 had attended the normal lessons either in the special normal classes provided, the city normal school, or other normal schools (Boston School Committee, 1881).

Response to Smith's Efforts

During the first years of his service, Boston's school committee documents rang with praise for Smith's vigorous efforts to implement the drawing program. In 1873 the drawing committee commended him for his "conscientious direction" (Boston School Committee, 1874a, p. 209). In 1874, Perkins, the chairman of the drawing committee, concluded his report with the wish that the schools might long retain Smith's services (Boston School Committee, 1874c), and in 1878 Perkins said that "we have reason to be grateful to our able director, Mr. Walter Smith, who, with ample knowledge of the merits and defects of foreign systems, organized and shaped [Boston's drawing system] to suit our peculiar circumstances" (Boston School Committee, 1878, p. 6).

However, enthusiasm for Smith's efforts was far from unanimous. There were those who continued to believe that drawing had no place in the schools, regardless of the method by which it was taught. Others found the method itself wanting, because it lacked artistry. The greatest internal complaint came from the affected teachers themselves, who on alternate weeks walked during their lunch hour to the Appleton Street School for the next exercise in Smith's system. It was hardly the exertion of the walk to Appleton Street that distressed them. Rather it was the fact that Smith was an exacting taskmaster. His examinations for certificates, it was claimed, "were more systematic and inflexible than any other department except Music" (Boston School Committee, 1875a, p. 28). Earlier Philbrick commented that "it was natural that [there] should be some grumbling, for there are always some who are averse to any extra exertion or any interruption to established routine" (1873b, pp. 225–226). A little later he pleaded for patience, noting that "extra pressure was inevitable in the introduction of so great an improvement." Two years later, Philbrick admitted that "great progress has been achieved, but not without friction and difficulty, owing to the conflict of pecuniary interests, the expense incurred, and the extra drafts made upon the time and strength of teachers" (Boston School Committee, 1874b, p. 261).

Smith organized a series of annual exhibits in Horticultural Hall, where the work of the pupils was displayed. Now for the first time the public could see the results of the program and note which schools were making progress and which, not. This proved to be a source of consternation among teachers, for they felt that their efforts were being put on trial.

Establishment of the Normal Art School

Though Boston's drawing committee was committed to the notion that drawing was to be taught by regular teachers like any other regular subject, it was nevertheless necessary for Smith from the start to make use of specially trained art teachers to help implement his system. It soon became evident that, with nearly 1,500 teachers and 40,000 pupils, not to mention the evening drawing schools, Smith could not do it all himself.

The solution proposed was establishment of a normal art school — a school that would specialize in the training of art teachers rather than artists or designers. No such institution existed in the United States; indeed, the Department of Science and Art at South Kensington was itself something of a novelty in this respect. The idea that an art teacher might require a different form of training than an artist was a radical notion, for throughout the centuries only artists had taught art, and then mainly to prospective artists! That art could be taught by anyone but an artist was a radical notion in the history of ideas.

A first attempt at creating such an institution took place in the spring of 1872, when Philbrick, as a member of the state Board of Education, presented a legislative committee on education with a proposal for a normal art school. Perkins, Smith, and secretary Joseph White joined with Philbrick in urging this legislative committee to report on a bill to the legislature, but public opinion was not prepared for it. In the following year, however, the Board of Education unanimously recommended the project. The legislature granted the sum of $7,500 (half the sum requested) for the purpose of training art teachers, at the same time setting aside a portion of a building in Pemberton Square, Boston, for the use of the proposed school. The school officially opened its doors on November 6, 1873 (Dean, 1924).

The mission of the school was reiterated many times both by the Board of Visitors that oversaw the affairs of the new school and by Smith himself. Smith himself made the following comments concerning the school:

> The object of the school is not simply to make artists or the teachers of artists. Whoever looks at any stock of our manufactures of any such kind as demand taste and artistic culture in their production, can see how much of skill and labor have been expended on design whose lack of beauty is evident and distressing. So long as foreign products in whose departments which admit the influence of art are artistic, while ours are inartistic, no system of protection can secure use in the competition. The work of your school, therefore, as tending in the education of artisans who shall be also artists, appeals directly to the most practical commercial interests. We cannot afford to be without it. (Massachusetts Board of Education, 1874, p. 7)

The success of the normal art school was far-reaching. Many of the school's graduates and certificate holders took positions in neighboring states, thus spreading Smith's ideas far beyond the confines of Massachusetts; but by far greatest exposure of the school was obtained by its exhibition of student work at the Centennial Exhibition in Philadelphia in 1876. Though the school was then only three years old, and still housed in crowded, temporary quarters, its exhibits attracted international attention. In particular, the French commissioners on education wrote in their report to their government the following:

> The public schools of Massachusetts presented a collective exhibit extremely remarkable, the most complete of all and the most methodically arranged. Such works bear witness to the excellence of the method. If we bear in mind that these are the result of but a few years, we must admit that never before have such remarkable results, in so short a time, been attained. As soon as the Massachusetts Normal Art School shall have had time to bear fruit, we predict for the industrial art of Massachusetts, new increase and a brilliant future. (quoted in Dean, 1924, p. 10)

Criticism of Industrial Drawing

As early as 1873, however, the position of industrial drawing in the schools was deteriorating. Economic hard times had followed in the wake of the Panic of 1873, changing the mood of the electorate. Anxious to reduce instructional costs and improve efficiency, the school committee had voiced plans to reduce, and if possible eliminate, the staff in such special subjects as drawing.

A second factor undermining the industrial drawing movement was the rise of the vocational education movement, which had its beginnings in American educators' exposure to vocational schooling abroad through the educational exhibits at the Philadelphia Centennial Exposition. Although Smith's exhibits on behalf of industrial drawing were commended, they were overshadowed by John Runkle's report to the Massachusetts Board of Education on the manual element in education. Most notable in this report was an extensive description of a Russian vocational school that successfully demonstrated the intellectual aspect of vocational training (Runkle, 1877).

Other difficulties besetting Smith came from a doubting public, one that was at times quite vociferous. From 1872 until 1883 the reports of the drawing committee were authored by Perkins, who on numerous occasions felt he had to defend the program.

The sort of drawing which we teach is no amusement, or special branch of culture, neither does [it] require any peculiar artistic aptitude. It should rather be called graphic science than art education, as it is based on geometry, and is of a thoroughly practical nature. It is equally indispensable as a basis for such knowledge as is needed in all industries, and for that higher knowledge required in the arts of design. From the nature of our public schools, we treat drawing in them from its utilitarian side, and are able only in a very limited degree to blend the aesthetic with the purely practical. (Boston School Committee, 1877, p. 232)

In 1879 Perkins described the quandary of the drawing committee in terms of three opposing groups who objected to the drawing program. He then went on to describe the attempt of the committee to maintain a middle course. One group objected to the program because they felt the schools should not deal with fine art; another objected to the high cost of the program; the third objected to the mechanical, inartistic quality of the program. He wrote:

With Drawing, on the contrary, there is no peace. Some persons, overlooking its industrial bearings, object to it as a study. They regard it as an accomplishment connected with the fine arts, and therefore unfit to be taught in the public schools. Others make war upon Drawing on account of the expense of teaching it, for which they can see no adequate return. Still a third party exists to denounce the system by which it is taught, as mechanical, unartistic, and worse than useless. Could they manage matters more to their liking they would turn the schoolrooms into studios, multiply special instructors, and provide fifty thousand children with casts, pictures, and autotypes as well as colors, charcoal, and other artistic materials. It will readily be seen that between these three classes of critics the Drawing Committee occupies a somewhat unenviable position. (Boston School Committee, 1879, pp. 3–4)

Opposition also took the form of criticism of both the textbooks and the program itself. In 1874 Smith's publisher, the James Osgood Co., became involved in an altercation with Woolworth Ainsworth Co., publisher of Bartholomew's textbooks. Bartholomew had prepared his books for use in the Boston schools, but with his resignation as teacher of drawing at the Girls' High School on the eve of Smith's arrival, the way was made clear for Smith to introduce his own textbook series. Whether Bartholomew's books were ever adopted in Boston or not is unclear, but it was the case that he had lost a lucrative market. A battle between the two publishers was inevitable. In 1874 a circular appeared with bold letters proclaiming DRAWING IN THE PUBLIC SCHOOLS by the use of the Smith books CONDEMNED. Smith's system was criticized because his lessons did not advance from the simple to the complex, because he offered faulty definitions of art terms and terms used in

the teaching of geometry, and because the manuals were artistically incompetent. Osgood was quick to publish a rejoinder in the form of a circular entitled simply *Drawing in the Public Schools*. The company questioned Bartholomew's credentials, his ability to deduce suitable practice from his theories, and even his connection with the 1870 legislation. It quoted from the published school committee reports to insinuate that Bartholomew was not competent to direct the drawing program.

On the eve of the Centennial celebration another attack was made upon the system of art education in Massachusetts, in the form of two articles in *The Nation* (1875, 1876). Although Clarke (1892) ascribed these articles to a hostility to free public schools and therefore to Smith's efforts to make the schools more useful, there is little in these articles to suggest hostility to public schooling per se.

The first article assailed the confusion between art education for industry and art education for purposes of artistic expression. Designers needed training of a "purely artistic kind which cannot be provided unless the mechanical element be kept out of it" (*The Nation*, 1875, p. 425). The mechanical element was exactly what Smith and Perkins had called "graphic science," an element that pervaded the Massachusetts system. This was not a new argument. Ruskin during his tenure as the first Slade Professor of Art at Oxford (1869–1877) had vehemently opposed the industrial drawing taught by the South Kensington School, believing its flaw to lie in the doctrine that design could be efficiently taught by rule, as a branch of manufacturing activity. In his view, the way to get artistic designs was to "educate men as artists, not teach art as a branch of manufacturing," a view to be discussed more fully in the next chapter. Unlike the carping critique from Bartholomew's publisher, there was an intellectual basis in this argument that could not be readily dismissed.

The Nation's articles questioned whether any system based on mechanical approaches to design could be effective in attaining the objective of better designs for manufacture.

Smith's Dismissal from the Boston Schools

It was during the two years of the Samuel Eliot superintendency (1878–1879) that a special investigating committee was appointed to examine all aspects of the school system with a view to cutting costs by eliminating programs that were either ineffective or too costly. The drawing program and its director were natural targets for this "Committee of Five," as it was called, since they were the center of a growing public controversy. Through the early months of 1880 and again in 1881 there were numerous letters to the editor and editorials in the morning and evening papers complaining

about Smith. There was an angry exchange of letters between Louis Prang, who had become Smith's publisher in 1875, and Smith on the front pages of the Boston *Daily Advertiser* and the *Evening Transcript*, with Prang's letters timed to appear on the eve of school committee meetings. Prang had introduced certain changes into Smith's books — adding "guide-points" — that made them unsuitable from Smith's standpoint.

This unfavorable publicity took its toll. In the early spring of 1881 the school committee met to make its annual determination of who should fill the position of drawing director. As head of the committee on drawing and music, Perkins was ready at the March 22 meeting to place Smith's name in nomination, when another member moved to postpone the vote until the next meeting. Of the 15 board members present, 6 voted for Smith, 5 cast blank ballots, and 3 voted for other persons. One board member apparently abstained. Since 13 votes were needed to renew Smith in his position, the election was postponed till the next meeting.

At the March 29 meeting Perkins read a communication from Smith regarding the subject of drawing books. Since Prang had made his altercation with Smith public knowledge in the Boston newspapers and in testimony before the school committee the previous month, Smith's report was probably an attempted rejoinder. Prior to the balloting Perkins moved that the doors to the meeting room be closed to the public, but the motion was defeated. The balloting began with Smith receiving 7 votes and 8 going to other persons. Since no decision was reached, another election was scheduled for the next meeting. On April 5 Smith's supporters were able to muster 10 favorable votes, the most he ever was to receive, but still not enough to renew his appointment. Four additional ballotings took place on April 12, with support growing for an alternative candidate, Henry Hitchings, the art teacher at the English High School. Finally, on April 26, after several more attempts, Smith's supporters capitulated and threw their support to Henry Hitchings, a teacher loyal to Smith and his program. Having received 14 favorable votes, Hitchings became Boston's second director of drawing. Smith was removed from the position, his ten years of labor ending in heartbreak (Boston School Committee, 1881).

Years after the fact, Clarke suggested that Smith was voted out by the accidental absense of one or two of his supporters, but the school committee proceedings tell quite another story. His failure to win reelection was not a mere accident. Smith was a center of controversy, and for the sake of harmony he had to be dismissed.[8]

Still another explanation might lie in the fact that by 1881 the methods used by Walter Smith were beginning to be perceived as "old fashioned." The system of starting with the straight line and proceeding through the elements of geometry had been around since the end of the eighteenth century. Now, the end of the nineteenth was approaching. In Britain the arts-and-crafts

movement, spurred by the writings of Ruskin and Morris, was changing attitudes toward the arts and their relation to manufacture. In France the impressionists had begun to revolutionize painting; the era of modern art had begun. Above all, change had begun to affect the character of society itself. Rising affluence had brought about a new and more numerous middle class, and it was their values and aspirations that were beginning to influence public education. It is doubtful that an industrial conception of art education was in accord with these values.

A telling example of this non-acceptance appeared in an editorial of the *Boston Evening Transcript* on February 24th, 1881, entitled "An Un-American System."

> Your English educator more conveniently classifies the children in the public schools at once into those who are "going to college" and those who are "intended for employment in the constructive industries." Having assumed the existence of these classes, the rest of his convictions follow easily. . . . We have no class "intended for employment in the constructive industries." Every mother's son of our Yankee schoolboys is intended for the United States Senate. If not, which one is not? Would anybody dare to go into the public schools of Quincy and pick out and set aside those boys who "are going to college" and those who are intended for Mr. Walter Smith's artisan class? (p. 4)

Industrial art education was perceived by this editorial writer as the product of a class-based society—as, indeed, it was.

CONCLUSIONS

Common school drawing made its first appearance in Pestalozzi's institute. It was taught in order to develop the faculty of perception through exercises that involved measurement of geometric forms. These exercises were not designed to elicit individual expression or to develop a sense of the beautiful, but to stimulate the rational powers of the mind. In this way children would learn to form accurate sense impressions as the basis for clear and distinct ideas. This pedagogy reflected the eighteenth-century philosophy of the Enlightenment, which viewed the power of reason as the means to improved lives and happiness.

Pestalozzi's methods also tended to reduce drawing to the mastery of a linear alphabet comprised of straight and curved lines. Even the title of Pestalozzi's manual *A B C der Anschauung*, alluded to the alphabet. The similarity between learning to draw and learning to write began with Pestalozzi and was repeatedly stressed throughout the century.

Common school art education insisted that talent was not a necessary

precondition for learning, that anyone who could learn to write could learn to draw. Moreover, anyone who could teach regular subjects could become a teacher of drawing.

Common school art was totally at variance with the aesthetic traditions of the fine arts. Throughout the century, art academies were gradually abandoning the linear, neoclassical drawing traditions of the latter half of the eighteenth century in favor of drawing styles showing romantic tendencies. While tonal drawing with charcoal became common in academies of art, the art of schoolchildren held steadfast to outline drawing. Common school art also did not stress the human figure.

Once the tie of common school art to industry was established, it could be justified as a school subject supported at public expense, though it was not a study that met with popular acceptance. As Smith implemented his program grade by grade, mounting public resistance was encountered, especially from the middle classes. There is evidence of public acceptance for the evening drawing schools which remained in operation until 1905. Yet it seems clear that industrial drawing would not have been introduced without the support of a rich and powerful minority seeking to promote their own economic interests.

We might speculate on why the common school art that was conceived by Pestalozzi for purely intellectual purposes ended up becoming the servant of the factory system as the Industrial Revolution spread. Both the factory and Pestalozzian drawing were products of a similar kind of reductionism in which complex tasks are broken into simple units that are rearranged to make learning or productive processes efficient (Ellul, 1967). When this happened there was a gain in productive efficiency but a corresponding loss in the aesthetic quality of manufactured goods, since manufacture ceased being guided by the artistic sensibility of trained craftsmen. And just as industrial manufacture lost an inherent aesthetic quality, so also did these schooling methods reduce the aesthetic quality of the art being taught.

Nevertheless, there were many individuals who decried this tendency as it emerged in the industrial sector of society, as we saw in Schiller. Indeed, one can view the cultural revolution known as romanticism as an alternative to the scientific rationalism that came into prominence during the nineteenth century. And just as the rationalistic pedagogies of Pestalozzi had their origins in the ideas of the Enlightenment, so did the romantic alternatives of Froebel and others originate in the philosophical idealism of Kant and Hegel. The following chapter looks at this stream of educational history.

CHAPTER FIVE

The Stream of Romantic
Idealism in Art Education

Throughout the nineteenth century a stream of romantic idealism influenced educational theory and practice. In many ways it arose in reaction to the methods of mass public education associated with the common school. In the hands of Prussian schoolmasters, Pestalozzi's pedagogical methods had acquired a Spartanlike stringency. New philosophies called these methods into question. The Kantian notion of mind as active process was embodied in Froebel's kindergarten. "Self-activity" in turn led to "self-expression" as a method for teaching the arts by the turn of the century. Ruskin's romantic ideas of artistic perception as a capacity for moral beauty also owed much to ideas rooted in the philosophy of German idealism that led to the romantic movement in literature and art.

Idealism entered American educational thought through two principal paths. One was through the New England transcendentalists, whose ideas were reflected in the theories and practices of Amos Bronson Alcott and Elizabeth Peabody. The other was through William Torrey Harris's interpretation of Hegel. Indeed, it was Alcott's influence on the young Harris that had paved the way for his immersion in Hegelian philosophy.

Idealist thought was instrumental in transforming the arts from mere "ornamental" branches of "polite learning" to subjects richly imbued with moral purpose. As long as art was merely ornamental, it was a desirable but dispensable luxury, suitable primarily for the daughters of the wealthy. Once it was seen as a medium for raising the level of public morals, it was rooted in firmer soil.

NEW ENGLAND TRANSCENDENTALISM AND EDUCATION

Transcendentalism was a religious, philosophical, and literary movement in the history of American thought. In religion it was post-Unitarian; its philosophy was Kantian; and its literature was both romantic and individualistic (Boller, 1974).

The Puritan belief in original sin and predestination abated through the early decades of the century, supplanted by belief in a benevolent deity and in human perfectibility through the individual's own efforts. However, intellectuals, such as Emerson, Thoreau, and Ripley, were growing increasingly alienated from society as they found it in the 1830s and 40s. The discrepancy between the Founding Fathers' vision of agrarian democracy and the industrial society taking shape was profoundly disturbing. Though creating material wealth, industrialization also brought with it urban crowding and human misery. These were outward signs of distress—Emerson worried about the inner signs as well in an 1838 address:

> The mind of this country, taught to aim at low objects, eats upon itself. . . .
> Young men of the fairest promise, who begin life upon our shores, inflated by
> the mountain winds, shined upon by all the stars of God, find the earth below
> not in unison with these, but are hindered from action by the disgust which the
> principles on which business is managed inspire, and turn drudges, or die of
> disgust, some of them suicides. (Emerson, 1950, p. 68)

The antiestablishment sentiment of these transcendentalists often took extreme forms. Thoreau "resigned" from society to seek resolution in nature, while Alcott attempted to found a utopian community called "Fruitlands." Similarly, Emerson, finding that his views were the subject of controversy, moved from Boston to the village of Concord, where he hoped to reconcile his views with the reality of established society.

With Kant, these New Englanders believed that our awareness of nature is made possible through the faculty of perception. These perceptions are then categorized under concepts of space, time, cause, effect, totality, and continuity; and as this occurs, we comprehend our perceptions. Yet Kant noted that since the mind begins its work with "perceptions" and not with "things-in-themselves," we can never have total understanding. No amount of perception can lead us to the consciousness of God. However, knowledge of the divine is possible because we can "transcend" these usual sensory channels and rely on the mind's intuitive faculties for this knowledge.

This transcendental perspective on our spiritual nature also explains how our ideas of morality arise, for the transcendentalists, with Kant, claim that all the data of the sensory world cannot explain the existence of the moral law, that such understandings are intuitive (Emerson, 1843/1950).

Transcendentalists took this argument as a license to go beyond the doctrines of Locke and Hume, who had declared that all knowledge and understanding is limited to what is learned by sense perception. Many of the transcendentalists believed that God was immanent in nature, that the universe was the product of a universal mind, and that all finite minds could commune with this universal mind.

Revelations of this sort were attended by the emotion of the sublime,

and these moments were deemed the only truly religious experience. Moreover, revelations of the divine were stronger in some minds than others. Women, for example, were generally regarded as being more intuitive than men, which explains why transcendentalists usually favored women's rights and felt that women's involvement in determining policies would lead to social betterment. Transcendental thinkers also believed that flashes of inspiration were more likely to occur in natural settings, where human artifacts and all that is artificial are absent.

The Educational Theories of Alcott

In 1834 Boston was filled with new ideas. Liberal theology, women's rights, growing opposition to slavery, and the heady doctrines of transcendentalism were all in the air. The moment was propitious for the founding of a new school by Amos Bronson Alcott based upon transcendental principles. A number of individuals had begun to question the quality of existing schools. There were complaints against the concentration on the ancient classics in secondary education, since not all children were destined for college. In 1821 the Boston School Committee founded the English High School to satisfy the demand for good education in the English language, mathematics, and natural philosophy. Two years later Fowle's monitorial school for girls opened with an impressive set of academic offerings. Thus alternatives to traditional education were then beginning to develop.

As a young man Amos Bronson Alcott served as a schoolmaster in the town of Cheshire, Connecticut, and somewhat later, ran a private school in Philadelphia called the School for Human Culture. This school was successful, but the death of its wealthy benefactor forced it to close. Alcott then moved to Boston in the hope of founding a similar school. In the summer of 1834 he met Elizabeth Peabody and showed her some letters and journals from his pupils at the Philadelphia school. These were the result of a method of teaching devised by Alcott involving "conversations," through which he drew out ideas from his students; quite remarkably, these ideas were pure illustrations of transcendental beliefs.

Peabody was deeply involved with transcendentalism (as was Alcott himself), and to her it seemed as though he was able to release the children's innate genius. For Alcott these words from the children were a direct testimony of the rightness of the transcendental point of view, for children were believed to be closer to the divine. Bedell's family biography (1980) of the Alcotts notes this with skepticism:

> Inevitably the thoughts that Bronson drew out of his pupils were his own. In his sublime and innocent arrogance, he remained totally unaware of the manner in which he molded his students' minds; he thought that their Platonic utterances

merely confirmed the divine rightness of his own ideas. And in fact, so rich, so intricate, so intellectually seductive were the methods he used to draw out these ideas that even the modern reader perusing the record of the school that Elizabeth kept is similarly beguiled. (p. 95)

At the time of this encounter Peabody was totally won over by Alcott. To her he was "destined . . . to make an era in society. . . . I told him I wanted him to make an effort for a school here and he said he wanted to" (quoted in Bedell, 1980, p. 91). Within hours after their first meeting, she started to find pupils for the school; in a few days, she had lined up more than six pupils, mostly from Boston's eminent families. Since Alcott did not himself teach the traditional subjects, such as Latin, French, and arithmetic, Peabody became his assistant, supplementing the program with these studies.

The school opened by Alcott and Peabody was organized around three divisions of subject matter, each intending to serve what he termed the *rational* faculty, *imaginative* faculty, and the spiritual faculty. Developing these faculties was the goal of the school. This threefold designation of goals was a direct reflection of his transcendental views, with the stress upon the spiritual faculty. The school gave instruction in reading, writing, arithmetic, spelling, composition, literature, biology, drawing, speech, conversation.

Importance of the School Setting

Like most transcendentalists, Alcott believed that intuitions from the universal mind come more readily in natural settings, away from the ugliness of cities. Consequently, the perfect location for a school would be in surroundings of great natural beauty. In his essay "Academic Groves," he says that "cities with all their advantages have something inhospitable to liberal learning, the seductions are so subtle and accost the senses so openly on all sides" (quoted in Haefner, 1937/1970, p. 48). Yet Alcott's schooling ventures were always located in cities, for this was where the children were.

Peabody explained that in preparing the rooms of the Temple School, as Alcott named his institution, he compensated for this lack of suitable surroundings by adorning the classroom with beautiful objects "as would address and cultivate the imagination and the heart." In the first chapter of her *Record of a School*, she described Alcott's schoolroom:

In the four corners of the room, therefore he placed upon pedastals, fine busts of Socrates, Shakespeare, Milton, and Sir Walter Scott. And on a table, before the large Gothic window by which the room is lighted, the Image of Silence,

"with his finger up, as though he said beware." Opposite this Gothic window, with his own table, about ten feet long, whose front is the arc of a circle, prepared with little desks for the convenience of the scholars. On this, he placed a small figure of a child aspiring. Behind was a very large bookcase, with closets below, a black tablet above, and two shelves lined with books. A fine cast of Christ, in basso-relievo, fixed into this bookcase, is made to appear to the scholars just over the teacher's head. The bookcase itself, is surmounted with a bust of Plato. (1836/1969, p. iii)

In order to prepare the classrooms, Alcott borrowed large sums of money from his in-laws to hire a cabinetmaker to construct desks and chairs and to buy textbooks, pictures, statues and other furnishings. Everything "material and external" was brought into harmony with the "serenity of spirit of unspoiled childhood and youth" (quoted in Bedell, 1980, p. 92).

The school, located in two rooms of the Masonic Temple on Tremont Street across from the Boston Common, (hence the name "Temple School"), opened its doors to 18 pupils on September 22, 1834. In the preface to the second edition of her *Record of a School* (1836/1969), Peabody explained how Alcott's methods differed from those of his contemporaries and why they were appropriate from a transcendental viewpoint:

Instead therefore of making it his aim to investigate External nature, after Spirit, Mr. Alcott leads them in the first place, to the contemplation of Spirit as it unveils itself within themselves. He thinks there is no intrinsic difficulty in doing this, inasmuch as a child can as easily perceive and name pleasure, pain, love, anger, hate and any other exercises of the soul, to which himself is subjected, as he can see the objects before his eyes, and thus a living knowledge of that part of language, which expresses intellectual and moral ideas, and involves the study of his own consciousness of feelings and moral law, may be gained. External nature being only made use of, as imagery, to express the inward life he experiences. (pp. iv–v)

Spiritual realities were thus given primacy in his educational labors, but after the children had identified spirit within themselves as part of their constitution, he made the study of nature available to them. Peabody described it this way:

But Mr. Alcott would not sequestrate children from Nature, even while this preparatory study of spirit is going on. He would be very thankful to throw all the precious influences of a country life, its rural employments, its healthful recreations, its beautiful scenery, around his scholars' minds. He thinks that the forms of nature, as furniture for the imagination, and an address to the sentiments of wonder and beauty and also as a delight to the eye, and as models for

the pencil, cannot be too early presented, or too lovingly dwelt upon. In lieu of these circumstances, which of course cannot be procured in Boston, he reads to them of all in nature which is calculated to delight the imagination and heart. He surrounds them also, with statuary and pictures in his school-room, and he has drawing taught to all his scholars, by a gentleman who probably possesses the spirit of Art more completely than any instructor who has ever taught in this country. (1836/1969, pp. xxi–xxii)

The drawing teacher referred to by Peabody was Francis Graeter. In a footnote in the preface to *Record of a School* she added that Graeter was "in contemplation to publish a work developing the whole art of drawing, especially from nature, in the same way as he has often done orally to such pupils as have received the most benefit from him" (p. xxii). Graeter also taught drawing at the school she ran with her sister Mary at Colonade Row between 1828 and 1834. In 1836 she mentioned him in a letter written to the music critic John Sullivan Dwight (Ronda, 1984).

Criticism of Temple School

The school's first year of operation was an extraordinary success, and at the start of the second year, it had an enrollment of more than 40 pupils. But in the succeeding year, Peabody gradually became disillusioned. She became concerned when Alcott's "conversations" turned to the Gospels. She felt that his repeated references to the saintliness of children would injure "the modesty and unconsciousness of good children by making them reflect too much on their actual superiority to others" (quoted in Bedell, 1980, p. 122). She also became disturbed when the "conversations" began to plumb the mysteries of love, birth, and death, including such matters as conception and circumcision, topics that were thought unfit for polite discussion among adults, let alone children.

As the school was about to enter its third year, Peabody resigned, largely in anticipation of the furor she felt would greet publication of Alcott's *Conversations with Children on the Gospels*. Her prediction proved to be correct, and Alcott became the object of public censure and ridicule. Though a few families remained steadfastly loyal, most withdrew their children, depriving Alcott and his family of income and leaving him in debt.

Though Alcott's school taught drawing, it played a minor role in the school's curriculum. A more direct application of transcendentalist views was seen in the attention to the visual quality of the school environment in

the use of pictures and statuary. This anticipated by 50 years the movement of the 1890s and 1900s to decorate schoolrooms and buildings.

FROEBEL AND THE KINDERGARTEN MOVEMENT

Friedrich Froebel was born in 1782 in Oberwissbach, Germany. His mother died when he was very young, and his early education was provided by his father. As a child he was extremely introspective and during his adolescence he served as a forester's apprentice. Later he studied agriculture and crystallography. In 1805 he became the private tutor for the sons of a prominent family. Three years later he and his pupils went to Switzerland to study with Pestalozzi for a period of two years. An admirer of Pestalozzi, he nevertheless felt that Pestalozzi's methodology was lacking in organization. Military service interrupted Froebel's involvement in educational activities, but he returned to it and in 1817 founded the Universal German Educational Institution.

In 1826 he published his major treatise, *The Education of Man* (1826). His philosophy of education was based on the idea of the world as an organic unity rather than a mere aggregate of unrelated parts. Though the universe has separate parts, it is nevertheless one universe. For Froebel this unity within diversity was the spiritual principle of God. Every element in nature or in human affairs must be seen both as independent and self-sufficient and as part of the larger whole to which it belongs. Though there are opposing tendencies in the world, there is also a larger unity, what Froebel called the "unity of opposites" (MacVannel, 1905).

Froebel conceived of development as the tendency of any entity to differentiate itself while still retaining its unity. This can be seen in the life of the plant, in animals, in the growth of the person, and in society. Through development, the self both differentiates itself from and integrates itself into the community.

Because development requires active processes, such as differentiation and integration, Froebel came upon his "principle of activity": "What the self is to be, it must become for itself." For Froebel, then, the essential feature of mind is activity. The mind is not something that must exist before it can put forth activities. Rather, it is the process of activities. Indeed, Froebel described lessons as "activities"; Pestalozzi had called them "exercises."

Mental development was an unfolding of inner aims, which, instead of merely representing the environment, makes it into a means of self-realization. Inner mental development moves outward in the expression of the self, and the outward moves inward in the realization of the self. Thus for

Froebel, as for the idealists in general, the life of the individual was a process of learning to know oneself through learning to know the objective world.

The Idea of the Kindergarten

Froebel developed his methods of teaching several years after writing *The Education of Man*. He called his school a "garden of children" (*kindergarten*) and devised a curriculum based on the principle of play. He saw play as an active representation of the inner life of the self, free from inner necessity and impulse. Play was also self-expression, revealing the nature of the child's soul. It is the fundamental medium and instrument through which children effect their own growth and reveal their future lives. Thus children grow and become educated through their own activities.

The educator, like the gardener, has to provide the proper conditions for growth, and the kindergarten is the place where these conditions are created. Thus Froebel devised a succession of play objects that he thought to be ideal materials for individual and group activities. Many of these didactic materials are of immediate interest in the history of art education because they led to the introduction of several art media into the school environment.

The Gifts and Occupations

Perhaps the most original of Froebel's didactic materials were the "gifts and occupations," which he developed in the period between 1835 and 1850 and described in his letters on the kindergarten. They were designed to enable the child to find unity in diversity in the forms and patterns of things and to understand the mathematical principles that express the harmony of the universe (Froebel, 1904).

The first gift consists of a box of six soft woolen balls in six different colors—the three primary colors and the three secondary ones. The children compare and contrast the six balls. This introduces them to the idea of similarity and contrast. They also see that the intermediate, or secondary, colors reconcile the attributes of the primary colors, for example, that orange is a synthesis of red and yellow. The balls also lend themselves to games, for the ball is one of our favorite playthings from cradle throughout adulthood.

The second gift consists of three objects made of hard wood: a sphere larger than the woolen balls of the first gift, a cube, and a cylinder. Of the three forms, only the sphere was previously encountered (in the woolen balls). The children contrast the hardness and smoothness of the wooden sphere with the softness and roughness of the woolen balls. They also compare them for lightness and heaviness and for the different sounds they

make when dropped. After this, they begin to compare the sphere with the cube. The sphere is round and can roll; the cube is not round, has several surfaces, and can only be moved by sliding. Finally, they encounter the cylinder, which combines some qualities from both the sphere and the cube.

The third to sixth gifts consist of blocks in progressively smaller subdivisions. The notion of a whole made up of parts is thus introduced, and when the cubes are called "bricks," the instinct of construction is awakened. The third gift (Figure 5.1) is a cube subdivided into eight smaller cubes, making block play possible.

The seventh gift introduces children to the notion of surfaces (see Figure 5.2). Rectangular and triangular woods in contrasting colors are used to generate patterns. Some versions use many colors instead of the natural colors of dark and light wood. All sorts of parquet designs are made possible by this gift.

The eighth and ninth gifts are forms of drawing using small sticks or laths and semicircular rings and arcs, respectively. In a variation of the eighth gift, small peas soaked to become soft are used to join the sticks in three-dimensional constructions.

The tenth gift (Figure 5.3) is drawing on a slate. One side of the slate is covered with a network of engraved lines, which help children measure and compare position and size and enable them to find the center and sides of the forms being drawn. Drawing on the slate is followed by drawing on paper, which is ruled like the slates.

The remaining ten gifts, referred to as the occupations, include such activities as perforating, that is, pricking a checkered paper with a needle to form a series of prescribed designs. Another consists of sewing on cards, whereby threads of different colors introduce the idea of the beautiful. Paper cutting and mounting are additional occupations. Later activities include braiding, slat weaving, paper folding, pea work, and clay modeling. With clay, the child is reacquainted with the sphere encountered earlier in the first gift.

What distinguishes a gift from an occupation is that the latter generally involves some transformation of a material, whereas the material in the gifts can revert to their original form. Many of the occupations demand a level of precision and dexterity in excess of the developmental capability of kindergarten-age children as this is currently understood, and yet in its day these activities were seen as a liberating force in the education of children.

Spread of the Kindergarten Movement

In the wake of the revolution of 1848, Germany entered a period of intense political conservatism. In that social climate the most innocent devi-

FIGURE 5.1.
"Third Gift," block play (Plate I), from Edward Wiebe, *The Paradise of Childhood: A Manual for Self-Instruction in Friedrich Froebel's Educational Principles* (Springfield, MA: Milton Bradley Co., 1869).

FIGURE 5.2.
"Seventh Gift, Laying tablets" (Plate XXVIII), from Edward Weibe, *The Paradise of Childhood: A Manual for Self-Instruction in Friedrich Froebel's Educational Principles* (Springfield, MA: Milton Bradley Co., 1869).

ation from standard schooling practice was regarded with suspicion. After flourishing for nearly 15 years, the kindergarten was suppressed. This dealt a cruel blow to Froebel that contributed to his premature death in 1852. But the cause of the kindergarten was taken up by a number of prominent women. The Baroness von Bülow became the spokesperson for the movement in Germany. Her social position and knowledge of languages enabled her to assume a leadership role throughout Europe. Having failed to obtain a revocation of the ban on kindergartens in her home country, she visited France, Holland, Belgium, Britain, Italy, and Russia to spread the word of Froebel's methods. Her success was especially noteworthy in the low countries and Britain.

THE AMERICAN KINDERGARTEN MOVEMENT. The story of the kindergarten in the United States is one about a group of "dauntless women" (Snyder, 1972) who established kindergartens, generally under private auspices, and worked to make kindergarten education an accepted part of public schooling. The first kindergartens were established by German-speaking immigrants familiar with them from the old world; the first of

FIGURE 5.3.
"Tenth Gift, Material for Drawing" (Plate XLV), from Edward Wiebe, *The Paradise of Childhood: A Manual for Self-Instruction in Friedrich Froebel's Educational Principles* (Springfield, MA: Milton Bradley Co., 1869).

these was established in 1855 by Mrs. Carl Schurz in Watertown, Wisconsin. In 1860 Elizabeth Peabody first learned of this school when she met Mrs. Schurz and her daughter during one of their visits to Boston. This event transformed the latter years of Peabody's life. Through it she became acquainted with the educational principles of Froebel. Later she was introduced to Froebel's writings, and shortly thereafter she opened the first English-speaking kindergarten in the United States on Pickney St. in Boston (Snyder, 1972).[1]

In 1867 she went to Europe to study Froebel's methods with Emma Marwedel in Hamburg. Peabody, who was then in her late sixties, recalled that Marwedel inspired her to make the kindergarten the main object of the remainder of her life. Upon her return to Boston she established a journal to explain and spread the principles of the movement, and in this respect served in America the role that Baroness von Bülow filled in Europe. Peabody's kindergarten was a private venture, though in 1870 the Boston public schools established an experimental kindergarten program, which was discontinued after eight years in an economy move.

A more successful kindergarten venture took place in St. Louis, Missouri, as a result of the efforts of Susan Blow. Her efforts were supported by the St. Louis Superintendent of Schools, William Torrey Harris. Harris sponsored Blow on a trip to New York to study with Madame Kraus Boelte, an authority on Froebel's system. Upon her return in the spring of 1873 she established the first training school in the United States for kindergarten teachers. Several years later, the St. Louis schools had 58 kindergarten classes under her supervision (Snyder, 1972).

Blow was responsible for bringing Emma Marwedel to America to train kindergarten teachers and help with the work of establishing kindergartens. Marwedel helped establish the first kindergarten on the West Coast, which also included a training school for kindergarten teachers. Among her first students was Kate Douglas Wiggin, who later became an important voice in the movement. Wiggin's work was supported by a group of West Coast women philanthropists, including Mrs. Leland Stanford, Sarah Cooper, and Pheobe Hearst. With their financial help, the Golden Gate Kindergarten Association was organized in 1879 and incorporated in 1884. By its fifth year of operation the association had itself established eight kindergarten classes and was responsible for aiding in the establishment of 44 other kindergartens in the Bay Area (Golden Gate Kindergarten Association, 1884).

American advocates of the kindergarten stressed the idea that the gifts and occupations could provide the foundation for industrial education. This was noted by Clarke, who made use of statements by Elizabeth Peabody and Emma Marwedel in the second volume of *Art and Industry* (1892). He

reproduced a circular originally published by Peabody, entitled *The Identification of the Artisan and Artist,* which was a lecture by Cardinal Wiseman (1869), along with Peabody's *Plea for Froebel's Kindergarten* (1869), in which she argued that the kindergarten was a primary art school and the proper foundation for industrial art education. The statement by Marwedel was based on her knowledge of both industrial art educational practices in Germany and the industrial drawing program of Walter Smith (see Chapter 4) in Massachusetts:

> This method of Froebel's leads the child very soon to the copying of nature: the hand having gained a guidance and direction by drawing in the net—[the tenth gift] making drawing a study by degrees, gradually training the eye to find measuring points for symmetrical arrangement of forms, and familiarizing the child with the scientific names of the lines and angles, and geometrical figures, which form the preliminary lessons of the system of Industrial Drawing so ably and convincingly set forth by Prof. Walter Smith. (quoted in Clarke, 1892, p. 663)

It is notable that the Massachusetts Drawing Act and the introduction of the kindergarten into the Boston schools occurred in the same year, 1870. The promoters of drawing were industrialists, bankers, publicists, and tradesmen. They were all men who had access to the channels of power in Boston and could use this power to bring about changes in the schools in accord with their interests. By contrast, the kindergarten movement was one promoted by middle-class women whose access to power was limited to private philanthropy. The differences in the ways the two movements were promoted was an accurate reflection of the lesser status of women in American society in the latter third of the nineteenth century. Peabody and Marwedel staked the future of the kindergarten on the rising interest in vocational education.

COMMERCIAL DISTRIBUTION OF THE GIFTS AND OCCUPATIONS. The 20 gifts and occupations required a set of didactic materials that had no previous history of use in schools. Children's toys in the nineteenth century, and before, were largely miniature imitations of the objects used by adults in daily living. Abstract objects such as blocks were uncommon before the time of Froebel, and their use in schools was unprecedented. To introduce such materials required their manufacture and distribution. Froebel had attempted to establish a company at Blankenburg that would have contained a model kindergarten, a training school, a factory for kindergarten materials, and a kindergarten publishing house. The enterprise was to be supported by shares to be taken by German women, but the scheme was too visionary and failed (Graves, 1929).

One of the first companies to supply these materials in the United States was the Milton Bradley Company, which was founded in Springfield, Massachusetts, in 1860. According to Webber's (1911) memorial eulogy to Bradley, the latter had initially fallen under the spell of Froebel through his meeting with Elizabeth Peabody and thereafter remained devoted to providing the means for making it possible to apply Froebel's teachings to the schools. Froebel invented the gifts, but it was Bradley who solved the problem of their manufacture.

Edward Wiebe's *The Paradise of Childhood*, a teachers' manual for use with the gifts and occupations, was first published in 1869 by Bradley. The 74 plates that accompanied the original publication were reprinted from *Goldammer's Kindergarten*, published a few years earlier in Germany. Revised editions were published in 1887 and 1888. In 1896 Bradley issued a twenty-fifth anniversary edition, which went through successive printings in 1899 and 1903: a 1910 edition, celebrating the company's fiftieth anniversary, was followed by additional printings in 1913, 1923, and 1928. Thus it was available on a regular basis for 59 years. Webber remarked that through much of this time "all of these undertakings were carried out through the strength of his [Bradley's] convictions and love for the cause, despite strenuous opposition from his business associates, who realized their futility from a commercial viewpoint" (Webber, 1911, p. 489).

Bradley's commercial catalogs of educational materials were organized in terms of the gifts. The product specified for each gift was generally presented in Froebel's original form, followed by new products replacing the original that were often described as "improvements." The fact that Bradley produced a varied line of products that deviated from Froebel's original versions suggests that he had a stable market and that Webber's assertion that he acted only "for the love of the cause" was probably an exaggeration. Bradley's company more than likely realized a profit from the sale of the gifts and occupations, since it continued to sell them for many years after Bradley's death.

Peabody, questioning the commercialization of Froebel's kindergarten materials, wrote: "The interest of manufacturers and of merchants of the gifts is a snare. It has already corrupted the simplicity of Froebel in Europe and America, for his idea was to use elementary forms exclusively, and simple materials,—as much as possible of these being prepared by the children themselves" (quoted in Barnard, 1890, p. 15).

Bradley was not the only company involved with the gifts and occupations. Another company selling them was the E. Steiger Company. An 1876 copy of the Steiger catalog was found in the Frank Lloyd Wright Archives, lending credence to the story that Wright's mother educated him with these materials (Kaufman, 1982).

A third vendor, the Prang Educational Company, promoted the teaching of art throughout the elementary grades with a program of instruction infused with ideas derived from Froebel. Louis Prang was a well-known publisher of colored lithographs, which he used in the manufacture of greeting cards, and published the first color reproductions of artworks by a process known as "chromolithography." He was involved with the publication of manuals for teaching drawing in the public schools. Walter Smith, director of drawing for the Boston schools, was one of his first authors.

By 1880, as explained in Chapter 4, Prang and Smith had ended their association over a textbook dispute, and subsequently Prang employed other authors to prepare art curricula for the school market. Among these were such writers as John Spencer Clark, Bonnie Snow, Arnold Dodel, and Mary Dana Hicks. Hicks later became Prang's second wife, and it is in her books that Prang's connection to Froebel becomes most discernible.

From Gifts and Occupations to Art Activities

Mary Dana Hicks came to Boston to write for Prang in 1879, shortly before Smith and Prang had severed their ties. Earlier, she had been the supervisor of drawing for the Syracuse, New York, public schools. In 1891 she addressed the National Education Association (NEA) convention on the use of type forms in instruction. Type forms were three-dimensional models, usually made of wood, in the shape of cubes, cylinders, spheres, and cones; they were used as still-life objects in model drawing. Type forms, in her view, could be linked to Froebel. "Form," she explained, "is an extension of an object: It concerns all tangible and visible things, from the worsted ball of the infant to the terrestrial globe" (Hicks, 1891, p. 796). The worsted ball was an obvious reference to Froebel's first gift. She compared normal schools, which based the study of form on abstract geometric shapes, with schools that introduced the shapes through presentation of miscellaneous objects. In her view the latter method thwarts the child's ability to develop a clear understanding of the object as representative of universal form. She used the example of a child who is engaged in comparing a sphere with a cube.

> He then discovers something like the type, an apple, an orange, and any of the pleasant objects which are beautiful to him. From one type form he passes to another; the group of three given by Froebel, the sphere, cube and cylinder, are followed by other groups by tablet-laying, by stick-laying, by paper cutting, by drawing, and still his world of form enlarges. As he studies his type form he studies all the forms about him, and in his mind are stored the images of these forms made perfect by the study of the types. (Hicks, 1891, p. 803)

Type forms were thus identified with Froebel's gifts, though the system by which these geometric forms were introduced was quite different in its particulars from Froebel's. The main point, however, is that her art program was justified by a psychology of perception similar to that which under-girded the gifts and occupations. In a word, Hicks transformed the gifts and occupations into art activities.

WILLIAM TORREY HARRIS AND IDEALISM

William Torrey Harris was born in 1835 in North Killingly, Connecti-cut. In 1844 his family moved to Providence, Rhode Island, where he attend-ed the city schools, followed by study at various New England private acade-mies. In 1854 he entered Yale, where, during his junior year, he became acquainted with Amos Bronson Alcott, who was to become a lifelong inspi-ration and friend. It was Alcott who first introduced him to transcendental-ism. Later Harris recalled that transcendentalism had enabled him to get beneath the surfaces and illusions of common sensuous experience.

Development of Harris's Philosophy

Harris subsequently moved away from the transcendentalism of Alcott, Thoreau, and Emerson, embracing in its stead the absolute idealism of Hegel. After moving to St. Louis he met Henry Conrad Brockmeyer; in 1866 they founded the St. Louis Philosophical Society. Harris devoted himself to the study of the four giants of German idealism: Kant, Fichte, Schelling, and Hegel. In 1868 Harris became the superintendent of schools for St. Louis, and in 1889 he was appointed Commissioner of Education for the United States, a role he occupied until his retirement in 1906.

McClusky describes the intellectual setting of the St. Louis movement in the following way:

> The St. Louis Movement in philosophy can best be understood against the backdrop of nineteenth-century America as a phase of the larger conflict be-tween naturalism and idealism. Under the impact of Spencerian Naturalism and Darwinian Evolutionism many pillars of the old religious orthodoxy were teetering. There was a prevailing fear that the new science would sweep away everything of value, leaving behind only "the meaningless evolutions of matter determined by a mindless mechanism." Some looked upon Harris as another Noah sent to save his people from the flood of materialism and agnosticism which was inundating the believing world. They may have been looking for too much, but their hope rightly focused upon Harris's strategic place in the coun-termovement to preserve traditional values. (1958, p. 116)

Harris based his support for traditional values in the Hegelian philosophy of institutions. Hegel took as his starting point the idea of reason as the supreme reality: Reason is "spontaneous, self-originating, free." This is a transcendental freedom that is above physical law, and its highest motive is the moral one. A human being, although a self-determining being intended for infinite moral progress, is unable to realize this potential alone; hence the need for institutions. Individuals are born without ethical principles; they must acquire them in order to partake of the blessings of civilized life. To make humans ethical is to enable them to live in the institutions of civilization and thus to participate in their fruits. A mere individual, isolated from the community, cannot rise above mere savagery; but by participating in institutions, humanity is spared the agony of reinventing the wheel (McClusky, 1958).

Harris saw the four great institutions as the family, civil society, the state, and the church. The school forms a transition between the family and the other three. On the one hand, education is not the monopoly of the school; on the other, it is not right to expect schools to provide what the other institutions should together give.

Harris viewed the church as the highest institution because it reveals the highest principle, that of the creator of the world. The state comes next in importance, building up self-respect and individuality under a free government wherein each citizen assists in making the laws. Civil society is next in the hierarchy, educating by preparing the individual for a vocation or profession. Finally, the family teaches proper forms of behavior toward one's equals and superiors, habits of cleanliness, manners, and the sense of right and wrong.

According to Harris, the schools should put a great deal of stress on discipline and moral training, which includes such behaviors as aiding one's fellow pupils and teachers, being punctual, being industrious at learning, and willingly obeying lawful authority.

Implications for Art Education

Harris also claimed that there were connections between the moral, the religious, and the aesthetic and that art styles were connected with religious ideals, the latter an idea he obtained from Hegel. Hegel divided religion into three forms, for each of which there are corresponding forms of art. The first form of religion is "nature religion," which situates the divine in heavenly bodies, in plants, and in animals. This would include all primitive religions, including the religion of ancient Egypt. The Egyptians built eternal dwelling places for the soul; their architecture and sarcophagi literally embodied the soul. The second form of religion is what Hegel termed "art-

religion," as exemplified by the Greeks, who literally worshiped beauty as divine. They were preoccupied with developing the body beautiful. The third stage is that of revealed religion, by which he meant Christianity. The art for this stage of culture was what Hegel called "romantic" art.

Harris considered the arts important because they are one of the three ways in which human thought reaches toward the divine. The first is through religion, the second is through art, and the third is through philosophy. Art may be defined as the piety of the senses, religion as the piety of the heart, and philosophy as the piety of the intellect.

> The effort to give visible forms or audible forms to it gives us the various branches of the fine arts and literature; the attempt to explain the world by the divine idea and to comprehend ultimate truth is philosophy. Thus we are to regard art and literature as having the same theme as religion and philosophy. The idea that sculpture and painting, music and poetry, have no other use than amusement must give way to the view which regards them as among the most serious and worthy occupations of the human soul. (1897, p. 262)

In the same address Harris discussed beauty not as something that art creates but as something that is given by the creator to humanity, which art celebrates. Great art is that which interprets the beauties of nature, an idea not unlike Ruskin's view of art. In Harris's view, the great majority of the public have little appreciation for beauty in nature because they have not studied it through the interpretations of art. Art should be taught "in order that men may be able to appreciate and produce the beautiful" (p. 270).

> The object of art education in the school is to develop in the pupil a love for beauty and the power to produce beautiful things. Without this love and power, man is dead to the beauty of his environment. To speak more specifically, we should teach pictorial representation for three distinct purposes: First, that we may be able to portray clearly and intelligently on paper things that can be better presented to the mind through the eye than through the medium of words, either for the purpose of aiding our own memories or of conveying distinct ideas to other people. Second, we teach drawing that we may be able to obtain keener perceptions of the beauties of nature, and that we may preserve what Mr. Ruskin calls true images of beautiful things that pass away, or which we must ourselves leave. Third, we teach pictorial representation in order — and here I am expressing Mr. Ruskin's ideas as nearly as I can recall his words — that we may understand the minds of great painters and be able to appreciate their work sincerely. (1897, pp. 270–271)

Here Harris drew upon Ruskin's *Modern Painters*. His own approach to art education was to use the masterpieces of art to teach the pupil about

the beauties of nature. But in the final analysis it was not the beauty of art that he considered important: for Harris, like Ruskin, believed that art was a source of spiritual truth. Both shared the notion that the art of past historical epochs reflect the moral conditions prevailing in those eras; Harris, however, tended to read the history of art as a kind of moral evolution, with the art of the present era (romantic art) representing the highest level of spiritual attainment.

The purpose of art education, as Harris understood it, is to develop in the pupil a deep respect for social institutions that would impose a degree of constraint upon personal action. Harris perceived in romantic art a spiritual evolution, which, in turn, he viewed as an indicator of the moral evolution of contemporary society; instilling an appreciation for this art would simultaneously instill respect for the status quo. Seen in this way, art is a conservative force. Art appreciation that introduces pupils to the moral ideals of the epoch could thus be harnessed by educators for purposes of social control.

Unlike Ruskin, who will be discussed more fully below, Harris was an educator guided by an idealistic philosophical system. He was not an art critic, as was Ruskin (perhaps the most influential art critic of the century). Harris did not deal with the realities of nineteenth century art—only with the idea of art in the abstract. If he had, he might have come to Ruskin's conclusion—that the decline in the integrity of architecture and the quality of design in industrial manufactures was itself a reflection of the moral conditions of nineteenth-century industrial society, one troubled by social inequities. In no way could Ruskin find evidence that the art of the Victorian era was an exemplar of moral progress. Quite the contrary—his art criticism became the basis for his social criticism.

RUSKIN'S INFLUENCE ON ART EDUCATION

Nineteenth-century industrial society exulted in its material progress. Yet a number of social critics recognized that a schism between material and spiritual concerns threatened both the social fabric and the human personality. In America, this was a major theme of Emerson and Thoreau. In England, one critic raising these concerns was John Ruskin. Emerson and Thoreau responded to this crisis by turning to nature; Ruskin turned to art, which he perceived as the means of maintaining balance between material and spiritual progress.

Soon after Ruskin graduated from Oxford, he began a public career that would span more than half of the nineteenth century, starting with the writing of several books on painting and architecture, namely *Modern Painters, The Seven Lamps of Architecture*, and *The Stones of Venice*. These

were written in a literary style that Victorian audiences found both informative and morally edifying. Though his subjects might have been the architecture of Italian or French buildings, he invariably came round to a moral lesson that could well apply to the Britain of his day. By this means he instructed the British middle class in the ways in which the arts of a nation reflect the moral conditions of its social fabric and become "the visible sign of national virtue" (Vol. 19, p. 164).[2]

The late art historian Sir Kenneth Clark remarked that by the end of the century a volume of Ruskin and Tennyson's *Idylls of the King* were the requisite symbols of respectability in middle-class English households (Clark, 1964). Ruskin's books went through several printings in his lifetime; he gave lecture tours, published widely in newspapers and journals, and testified before Parliament; and Ruskin reading societies flourished.

Views on Art

Ruskin's views on art and education are not difficult to read and understand; but, owing to the vast extent of his writing, they are extraordinarily difficult to summarize. *The Works of Ruskin* (1903–1912) span 38 volumes, with the 39th devoted to a general index. Fortunately, Edward T. Cook, his biographer and anthologist, prepared a concise, sympathetic digest of his leading ideas in *Studies in Ruskin* (Cook, 1890). In its opening chapter, Cook describes Ruskin's view of art as "the expression of man's rational and disciplined delight in the forms and laws of creation of which he is part" (p. 5). Ruskin saw art as the imitation of nature, but with the added proviso that such imitation should also be touched with delight. Yet imitation and delight, though necessary, are nevertheless insufficient. A moral purpose also has to be present for there to be great art. This is realized when it praises God and his creations. Greek art was praise for God's most noble creation, the human form.

Since good representation is difficult to achieve, Ruskin believed that artists should devote time only to the most noble of subjects. Life is too short and the craft too long in its learning to waste time "in painting a boor instead of a gentleman, or an 'impression' of a ballet-girl instead of a vision of angel choirs" (quoted in Cook, 1890, p. 8). In *Modern Painters* Ruskin declares that "the art is greatest which conveys to the mind of the spectator, by any means whatsoever, the greatest number of the greatest ideas" (Ruskin, Vol. 3, p. 92). To study great works of art is to come into contact with these great ideas.

Ruskin also believed that "the essence of art is beauty, and the essence of beauty consists in its appeal to the senses." Beauty is what "one noble spirit has created, seen and felt by another of similar or equal nobility"

(Ruskin, Vol. 15, p. 438). The intuitive power of artists enables them to discern the truths and beauties of nature to make these the basis of art, but the critic who can perceive the spiritual content of the artist's work is also engaged in a similarly imaginative exercise.

For Ruskin art was neither recreation nor amusement. Though the true object of art evokes pleasure, the ultimate purpose of art is that of giving expression to the creating spirit of the universe. Thus all great art is at the same time religion, and the true artist must perforce be religious, though religion in Ruskin's sense had little to do with established theology or denominational dogma. All art is based upon laws of organic form derived from nature as created by God. This is the basis for claiming that art is a source of spiritual insight and morality and thus important in human progress. By contrast, art whose sole purpose is pleasure leads to decadence. Ruskin's art criticism was at the same time social criticism as well. His *Stones of Venice* describes what he regarded as a decline in religious faith as signaled in the transition from the Gothic to the Renaissance style (Cook, 1890).

He was an advocate of the Gothic style, but his advocacy went beyond championing its physical appearance; he also wanted to see the restoration of social life based on the early ideals of the medieval community as he deemed it. Gothic art was moral art because, in his view, it was based on natural facts, simultaneously serviceable, memorable, and beautiful because it reflected the creator. It created not only for the contemplation of beauty, but also to satisfy the wants of the community of the faithful. Because it was wedded to spiritual purpose, it was naturally beautiful; while much architecture in his own generation was wedded to economic materialism, and hence ugly. In his architectural criticism, he conceived art as a counteractive force that should attempt to shift the goals of English society to higher purposes. To a very large extent, Ruskin believed that the social redemption of England lay in recovering what it had lost. Nowhere is this more evident than in his first inaugural lecture at Oxford.

> The England who is to be mistress of half the earth, cannot remain herself a heap of cinders, trampled by contending and miserable crowds; she must yet again become the England she once was, and in all beautiful ways. (Ruskin, Vol. 20, p. 43)

Views on Art Education

Ruskin's philosophy of art education was informed by his social views and his views about the moral nature of art. For him there were two aspects involved in creating and responding to art, namely "perception" and "inven-

tion." The power of invention is given to very few, and it cannot be taught because it is God-given. Perception, by contrast, can be taught. The function of art education is to help individuals perceive the beauties of God's work in the material universe (Vol. 14 and 15). While some individuals have a natural talent for perceiving these beauties, many lacking this talent can improve their powers of perception through such tasks as drawing. As drawing improves perception, the individual's taste also improves.

Ruskin also noted that drawing has practical benefits and thus should be regarded as an integral part of general education. He believed that through the teaching of art one could teach everything. In his essay "Education in Art," he wrote:

> But the question, however difficult, lies in the same light as that of the uses of reading and writing; for drawing, so far as it is possible to the multitude, is mainly to be considered as a means of obtaining and communicating knowledge. He who can accurately represent the form of an object, and match its colour, has unquestionably a power of notation and description greater in most instances than that of words; and this science of notation ought to be simply regarded as that which is concerned with the record of form, just as arithmetic is concerned with the record of number. (Vol. 14, p. 143)

Moreover, the practical use of drawing is not limited to schooling at the primary levels. His Oxford inaugural lecture proposed a plan of art instruction in which studies of history and the natural sciences would be integrated into the study of art.

> While I myself hold this professorship, I shall direct you in these exercises very definitely to natural history and to landscape; not only because in these two branches I am probably able to show you truths which might be despised by my successors; but because I think the vital and joyful study of natural history is quite the principal element requiring introduction, not only into University, but to national, education, from highest to lowest. (Vol. 20, p. 35)

The idea of integrating other subjects into the study of art was not new to Ruskin at the time of his Oxford professorship, for he had described the same notion 16 years earlier in a letter to Sir Henry Cole, though on this occasion his attention was on the education of children:

> I think it would be much *more* sensible to consider drawing as in some degree teachable on concurrence with other branches of education. Geography, for instance, ought to introduce drawing maps and shapes of mountains. Botany,

shapes of leaves. History, shapes of domestic utensils, etc. I think I could teach a boy to draw without setting *any* time *apart* for drawing, and I would make him at the same time learn everything else quicker by putting the graphic element in other studies. (Vol. 36, p. 136)

Oxford Professorship

Oxford University is the oldest university in the English-speaking world, and like all universities founded in the Middle Ages, its curriculum heretofore had never included the visual arts. Ruskin realized this and regarded his appointment as Slade Professor of Fine Arts to be an unprecedented event in advancing the role of art in English culture (Vol. 20, pp. xviii–xx). Ruskin's work at Oxford took three forms. The first and probably the most far-reaching was the lectures on art. These were delivered to large audiences and, by Cook's account, were well attended. In letters written while the lectures were being prepared, Ruskin commented upon the fact that he found their preparation to be extremely difficult. In Cook's opinion, he took more pains in writing the Oxford lectures on art than anything he had done previously and therefore was disappointed that they were not more widely quoted and read (Vol. 20).

His second task involved the founding of a collection of artworks arranged to illustrate the qualities of good art, while the third involved the establishment of a drawing mastership. Ruskin began to organize the art collection almost immediately upon accepting the professorship, since his lectures and teaching depended on appropriate illustrations. The drawing mastership was proposed and added two years later, in 1871.

> I conceive it to be the function of this professorship . . . to establish both a practical and critical school of Fine Art for English gentlemen: practical, so that if they draw at all, they may draw rightly, and critical, so that they may both be directed to such works of existing art as will best reward their study, and enabled to make the exercise of their patronage of living artists delightful to themselves by their consciousness of its justice, and to the utmost beneficial to their country, by being given only to the men who deserve it. (Vol. 20, pp. 27–28)

> The object of instruction here is not primarily attainment but discipline; and that a youth is sent to our universities, not (hitherto at least) to be apprenticed to a trade, nor even always to be advanced in a profession; but always to be made a gentleman and a scholar. . . . To be made these—if there is in him the making of either. (Vol. 20, pp. 18–19)

The time of Ruskin's tenure was one which saw large influxes of mid-

dle-class men to Oxford, heretofore the citadel of upper-class privilege. Ruskin believed that it was important for the emergent middle classes to become sufficiently knowledgeable of art to be able to exercise wise judgment in their patronage of the arts, and he expressed the worry that a well-intended but unintelligent patronage would be easily deceived by superficial qualities. An unwise patronage was destructive of art. While Ruskin desired art education for all, he felt that these newly wealthy classes had a special obligation to use their taste wisely.

The drawing master appointed by Ruskin was Alexander Macdonald, and the curriculum he followed was prepared by Ruskin himself. Cook tells us that the drawing mastership was proposed by Ruskin to carry out his "special theories of art education." He wanted to replace the South Kensington system then in operation at Oxford, as in most cities in the country. He wanted his drawing school to exemplify values that were absent in this rival system (Cook, 1890).

> After carefully considering the operation of the Kensington system of art teaching throughout the country, and watching for two years its effects on various classes of students at Oxford, I became finally convinced that it fell short of its objects in more than one particular; and I have, therefore, obtained permission to found a separate Mastership of Drawing in connection with the Art Professorship at Oxford; and elementary schools will be opened in the University galleries next October, in which the methods of teaching will be calculated to meet requirements which have not been contemplated in the Kensington system. (Vol. 27, p. 159)

In the same year Ruskin wrote to Charles Eliot Norton of his plans for the Drawing School:

> At Oxford, having been Professor a year and a half, I thought it time to declare open hostilities with Kensington, and requested the Delegates to give me a room for a separate school on another system. They went with me altogether, and I am going to furnish my new room with coins, books, catalogued drawings and engravings, and your Greek vases; the mere fitting will cost me three or four hundred pounds. (Ruskin, 1904, p. 33)

Ruskin's method of teaching drawing differed in method as well as purpose from South Kensington's. The chief difference between the two, as described by Cook, was that Ruskin taught students to arrange broad masses and colors first and to put in the details later, while South Kensington taught students to draw the details first. The South Kensington system was principally a course in the design of decorations for industry.

In Cook's judgment, Ruskin's drawing school was not a success. He

had few undergraduate male students, though it was well attended by "the young ladies of Oxford" (1890, p. 67). The drawing school was never fully admitted to regular status as a branch of liberal arts studies at Oxford, but in many respects the combination of Ruskin's program of lectures, the teaching collection of artworks, and the drawing mastership provided a model for the study of art that began to be followed in American universities, most notably at Harvard (see Chapter 3).

Opposition to South Kensington

For Ruskin the fatal flaw in the South Kensington system was the belief that design could be effectively taught by rule, as a branch of manufacturing activity. By contrast, he said that the way to obtain artistic designs for manufacture was to "educate men as artists, not teach art as if it were a branch of manufacture. . . . Try first to manufacture a Raphael; then let Raphael direct your manufacture" (Vol. 16, p. xxix). Of course, as one could not manufacture a Raphael, neither could one teach design. Hence the schools of design were involved in a fallacy. South Kensington confused art as applied to manufacture with manufacture itself. Years later (1877) Ruskin wrote, with obvious vituperation:

> The suddenly luminous idea that Art might possibly be a lucrative occupation, secured the submission of England to such instruction as, with that object, she could procure: and the Professorship of Sir Henry Cole at Kensington has corrupted the system of art teaching all over England into a state of abortion and falsehood from which it will take twenty years to recover. (Vol. 29, p. 154)

Ruskin's prophecy was optimistic, for South Kensington's influence did not begin to abate until 1895, with the preparation of the *Alternative Illustrated Syllabus of Instruction in Drawing in Elementary Schools* by Ebenezer Cooke. As a young man Cooke had taken drawing classes from Ruskin at Working Men's College, and he became a lifelong admirer of Ruskin's views on the teaching of art. He also believed that schooling could be improved by carrying Froebel's methods beyond the kindergarten.

Though the *Alternative Syllabus* did not come directly from Ruskin, it virtually banished the straight-line geometric drawing approach that was the prevailing characteristic of the old syllabus. It introduced brushwork and recognized the needs of children for spontaneous activity, the latter idea reflecting the influence of Froebel. There were also more lessons involving drawing from nature. Of critical importance, the alternative syllabus also enabled schools to diversify their drawing programs. The former syllabus mandated the same curriculum for all schools, and students were then evalu-

ated by standard examinations administered by the drawing inspectors of South Kensington. The *Alternative Syllabus* effectively did away with that system by making the standard examination optional. South Kensington's stranglehold was lessened, and in this sense, Ruskin's criticism had done its work.

Art Education for Workmen

In the years before the Oxford professorship, Ruskin taught for a period of five years (1855–1860) at the Working Men's College. He taught drawing by a method based upon the accurate observation of nature. A memorandum described the course and its objectives.

> The teacher of landscape drawing wishes it to be generally understood by all his pupils that the instruction given in his class is not intended either to fit them for becoming artists, or in any direct manner, to advance their skill in the occupations they presently follow. They are taught drawing, primarily in order to direct their attention accurately to the beauty of God's work in the material universe; and secondarily, that they may be enabled to record with some degree of truth, the forms and colours of objects, when such record is likely to be useful. (XVI, p. 471)

Ruskin's *Elements of Drawing* was devised in connection with his teaching at the Working Men's College, and its principal object was to teach drawing by means of perception. Artistry in Ruskin's view contained both perception and invention, but only perception could be taught. What distinguished one school or system of drawing instruction from another was the difference in the level of refinement in perception it cultivated.

When we compare these attitudes toward art education with those from the period of his Oxford professorship, we see that his educational objectives were virtually the same — to improve taste through perception.

The Promotion of School Decoration

Ruskin believed that the aesthetic quality of one's surroundings was important in developing taste, and for him taste meant "the instantaneous preference for the noble thing to the ignoble [which] is a necessary accompaniment of high worthiness in nations or men" (Vol. 16, p. 144). The development of taste was a critical part of educating the child to become a civilized adult.

On the matter of pictures for use with children in the schools, Cook noted Ruskin's support for the activities of the Art for Schools Association, which was active in producing and circulating prints to schools. Ruskin was

president of this association, which was founded in 1883 by Mary Christie (Vol. 27).

Collapse of Ruskin's Moral View of Art

By the middle of the 1870s "art for art's sake" had become a fashionable slogan; the aesthetic movement was underway in London. In its early phases it was an attempt to turn away from the sordidness of an industrial age. Its early heroes were William Morris and Edward Burne-Jones. As discussed more fully in Chapter 6, Morris was successful in his attempt to produce high-quality textiles, books, and other handmade articles, but the methods of traditional craft could not hope to compete with modern machinery in its capacity to inundate the market with cheap, ugly products. Because his goods were exceedingly expensive, he provided objects that only the sophisticated and rich could afford. Morris's gospel of redemption through crafts degenerated into a doctrine of art for art's sake. The aesthetes, in contrast to Morris and Ruskin, spent most of their time repudiating morality as a purpose for art.

In 1877 an extraordinary event occurred that drew lines of combat between Ruskin, as the champion of the Victorian view of art as a serious moral undertaking, and the painter, James McNeill Whistler, who felt that an artist's primary task is to make art. Ruskin found several of Whistler's paintings at an exhibition he attended to be highly offensive. He responded with a vituperative critique: "I have seen and heard much of cockney impudence before now, but never expected to hear a coxcomb ask two hundred guineas for flinging a pot of paint in the public's face" (quoted in McMullen, 1973, p. 183).

Whistler sued for libel, and though Ruskin was eager to meet the challenge, illness kept him from participating in the trial. Instead, he arranged to have Edward Burne-Jones testify in his behalf. Whistler's attorney attempted to show that he was an accepted artist whose paintings had been widely exhibited and who had received numerous commissions before his reputation was damaged by Ruskin's criticism. Ruskin tried to show that Whistler was a lazy eccentric who duped the public by painting his "nocturnes" in a matter of days and then sold them for outrageous prices. Whistler defended himself by articulating his art-for-art's-sake views.

I have perhaps meant rather to indicate an artistic interest alone in the work, divesting the picture from any outside sort of interest which might have otherwise attached to it. It is an arrangement of line, form, and color first; and I make use of any incident of it which shall bring about a symmetrical result. (quoted in McMullen, 1973, p. 188)

Whistler was awarded damages in the amount of one farthing (he had sued for 1,000 pounds), and both parties had to pay their own court costs. Ruskin regarded the incident as a defeat and soon afterwards resigned from his Oxford professorship. Whistler's defense of his work as "an arrangement of line, form, and color first" introduced to the British public the first salvo of a new view of art that was beginning to take shape on the continent. Though not part of the painting revolution underway in Paris, Whistler articulated one of its basic tenets—that painting could exist on its own terms, without story-telling or moralizing.

The moral view of art crumbled under other onslaughts as well. Among Ruskin's contemporaries were Darwin and Marx. Darwin, though a religious man himself, provided a purely material explanation for the diversity of nature, removing the necessity of a divine principle, while the dialectical materialism of Marx was used to justify a revolutionary solution to the same kind of industrial plight that Ruskin toiled fruitlessly to remedy by guild socialism. For Ruskin art was religion, but a religion needs believers, and by the end of the century, art was deposed by science as the new panacea for all of mankind's troubles.

ART IN THE EDUCATION OF WOMEN
IN NINETEENTH-CENTURY AMERICA

Unlike the education received by boys in the early part of the nineteenth century, girls' education usually allowed for some exposure to the arts; indeed, "accomplishment" in art or music was deemed a moral virtue.[3] The common school had assumed the task of improving public morality early in the century, and by the 1860s women had entered the teaching profession in large numbers. It has only been in recent times that writers on the history of art education have recognized that women, by virtue of their greater likelihood of having some knowledge of art, became major promoters of the teaching of art. By the 1890s women were using art to teach morality, especially in the school decoration and picture study movements, but before these art appreciation movements could take hold, public attitudes towards the arts had to be altered.

In the early part of the century the view was commonly held that lessons in drawing were luxuries to give young ladies from fine families—a "refining accomplishment," a mark of status and respectability. Art as "accomplishment" was rarely, if ever, supported at public expense, though it was quite common in private education. References to art education denigrating the tradition of the "accomplishments" appeared early in the writings of Fowle (1825) and in articles by Mary Ann Dwight (1859).

In the early years of the century, girls had few opportunities for school-

ing generally, let alone education in the arts. Dame schools, almost always taught by women, often in the home, operated to prepare children for the primary schools. Some girls went to primary schools, but they rarely went on to the grammar schools until the 1830s or 1840s. Wightman's history of Boston's primary schools (1860) notes that school mistresses were first hired as early as 1819, indicating that some provision for educating women was in place. Outside of Boston and its environs, most girls were educated within their families, although the girls of wealthier families were often educated at private schools.

Private schools for women began to appear for the daughters of wealthy families, and in these schools singing and drawing was introduced in a kind of "finishing" school treatment, which also included elocution, literature, and French. Girls were taught these things primarily to equip them for marriage. Early attempts to provide quality education for girls are seen in the efforts of the Reverend Joseph Emerson, who "set himself systematically to the great enterprise of reforming and elevating the system of female education" (McKeen & McKeen, 1880). Though meeting with opposition from many who contended that a woman's mind was incapable of high culture, he enlarged the curriculum then in use with girls.

Some Experiments with Female Education

The founding of the Female Monitorial School in Boston in 1823, Abbot's Academy for Girls in Andover, Massachusetts, in 1829, and Girls' High and Normal School in Boston in 1852 are three noteworthy instances of efforts to educate girls; they are of interest to us from the standpoint of teaching art.

Fowle's monitorial school, discussed in Chapter 4, was significant because it demonstrated that girls could be taught with the same instructional approaches as those used with boys. The drawing course developed by Fowle was based upon geometric principles, and he was apparently successful in teaching it to girls. Abbot's Academy attempted to provide girls with the same rigorous academy education proposed by Milton for boys nearly two centuries earlier. It perceived art as a source of great humanizing ideals from ancient civilizations. The Girls' High and Normal School was created to fill the gap left by the closing of the Female Monitorial School in 1842. A drawing program was developed for the school by Bartholomew, but other forms of art education were introduced there as well.

Public and Private Schooling

In the antebellum era, common schooling was supported as a means of securing social harmony through teaching practical and moral studies. Dur-

ing the postbellum era, an upwardly mobile middle class played an increasingly dominant role in setting schooling policies. They were not content with practical studies, wanting in their place educational programs that would offer opportunities for social improvement. In Chapter 4, we saw how class differences in educational policy resulted in a conflict between an upper-class minority, which advocated industrial drawing, and the middle class, which opposed this as training for a working-class vocation to which they did not aspire.

Public schools had to demonstrate that they could provide opportunities for upward mobility, and they did so by offering the same cultural studies offered by private schools. This began in the decades following the Civil War, and by 1900 most middle-class pupils attended public high schools rather than private academies as college preparatory institutions.

ART AT ABBOT'S ACADEMY. In a volume commemorating its fiftieth anniversary, McKeen and McKeen (1880) described Abbot's new department of art history as the "latest important addition to the course of study" (p. 81). The department started as a club "to study the history of painting, sculpture, and architecture" (p. 86). The founder of the club was Professor Edward A. Park, who held meetings devoted to the study of art in his home for several winters. In 1873 the history of art was formally introduced into the course of studies. The authors describe the course in the following way:

> Our general method of study is this: after a rapid survey of the field of Asia and Egypt, such attention as time will allow is given to architecture and plastic art in Greece and Italy. Beginning with the thirteenth century, the history of painting is taken up, noting the causes of its growth and decay; the influences received from climate, nationality, government, and religion. As far as possible, acquaintance is made with the lives and works of the greatest masters, both of the Northern and Southern Schools. (McKeen & McKeen, 1880, pp. 81–82)

A collection of 450 photographs, 117 etchings, 212 heliotypes, 267 engravings, and 31 casts were listed by McKeen and McKeen as resources for art teaching. In addition, the school had oil copies of Corregio's *Madonna* as well as alabaster copies of statuary from the Louvre and Vatican museums. This emphasis on art history, which gave the subject a genuine cultural significance, is a first indication that during the postbellum era the finishing school notion of art was being supplanted by a profoundly deeper sense of its cultural importance. (Of interest is the fact that the teaching of art history at Abbot's Academy antedated its introduction at Harvard by one year.)

THE ARTS AT GIRLS' HIGH AND NORMAL. The drawing taught at the Girls' High and Normal was neither in the private finishing school tradition

of the "accomplishments" nor wholly in the geometric tradition of common school art. Rather it lay somewhere in between. Its curriculum was devised by William Bartholomew, who taught there between 1852 and 1871. His drawing manuals bear some kinship with the common school tradition that based the teaching of drawing upon geometry, but he also emphasized drawing as a way to sharpen attention to the beauties of nature. Drawing was both a cultural and a practical study.

In 1871 the school received a most impressive gift, consisting of a set of casts donated by the American Social Science Association. This collection was selected and arranged by Perkins, later to be head of the committee on drawing of the Boston School Committee, with "especial reference to the aesthetic culture of the young ladies of the school" (Boston School Committee, 1872, pp. 310–11). Four pages of the drawing committee's report were devoted to describing in elaborate detail 22 casts received by the school, including a caryatid from the frieze of the Parthenon, brought to England by Elgin in 1814; Diana, Venus, and Polymnia from the Louvre; and other works from the Vatican and British museums.

It is likely that this gift was made because art in the cultural sense was appropriate for the education of women, especially those who were about to enter the teaching profession, and by the 1870s teaching had largely become a women's profession. Young women preparing to teach needed to be ladies of high moral character. Ability in art or music was often taken as evidence that a high standard of moral refinement had been achieved. When we compare this gift with the list of art reproductions at Abbot's Academy, we begin to see how the donors wished the public schools of Boston to possess the cultural advantages of private academies.

The art history course at Abbot's Academy and the cast collection at Girls' High and Normal are indicators that art appreciation had begun to be accepted as part of a girls' secondary education, but these examples were not typical of educational practices in the 1870s. Industrial drawing remained the official form of art education in the Boston schools through the 1870s and 1880s, not changing until the 1890s.

SCHOOLROOM DECORATION AND PICTURE STUDY

In 1892 a movement to decorate schoolrooms with reproductions of artworks emerged, with the object of promoting artistic culture. It took the form of an organization called the Boston Public School Art League. This organization was founded by a Salem artist named Ross Turner. Similar organizations were established in other cities across the nation. In 1896 the Brooklyn Institute of Arts and Sciences held an exhibition of works suitable

for use in schools (Stankiewicz, 1984). The Boston league's efforts were not unlike those of the Art for Schools Association in England, headed by Ruskin.

Picture study as an art activity began at the turn of the century and gained adherents through the first decade of the twentieth century. In 1899 the *Perry Magazine* made its appearance, though it ceased publication in 1906. It contained articles on the use of art reproductions in the classroom as well as advertisements for Perry Prints. In 1908 Bailey published the proceedings of his symposium on picture study, whose 14 participants were all school art supervisors in major cities (Bailey, 1908). The arguments used by a number of these supervisors were imbued with Ruskin's ideas. Stankiewicz (1984) concluded that "adherents of both movements believed that great artists were exemplars of high moral character, that exposure to works of fine art could help students develop spiritual and practical virtues" (p. 61). American art educators of that period were anxious to connect art study with the acquisition of American virtues, especially for the children of immigrants. Stankiewicz went on to tie these movements in art education to the role of women in education as moral guardians:

> Told by Ruskin and other Victorian writers that they had a duty to refine the lives of those around them, women took an active role in organizing school art societies to promote the distribution and study of pictures. The growing feminization of teaching coupled with women's roles as guardians of culture contributed to the development of the [school as] conservative museum of virtue. (p. 61)

CONCLUSIONS

The equating of art with high moral purpose originated in arguments first voiced in the writings of German idealist philosophers, and gradually these influenced the arts through the romantic movement. Romanticism radically altered the notion of mind from that of a passive receiver of random impressions to that of an active organizer of perception to make the world comprehensible. Mind was a power that could imaginatively reconstruct the world in alternative forms, creating beauty in art and heightening the sense of morality. In line with this idea, the arts came to be seen as sources of profound moral insights rather than mere ornamental accomplishments.

The idea that the mind could receive intuitive knowledge that transcended the limits of perception gave rise to New England transcendentalism. This movement contributed to the change in the intellectual status of women; since they were thought to have greater intuitive, or spiritual, insight

than men, they were thought to be superior to men as moral guardians. As the moral purpose of general education rose in importance, teaching became a largely female occupation, though economic factors also contributed to its feminization.

The notion of the child had also changed. Previously children had been seen either as creatures born in sin or as untamed animals in need of civilization by training. As romantic idealism gained ground, children became perceived as creatures with innate divinity, innocent at birth but subject to corruption by evil. Alcott's Temple School was an abortive attempt to base instruction upon idealist views of transcendental principles.

Froebel's view of the mind as self-activity was the basis for an educational innovation, the kindergarten. His organization of instructional materials in the gifts and occupations yielded activities to stimulate the mind's growth, eventually transforming art education from sterile exercises in drawing to activities rich in a variety of manipulative media. Of equal importance was the fact that imagination and self-activity foreshadowed the movement toward self-expression in the twentieth century.

Being largely women, the supporters of kindergarten education lacked the social power to modify the schools in a humane direction. Instead, the movement sometimes had to compromise, espousing the values of vocationalism and industrial art education, values then championed by men in social power, in spite of the fact that such values had little to do with Froebel.

Harris's Hegelian idealism provided a profoundly conservative argument for art, music, and literature in general education as sources of moral teaching and as defenders of social institutions.

There were marked differences between the art training received by girls and boys. Common school art, with its rational emphasis based in geometric structure, can be characterized as masculine art education. Feminine art education, by contrast, tended to promote the teaching of art as high culture. This occurred in private schools for women, infiltrating the public schools as these women became teachers.

As they came under the domination of the middle class, public schools began to emulate private preparatory institutions. This tended to accelerate the introduction of art teaching into the curricula of secondary institutions.

Ruskin's work in supporting the Art for Schools Association in England provided an example for similar activities in America. However, his most important and lasting contribution was his pioneering of a totally new direction for art education, one wedded to the rules of neither art academies nor industrial design; rather, he situated it within the liberal arts. Ruskin's legacy lives today in the fact that most colleges offer some form of art appreciation in their basic curricula.

CHAPTER SIX

Social Darwinism and the Quest for Beauty

Throughout the nineteenth century a changing industrial order was indirectly responsible for a host of new institutions for the teaching of art. These institutions were then shaped and reshaped as new social wants were recognized. By the turn of the century demands for social reform were heard throughout the land. The populist movement emerged in rural America, while in the industrial cities labor strife broke out as the first trade unions came into being. Women were demanding voting rights. Settlement houses came into being to help immigrants adapt to their new country. The factors that gave impetus to the efforts to reform society also worked to change the character and mission of the schools. Change also occurred in the schools as new theories about child development and learning found its way into teaching. Long regarded as an art, teaching itself began to change as a result of science.[1]

In this chapter we will deal with the ways in which science influenced education at the start of the twentieth century. We will examine the rise of psychology as a science and its applications in child study, in intelligence testing, and in studies of child art. Social Darwinism, which arose in the nineteenth century, became the rational warrant for the social efficiency movement at the dawn of this century. The demand for efficiency raised basic philosophical questions about the practical utility of all subjects in the curriculum, including the arts.

Another form of scientific influence was Dewey's approach to problem solving, which in turn influenced the progressive movement. For Dewey the method for testing educational theory was that of the scientist. Science was also felt in the form of the nature study movement, which held that the content of study should be drawn from everyday observations of nature as seen in the change of seasons and wildlife, rather than from books. But science directly influenced the arts as well. Some of the ways in which this influence was felt are described below.

CHANGES IN TECHNOLOGY. The invention of photography in the 1840s was one of the most discernible ways whereby science influenced art. By 1860 photography had become the principal method for documenting images. In one sense this liberated artists from the need to serve as portrait painters. More important, however, was its profound effect on how artists saw their world. The invention of aniline dyes and other chemical pigments widened the palette available to painters, while new materials and building techniques brought about changes in architecture. New theories accounting for the effects of light and color, coupled with the brighter palette made possible by chemistry, influenced the canvasses of impressionist painters (Grosser, 1956).

DISCOVERY OF THE UNCONSCIOUS. The discovery of the inner world of the mind, of subconscious drives and hidden fears, influenced artists to abandon the realism of everyday appearances and focus on the deeper reality of inner psychological states. Such styles as expressionism and, later, surrealism appeared as a consequence (Fleming, 1968).[2]

PRIMITIVISM AND CULTURAL RELATIVISM. With the longstanding traditions of academic art called into question, artists began to find new sources of inspiration in the art of so-called primitive peoples (Goldwater, 1938/1986). African art influenced Picasso, while the primitive imagery of child art can be seen in Klee. Concurrent with these developments in art, anthropologists such as Ruth Benedict began to suggest that the life, customs, and values of other cultural groups merely provide different views of reality, underscoring the growing belief that Western culture has no monopoly on truth.

ABSTRACTION AND SCIENTIFIC REDUCTIONISM. The great retrospective show of Cezanne in 1907 brought home to a generation of young painters the idea that all visual forms could be reduced to the cone, the cube, and the cylinder. Cezanne sought to realize some underlying truth through his analyses of pictorial form. By 1911 artists such as Braque and Picasso had assimilated Cezanne's lesson and went on to invent a new style of painting that reduced the image to constituent units that then could be rearranged at will to produce new realities. Cubism was thus born. Other artists, such as Kandinsky and Malevich, abandoned the image altogether and sought to discover principles of art in the analysis of pure form. Vitz and Glimcher likened this approach in art to scientific reductionism.[3]

As an intellectual approach this attitude assumes that understanding a given phenomenon requires first, the discovery of a new, more fundamental level of

reality that lies beneath or behind the familiar level of understanding, and second, that this new basic level can be analysed or broken down into subsystems, elements, relationships, processes and so on, which account for and explain the observations at the familiar level. (1984, p. 12)

Though artists were not seeking explanations of phenomena, there was a widespread conviction that all art rested upon a foundation of elements and principles, providing what was believed to be a definitive basis for the study and analysis of previous styles and the evolution of new styles. Design was seen as the foundation of art instruction. This was exemplified by the art pedagogy of Arthur Wesley Dow, Denman Ross, and later by the masters of the German Bauhaus. Courses in design throughout the century have borne such titles as "Design Fundamentals" or "Foundational Studies."

AMERICAN ART AT THE TURN OF THE CENTURY

The opening decade of the century found American artists generally innocent of the developments taking place in Paris, Vienna, and Rome. Artists like Maurice Prendergast and Childe Hassam were quietly assimilating the lessons of the impressionists and postimpressionists, but the academic approach to art, which had fallen into disrepute in France, still dominated American art. In spite of the fact that there was dynamic growth in business and industry, and a sense of human triumph over nature with the building of the Panama Canal, progress in art was still measured by a strict adherence to academic convention. The National Academy of Design maintained a painting tradition based on the finished picture, careful shading, realistic portraiture, and sentimental landscapes. A group of realist painters known as "The Eight" challenged these conventions, but few art dealers would feature their work.

The only way for an aspiring artist to become accepted was to exhibit in the annual shows of the National Academy of Design and be judged by its academics. With the landmark International Exhibition of Modern Art, now referred to as the Armory Show of 1913, the hegemony of the National Academy of Design was successfully challenged. Schwartz (1984) explained that the Armory Show was actually two shows in one. The American section attempted to show the parallels between American art and the art of Europe; the European section, mostly French, was organized chronologically to show the continuous development of modern art from Ingres and Delacroix to postimpressionism and cubism.

It is rare that any one event can be singled out as a turning point in the history of art. Change in this area occurs slowly and the character of an era seems only to

emerge with the passage of time. This, however, was not true as the result of the Armory Show. In 1913, a little more than a decade into the twentieth century, the Armory Show crystallized the situation of American artists and clarified the relationship of American art to Western European painting and sculpture. Indeed, the underlying philosophy of the exhibition expressed that "art must be alive," that new life pre-supposes change and that the new may at first appear strange but it will eventually be accepted and become the old, thus the inevitably of revolution and the continuity of tradition. (Schwartz, 1984, pp. 68–69)

Though there was a great outcry of condemnation and ridicule of modern art in the popular press, it was evident that American art looked plain, stilted, and underdeveloped. In short, the show became a turning point in American art. It encouraged the opening of many new galleries, created a generation of new and more adventurous collectors, and brought into play a new set of aesthetic values and standards of artistic judgment. Above all, it had a profound influence upon American artists. Stuart Davis claimed that the Armory Show was the "single greatest influence I have experienced in my work. All immediately subsequent efforts went toward incorporating Armory Show ideas into my work" (quoted in Schwartz, 1984, p. 75).

Though this new art was eventually to have a profound influence on American art teaching, it had virtually no impact prior to World War I. Professional instruction was based on traditional academy studies, while art teaching in public schools was under the influence of Britain's arts-and-crafts movement. The impact of the Armory Show is well documented in the annals of art history, but this latter movement is often overlooked in the history of American art education. Therefore, we shall examine it in some detail.

THE BRITISH ARTS-AND-CRAFTS MOVEMENT

The arts-and-crafts movement was more than an art movement; it was also a social mission to remedy the wrongs of the Industrial Revolution. It was an attempt to improve the quality of life of working men and women, to make culture available to everyone and not just the few, and to reestablish the union of art with craft, lost since the Renaissance.

Development in Britain

The movement's ideals originated in the writings of Carlyle and Ruskin, but, as noted in Chapter 5, it was with William Morris that these ideals resulted in action. Morris insisted that he did not want art for a few, any more than education for a few or freedom for a few. He and other leaders of

the movement had become socialists, for in their view art could not have a real life and growth under the contemporary system of "commercialism and profit mongering." For Morris the revival of the crafts was more than a mission to restore beauty; it was a way to reform society. Another central figure in the arts-and-crafts movement was Walter Crane, who also adopted socialism. He asserted that "as a class, the modern workman is engaged in a great economic struggle — an industrial war, quite as real, and often as terrible in its results as a military one — to raise his standard of life or even to maintain it amid the fluctuations of trade, and, as a rule, he is not in a position to cultivate his taste in art" (Crane, 1905, p. 28).[4]

The movement's protagonists reviled mechanical methods of production as well as the insincerity they found in the excessive and arbitrary use of ornamentation characteristic of the Victorian era. Beauty, they proclaimed, was to be found in simplicity rather than complexity. The industrial system had to be abandoned and the guild system of manufacture and education had to be restored. If apprentices were educated by masters, then the design of crafts would be an integral part of the training process and design education would be a natural outgrowth of mastery of a craft. Morris's writings and lectures inspired a number of younger artists to devote their lives to the crafts.

Between 1880 and 1890 five societies for the promotion of artistic craftsmanship were established in England. This included the Century Guild, founded by Arthur H. Mackmurdo in 1882. In 1884 the Art Workers' Guild, made up of architects, painters, designers, sculptors, and craftspersons of all kinds, was founded. In the same year the Home Arts and Industries Association made its appearance, organizing village classes in woodcarving, pottery, metalwork, and other crafts. In 1888 both C. R. Ashbee's Guild and School of Handicraft and Walter Crane's Arts and Crafts Exhibition Society were founded. As the movement spread, its principles also came to be accepted in most art schools geared to the education of artisans (Crane, 1905).

The four principles of the movement were *regard for the material, regard for the use, regard for construction*, and finally, *regard for the tool*. Of the first principle Morris said the following:

> Never forget the material you are working with and try always to use it for doing what it can do best; if you feel yourself hampered by the material in which you are working, instead of being helped by it, you have so far not learned your business. (quoted in Zueblin, 1902, p. 284)

The second principle asserts that the form, design, material, or decoration of an object should not be harmed or injured by the use for which it was made; nor should they annoy or inconvenience its user. The decoration of

furniture, for example, must be appropriate for its use. A later expression of this idea is that form should follow function. The construction principle demands that the structure of an object should bear witness to itself and be the source of its beauty. The principle of regard for the tool asserts that there should be active expression and sense of delight in the work of a tool. The throwing marks of the potter's hands, for example, or the natural marks of a wood chisel are to be preferred to the mechanical finish produced by industrial machinery.

In the 1890s the South Kensington School of Art became known as the Royal College of Art, with Walter Crane as its head. During his tenure courses in the crafts were introduced, many taught by members of the Art Workers' Guild. Crane was also instrumental in paving the way for the study of design as a foundational study in the training of artists and designers.

Impact in the United States

Handmade objects became highly fashionable for the wealthy. Indeed, Morris's patrons had to be rich for hand made objects were not inexpensive. In addition, the movement had a profound effect on domestic architecture both in England and the United States. Its aesthetic principles were exemplified in houses designed by H. H. Richardson and Frank Lloyd Wright. It was promoted by Gustav Stickley's book *Craftsman Homes*, published in 1909, which demonstrated how the style could be applied to homes for less affluent clients. Though beginning in the 1880s in England, its popularity in the United States reached its height during the first decade of this century (Stickley, 1909).

A number of prominent leaders of the movement made lecture tours in the United States to advocate the ideals of the movement. Walter Crane visited in 1890, and Charles and Janet Ashbee made regular trips throughout the 1890s, including a visit to Jane Addams's Hull House in Chicago. Similarly, many Americans who had traveled to Britain were inspired to propagate the movement in the United States. Elbert and Alice Hubbard founded a craft community known as Roycrofters in East Aurora, New York, in 1895, following a visit to Morris's Kelmscott Press the previous year. They helped popularize the Morris ideals of the craftbook in this country. Similarly, Ellen Gates Starr founded the craft program at Hull House after learning her craft at the Doves Bindery in England (Callen, 1979).

ESTABLISHMENT OF CRAFT ENTERPRISES AND COURSES. A growing number of socially prominent women were involved in establishing U.S. craft enterprises, several of which also had educative consequences. A school

of design was founded in Cincinnati, Ohio, and by the middle 1870s it had become an early center of interest in china painting. In 1874 a class was offered at the school to women of means seeking a pastime. Among these were Mary Louise McGlaughlin, whose overglaze decorative ware was subsequently displayed at the Philadelphia Centennial (Callen, 1979).

McGlaughlin learned of underglaze methods of decoration at the Centennial and proceeded to develop her own quite successful system. The new techniques were taught by the Cincinnati Pottery Club, and women from many parts of the country came there to study pottery decoration. Another prominent Cincinnatian was Maria Longworth Nichols, who founded the Rookwood Pottery with the support of her father. In October 1881 she started the Rookwood School of Pottery Decoration, which offered classes in over- and underglaze decoration, though the classes were soon discontinued. The Rookwood Pottery itself produced wares until it closed during the Great Depression.

Though these women were from the upper classes, their initiatives inspired women less prominently placed on the social ladder. Dozens of advertisements for china-painting classes and other forms of ceramic decoration appeared in the back pages of *Keramic Studio*, which would indicate that among women it had become a serious enterprise. As women studied the designs and patterns for painting, they also acquired the aesthetic principles of the arts-and-crafts movement; and since many of these women were also art teachers, these principles found their way into classrooms.

The arts-and-crafts influence was felt in professional art schools as many opened departments in the crafts, especially those related to major industries. This is illustrated by the career of Charles Fergus Binns and the founding of the New York State College of Ceramics in 1901 at Alfred, New York.

CERAMIC ARTS AT ALFRED UNIVERSITY. Prior to 1900 formal education in the ceramic arts was virtually nonexistent in the United States. The Ohio State University had opened the first ceramic engineering department in 1895, but it emphasized the technical and industrial, rather than the artistic, aspects of the industry. In the 1870s, such American wares as textiles had been unable to compete successfully against foreign products in the marketplace, and many factories had had to recruit designers and ceramic technicians from overseas, since locally trained personnel were unavailable. This was probably the reason Charles Fergus Binns came to the United States.

Binns was born in 1857 in England, where his father was a director of

the Royal Worcester Porcelain Works. At the age of 14 he was apprenticed at the Royal Worcester Factory, where he learned every phase of the production process while at the same time studying chemistry at Birmingham. He produced a number of writings on the technical aspects of clays and glazes. Though he had first traveled to the United States as an exhibitor at the Columbian Exposition in 1893, he immigrated in 1897 (Perkins, 1956).

Binns's program at Alfred was unique in its time because it dealt with the craft from both its technical and aesthetic aspects. In 1902 a normal class featuring the use of clay in teaching was added, and preparation of art teachers for New York State certification continued to be offered at Alfred until 1933. Thus we can see how ideas of art that had originated in Britain during the 1880s gradually found their way into American classrooms.

MAGAZINE PUBLICATION. Magazines played a unique role in the arts-and-crafts movement in the United States. Because they could be distributed by mail, they played a more obvious educational role than in European countries, where distances were much smaller. By the late 1890s photomechanical reproduction had become a technical possibility. *The House Beautiful* made its appearance in 1896. In 1899 Adelaide Alsop Robineau and her husband bought the magazine *China Decorator*, which reappeared under the new title *Keramic Studio*. She studied with Charles Binns at Alfred University and was a renowned ceramic artist in her own right. *Keramic Studio* was a nationally distributed monthly that provided its readers with superb photographic reproductions of pottery, many in full color. Early issues described the ceramic college that had opened at Alfred, New York, and recounted lessons on design from such renowned teachers as Arthur Wesley Dow. Later issues dealt with other crafts, such as pyrography, bookbinding, and metalwork. In 1901 *The Craftsman* (see Figure 6.1) also began publication.

Two educational publications made their appearance in 1901: the *Applied Arts Book*, which eventually became the *School Arts Book*, and the *Manual Training Magazine*. If one compares the illustrations in these two educational publications with those in either *Keramic Studio* or *The Craftsman*, one can see the extent to which the arts-and-crafts style was infiltrating public education as well. The *School Arts Book* and its founding editor, Henry Turner Bailey, are discussed in detail later in this chapter. The influence of the arts-and-crafts movement on school craft products can be seen in design exercise from the *Applied Arts Book* shown in Figure 6.2, which also reflects traditional Japanese influence.

FIGURE 6.1.
Title page of *The
Craftsman* (magazine),
c. 1902, showing the
stylistic influence of
William Morris's
Kelmscott Press.

INFLUENCE OF SCIENCE
ON EDUCATIONAL PHILOSOPHERS

The concern with the life of the mind as self-activity, so characteristic of
the idealist philosophies of the nineteenth century, was replaced by a philoso-
phy of scientific rationalism. This intellectual movement posited that all philo-
sophical problems should be resolved by the methods of science, in effect
declaring that traditional philosophical inquiry was no longer viable. The
nature of the universe, the origin of life, the evolution of consciousness—all
these could be explained by the action of natural laws. God, mind, and spirit
were not needed to explain human nature or to justify human actions.

Herbert Spencer

A typical proponent of this view was the nineteenth-century English
philosopher and educator Herbert Spencer. According to Cremin (1964),

Spencer was the chief conduit of social Darwinism to Americans. Spencer viewed history as "the progressive adaptation of constitution to conditions . . . the adjustment of human character to the circumstances of living" (quoted in Cremin, 1964, p. 93). In 1861 Spencer posed the question, "What knowledge is of most worth?" (Spencer, 1861/1966). He argued that the degree to which a subject potentially contributes to the survival of the individual should determine its place in education. Since the aim of education is preparation for life, one begins by teaching students those activities ministering directly to self-preservation. Then one teaches those that secure the necessities of life, followed by those concerned with the rearing and disciplining of offspring. Finally, one teaches those that support proper social and political relations, including those devoted to the gratification of tastes and feelings. In this final group he placed the arts. Thus the doctrine of evolution was invoked to provide a rational basis for determining the relative importance of the subjects in the curriculum, and by Spencer's reckoning the arts assume a minor role.

FIGURE 6.2.
Illustration showing
Japanese influence, from
Applied Arts Book
(1901–1902), 2, 332.

This type of Spencerian thought was to foster an aggressive utilitarianism in which all aspects of education were valued according to their visible, practical benefits. But there was another side to Spencer's thought that had positive implications for art education. Macdonald (1970) notes that Spencer was not opposed to art education, though he did take violent exception to the type of drawing education fostered by the Department of Science and Art of South Kensington. Spencer actually used the theory of evolution to justify drawing, based on the nature of the child.

> Had teachers been guided by Nature's hints not only in making drawing a part of education but in choosing modes of teaching it, they would have done still better than they have done. What is it that the child first tries to represent? Things that are large, things that are attractive in colour, things round which pleasurable associations must cluster, human beings from whom it has received many emotions; cows and dogs which interest by the many phenomena they present; houses that are hourly visible and strike by their size and contrast of parts. And which of the processes of representation gives the most delight? Colouring. Paper and pencil are good in default of something better; but a box of paints and a brush — these are treasures. (quoted in Macdonald, 1970, p. 321)

Macdonald notes that this passage from Spencer antedated Darwin by five years, that his views of learning were derived from Lamarck, that he believed "that a child's early art expressed needs that must be fulfilled in order to engender new habits and modify and develop the mind," and that he thought that "the question is not whether the child is producing good drawings. The question is, whether it is developing its faculties" (p. 322). Spencer concluded that the fulfillment of the art needs expressed by the child was necessary both for its own evolution and for the "perpetual evolution of *homo sapiens*," that "anything which repressed the inherited nature of the child was hindering evolution" (p. 322). It was no wonder that he condemned the drawing curriculum that had been established by South Kensington.

Granville Stanley Hall

Like Spencer, G. Stanley Hall was strongly influenced by Darwin. According to Cremin (1964), Hall had earned Harvard's first doctorate in psychology in 1878. After several years of additional study in Germany, he returned to the United States and accepted a professorship at Johns Hopkins University. In 1889 Hall became president of Clark University in Worcester, Massachusetts. During the 1890s Hall had become one of the foremost figures in the field of psychology. He called his basic thesis the "general

psychonomic law," which claimed that "ontogeny recapitulates phylogeny"—the biologists' maxim asserting that the development of the individual follows the pattern of the evolution of the species—applied as well to the psychosocial development of humans: In the process of growth, the child passes through all the stages from savagery to civilization. If we want to understand the evolution of humanity, we need to study the development of the child (Cremin, 1964).

Under his leadership observations of the child began in earnest; indeed, by the turn of the century educators could look back to Pestalozzi and Froebel as inspired but prescientific observers. In 1883 Hall published *The Content of Children's Minds*, and in 1891 he founded the journal *Pedagogical Seminary*. He was among the first to argue, on the basis of scientific evidence, that the mind of a child is different from that of an adult and that educational practice should reflect these differences.

William James

In 1890 William James published his *Principles of Psychology*, which bore some resemblance to Spencer in its attempt to explain the phenomenon of mind by the Darwinian doctrine of evolution. Spencer, we recall, saw mind as that instrument which enables the individual to adapt to the environment and thus to increase the prospects of survival; but by Spencer's reckoning, education could not hope to improve the species, since evolutionary processes bring about changes over long stretches of time. Education thus could never be an important basis for the progress of civilization. At best it could help individuals adapt to their circumstances.

By contrast, James believed that the business of intelligence is not merely to adapt to circumstances but to change them as well. For Spencer science revealed a deterministic world ruled by the laws of causality, while for James human intelligence was an instrument by which individuals could create better lives for themselves. Dewey was to enlarge on the tradition of James, in that science for him was a method for acquiring knowledge of the world that can be used to enhance the prospects of survival.

John Dewey

The philosophy of John Dewey had a revolutionary and lasting impact on education. In Dewey's view the individual does not experience the world with an empty mind but perceives it through a screen of previous knowledge acquired through previous encounters with the world. As a consequence, certain aspects of the environment may have a determining effect upon what will be found to be of interest in a new situation. Predispositions to perceive

reality in a certain way constantly undergo reconstruction as new experience is gained, and intelligence constantly revises one's conception of reality. New knowledge enlarges the individual's capacity for change.

Rejecting the kind of determinism espoused by Spencer, Dewey pictured human beings not as passive spectators in a world whose future outcomes have already been determined, but as individuals functioning in an immensely complex environment. Since this environment is one that is changing, individuals must modify their behavior through experiences that yield knowledge and understanding. The operation of intelligence to produce knowledge was what Dewey called scientific method, and such knowledge was instrumental in one's survival. Dewey resisted the idea that there were absolute laws of science and preferred to view new knowledge as more adequate instrumentalities for dealing with changing situations. These ideas influenced the teaching of art at Dewey's Laboratory School at the University of Chicago, which is discussed later in this chapter (Jones, 1952).

EDUCATIONAL MOVEMENTS AT THE
TURN OF THE CENTURY

In what follows we will consider a series of movements in general education that affected the teaching of art. These include the child-study movement, which began in the 1880s with Hall but whose impact upon art education first began to be felt around 1900; the social efficiency movement, whose impact was felt between 1910 and 1918; and the manual training movement, which began in the late 1870s but whose influence on the teaching of art was felt largely between 1900 and 1920. In addition we will look at nature study as a movement and, finally, the progressive movement in its early stages as manifested in the schools headed by Francis W. Parker and John Dewey.

Child Study

As noted earlier, psychology as a science was greatly influenced by Darwin's theory of evolution. Hall's general psychonomic law claims that the child passes through a series of developmental stages that correspond to the stages the human race passed through in its progression from savagery to civilization. This belief strongly suggests that the races that have developed civilized culture are farther up on the evolutionary ladder than others. Tribal arts were seen as primitive, like the art of children, and not surprisingly, child art was often compared with tribal art. This type of comparison was common among early students of child art, as can be seen in James Sully's (1890) comment:

In much of this first crude utterance of the aesthetic sense of the child we have points of contact with the first manifestations of taste in the race. Delight in bright glistening things, in gay tints, in strong contrasts of colour, as well as in certain forms of movement, as that of feathers—the favorite personal adornment—this is known to be characteristic of the savage and gives his taste in the eyes of civilized man the look of childishness. (p. 299)

JAMES SULLY. In the years between 1890 and 1905 a number of individuals began to study the untutored drawings of children. James Sully was a professor of psychology and philosophy at University College in London. His *Studies in Childhood* was one of the first occasions on which child art was categorized according to developmental stages. Published in both Britain and the United States, this book was reviewed in such American periodicals as the *Journal of Childhood and Adolescence*. Sully frequently cited the work of both Hall and Earl Barnes, demonstrating the international character of child study as a movement and, particularly, the interest in the evolution of drawing as a manifestation of the growth of the child's mind.

Sully made use of drawings from many sources. He characterized the early scribble drawings of 2- and 3-year-old children as a kind of "imitative play-action." Children, in his view, may set themselves to draw and make believe they are drawing something when in fact they are scribbling. Using an image made by a 4-year-old girl, Sully noted that it was "closely analogous to the symbolism of language" in that the representation was arbitrarily chosen as a symbol and not as a likeness. Sully was one of the first to use the expression "the child as artist," which was a title for one of the chapters in *Studies in Childhood*.

EARL BARNES. Another contributor to the child study movement was Earl Barnes, who published two volumes of articles entitled *Studies in Education* (1896–97, 1902). The first volume consisted of studies made by Barnes and his students in California between 1890 and 1897. The second volume gathered together studies made by similar investigators in England and America. The first volume included studies of the pictorial evolution of a man, analyses of the illustrations children made of stories, drawings as evidence of the fragmentary quality of children's thinking, and a study of children's attitudes toward problems of perspective.

The articles in the second volume usually contained an illustration by a child followed by an analysis of the child's mind based on the content of the drawing. One article, "Children's Hieroglyphics," claimed that children preferred to draw in symbols rather than represent objects as they appear, and the author hoped to be able at some point to observe children evolving phonetic symbols to form an alphabet: "We shall learn how to make the

child's love for drawing lead directly into writing; and we shall thus bring drawing into its true place as an art of expression" (Barnes, 1902, p. 76). This expectation that there was a connection between drawing and writing was another expression of the recapitulation doctrine.

GEORG KERSHENSTEINER. Working on a much larger scale than either Sully or Barnes, Georg Kershensteiner, school superintendent for the city of Munich, Germany, published the results of his investigations of child art in 1905. He sought a set of principles on which the drawing instruction of children should be based, but he ended up with a giant empirical survey aimed at finding out how the graphic expressiveness of the untutored child develops from its primitive beginnings. He collected nearly half a million drawings from 58,000 schoolchildren in Munich, attempting to include only drawings that had been done without teacher interference. He then classified these drawings according to the age, sex, and social class of the children who had made them. He concluded that children's drawing ability developed naturally and regularly toward the development of visible reality in space (Werckmeister, 1977).

EBENEZER COOKE. What became clear to these first investigators was that drawing ability was governed by a process of lawful development, not unlike that of language capacity or handwriting. Though these studies were generally descriptive, prescriptions as to the proper methods for teaching art to children soon appeared. In England Ebenezer Cooke was one of the first to call into question past authorities on art teaching based on what was being revealed in the new studies of child nature. Recalling the beliefs that had guided the teaching of art in the past, he noted that the headmaster of the South Kensington School of Art had announced officially that color principles could not be taught, while his mentor, Ruskin, had declared the brush to be "too difficult for beginners." Cooke declared that these earlier pronouncements were based on prejudice but that now "science was questioning all" (Cooke, 1912, p. 96).

Cooke anticipated the movement toward self-expression in art education, but his statement is also important because he attempted to base teaching methods on scientifically based observations rather than on past authorities, thus demonstrating that science directly affected the ways in which people thought about education, including art education.

Social Efficiency

In Chapter 5 we examined the romantic idealism of William Torrey Harris, which was a bulwark resisting an encroaching tide of scientific materialism as preached by such individuals as Herbert Spencer. As long as

this materialism was constrained by Harris's conservative vision, the classics, literature, the visual arts, and music could find their warrant in the school curriculum as a moral force. Yet Spencer's ideas increasingly acquired a popular following.

A dramatic instance of this is seen in the 1895 *Report of the Committee of Ten* for the reform of secondary education. In 1892 ten prominent educators were appointed by the National Education Association to study the high school curriculum. Like Spencer, they also asked "what knowledge is of most worth?"; and their answer to the query was not unlike Spencer's own. This committee was headed by Charles W. Eliot, president of Harvard, a man who began his academic career in the study of chemistry. He also is credited with writing the final report for the committee (Harris, 1894). The report questioned the efficacy of a classical education grounded in Latin and Greek as a suitable preparation for life, seeing greater value in the study of modern languages and science. As might be expected, the subject of art received only scant attention. The lengthy report devoted one solitary paragraph to the arts:

> The omission of music, drawing, and elocution from the programmes offered by the committee was not intended to imply that these subjects ought to receive no systematic attention. It was merely thought best to leave it to local school authorities to determine, without suggestions from the committee, how these subjects should be introduced into the programmes in addition to the subjects reported on by the conferences. (Committee of Ten, 1895, p. 1442)

The committee's virtual silence implicitly declared the arts unworthy of comment, a mere matter of local choice. Since this report was to affect policy for secondary education for the next 25 years, it doomed the arts to the status of elective studies. This committee's recommendations also did much to standardize the requirements for college entrance; and because no arts were discussed, no recommendations regarding preparation in the arts as a prerequisite to college entrance were made.

In 1895 the report affected few students, since most left school after completing the grammar school grades. Few entered high school, and fewer still completed high school. However, by the end of the first quarter of the twentieth century, the report had begun to have a serious impact on the teaching of art. By then a higher percentage of students were entering and completing high school, and it was then that the curriculum patterns set during the 1890s had their impact. In 1918 a commission on the reorganization of secondary education issued its *Cardinal Principles of Secondary Education*, which retained the basic frame of Spencer's ideas, relegating the arts to leisure pursuits.

John Spencer Clark (1894), a writer of art textbooks for the Prang Educational Company, commented extensively on the "Report of the Com-

mittee of Ten," saying that "its spirit and methods are admirably scientific, but . . . they take too little account of imagination and feeling; lay comparatively too much emphasis on facts and too little upon ideals" (p. 375), and that he finds "no recognition of art either as an historic inheritance or as a spirit-inspiring individual expression" (p. 376). He concluded that

> To leave art out of our plans for the education of the young is to deny to growing minds that strong inspiration which comes from a knowledge of man as a creator. To use art wisely as a means of education is to put the growing mind in touch with the growth of the race. (p. 381)

Clark's defense of art was based totally on cultural and moral grounds, using the reasoning of the romantic idealism that was still popular in the 1890s. But Spencer's writings on education had begun to liberate the field of education from its philosophical moorings. Science had begun to acquire the same kind of canonical authority once ascribed to philosophy and theology, and Clark's pleas went unheeded.

By the early 1900s other aspects of social Darwinism were affecting education. William Graham Sumner argued that those who hold power in society gained it by virtue of being the "fittest." Survival in competitive capitalist society was seen as testimony to the superiority of the businessman and his suitability for leadership. Thus science sanctioned the businessman as being most fit to rule. Having received the blessing of science, the businessman's standard of efficiency became the standard for judging the efficiency of the institutions of government and education. American educators soon began to utilize the techniques of science and business to make the schools more efficient by the elimination of nonproductive procedures and subjects—and even of students judged too dull to profit from schooling. By 1912 a new literature on the scientific management of schooling had come into being; indeed, school administrators increasingly began to think of themselves as managers in the business of education (Callahan, 1962).

Spurred by increasing criticism of the schools in the press, they attempted to measure the efficiency of teachers, the productivity of the curriculum, and the intelligence of children. With these data they proposed to eliminate waste by channeling pupils into courses where their abilities could be scientifically developed. If tests determined that a child was too dull to profit from education, the child would be trained in ways commensurate with his or her innate ability.

Alfred Binet provided a common measure for testing intelligence with the development of the first IQ test, grounded in the assumptions that children of the same age group may very well exhibit differences in their intellectual ability and that a measuring device should be able to exhibit the level of a child's natural intelligence. In succeeding years many psychologists, including Binet himself, began to note that children from poorer social

classes were generally shown to have lower IQ scores than upper-class children, but he did not question the test itself. In a curious way, the intelligence test became what some Marxist critics, such as Gilbert Gonzales, call "a principal criterion for explaining socioeconomic inequality" (Gonzales, 1982). Thus rich and powerful members of society, who formerly justified their success by citing their hard work and thrift, could now cite the inheritance of superior intelligence as well.

Soon after the turn of the century it became clear that art teachers could no longer take comfort in arguments warranting art as a way to teach culture and morals. Although such arguments provided the rationale for the picture study activities that enjoyed a measure of popularity as art activities, many were demanding scientific evidence to support such claims. A telling sign of this appeared in "The Waning Powers of Art" by David Snedden (1917). Snedden, an educational sociologist on the faculty of Teachers College, Columbia, challenged the longstanding assumption that the arts were important, first noting that this assumption is usually derived from "other civilizations than our own and chiefly representing other stages of evolution." He wondered whether we might have reached a stage of development when art is less vital and compelling than was formerly the case:

> Perhaps the functions of art in ministering to the primal needs of society are not what they once were, and so, as a consequence, while society may still be willing to spend of its energies and resources freely on art, it now refuses to take art seriously because it cannot make of it a means toward realizing the more serious and worthy things of life. Strong men decline to make the production of art works a career, although they are willing to see their daughters follow it as a lightsome and not too prolonged vocation. (p. 805)

He then surveyed all of the uses of art in past societies, for example, music can move men to worship, or to make love (which perpetuates the species), or to work in harmony. "If we possessed sufficient data . . . we should probably find that many forms of art had during the long periods when they possessed great social vitality, a very large 'survival value'" (p. 806). But then he asked whether similar needs confronting early societies still exist in modern society. He concluded that while art still had a place in life, it is not as important for the survival and expansion of civilized societies as science.

Manual Training

The idea of manual training as an element of general education was first proposed by John D. Runkle, president of M.I.T., as early as 1876. At the Philadelphia Centennial, Runkle saw a Russian instructional exhibition featuring the Moscow Imperial Technical School. The exhibit presented a

series of graded manual exercises that demonstrated two principles: that manual training could furnish needed mental discipline suitable for all children and that it could prepare students to enter certain lines of industrial activity.

Because manual training is also mental training, Runkle argued that it should be a regular part of general education. He established workshops at M.I.T. and began a manual training high school affiliated with the institute. His report *The Manual Element in Education* (Runkle, 1877), which was published by the Massachusetts Board of Education, contended that manual training was essential if the schools were to be responsive to the needs of an expanding industrial society. His arguments were expanded upon by Calvin M. Woodward of Washington University in St. Louis, who established the Manual Training School there in 1880.

Runkle and Woodward had to walk a thin line between a conception of manual training as education for an industrial labor force and one of manual training as an integral part of schooling as cultural education. Manual training, they argued, educated the mind through the hand; thus it was liberal, intellectual training. Woodward also maintained that manual training taught the moral values of precision, logic, diligence, and economy (Lazerson & Grubb, 1974).

In 1899 *The Manual Training Magazine* began publication and served as the organ of the movement. In 1918 the journal changed its name to *The Industrial Education Magazine*, a telling sign that the movement had become part of the larger and more aggressive vocational education movement.

In its early phases the manual training movement emphasized the virtues of craftsmanship and shared many of the goals of art educators. There was a belief that utility and beauty were common to both. John Frieze felt that "an important characteristic of this instruction is the development of the idea that the line of service and the line of beauty frequently evolve together" (1926, p. 116).

Nature Study

Nature study was in some ways a companion movement to manual training. It also attempted to overcome the excessive bookishness that was increasingly the subject of criticism of the schools. Though the renowned Swiss-born naturalist Louis Agassiz was reputed to have given the movement its motto — "study nature, not books" — he was not directly connected to the movement to introduce nature study into the schools. Agassiz was an enormously popular lecturer, who traveled widely in the United States and inspired in many adults an interest in natural history and geology.

Nature study appears to have been a substitute for object lessons, which

were pioneered at the Oswego Normal School. Object lessons aimed at involving all of the child's senses in acquiring knowledge, but they were criticized because there was little or no connection between one lesson and another. The knowledge taught was a mere collection of isolated facts. H. H. Straight, who had come under the influence of Agassiz, saw the insufficiency of this approach and began to correlate the subjects of study with the observations of natural phenomena that the children could see for themselves, such as the growth of plants in the spring, or the migration of birds in the fall.

In 1883 he joined the staff at the Cook County Normal School in Chicago, where, with Francis Wayland Parker, he worked to make the sciences an integral part of the school curriculum. Straight died in 1886, but his work was carried on by Wilbur S. Jackmann, who published bimonthly pamphlets called "Outlines in Elementary Science." These were republished in 1891 under the title *Nature-Study for Common Schools*, and this term has been in use since that time. Concurrent developments in nature study also were undertaken at Bridgewater Normal School in Massachusetts and at Teachers College, Columbia. In 1905 *The Nature-Study Review* began publication, and in 1908 the American Nature Study Society was formed, with the *Review* as its official organ (Bailey, 1920).

Early Progressive Education

Cremin's (1964) history of progressive education devotes a chapter to the pedagogical pioneers whom he sees as forerunners of the movement. Among those he singles out for special mention were Francis Wayland Parker and John Dewey. It will be instructive to compare the educational accomplishments of these two men, because their ideas about the arts and their place in the curriculum were forerunners of what was to become common practice during the Progressive Era.

FRANCIS WAYLAND PARKER. Korzenik (1985) describes the early career of Parker as a teacher in the North Grammar School of Manchester, New Hampshire. Parker was born in Bedford, New Hampshire, in the fall of 1837. His grandfather and mother were teachers. After his father's death he worked on a farm and obtained his education at a private academy during the winter months, becoming a country schoolmaster at the age of 16. Following service in the Civil War, he taught in Manchester, New Hampshire. He then went abroad for two years to study the schools of Prussia, Switzerland, and Holland, where he learned about Pestalozzi and other reformers. On his return, he became principal of the first normal school in Dayton, Ohio. In 1873, his reputation as an educational innovator

established, he became school superintendent in Quincy, Massachusetts. Here he abandoned the standard curriculum based on traditional textbooks and rote learning. Under his supervision teachers learned to use the newspaper and devise other materials for the teaching of reading and language. Geography was taught by taking trips into the countryside, while drawing was added to teach manual dexterity and individual expression. Then, after serving a year as a supervisor in the Boston schools, where his new ideas were deemed too controversial, he was invited in 1880 to become principal of the Cook County Normal School in Chicago (Cremin, 1964).

Korzenik (1984) explains that the central thesis in Parker's educational philosophy was that children can only learn what is meaningful to them in their daily life, that meaning is rooted in their own experience. Teachers can help children through experiences that help them attend to objects in their environment and through helping them express their understanding of what has been attended to. Attention and expression were thus the core of his method.

Attention involves the senses. We attend by looking, listening, and touching. Parker also believed that attending stimulates "intense acts of imagination" and that attending makes one want to express, while expressing makes one want to attend more. The modes of expression were gesture, voice, speech, music, making, modeling, painting, drawing, and writing. Thus for Parker the arts were central in the curriculum. Korzenik described Parker's approach in the following way:

> For Parker, the child's education demands expression in diverse media. He said, "Every child has the artist element born in him; he loves to model objects out of sand and clay. . . . Give a child a piece of chalk, and its fancy runs riot: people, horses, houses, sheep, trees, birds, spring up in the brave confidence of childhood. In fact, all the modes of expression are spontaneously and persistently exercised by the child from the beginning except writing. It sings, it makes, it moulds, it paints, it draws, it expresses thought in all forms of thought expression, with the one exception." (Korzenik, 1984, p. 290)

In Parker's school the arts were seen as ways to secure meanings in the world. One can see this in the science program under Parker, which was begun in the form of nature study. The children were taken on trips through the neighborhood and along the Chicago lakeshore to make observations and drawings, thus correlating their work in science with their studies in language and art.

DEWEY'S LABORATORY SCHOOL. John Dewey established the Laboratory School at the University of Chicago "to discover in administration, selection of subject-matter, methods of learning, teaching, and discipline, how a school could become a cooperative community while developing in individuals their own capacities and satisfying their own needs" (quoted in Cremin, 1964, p. 136). It was based on the notion that:

> Life itself, especially those occupations and associations that serve man's social needs, should furnish the ground experience of education, that learning can be in large measure a by-product of social activity; that the main test of learning is the ability of individuals to meet new social situations with habits of considered social action; and that schooling committed to cooperative effort on the one hand and scientific methods on the other can be of beneficial influence on the course of social progress. (Cremin, 1964, p. 136)

The Laboratory School opened in January 1896 in a private dwelling with 16 pupils and 2 teachers. A retrospective account of the school was published by Katherine Camp Mayhew and Anna Camp Edwards (1936/1966), sisters who taught at the school during its formative years. By October 1896 the school had 32 children and a staff of 3 regular teachers, one of whom taught manual training. In 1898 the school moved into larger quarters and assumed a departmental mode of organization. A subprimary department was added to include children aged 4 and 5. A gymnasium and manual training rooms were added in an attached carriage barn, while art and textile rooms occupied the large attic rooms. By 1902 the school had 140 pupils and 23 instructors. Dewey served as its director, while his wife served as principal.

Dewey saw the school as an experiment to obtain answers to four main problems or questions. The first was whether it was possible to integrate the school with the home and neighborhood. In his view, traditional schools were isolated from the world of experience. If the child's play and occupations at home and in the neighborhood are interesting, why should the same not be true of the school? (Mayhew & Edwards, 1936/1966).

In his second question he asked:

> How can history, science, and art be introduced so that they will be of positive value and have real significance in the child's own present experience? . . . How much can be given to the child of the experiences of the world about him that is really worth his while to get: how far first-hand experience with the forces of the world and knowledge of its historical and social growth will enable him to develop the capacity to express himself in a variety of artistic forms? (quoted in Mayhew & Edwards, 1936/1966, p. 25)

The third question concerned how much of the "formal symbolic branches of learning—the mastering of the ability to read, write and use figures intelligently" (p. 26) could be gained out of other studies and occupations? Children engage in the occupations because of their intrinsic appeal, but to what extent can these occupations be used to lead the child to acquire skill in reading, writing, and mathematics?

In the final question Dewey asked whether the hand and other motor organs, in connection with the eye, "can be used to help children gain experience and come in contact with the familiar materials and processes of ordinary life? . . . Carpentry, cooking, sewing, and weaving all require different sorts of skill and represent, as well, some of the most important industries of the everyday outside world" (quoted in Mayhew & Edwards, 1936/1966, p. 27). They appeal to children and lead them to form habits of industry and neatness as well as to care for tools and utensils.

Dewey saw these intrinsically interesting occupations as the instruments that could lead to a broad intellectual life, and the school was organized around these activities rather than formal subjects. Similarly, the arts were not taught as subjects but in conjunction with these occupations. Mayhew and Edwards describe the art education in the following way:

> The children handled raw materials of many kinds and had the satisfaction of shaping them to their own planned ends. Under guidance these results grew into more and more finished products of greater meaning and artistic value. (1936/1966, p. 341)

Dewey saw art as

> an attitude of spirit, a state of mind—one which demands for its satisfaction and fulfilling a shaping of matter to new and more significant form. To feel the meaning of what one is doing and to rejoice in that meaning, to unite in one concurrent fact the unfolding of the inner life and the ordered development of material conditions—that is art. (quoted in Mayhew & Edwards, 1936/1966, p. 348)

This definition of art, which appeared in 1936, is reminiscent of his *Art as Experience*, published in 1934. Mayhew and Edwards noted that "the school seems to have had a groping faith that genuine artistic expression may grow out of the manual arts and carry on to their spiritual meaning many of the processes of daily life" (1936/1966, p. 348). This would have been consistent with the Deweyan notion that art is not a segregated realm of endeavor but is a quality that makes certain experiences worthwhile.

The schools run by Parker and Dewey were in many ways forerunners of what was to become commonplace during the progressive movement, which flowered after the First World War, but practices in their schools were in no

way typical of the public schools at the turn of the century. Parker's idea of expression anticipated by two generations the philosophy of creative self-expression that came into prominence during the interwar years. Dewey's conception of occupations was reminiscent of Froebel, but his occupations were bound up with the day-to-day tasks of the real world and a psychology of childrens' interests rather than with Froebel's ideal forms.

Neither Parker nor Dewey believed that subjects should be taught in isolation. Each attempted to synthesize elements from the various educational reform movements of the period by devising activities in nature study and the manual occupations.

ART TEACHING PRIOR TO WORLD WAR I

In the period between 1900 and World War I a transition occurred from simple drawing instruction to more inclusive education. This transition is well documented in Henry Turner Bailey's annual reports to the Massachusetts Board of Education and in those of his successor, Walter Sargent. Sargent also wrote the art education entry in the 1916–1918 biennial survey conducted by the U.S. Bureau of Education (Sargent, 1921). The early volumes of the *School Arts Book*, of which Bailey served as the first editor, also provide a ready reference to the types of art activities recommended by art supervisors and teachers. Another major source is the survey of art education prepared by James Parton Haney (1908).

Evidence of Transition

Before dealing with these sources, a short biographical sketch of Bailey is provided to show the range of his activities during the last decades of the nineteenth and first decades of the present century.

HENRY TURNER BAILEY. Born in Scituate, Massachusetts, on December 9, 1865, Bailey attended the Massachusetts Normal Art School at a time when Walter Smith's ideas would still have prevailed. He taught in the evening drawing schools of Boston during the 1884–1885 school year, and in the 1886–1887 school year he also acted as the supervisor of drawing in the Lowell, Massachusetts, public schools. In 1887 he graduated from Massachusetts Normal and in the same year became the agent for industrial drawing for the Massachusetts State Board of Education, replacing Charles Carter, who became art supervisor for Denver, Colorado. Thus his tenure was separated from that of Walter Smith by only five years. His first annual report in 1888 contained an outline for an eight-year course of study in industrial drawing that was based on Smith's approach (Bailey, 1889). In

1901 Bailey resigned to become editor of the *Applied Arts Book*, a journal that changed its name to the *School Arts Book* in 1903.[5] In 1916 he resigned his editorship to become head of the Cleveland Art Institute, where he remained until his retirement in 1930.

ANNUAL REPORTS. His successive yearly reports document a change in direction from drawing as an industrial skill to drawing as a means for acquiring a knowledge of the elements of beauty. When we compare his first report (Bailey, 1889) with that for 1896–1897 (Bailey, 1897), we see that the latter is illustrated with art masterpieces as well as containing diagrams about composition and questions to be used by teachers to guide the child's explorations of subject and meaning. The former, by contrast, began with the study of geometric forms and the details of those forms, in the manner of Smith (Bailey, 1897).

His annual report for 1897 shows an increasing distance between the original idea of industrial drawing and his current view, which called for a liberalization of the educational approach to include nature drawing, drawing from the human figure, and portrait painting. In fact, he believed that "any exercise which tends to develop a finer perception of beauty, a more discriminating taste has an industrial value" (Bailey, 1897, p. 334). His last report (1903) strongly asserted the ideals of the arts-and-crafts movement, with references to Ruskin's *Modern Painters, Prosperina*, and *Laws of Fesole*.

THE 1899 EXHIBITION. Bailey organized an exhibition of drawing in the public schools of Massachusetts that established a record of the kind of art that was exhibited in the name of industrial drawing for the year 1899. A total of 9,000 drawings were included in the exhibit, which included work from elementary, secondary, and normal schools as well as work from the free evening drawing schools and the Normal Art School. Bailey's observations about the exhibit in his annual report reveal how the show differed from the exhibits prepared by Smith in the 1870s.

> The general use of color in the public schools has come within the last decade. How dead and ghostly an exhibition of fifteen years ago would have appeared beside this! This had the fresh, rosy look of a sunny-haired child in gay clothing. The coloring was often too intense and crude, perhaps (the child's mother lacked taste and the child had been romping!), but it betokened a health, a freedom, a delight in being alive, hitherto unknown in our public school drawing. (Bailey, 1900, pp. 416–17)

The report was illustrated with student examples of model drawing, pictorial composition, decorative arrangements from nature possessing a strong Japanese influence, designs for stained glass windows, textiles, and metalwork.

REVIEWS OF TRENDS. While the show was impressive, it would be wrong to conclude that it typified art educational practices around the United States. Massachusetts was in many respects atypical in that it was the only state to have a normal art school and that school districts around the state hired a high percentage of its graduates. Bailey's annual report had reported that 167 cities and towns employed supervisors of drawing, with 116 being graduates of the normal art school. All told, the total number of persons employed in teaching drawing for 1899 was 279 (Bailey, 1900). In addition, Bailey reported on the status of industrial drawing in the high schools. Of the 212 school districts in the state, 96 required the study of drawing for one year, 55 listed it as an elective study for one year, while 61 reported that drawing was not taught at all. Other eastern states were also active in encouraging the teaching of art, notably Connecticut and New York, but not to the extent that it was supported in Massachusetts.

In a 1914 issue of *School Arts Magazine* Bailey published an article that documented the changes that had occurred in the period from 1885 to 1895, noting that in the period preceding 1885 there was "no illustrative drawing, no drawing from nature, no drawing from common objects, no handicraft, and no color . . . to be found" (1914, p. 1). These kinds of activities were available with greater frequency after 1895.

In 1921 Sargent published the art education entry in the *Biennial Survey of Education* for the Bureau of Education for the 1916–1918 period. This surveyed the status of art education for the nation as a whole. On the subject of art instruction in the elementary schools, Sargent observed that it "has been quite general throughout the country for some years," that it was taught to illustrate other subjects, and that there was "an especially close correlation with the manual arts." Finally, there was "more definite attention to developing appreciation of good pictorial art and of excellent constructive and decorative design." Similar trends were also found in secondary education (Sargent, 1921, p. 237).

THE SCHOOL ARTS BOOK. While still serving as state art supervisor, Bailey, in conjunction with two other Massachusetts art supervisors, Fred H. Daniels and James Hall, began to publish the *Applied Arts Book*. This was published from September 1901 to June 1903. The June 1903 issue announced that beginning with the September issue, the magazine would be called the *School Arts Book*.

There is no exact way to determine whether the pages of this publication truly reflect what was actually taught in the schools, though the illustrations in the magazine showed examples of art that were similar to those seen at the 1899 exhibition. It is also clear that the magazine's contents were to some extent determined by what would sell copies. Most of the articles were devoted to seasonal topics and handicraft activities. Holi-

day projects and handicrafts were probably popular among the magazine's subscribers, which suggests that these subjects made up a large portion of the art activities then being offered in schools.

Bailey's editorial statements did not always reflect the actual contents of the magazine. For example, he devoted a high percentage of his editorials to picture study, schoolroom decoration, and the appreciation of beauty in nature; but as a general rule the magazine's articles tended to place greater emphasis on such factors as the changing of the seasons as natural phenomena, rather than using them as a source of inspiration or aesthetic experience.

The geographic distribution of the contributors suggests that most were either teachers or supervisors in eastern cities and suburbs or that they were teachers in normal schools. Teachers and supervisors from larger non-eastern cities, such as St. Louis and Chicago, were also represented. Few articles originated in rural communities, though a number of articles, written by staff members or by normal school faculty, were addressed to this audience.

Art Subjects Taught

Using the subject classifications of the articles in the *School Arts Book* (1903–1912), we can get an approximate idea of what was taught in the art classes of the period. Publications such as the *Manual Training Magazine* also listed similar activities, especially in the area of crafts and drawing.

APPRECIATION OF BEAUTY. The study and appreciation of beauty was a crusade to be pursued on many fronts. The most direct approach was through picture study activities or schoolroom decoration projects, which were justified by a belief in the moral influence of art, a practice in accord with nineteenth-century romantic idealism. In 1908 Bailey published a symposium on picture study in the *School Arts Book* that consisted of several short articles from art teachers and supervisors describing their lessons (Bailey, 1908). In the previous chapter we noted that the *Perry Magazine* was one of the leading advocates of picture study, though it had ceased publication by 1906. The subjects of the pictures as exemplified in Figure 6.3, in *School Arts Magazine*, often coincided with patriotic celebrations or holidays in the school calendar.

A number of accounts of the picture study and schoolroom decoration movements (Stankiewicz, 1984) tend to create the impression that this was the principal art activity from the 1890s to World War I, but if the ratio of such lessons to other subjects taught is reliably indicated in the *School Arts Book*, it is more tenable to assume that picture study was at best an occasional activity.

FIGURE 6.3. "Picture Study 7, Pilgrim Subjects," from *School Arts Magazine* (1920), 20 (3), 130, showing *Pilgrims Walking to Church*, a painting by George Henry Boughton. Courtesy of the New-York Historical Society.

NATURE DRAWING. The appreciation of beauty was also to be culti-
vated through drawing from nature. Nature drawing was often integrated
into nature study, which, as we saw earlier, was a full-fledged movement in
its own right. Drawing activities were suggested as ways to sharpen chil-
dren's perceptions of the natural environment and to appreciate beauty in
nature. A number of books and articles from this period stress the double
purpose of the nature study curriculum, as we can see in the passage that
follows.

> Nature study leads up gradually to a grasp of scientific classifications, of the
> systematic order and law that prevail in the world; in short, ultimately, to a
> perception of the plan and wisdom that pervade nature. Here we are on the
> threshold of religion. The esthetic interests and tastes cultivated by nature study,
> the perception of beauty and grandeur and harmony, are among the strongest
> educative influences of science study. Some even claim that nature is essentially
> moral in its teaching, and we may all agree, at least, that indirectly many moral
> qualities are strengthened by a wise method of science study. (McMurry, 1899,
> p. 14)

Many of the nature drawing lessons were lessons in design as well, since
plant forms were frequently used to ornament objects. The nature study
emphasis thus was consistent with the aesthetics of the arts-and-crafts move-
ment.

HANDICRAFTS. By far the largest group of activities in *School Arts
Book* consisted of applied arts, manual arts, or handicrafts. There are a
number of reasons why these activities were so numerous. One was a direct
result of the scientific studies made of childrens' interests and the increased
emphasis that school reformers began to put on the need for activity in
which visual and manual learning was paramount.

A second was the practical emphasis placed on approaches to learning
as a result of the social efficiency movement. Art for art's sake would not
have met with popular approval in an era of efficiency and common sense.
Manual training and *applied arts* were terms often used interchangeably,
and writers of the period often voiced the opinion that the teaching of
craftsmanship would help to instill an appreciation of the importance of
beauty in the manufacture of utilitarian objects. We saw this with John
Frieze, who viewed the matter from the perspective of the manual training
movement, but it is equally evident in Walter Sargent's *Fine and Industrial
Arts in Elementary Schools* (1912).

A third reason for the popularity of crafts in programs of art and
manual training was the arts-and-crafts movement itself, which was then at
the height of its popularity in the United States. This was a major revolution
in popular taste, especially that of the middle classes.

MODEL AND OBJECT DRAWING. In the listings of subjects in *School Arts Book* we find that model and object drawing activities were not nearly as numerous as handicrafts. The lessons appear to be descendants of the model and object drawing lessons introduced by Walter Smith in the 1870s. To some extent they were derived from the object teaching that was common in the last few decades of the nineteenth century. Many of these lessons made use of the same type forms used by Mary Dana Hicks in the 1890s (see Chapter 5). They allowed children to learn to group objects in still-life arrangements and to portray the third dimension on a two-dimensional surface. Between 1900 and 1910 the geometric type form had given way to simple pottery forms or statuary arranged in a still-life composition.

COLOR AND DESIGN. The *School Arts Book* index listed the subject of color separately from that of design. The lessons introduced the terminology associated with the study of color, such as *harmony, monochromatic, hue, value*, and *intensity*. The lessons on design fell into two categories. The first, applied design, included such topics as all-over and border patterns, which were shown as ways of decorating objects; commercial art and interior design; and procedures for conventionalizing such natural forms as plants and animals. The second category, theory of design, included elements, principles, and "laws" of design. This latter category was less in evidence in the magazine than the applied forms of design.

Development of Design Theory

Many influences contributed to the development of design theory. One was an increasing hostility to academic approaches to art that based the study of art in the skills of representational drawing. Another was a growing awareness of art from non-Western cultures. The extensive collections of decorative art in London's Victoria and Albert Museum, for example, made possible a more systematic study of ornament from many different places and historical periods, greatly facilitating the compilation of works such as Owen Jones's encyclopedic *The Grammar of Ornament* (1856/1982). Similarly, Arthur Wesley Dow was inspired by the collections of oriental art at the Boston Museum of Fine Arts to prepare *Composition* (1899/1913). Because Dow was a significant contributor to the study of design in the United States, we will describe his ideas in more detail.

DOW'S SYNTHETIC ART EDUCATION. *Composition* was a new kind of art book, in which Dow described his synthetic exercises. Later editions of this book appeared until 1940. What distinguishes his from other drawing and painting methods was that it is based on elements and principles of design. Dow explained how, "thoroughly dissatisfied" after studying the

academic theory of art for five years in France, he came to devise his system:

> In a search for something more vital I began a comparative study of the art of all
> nations and epochs. While pursuing an investigation of Oriental painting and
> design at the Boston Museum of Fine Arts, I met the late Professor Ernest
> Fenollosa. He was then in charge of the Japanese collections, a considerable
> portion of which had been gathered by him in Japan. . . . He at once gave me
> his cordial support in my quest, for he also felt the inadequacy of modern art
> teaching. He vigorously advocated a radically different idea, based as in music,
> upon synthetic principles. He believed music to be, in a sense, the key to the
> other fine arts since its essence is pure beauty; that space art may be called
> "visual music", and may be studied and criticized from this point of view.
> Convinced that this new conception was a more reasonable approach to art, I
> gave much time to preparing with Professor Fenollosa a progressive series of
> synthetic exercises. (1899/1913, p. 5)

Dow taught his system in Boston with success. He was then invited to
the Pratt Institute, where he taught life drawing, painting, design, and nor-
mal art as well as a course for kindergarten teachers. In 1900 he established
a summer school in Ipswich, Massachusetts, for "the purpose of obtaining a
better knowledge of the relation of art to handicraft and manual training"
(1899/1913, p. 5). In 1904 he became director of fine arts at Teachers
College, Columbia University, arriving there in the same year as Dewey.

In Dow's system there were three basic elements of design: line, *notan*
(light and dark), and color. Line refers to boundaries of shapes and the
interrelations of lines and spaces. Line-beauty is the result of a harmony
made up of lines in various combinations. *Notan*, a Japanese word meaning
dark/light, refers to the massing of tones of different values. *Notan*-beauty
means the harmony resulting from the combination of dark and light spaces
in buildings, pictures, or nature. Color refers to the quality of light. These
three elements exist in a hierarchy. Good color depends on good *notan*, and
good *notan* depends upon good spacing, which is determined by the place-
ment of lines. Thus in his view it made sense to begin the study of design
with the element of line. Some of Dow's exercises in landscape composition
based on the use of line and *notan* are shown in Figures 6.4 and 6.5.

In addition to the three elements, Dow posited five principles of compo-
sition: opposition, transition, subordination, repetition, and symmetry. All
of these are, in turn, dependent upon what he called the great general
principle of proportion, or good spacing. Dow illustrated each of these
elements and principles with reproductions of artworks from architecture,
painting, sculpture, and the crafts to demonstrate that they are universal.

Dow called his theory of design "synthetic" because he believed his
elements and principles were the building blocks for all forms of art past,

present, and future. The fact that his book was in print for over a third of this century suggests that it was widely used in teaching (Hook, 1985; Mock-Morgan, 1985). Figure 6.6 appeared in the Hammocks' (1909) series called *The Manual Arts for Elementary Schools*. The flower and fruit forms bear a striking resemblance to the work of Dow's students shown in Figure 6.7.

DENMAN ROSS AND HIS THEORY OF PURE DESIGN. Appearing concurrently with Dow's system was the system of "pure design" devised by Denman Ross, a teacher of painting and design at Harvard. Like Dow, Ross also discussed elements and principles; but unlike Dow, he neither deduced his elements and principles from existing works of art nor illustrated his texts with existing artworks. He proceeded from the simplest element, consisting of a single dot, and then built relationships based on the study of position, direction, distance, and interval. From the dot he moved to lines, to outlined forms (shapes), and then to tone and color. At each step he defined terms and postulates in the manner of a visual scientist. And, indeed, he consciously pursued design as a science.

> Painting is a scientific practice. It is a way of doing things which must be understood and mastered. The life which the painter expresses by painting, when he has mastered the art, may be intensely emotional and personal or it may be severely intellectual, with nothing personal in it. When the speaker or writer has mastered the language, by scientific methods, by the analysis of samples and by experimental practice, he proceeds to talk or write. (Ross, 1912, p. 9)

Ross did not have the impact on the teaching of design in public schools had by Dow largely due to the fact that he was not a teacher of teachers. Dow's system also seemed better to explain what makes works of art visually effective, thus lending itself to ready application in teaching.

Separation of Art from Vocational Education

In 1910 Bailey wrote of a growing split between art education and industrial/vocational education, and he encouraged teachers of art to hold fast to their ideals emphasizing the appreciation of beauty.

> As teachers of drawing we must hold to our ideals of beauty. "Make everything beautiful", must be our motto. And we must hold to this with an ever tighter grip these days when the clamor for "Industrial Education" is increasing. (1910, p. 32)

No.37 A Landscape in three
proportions

FIGURE 6.4. "A Landscape in three proportions" (Exercise No. 37), from Arthur
Wesley Dow, *Composition* (1899; rpt. New York: Doubleday Doran Co., 1913).

He went on to suggest that those people promoting industrial education
lack appreciation of the ideals necessary for progress and that we should be
developing artists, not technicians. He cautioned:

> Unless our Industrial Education opens the minds of working men to the beau-
> ties of the world, to the glories of artistic achievement, to the eternal principles
> of art, we shall continue to steal our designs from Germany and France, and all
> our industrial training will go to the making of clever parrots and monkeys.
> (1910, p. 33)

Bailey was obviously reacting to the increased demands for vocational
education relevant to an industrial age. Demands for educational offerings
that met the criteria of social efficiency were in the air. In 1906 the Massa-
chusetts Board of Education had published a report on industrial and tech-
nical education, which was especially critical of manual training (Lazerson
& Grubb, 1974).

The report recommended that the elements of industrial training and
mechanical sciences should be taught in the public schools, that in addition
to this elementary teaching there should be distinctive industrial schools
separated from the rest of the public school system. Throughout the 1880s

FIGURE 6.5. Landscape compositions in light and dark (Exercise No. 47), from Arthur Wesley Dow, *Composition* (1899; rpt. New York: Doubleday Doran Co., 1913).

industrialists had been among the most prominent advocates of manual training, but now their demand was for a more relevant form of industrial education. As long as manual training had a link with the crafts and design, its purposes were allied with those of the drawing teachers; but gradually a separation between the two groups took place. This is seen in the growth of separate organizations for both types of teachers.

FIGURE 6.6.
Flower forms based on
nature study and
Japanese composition,
illustration from C. S.
Hammock and A. G.
Hammock, *The Manual
Arts for Elementary
Schools: Seventh Year*
(New York: D. C. Heath
& Co., 1909, p. 4).

The Emergence of Art Teachers Associations

The first professional organization of art teachers in the United States was founded in 1874 in Massachusetts under the guidance of Walter Smith. According to Bennett (1937), this group was "essentially an undergraduate organization of the Massachusetts Normal Art School, and ceased to function after a few years." In 1882 a second organization, known as the Industrial Art Teachers' Association, was formed in Boston. "Its purpose was to stimulate the free discussion of vital professional subjects at a meeting to be held once a year" (Bennett, 1937, p. 493). In 1883 the National Education Association also established a Department of Art Education, which met for the first time in 1884.

At the Columbian Exposition in 1893 another new association, the Manual Training Teachers Association of America, was formed. Its first annual meeting was held the following year at the Drexel Institute in Philadelphia. In 1895 this association changed its name to the American Manual Training Association to permit nonteachers to become members. Then in

FIGURE 6.7. "Line Composition, Junior Class, Teachers College, New York, N.Y.," showing the influence of Dow's teaching; from J. P. Haney, *Art Education in the Public Schools of the United States* (New York: American Art Annual, Inc., p. 301).

1899 the association changed its name once again, to the Eastern Manual Training Association. Around 1900 the art teachers of the eastern states had been building up an organization under such leaders as Solon P. Davis, who was its first president. Other persons prominent in this organization were Fred Daniels, Walter S. Perry, George Bartlett, and Arthur W. Dow. In 1909, this group combined with the Eastern Manual Training Association to form the Eastern Art and Manual Training Teachers' Association. In 1915, at its annual meeting at Buffalo, the group shortened its name to the Eastern Arts Association.

A second group also owed its inception to the Columbian Exposition held in Chicago. On August 10, 1893, a group of art teachers met at the Chicago Manual Training School to found the Western Drawing Teachers Association, electing as its first president Ada M. Laughlin. Its first annual meeting was held in Milwaukee, Wisconsin, in 1894. When the Manual Training Teachers Association of America elected in 1899 to become a regional instead of national group, it left the manual training teachers of the Midwest without any professional affiliation. In 1903 a committee of the Western Drawing Teachers Association, headed by Bonnie Snow, recommended that after the 1904 meeting the association change its name to the Western Drawing and Manual Training Association. In 1919 the group became known as the Western Arts Association (Bennett, 1937).

The Eastern Arts and Western Arts Associations became the two art teachers associations. A generation later, following the Second World War, these groups joined forces to become the National Art Education Association.

Thus, in the years following World War I, art teachers ceased to be identified with teaching for industrial purposes, even though the subject had initially been introduced for this purpose. Having lost its initial purpose, art had become a subject taught for cultural purposes.

Normal Art Schools

As we saw in Chapter 4, the commonwealth of Massachusetts established the first normal art school in 1873. It was the first art school in the nation established under state sponsorship exclusively devoted to the training of art specialists; indeed, it was the only such school ever to be established for that purpose. Other professional art schools were established under private auspices, but they were not exclusively devoted to the training of art teachers. Among these were the Pratt Institute and the Cleveland Art Institute, both of which came into being in the 1880s. Schools such as Pratt and Cleveland contained normal art departments whose purpose was to prepare art teachers and supervisors. The course of study for art specialists varied from one school to another. For example, in 1908 the course at Pratt was a two-year course, while the Cleveland course was five years in length (Haney, 1908, pp. 325–51).

Emergence of the Art Supervisor

Starting with Walter Smith in 1871 in Boston, urban school districts and state departments of education began to hire art specialists to oversee the teaching of drawing and the expanded host of art subjects that were later

introduced. Many of these supervisors were graduates of normal art schools. For example, Mrs. E. M. Dimmock, Chicago's first supervisor of drawing, was a graduate of Massachusetts Normal Art School. Earlier we noted that Bailey's annual report to the Massachusetts Board of Education for 1898–1899 discussed the influence of the Normal Art School in providing special art teachers and supervisors throughout the cities and towns of Massachusetts. Here we see that its graduates made their way to positions in other states as well.

In 1908 Haney listed numerous art supervisors on the cooperating committee organized to help with the preparation of his *Art Education in the Public Schools of the United States*. Supervisors of art were listed in such cities as New York, Utica, Buffalo, Denver, Hartford, New Britain, Trenton, Newark, Boston, Springfield, Worcester, North Adams, Newton, West Newton, Washington D.C., Oakland, San Francisco, Los Angeles, Fort Worth, Chicago, Milwaukee, New Orleans, and Providence.

CONCLUSIONS

From the 1890s to the First World War art education went through several transitions. The first was from a subject limited to the teaching of drawing to one encompassing a wider designation of art, including appreciation, design, and crafts.

Industrial education itself was transformed into vocational education, and by World War I it had divorced itself from education in art, although the original industrial purpose for art education survived in the form of handicrafts and the ideals of the arts-and-crafts movement.

As a social movement, the arts-and-crafts movement failed to achieve its mission of reforming productive processes. However, it achieved notable success in changing public taste. Like picture study and schoolroom decoration, its role in schooling was also limited to the cultivation of taste and appreciation of the beautiful.

With the industrial mission of art education lost, art teachers turned to the teaching and appreciation of art and natural beauty as their reason for being. This lack of utilitarian mission tended to reduce the importance of the subject, as is seen in its relegation to elective status in secondary education.

Yet in spite of a decline in the overall importance of the arts in education, more students actually had access to such studies, since students were attending high school, where they could elect to study art, in greater numbers. At the turn of the century nearly 40 percent of the towns and cities in Massachusetts required a year of formal study in art at the high school level.

The idea that art should be a required study is still an unfulfilled goal in our own time.

The movement known as progressive education began in the work of Parker and Dewey and continued to grow. Their experimental work in Chicago was informed by scientific studies of children's natural interests as a basis for the curriculum. They enlivened the curriculum with nature study and manual occupations, and both recognized that the arts had important consequences for stimulating the child's powers of observation and interests.

In spite of the obstacles that faced art education at the turn of the century, important strides were made. This is seen in the number of cities and towns that began to hire art specialists and supervisors to work with regular teachers in the teaching of art. It is also seen in the rise of professional associations for art and manual training teachers, as well as in the rising number of such professional publications as the *School Arts Book*.

In the next chapter we will see the scientific rationalism that began in the 1890s manifest itself as the scientific movement of the years between World War I and World War II. At the same time, a countervailing movement arose to change the fortunes of art education. Like the scientist at the end of the nineteenth century, the avant-garde artist was to become a new form of cultural hero, and under the banner of creative self-expression, the fortunes of art education rose again.

CHAPTER SEVEN

The Expressionist and Reconstructionist Streams in Art Education

The period between the two world wars opened with a spirit of optimism in the wake of a victorious war fought to make the world safe for democracy. It was a time marked by a rebelliousness against Victorian attitudes and inhibitions. Freudian psychology provided the rational warrant to eliminate puritanism from American life, a cause brought into the progressive movement by a number of educators.

The optimism of the 1920s faded with the stockmarket crash of 1929 and the deepening economic crisis that ensued. As depression spread, the dream that poverty had been banished from American life evaporated. Marxists declared the downfall of capitalism, while new ideologies like communism, nazism, and the America First movement gained willing adherents. Economic paralysis dramatically altered the mood and direction of progressive education, which also had lasting impact upon the teaching of art.

In Europe the war brought an end to long-established autocracies in Germany, Austria, and Russia. Though this sometimes cleared the way for democratic forms of government, it did not eliminate the national rivalries that had led to the war in the first place. A defeated Germany established a democratic constitution and the Weimar Republic. Its growth was blighted by economic chaos and conservatively nationalist forces that eventually led to the totalitarian rule of the Nazi Party. Yet during the chaotic times before Hitler came to power, Germany was the scene of the Bauhaus, one of the major developments in twentieth-century art education.

In this chapter we encounter three streams of influence acting upon art education. The first is the *scientific* movement in general education, which devised ways of testing academic ability and achievement and scientific

means of curriculum development. The second I call the *expressive* stream, because it gave rise to creative self-expression as a method of education. The third, the *reconstructionist* stream, came to the fore during the Great Depression, when social reforms were necessitated by the country's economic stress. Each of these streams was connected with the progressive education movement, and the impact of all was felt in art education.[1]

AMERICAN ART DURING THE INTERWAR ERA

The Armory Show introduced American artists to European avant-garde art, an influence that can be seen in the work of Milton Avery, John Marin, Stuart Davis, Ben Shahn, Arthur Dove, Charles Sheeler, and Charles Demuth. Yet American art generally remained narrow and conservative. Influential eastern museums in the years between the Armory Show and the Great Depression "had defected to an art-for-art's-sake exclusiveness" (Marling, 1974, p. 7). Prominent galleries featured either the modernist styles of the Armory Show or old masters.

Within a month of the Wall Street crash, a new museum, which placed modernism on a permanent footing in American life, made its appearance. The Museum of Modern Art in New York opened in a few rooms in an office building on Fifth Avenue with an exhibition of Cezanne, Gauguin, Seurat, and Van Gogh. In its first decade, more than a million persons viewed its 120 temporary exhibitions.

Other museums also featured modern art. In 1934 the Wadsworth Atheneum in Hartford, Connecticut, became the first in the United States to stage a one-person show of Picasso. The Arts Club and Art Institute of Chicago and the museums of Boston, Cleveland, and Philadelphia followed suit in featuring the advanced styles of European and American artists (Porter, 1971). Many progressive educators, such as Harold Rugg, identified closely with the artistic and intellectual avant-garde of the 1920s, modeling educational reforms after the rebellion of artists against academic stricture.

In the decade between 1933 and 1943 the Works Progress Administration (WPA) of the New Deal began to take an interest in the artist. Initially a means of providing relief for unemployed artists, its liberally oriented bureaucracy soon made it possible for nonacademic artists to obtain important mural and sculpture commissions in government buildings. The WPA, however, sponsored numerous other projects as well, including the "Index of American Design," which documented American primitive art, such as old salt-glazed pottery and weathervanes; a highly effective art education program in the public schools and settlement houses, implemented through a

"loan artists program" that sent experienced artists to culturally underdeveloped regions; traveling exhibitions that circulated through a network of federal art galleries; and community art centers that brought original works of art and art classes to isolated corners of the nation — all during a time of financial distress (O'Connor, 1972).

THE PROGRESSIVE EDUCATION MOVEMENT

Before World War I educators had been imbued with the idea of achieving social efficiency through scientific methods of administration, curriculum development, testing, and surveys. Though such methods were supposed to improve education, they also resulted in a standardization of educational practices and a concurrent stifling of innovation in public education. With a few notable exceptions, innovative schooling experiments occurred under private auspices. Some of these were described in John and Evelyn Dewey's *Schools of Tomorrow* (1915). These experiments, though new in spirit, represented to the authors a return to the tradition of Rousseau, Pestalozzi, and Froebel.

These schools had a number of principles in common, including the beliefs that teaching and learning should be based upon the natural development of the child and that education should be grounded in real experiences, organically related to the social life of the community. The activity programs of these schools mirrored the conditions of actual life. These schools ascribed great importance to children's interests as the main criterion for selecting school experiences, and they uniformly decried the preoccupation with empty abstractions that had come to typify standard schooling practice.

Schools of Tomorrow was a harbinger of needed reform in American education, and the principles it illustrated were amplified in Dewey's classic volume, *Democracy and Education* (1916/1953). With America's entry into World War I, reform efforts of the sort advocated by Dewey were set aside. The war itself also revealed many shortcomings of the nation's schools, including an embarrassingly high number of army inductees who received low scores on the army Alpha Tests. As the crisis of the war revealed, the schools had failed the nation.

The Scientific Movement

During the postwar era a group of progressive educators attempted to base the reform of the schools on scientific research. The work of this group did not affect the teaching of art directly, but it did lay the groundwork for

the development of research methods for studying the nature of talent in the arts and its relation to general intelligence.

In 1922 Edward L. Thorndike wrote that "whatever exists at all exists in some amount" (p. 16), that to know something thoroughly means knowing both its quantity and its quality. Educational change can be seen in things made, words spoken, acts performed and the like. Measurement of these products is possible, and Thorndike believed that pedagogy could develop into a science through the use of knowledge produced by such tests and measurements.

PSYCHOLOGICAL STUDIES OF ARTISTIC APTITUDE. Slow in coming, application of science to art instruction was chiefly represented by psychological studies for assessing artistic abilities in relation to general intelligence. The first intelligence tests typically included tasks requiring verbal and mathematical reasoning abilities; art-related abilities, such as drawing or design judgment, were rarely, if ever, represented in the item pools determining the makeup of human intelligence. Thus it was not surprising when researchers concluded that art did not correlate very highly with general intelligence.

This conclusion was evident in a summary of these early studies of artistic abilities. Zimmerman (1985) notes that "a number of studies attempted to demonstrate that aptitude in the visual arts is controlled primarily by special talents rather than by general intellectual ability" (p. 269). She also notes that these studies tended to define art aptitude as representational drawing ability. Zimmerman reports that by 1919, H. T. Manuel, who surveyed the role of talent in drawing ability, had concluded that art ability "was independent, or partially independent, of general intelligence" (p. 270).

Zimmerman's review included psychologists like Florence Goodenough, who in 1926 reported on relationships between general mental ability and performance on drawing tests, in particular her Draw-a-Man Test. She contended that general intelligence could be determined by analyzing childrens' drawings of people. She also insisted that her test measured not drawing talent per se but rather the remembered detail the child observed and put into drawings of persons. Thus the possession or nonpossession of drawing ability did not affect the test's validity as a measure of intellectual ability.

In the period between 1929 and 1939 Norman C. Meier and his students at the University of Iowa conducted a series of studies in the psychology of art. Zimmerman singled out Tiebout and Meier's study for special mention. It examined the relationship between art ability and general intelligence, taking issue with the generally accepted theory that relegated

art to the status of a special gift. These researchers found that higher-than-average intelligence characterized successful artists, which led them to conclude that general intelligence is a factor that, when present with other factors, contributes much toward the success of an artist (Zimmerman, 1985).

Much, if not most, of this psychological research failed to enter into the pedagogical discussions of art teachers. Although Ayer's review of drawing abilities was included in the NSSE *Eighteenth Yearbook* (1919), this was not a reference specifically addressed to art teachers.

SCIENTIFIC APPROACHES TO CURRICULUM PLANNING. In 1924 Franklin Bobbitt published *How to Make a Curriculum*. In his view, the goal of educational science is to construct a general blueprint for all educational activity based on "a broad overview of the entire field of a man's life" (quoted in Cremin, 1964, p. 199). Since education is preparation for adulthood, the educational task is to classify the full range of human experience with a view to building a curriculum to prepare for it. The process of analysis would attempt to uncover "the actual activities of mankind" (quoted in Cremin, 1964, p. 199). Bobbitt concluded that although most people have little use for drawing, they do need to exercise artistic judgment in choices of clothing and home furnishings. Bobbitt's critics were quick to point out that his approach defined the goals of education in terms of life as it is, with little emphasis upon life as it might be (Cremin, 1964).

Though the scientific movement was generally popular with educators, it does not appear to have had the impact upon the teaching of art that the child study movement had had at the turn of the century. The attempt to measure and predict student performance on the basis of tests tended to weaken the position of the arts in education, since art abilities did not appear to correlate with general intelligence. Like Thorndike's views on the transfer of training, the result appeared to strengthen the age-old belief that artistic aptitude was a special gift; and as long as it was seen as special, its place in general education was vulnerable.

The Expressive Ideology

In order to understand the origin of the creative self-expression movement, it is important to recall the intellectual climate in America in the years following the war. Malcolm Cowley's (1934/1951) vivid description of life in Greenwich Village during the 1920s describes prevailing beliefs of the era. Among these were "the idea of salvation by the child. — Each of us at birth

has special potentialities which are slowly crushed and destroyed by a standardized society and mechanical methods of teaching." Another was "the idea of self-expression. — Each man's, each woman's, purpose in life is to express himself, to realize his full individuality through creative work and beautiful living in beautiful surroundings." Still another was "the idea of liberty. — Every law, convention or rule of art that prevents self-expression should be shattered and abolished" (pp. 69–70). Puritanism is the great enemy. To Cowley's list of beliefs we could add "the doctrine of salvation through the arts, the intoxicating idea of artist-leaders who would unleash the true spiritual forces in American life" (Cremin, 1964, pp. 205–206).

INFLUENCE ON EDUCATORS. Expressionism pervaded all the arts of the time, as seen in the dance of Isadora Duncan and Martha Graham, the painting of Max Weber and John Marin, and the photography of Alfred Steiglitz — artists who expressed deeply felt truths about the world in new visual forms. Cremin finds that this expressionist credo was at work in Caroline Pratt's play school in Greenwich Village:

> She saw the children as artists, each with an intense desire to express and internalize what he had seen, heard, felt, each with his own personal perception of reality. An artist starts out with an idea, she once wrote, but he clarifies it through his method of dealing with it. "He is dominated by a desire to clarify his idea for *himself*. It is incidental to his purpose to clarify it for others." (1964, p. 205)

Writing from a sociological rather than a literary perspective, Ware (1935) advanced the view that the pedagogy of the progressive schools in Greenwich Village was a response to the changing character of the urban intellectual community, especially the increase in a well-educated, middle-class clientele.

Creative self-expression received its scientific sanction from Freudian psychology. Freudian theory postulates that the unconscious mind is the real source of human motivation. Accepting this view, educators believed that the real task of education was not to repress the child's emotions but to sublimate them into socially useful channels. Margaret Naumberg, who founded the Children's School, later called the Walden School, wrote that "all prohibitions that lead to nerve strain and repression are contrary to the most recent findings of biology, psychology and education. We have got to discover ways of redirecting and harnessing this vital force of childhood in constructive and creative work" (quoted in Cremin, 1964, pp. 210–211).

By applying the general principles of psychoanalytic psychology, Naumberg believed that "she could go beyond the constriction, the repres-

sion, and the misdirection of the group-minded mass methods of Horace Mann and John Dewey to a pedagogy that would preserve the vitality of each fresh crop of children entering the school" (Cremin, 1964, p. 212). Cremin notes that as far as Naumberg was concerned "one could do nothing with social groups as they then existed . . . but one could do something with individuals." Thus the school should not concentrate on social action but involve itself "in individual transformation" (p. 212).

THE CHILD-CENTERED SCHOOL. Harold Rugg and Ann Shumaker's book *The Child-Centered School* (1928) is probably the most widely quoted reference on creative self-expression as a school reform credo. The authors based their book on the program and philosophy of the Lincoln School at Teachers College, Columbia University, although the book surveyed progressive teaching practices in a variety of schools, including both the City and Country School and the Walden School. Its pages were liberally illustrated with children's art from Florence Cane's classes at the Walden School.

Rugg and Shumaker claimed Parker's and Dewey's turn-of-the-century efforts to be the antecedents of the child-centered school. Yet there is a fundamental difference between these authors' version of child-centered schooling and the schools described in *Schools of Tomorrow* (Dewey & Dewey, 1915). The Deweys saw the school as a learning community that stressed both individual growth and cooperative community living through group activities. They called for a school close to the life around it, one that prepared students to understand society, to live intelligently within it, and to change it to suit their vision of a better life (Cremin, 1964). By contrast, the child-centered school was more intent upon releasing the child from social and psychological forces believed to constrain personal growth. As we saw above, Naumberg had no use for social groups as the basis for instruction. For her the answer lay in the child's individual transformation (Cremin, 1964).

Cremin (1964) explains that "whereas the Deweys had seen the crux of progressive education in its connection with social reformism, Rugg and Shumaker found their insight in its tie with the historic battle of the artist against the superficiality and commercialism of industrial civilization" (p. 183). Cremin goes on to say that the key for them "was the triumph of self-expression, in education as well as in art" (p. 183). He also notes that Rugg was part of the Greenwich Village circle of artists and literati who clustered around Alfred Steiglitz "drinking the heady wine of bohemian protest against puritanism, Babbitry, and machine culture" (p. 182).

Rugg and Shumaker posited the artist as the model for the reform of education:

To comprehend the significance of the child-centered schools, one would need, indeed, to understand the attempts of the creative artist to break through the thick crust of imitation, superficiality, and commercialism which bound the arts almost throughout the first three centuries of industrialism. (1928, p. v.)

Rugg and Shumaker also declared that "the artist in Everyman's child is being discovered" and that the "lid of restraint is being lifted from the child of the common man in order that he may come to his own best self-fulfillment" (pp. 62–63). Yet if Ware's conclusion that progressive schools were patronized by the affluent middle class was correct, then their enthusiastic declaration was at variance with reality.

The Reconstructionist Ideology

The theme of social reconstruction was one that went back to the origins of the progressive movement, which had its roots in the political progressivism of the turn of the century. At that time progressive education was one of several reform movements that had attempted to improve the lot of the individual, and it grew out of the same soil that gave rise to populism in rural America, women's suffrage, and the settlement house movement. When Dewey was at the University of Chicago he was strongly influenced by Jane Addams, and Addams herself had much to say about educational reform. In *Democracy and Social Ethics* (1902/1964) she wrote: "We are impatient with the schools which lay all stress on reading and writing suspecting them to rest on the assumption that all knowledge and interest must be brought to the children through the medium of books" (p. 180). To remedy the situation the school would have to "cast itself in the world of affairs much as the settlement has done" (Cremin, 1964, p. 62). Dewey's Laboratory School organized its educational activities around the experiences of community living, reflecting this spirit of reform.

The group of progressive educators identified as reconstructionists, including George S. Counts and William H. Kilpatrick, reasserted many of Dewey's ideas from the 1890s. They believed education should "prepare individuals to take part intelligently in the management of conditions under which they live, to bring them to an understanding of the forces which are moving, to equip them with the intellectual and practical tools by which they can themselves enter into direction of these forces" (Kilpatrick, 1933, p. 71).

A radical expression of the reconstructionist theme was sounded by George S. Counts in his manifesto *Dare the School Build a New Social Order?* (1934/1978). He complained that progressive education "has as much aim as a baby shaking a rattle" (p. 6). He condemned it for having no theory of social welfare, unless it be that of anarchy or extreme individual-

ism. And he proceeded to attack the liberal sentiments of the upper middle class who sent their children to progressive schools, noting that they placed "an inordinate emphasis on the child and child interests" (p. 8). He continued:

> If Progressive education is to be genuinely progressive, it must emancipate itself from the influence of this class, face squarely and courageously every social issue, come to grips with life in all its stark reality, establish an organic relation with the community, develop a realistic and comprehensive theory of welfare. . . . In a word Progressive Education cannot place its trust in a child-centered school. (pp. 9–10)

TEACHING ART: THE EXPRESSIVE STREAM

The scientific study of the child had been under way since the 1880s, but heretofore no one had looked at children's art "as art." It was likened to the art of primitive savages, meaning that it was not art in the accepted Western sense. When artists began to discover that "primitive" art had aesthetic qualities worthy of serious consideration, child art also began to be taken seriously. Franz Cizek, a Viennese artist, was the first to claim that art made by children had intrinsic value.

Franz Cizek in Vienna, Marion Richardson in England, and their counterparts in the United States began to establish an art pedagogy based on the premise that children are artists and that their art, like all art, is inherently valuable. And yet it was a vulnerable art, one easily corrupted by adult influences. This newer pedagogy became known as free-expression. In the United States it was called creative self-expression. Rugg and Shumaker explained how the new art pedagogy differed from the old in their critique of Dow (see Chapter 6).

> Dow, in the elaboration of his theories, first published in 1899, approached art instruction not from the traditional standpoint of teaching children to draw, but from that of principles underlying art, the fundamentals of design applicable equally to abstract compositions, costume design, the decoration of the home, or the manufacture of a teacup. His object was to organize the work in art so that there would result "a steady growth in good judgment as to form, tone, and color through all grades from the kindergarten to the high school." (1928, p. 217)

They went on to explain that appreciation, rather than creative expression, was Dow's objective. By contrast, they declared that "we . . . are interested in the story of creative art in the school. We are concerned with the way

in which the protagonists of art use their materials in the development of self-expression" (Rugg & Shumaker, 1928, p. 217).

Rugg and Shumaker noted that the art education of the child-centered school did not come from the professors of art education such as Dow, but from "artist-teachers." Indeed, most self-expressive art teaching, as they described and advocated it, was by artists who were deeply imbued with the conviction that there is an affinity between the activity of the artist and the graphic expression of the child.

The Discovery of Child Art

We noted in Chapter 6 that G. Stanley Hall and others believed that if one wanted to understand the evolution of humanity one should study the development of the child. The growing child reenacted the drama of cultural evolution. Wilhelm Viola believed that the converse was also true, that "the best way to understand Child Art [was] to study primitive art" (Viola, 1936, p. 14). And as we have seen, child art was frequently likened to the art of primitive peoples. It was also a fact that avant-garde artists at the turn of the century began to admire the aesthetic qualities of primitive art. In their view primitive did not mean less civilized; rather, it was an expression of an art style in its early phases, a style with a potential for further development.

By contrast, many contemporary artists thought that Western representational art was a pictorial tradition in a state of decadence, approaching its end. Some art history textbooks had also begun to describe Western art as having been in decline since the end of the Renaissance. To the avant-garde, abstract and expressionist styles were attempts to establish a new aesthetic tradition with a potential for further development comparable to that they ascribed to primitive art. Macdonald (1970) noted that among the forms of primitive art that came to be recognized was the art of children. One of the first to posit the aesthetic attributes of child art was Franz Cizek.

FRANZ CIZEK. Born in 1865, Cizek entered the Vienna Academy of Fine Art at the age of 20. While an art student he became acquainted with a group of architects, designers, and painters involved with a movement known as the Vienna secession, the Viennese counterpart of art nouveau. Their architectural and decorative artforms were strongly influenced by the symbolic, antirealistic tendencies of Gustav Klimt, the most widely known member of this circle.

According to Viola (1936), Cizek made his momentous discovery about child art when he was a beginning art student. The children of the carpenter with whom he lodged came to his room and wanted to draw and paint. He

gave them paper and pencil, paints and brushes as they asked for them. The children, he observed, set to work producing most unusual things, but always of the same type, which startled Cizek, because he saw in their creations a likeness to a style of art that heretofore had been unnoticed. In addition, he observed the graffiti of children in the Vienna streets. Again, he noticed that there were many similarities in their work. He viewed this as an art that only the child could make and that should be admired for its own sake.

Cizek showed his friends in the secession group the child art he had collected, and among them the idea of a new art education based on child art took hold. Cizek was encouraged by the group to open a private art school for child art. At first he was refused permission by the educational authorities, but in 1897 he succeeded in obtaining permission. In 1904 the director of the Vienna School for Arts and Crafts (Kunstgewerbeschule) incorporated Cizek's juvenile class into his institution, where it remained until Cizek's retirement in 1938 at the age of 73. He continued to do some teaching until 1941 in spite of increasing blindness; he died in 1946.

Writing in 1936, Viola recalled that Cizek was strongly opposed by the conventional art teachers of his day, some of whom petitioned the Minister of Education to prevent this "corruption of youth." Nevertheless, Cizek's reputation spread to other countries. Viola, who had himself sought refuge in England during World War II, stated that Cizek was not appreciated in his own country, that without the support of England and America, the juvenile art class would probably no longer exist.

However, recollections of Cizek's students do suggest that he also enjoyed a local reputation. In 1981, Mimi Fraenkl recalled that during 1918–1919 or 1919–1920 she made a cut-paper illustration under the guidance of Leopoldine Seidl, an assistant to Cizek. Seidl taught art at the College Lyceum and combined Cizek's method with her own, which included drawing from nature and perspective. Though Fraenkl did not attend the juvenile art class, she was indirectly exposed to its influence. The fact that Seidl's reputation as a teacher of art was based on her work with Cizek suggests that Cizek had local recognition. In 1924 Fraenkl also became a student of Cizek at the Kunstgewerbeschule, taking his decoration course.[2]

CIZEK'S METHODS. Cizek has been compared to Rousseau in his insistence on avoiding all adult influence, but in some sense Cizek was more extreme. Rousseau recognized some need for adult guidance, while Cizek's class was not taught at all in the usual sense of teaching. Francesca Wilson, who did much to spread Cizek's ideas in Britain, produced a series of handbooks on Cizek's methods, and what they described led one reviewer to conclude that "there was no insistence on technique, no ordered method of

study. . . . Method, material, subject, purpose, all these are left to the child's free choice" (quoted in Macdonald, 1970, p. 345).

In spite of his hands-off philosophy, a number of English and American writers pointed to what Macdonald termed a paradox in Cizek's method. Cizek would tell observers that his method consisted of "taking the lid off," while most teachers clamped the lid on. Yet he also insisted that "a teacher must give his pupils strictly correct ideas, if they are to get a solid basis for their work" (quoted in Macdonald, 1970, p. 346). Cizek sometimes did allow his pupils to use sophisticated adult concepts, provided that they brought out the decorative qualities he considered most suitable for child art. But he did not introduce children to those adult concepts that he thought unsuitable for them, such as realistic color schemes. He knew what child art was supposed to look like, and he knew how to get children to produce it!

After reading Cizek's philosophy and looking at the images of child art, we can agree with Macdonald's (1970) description of Cizek's child art:

> Far from being free and fluent with the bold, delightfully crude, and imaginative touches found in free child art, the work illustrated is extremely sophisticated, extremely competent, and very much influenced by adult folk art and illustrations done for children's tales by adults. Many of the works, notably the patterns of the complicated woodcuts and papercuts, require very careful measuring and working out. (pp. 344–345)

The student cut-paper work from the 1920s shown in Figure 7.1 exemplifies Macdonald's conclusion. Yet in Francesca Wilson's view "the technique of so many of these pictures is so marvelous for such young children" (quoted in Macdonald, 1970, p. 345). Macdonald concludes that Wilson and Wilhelm Viola "were so carried away by Cizek's philosophy of self-activity and free expression that they blinded themselves to the firm methods he used with his pupils" (p. 345). Indeed, when one reads Viola's shorthand transcripts of Cizek's lessons in *Child Art* (1946), one is struck by the highly directive nature of his teaching.[3]

It is apparent that Cizek's art lessons were not as free as Viola and Wilson believed, and we might well raise the question of whether he deserves to be called the father of free-expression. Yet it would be wrong to deny Cizek his due, for *freedom* is a relative term, and compared to the standards of his day in the Viennese schools, his was a comparatively free pedagogy.

The Artist-Teacher

From the 1920s through the 1940s a number of individual artist-teachers were developing creative self-expression as a method. Most of these

FIGURE 7.1.
"Fruit and its Decorative
Arrangement" (Plate 4),
from Franz Cizek,
*Children's Cut Paper
Work* (Vienna: Anton
Schroll Co., 1927).

teachers were employed by private progressive schools, though in a few instances they taught in public schools. Rarely did they teach in colleges except on an occasional or part-time basis. All in their own ways contributed to this pedagogy, often succeeding in putting into practice the noninterventionist teaching philosophy first enunciated by Cizek. This group included Marion Richardson, Florence Cane, Natalie Cole, and Victor D'Amico, all of whom will be discussed below. Each expressed the belief that the child is an artist with an innate desire for expression and that this natural expression is thwarted by formal teaching methods more appropriate for adults. They also asserted that art teaching is best done by highly sensitive individuals who are artists themselves. Peppino Mangravite (1932), yet another member of this group, expressed this view very well:

> I believe that it is absolutely impossible for anyone who is not an artist to succeed in teaching art. The made-to-order teacher of art depends upon standardized methods rather than his own sensibilities. No one but an artist has the delicate intuition to sense what another person is trying to express. (1932, p. 33)

Like Cizek, he believed that children have true creative vision but that this vision is destroyed by children's illustrated books and by exposure to art in museums. Yet each of these teachers influenced children in specific ways,

as can be seen in the stylistic similarity of work done by the pupils of a given teacher. While each teacher freed children from the art taught in conventional schools, all influenced their pupils' work with their own preferences and biases.

MARION RICHARDSON. In her autobiographical account Richardson (1946) described growing up in a large, poor family. A scholarship student at the Birmingham (England) School of Art, in her senior year she studied with the school's headmaster, Catterson Smith. Smith impressed upon her the ideas that one should rely on one's visual powers rather than skill of hand and that one should never begin a drawing until one has a clear image of the subject. Smith would show lantern slides to his students for a few moments, after which the image would be withdrawn. Richardson described the process further:

> We closed our eyes and, keeping them closed, quickly outlined the picture. This "shut-eye" drawing was perhaps Mr. Catterson Smith's greatest contribution to art education. It was a wonderful means of clarifying and impressing the image and of keeping it before us while we set to work with open eyes. (1946, p. 12)

This technique of developing strong mental images of the subject prior to drawing or painting passed over into her own teaching. Using vivid language she would describe landscapes, skies, a green-grocery store, the Russian ballet, or people riding in railway carriages. The children were asked to visualize these in their own way. Many of the pictures were of the town of Dudley, England, where she taught in the high school, and once the children began to use the technique on their own, they brought to school pictures they had made at home.

> As I have said, I knew that the children did their best work when painting from a mental image; this was for most both rich and fertile, but some were unable to select from a shifting, kaleidoscopic inward store. I was myself a natural visualizer and found that the children were interested in descriptions of my own imagery; that as I talked something passed between us, and that whatever possessed for me the genuine picture quality had a sort of incandescence which I could communicate. (1946, pp. 14–15)

FLORENCE CANE. In many ways Florence Cane's work is reminiscent of Richardson's, but having children make creative art was not her only reason for teaching art. She viewed artistic expression as important because it contributed to psychological development. This was a theme that was to be developed further in the late 1940s in the teaching of Viktor Lowenfeld, but as early as 1932 Cane wrote:

The quality of the painting inevitably develops if the child develops as an individual, and equally the child grows with his growth as a painter. Therefore, the direction of my teaching has been toward the liberation and growth of the child's soul through play and work and self-discipline involved in painting. (1932, p. 42)

Cane was the painting teacher at the Walden School in New York City and her sister, Margaret Naumberg, was director of the school. Both were deeply influenced by Freudian ideas about repression and the ways it can lead to neurotic behavior. Cane briefly described her method in the following way:

I begin by giving the child carefully chosen materials, materials that respond well. The crayons must be soft enough to mark easily, not to require pressure, and yet not so soft they will smudge. Paper must be good enough in quality to take the strokes well and hold them. . . . Watercolors must be moist in order to respond. Brushes must be large to keep the work free. (1932, p. 44)

Next she attended to the free use of the body. Children should stand well, so that they may sway easily from one foot to another: "One should be able to dramatize a gesture, as a dancer or an actor would" (1932, p. 45). She explained that having given the child his materials, that she trusts him "to do what he wants and let him continue to draw or paint as long as his interest lasts" (1932, p. 45).

For children older than age 10, her plan changed. The children would leave the classroom and come to her in the studio. Their work "is more differentiated now and is being carried beyond mere spontaneous impulse" (1932, p. 45). At this point she introduced more elaborate materials, such as oil paints, colored inks, linoleum, wood blocks, or clay. She also conducted activities involving the practical arts. She insisted that she never suggested subjects, that these were always the children's choice, that their interest began to flag if the subject was "not really dear to them" (1932, p. 46). Cane published her definitive statement on her teaching philosophy at a much later point in her career, in *The Artist in Each of Us* (1951).

Illustrations of Cane's students' work can be found in issues of *Progressive Education*, to which she was a frequent contributor, in Rugg and Shumaker's *The Child-Centered School* (1928), and in Hartman and Shumaker's *Creative Expression* (1932/1972). Though her children were free to choose their own subjects, one does sense a pervasive stylistic similarity in the work of her Walden students. In contrast to Richardson's students, whose work showed a preference for local color, Cane's students' work was marked by a preference for themes bordering on fantasy and the supernatural.

NATALIE COLE. Cole's career was somewhat unusual in that her pupils were mostly poor children of Mexican, Japanese, and Chinese ancestry, not upper-middle-class children attending the kind of private progressive schools disparaged by Counts (see above). And her 1940 book, *The Arts in the Classroom*, was a widely used textbook.

Cole believed it was necessary to motivate children through discussion and build-up: "The child must have his mind and emotions aroused about something and want to paint before he can paint well" (1940, pp. 3–4). Unlike Cane, who tended toward individual conversations with each child, Cole tended toward group discussions. She based the theme of her lessons on their actual experiences—a school trip to a macaroni factory, say, or lunch in the school cafeteria: "When the child is full of ideas, his picture will spill out somehow. The teacher's job is to help keep it coming by giving praise and encouragement" (1940, p. 5). Teachers should not show children what to do: "The moment a teacher draws on the board or paints on paper, that moment is the child crippled and inhibited" (1940, p. 9). Indeed, she re-marked: "Children have genius—yes. But the teacher must dig to get at it. Gold is seldom found for the idle taking" (1940, p. 10).

She attempted to elicit certain qualities in children's painting. Cole believed that the paintings should be big—"This is the way children work naturally"—and she encouraged children to make the image "bump the sides" of the paper: "Don't let us see any little stingy, 'fraidy cat' pictures. Make your picture fill your paper till it bumps the sides" (1940, p. 12). She justified having the children begin to paint by using outlines: "I believe that beginning with an outline makes painting easy for the teacher as well as the child. . . . This is a way of limiting the child to free the child. Children accept this way of doing and are quick to realize that it is fair and wise" (1940, p. 13). Once again, we are struck by the stylistic similarity of the imagery her children produced under her influence.

VICTOR D'AMICO. Throughout the 1930s and 1940s, Victor D'Amico's teaching and writing were major influences in the field of art education. He began his career as art teacher and later head of the Fine Arts Department of the Ethical Culture School in New York. Later he became the director of the Department of Education and Peoples Art Center of the Museum of Modern Art and served as a part-time instructor at Teachers College, Columbia. He was the designer and organizer of the American art education exhibit at the Brussels International Exposition in 1960, and in later life he taught art in East Hampton, Long Island. His *Creative Teaching in Art* (1942/1953) went through seven printings. D'Amico accepted the premise that the child is a creator, but he felt it was wrong to compare the child with the artist.

Perhaps now more than ever the distinction between the creative child and the professional artist should be clearly drawn. If the child is like the artist, the similarity is in his awareness of design for its own sake and his ability to subordinate subject matter and the story element to the elements of form, line, and color. (1942/1953, p. 1)

D'Amico's method of art teaching had two aspects to it. The first was to help children recognize their own experiences, such as family life, travel, and holidays, as sources of inspiration. The second was to help make the child conscious of art values. While the young child uses line and color almost intuitively, the adolescent thinks of these as factors or means of producing an idea in visual form. As adolescents become conscious of technique, they can be taught what they need to know, but the teacher should relate this instruction to the needs and interests of the child. Too much teaching or teaching about techniques where there is no felt need would confuse children.

D'Amico divided his text into chapters on such media as painting, sculpture, pottery, the graphic arts, collage, and design. Indeed, his text was one of the first to introduce collage into the schools. What appealed to prospective art teachers was its emphasis on the practical problems of teaching in the studio, its attention to technique that was lacking in the writings of artist-teachers who dwelt almost entirely on motivation and encouragement.

TEACHING ART: THE RECONSTRUCTIONIST STREAM

In this section we look at the influence of reconstructionist thought on art education. Reconstructionist thought derives from Dewey's concept of experience as the stuff that brings about the reconstruction of knowledge and, ultimately, social institutions as well. Dewey also discussed "art as experience," and seen in this light artistic encounters can serve to reconstruct knowledge as well. Art in this sense is more than personal expression; it is also a means for transforming individual life and society.

Others saw art as a resource with which to solve problems of daily living in the home, school, or community. Appreciation in this sense was the recognition of its power to solve problems. In this view the contemplation of masterpieces in all their remoteness and grandeur has little place. The emphasis is away from art in its isolation from life, toward art as an integral part of human activity. Art history shows how art was linked to worship, statecraft, and manufacture as well as personal expression; since it is thus an integral part of life, to the reconstructionists it made sense to integrate it into

the rest of the curriculum. Art was not to be taught in isolation from other studies.

This change from an emphasis on self-expression to the study of art in society was partly a result of the economic stress of the Great Depression. Though the psychological adjustment of the child was considered important, the survival of society itself was also a priority.

Art Education During the Great Depression

Just prior to the 1929 crash, Royal Bailey Farnum could make the following optimistic prediction about the future of art education:

> Art education in the United States has never been on a firmer footing than at the present time. It faces a future secure in the knowledge that during the past ten years its social, economic and educational values have been demonstrated and acknowledged and generally put into practice. (1932, p. 297)

He concluded by saying that "the stage is set for more powerful and effective work with greatly enriched returns in the next decade, even in the next two years" (p. 322). Fate had written a different script for the institutions and people involved in teaching the arts. The crash of 1929 plunged the country into the deepest economic depression in its history. It occurred during the Hoover administration, and though corrective economic measures were invoked, it was not until Roosevelt's New Deal that a semblance of national confidence was restored. Although signs of recovery were in evidence by Roosevelt's second term, the Great Depression spanned the entire decade.

More than 2,280,000 children were unable to attend schools because they were closed, mainly in rural parts of the country, where 2,000 schools in 24 states failed to open in 1933. Many cities and states shortened the length of their school terms; teacher salaries were repeatedly cut until they reached levels earned by unskilled laborers. In 1933 the average teacher was paid $750 per year, with some black teachers in the rural South earning less than $100 per year. Salaries were somewhat better in urban centers, but there was a steady decline from the highs of 1929, when teachers at the maximum were earning $3,000 per year; in 1934, maximum annual earnings had fallen to $2,000.

As salaries were falling, the number of secondary school students was dramatically rising, especially in the cities. The National Relief Administration rigorously enforced the child-labor laws to keep teenaged youth out of the job market; hence, they remained in schools in unprecedented numbers. The high school truly became the secondary school for all the people instead

of for those few preparing for college. With more students enrolled and less money available, it was not uncommon to find 40 to 50 students crowded into a classroom.

In a U.S. Office of Education survey conducted in 1933, 700 typical cities were asked to report on the effects of the Depression on music, art, physical education, and industrial arts. Thirty-five cities reported having eliminated art programs entirely, while 67 had reduced art instruction. Thus a total of 14.6% of the school districts surveyed either eliminated or reduced their art programs. We do not know how many of the schools in the 700 cities had previously taught art on a regular basis, however, and this may affect the data—districts that did not teach art to begin with could not register a curtailment as a consequence of the Depression, even if it forced them to cancel plans to implement new programs.

A parallel survey conducted by the Music Educators National Conference (1934) produced similar results, namely that most school districts did not eliminate their music and art programs, though some programs were curtailed. One exception was instrumental music, where programs were drastically reduced. Together these reports show that the Depression did not bring about the drastic elimination of art or music programs that some educational historians, such as Connell (1980), have suggested. Rather, it is more accurate to say that there were curtailments in such programs, and, in some cases, serious reductions in the number of special teachers or supervisors of music and art. These arts were affected along with the whole of general education.

CHARACTERISTICS. If liberation from puritanical repression was the concern of the 1920s, the reform of society preoccupied the 1930s. In Harold Benjamin's introduction to Leon Winslow's *The Integrated School Art Program* we see the reconstructionist view in art education clearly articulated.

> Activities that have become divorced from community life and purposes are perhaps suitable or even indispensable for a school purporting to give a timeless culture for its own sake, but they are unsuitable for a school as a living community.
>
> Art as a cult, as an esoteric experience for privileged devotees, may be the art that is needed in a school of the first type. Art as a service to men living a common life, art as a means of attaining community goals, is certainly needed in the modern school. (in Winslow, 1939, p. viii)

Art as a means of solving the everyday problems of living replaced the pursuit of beauty for its own sake, an attitude appropriate to an age that

celebrated the common man. To be sure, Dow and Sargent in the previous generation had also supported the teaching of utility in crafts and manual training, but the overall emphasis at that time had been on teaching the principles of beauty for their own sake. Now the emphasis turned to the problems of daily life, an idea expressed by Melvin Haggerty in *Art, a Way of Life* (1935):

> Art as a cult may be a hindrance rather than an aid to art as a way of life, and it clearly seems to be so in many cases. The teacher's art must be that of the broad and crowded avenues of life, the home, the factory, and the market place. It is this conception that must be clarified and dramatized in concrete ways, if art is to take its place in the schools as a major and vital instrument of cultural education. (p. 43)

A second prevailing characteristic of reconstructionist art education was the emphasis on the integration of subject matter. A unit of instruction should be broader than a single subject. It should consist of many subjects carefully balanced with each other to produce a richer learning environment. The art teacher would be expected to relate instruction in art to such fields as history, geography, social studies, language arts, science, mathematics, and the industrial arts. The trend was toward a unified school experience and away from traditional subject-matter boundaries. Teachers would plan instruction in concert with other teachers in an attempt to break down the boundaries that had fragmented the curriculum. "In such an educational program," Winslow explained, "art must be made to function broadly as an integral part, the creative-appreciative part, of the elementary and secondary school curriculums" (1939, p. 33).

A third characteristic was an emphasis on community. The community beyond the school was seen as an appropriate arena for action. A dramatic example of this emphasis is seen in the five-year art education project in Owatonna, Minnesota, between 1933 and 1938.

THE OWATONNA ART EDUCATION PROJECT. In his account of the Owatonna art education project, Ziegfeld (1944) recalled that the idea for the project began in 1931 when, in a speech before a group of art teachers in Minneapolis, Melvin Haggerty raised the following questions:

> What can teachers of the fine arts do to prepare young people against the day of threatening boredom, depleting play activities, the grinding monotony of a machine-made day? Is the program of art instruction in the school geared to elevate community taste in all those matters that make up the visual aspects of American life? Is the major task of art instruction in the schools to be the

specialized training of the few or the cultivation of taste in all? (quoted in Ziegfeld, 1944, p. 4)

The project was to be carried out in a typical American community. The definition of a typical community was one whose population was between 5,000 and 8,000, with no dominant racial, religious, or economic group. Communities having a single industry or a college were not deemed typical. It also had to be a community that had no art program in its public schools.

There were three phases to the project. The first was to survey the community to determine what role art played within it and where the emphasis in the curriculum should be placed. The second was to develop a course of study in art for the schools. The third dealt with the possibilities of art in the daily life of the community (Ziegfeld, 1944, pp. 4-6).

OWATONNA'S SCHOOL ART PROGRAM. During the first year elementary classroom teachers taught art under the supervision of Ziegfeld and the rest of the project staff. These were free creative activities such as illustration, modeling, and construction work. The teachers were shown how these activities could be related to other school subjects. By the fall of the second year the project staff had some of the results of the community study, and this enabled them to devise a new approach to the teaching of art:

> They had discovered that although art permeates all the areas of living, it becomes most significant and most meaningful when it touches those areas in which people carry on the greater part of their daily activities—in other words, when it is intimately connected with everyday experience. Therefore if art is to become a usable medium of expression it must be taught in relation to the fundamental areas of living. For example: To everyone, young or old, one's own self and one's personal problems constitute the most important area of experience. Next comes one's home, as the results of the community study so unexceptionally revealed. Next, for children, comes the school, and after that the community as a whole. (Ziegfeld, 1944, p. 62)

Ziegfeld felt that the subject matter should somehow be organized into these areas, but in addition he identified nine broad divisions of subjects within the curriculum. These included art in commerce, industry, printing, recreation, basic design principles, and color to help students make intelligent judgments and gain a large view of the field of art. During the second year of the program the following project objectives were identified:

To develop a well-adjusted integrated personality

To experience creative activity in various art fields, using various tool and media

To develop an awareness and an appreciation of art in the environment

To develop the ability to solve everyday art problems

To become increasingly interested in improving the environment through the thoughtful solving of art problems

To become increasingly sensitive to differences of merit in art products

To acquire such knowledge as will aid in appreciating art objects or in solving art problems

To develop progressive, open-minded attitudes toward art

To develop resourcefulness in leisure-time pursuits and hobbies

To have an opportunity to develop unusual talent

A broad range of activities was pursued, including drawing, painting, and sketching. Students had opportunities to learn about the expressive use of color, form, and the elements of design. Teachers used art to illustrate content in other subjects, such as history, literature, and geography. A large portion of class activities were related to art problems in the environment. Students designed houses or made models of them; they planned interiors and landscaping. They decorated windows for local shops, designed labels for products of the local cannery, and worked on projects dealing with industrial design. Art was also used in service projects within the school as it became increasingly involved in the teaching of other subjects.

IMPACT OF THE PROJECT. On October 7, 1937, Haggerty died suddenly, and Ziegfeld was asked to become the project's director for its remaining year. Haggerty and the project staff did not propose to evaluate the project by amassing statistical evidence to measure their success. Ziegfeld's report cited a number of indicators that the five-year project had succeeded. The first was the fact that the Owatonna public schools continued to support the art program after the Carnegie funds were discontinued. The foundation provided funds to publish the final report and course syllabi, some of which were printed during World War II. Other indicators were the large number of requests received by the project staff for speakers on art subjects and establishment of night classes. The head librarian for the town indicated that the circulation of art books increased. Direct appraisal from the residents of the town also indicated that the project was highly regarded.

In 1938 the Owatonna high school curriculum was introduced into University High School in Minneapolis, where it was taught by a former member of the project staff. Word of the project was disseminated in numerous speaking engagements by Haggerty and the project staff, not to mention a number of project publications printed by the University of Minnesota Press. Most significantly, Haggerty's work led to the preparation of the first National Society for the Study of Education yearbook devoted to

art education, *Art in American Life and Education* (NSSE, 1941). Haggerty was to have been the editor of this landmark document, but upon his death that task was undertaken by Thomas Munro. (This yearbook is discussed in some detail below.) The basic principles underlying the project survived in *Art Today* by Faulkner, Ziegfeld, and Hill (1941), a major textbook that went through four editions between 1941 and 1987.

Integration of Art With Other Studies

Leon Winslow's *The Integrated School Art Program* (1939) synthesized many of the leading educational innovations used to define progressive education. It strongly advocated creative expression but also maintained that art should be taught for broad cultural purposes, that in this capacity it can function as an important integrating agent in the curriculum. Winslow believed that aesthetic growth both enlarged children's social outlook and enriched their lives.

His curriculum model was based on balance between general information and technical information. He perceived general information as derived from all the subjects of the curriculum, such as geography, history, language, science, arithmetic, health, and music. Proper teaching, in his view, builds on these general subjects, because they are the sources of the problems or issues that are the subjects of art or purposes for which works of art are made. The technical side of the curriculum, derived from art itself, has to do with such art techniques and aesthetic considerations as form, line, mass, color, design, representation, lettering, fitness, medium, and harmony.

Winslow also believed in a balance between directed and creative activities. Directed activities are those that involve control, dictation, tracing, copying, criticism, drill, reading, demonstrating, and suggestions from the teacher. Creative activities involve freedom, originality, experiment, imagination, inspiration, emotion, expression, and appreciation. In creative activities the teacher may help the children recall their experiences by having them talk about objects and episodes that have interested them most, while in directed experience the teacher calls attention to specific problems to be solved artistically.

THE INDUSTRIAL ARTS PROGRAM AT THE FIELDSTON SCHOOL. From the days of the school's founding in 1878 by Felix Adler, the Fieldston School in New York City had a strong social orientation, reflecting its connection to the Ethical Culture Society, which Adler had also founded. In theory the curriculum was not developed in isolation from the larger social setting. Art was taught in conjunction with other subjects. The industrial arts teacher planned his or her program in concert with other staff of the

school, and the activities were designed to correlate with topics being covered in other branches of study. If a third-grade class was studying Indian life of the eastern woodlands, art activities would be based on the ways that utilitarian objects could be made from the local materials in the environment. The children would study the objects known to have been made by the local Indian cultures and work on similar objects, such as moccasins, articles of clothing, ceremonial objects, and the like. Children studying the life of the first white settlers would learn how to weave and dye cloth from wool, make soap, candles, and tools with wood, etc.

CRITICISM OF INTEGRATED PROGRAMS. Journals such as *Art Education Today*, which began publication in the 1930s, looked with favor upon integrated art programs. In the years after World War II, criticism of integrated school arts programs began to mount. Generally, the feeling grew that art had become the servant of other studies, that it was not valued as important in its own right. A second criticism was that the method could work only with extremely capable teachers well versed in all the subjects of the curriculum or in an environment in which teachers could pool their special knowledge via team teaching. Public schools rarely had the kind of administrative flexibility to permit such planning.

STATUS OF ART TEACHING IN THE SCHOOLS

Earlier we described the expressive and reconstructionist streams of influence as having had an impact upon the teaching of art in the public schools. In the school reports of the 1930s one can detect a shift in the language from a concern with art appreciation as a study of masterpieces to a concern with art in daily living. For example, in 1927 the elementary art program in Cleveland, Ohio, was described in the following way:

> Art, like music, is taught with an eye to its appreciation values. Observation and experience show that he who has tried to create beauty gains from the experience a livelier appreciation of the works of others. For this reason drawing is generally taught throughout the school system. Drawing exercises afford a means of expression for those children who need it, and many of these have been found to possess genuine creative talent. (Cleveland Board of Education, 1928, p. 113)

By the middle 1930s the language describing art education programs was beginning to change. The reports discussed social adjustment and the development of desirable personality traits as goals of art education. The language of creative self-expression had found its way into public schools.

The many many beautiful results of child expression are not secured through the medium of criticism, or through dictated lessons, but are the result of sympathetic understanding and judgment on the part of the teacher. The wise teacher will seek to encourage the elements of originality, initiative and creative expression so evident in young children. Any attempt to impose adult standards at this level is destructive of the child's growth. (Cleveland Board of Education, 1936, p. 39)

Art Supervision in the Schools

Throughout the 1920s and 1930s the larger cities in the nation employed art supervisors to oversee elementary art instruction. These supervisors usually did not teach art but rather provided guidance to regular classroom teachers. Elementary art teachers were rare, found in a few suburban communities along the eastern seaboard and in private schools (Farnum, 1932). Most elementary school children were taught by classroom teachers using the suggestions of the art supervisor. These art supervisors were extremely important in keeping art alive in the schools during the Depression era, since school districts were more likely to retain a single supervisory position than an entire cadre of specialized teachers in the effort to keep the subject in the curriculum.

In 1929 William Whitford, a professor of art education at the University of Chicago, suggested that the art curriculum should cover four categories: drawing, to provide the graphic experience; design, for the ornamental experience; construction, a motor-constructive experience; and appreciation, the mental experience. Looking back to the 1930s, Barkan (1962) said that the media used to teach art were largely limited to hard pencils, paper in small sizes, crayons, india ink, transparent watercolors, and vine charcoal for advanced students. His list suggests that the curriculum of the period was largely two dimensional, so that Whitford's prescription seems not to have been adopted. Judging by the activities pictured in *School Arts Magazine*, three-dimensional constructive activities were usually limited to pasteboard or tagboard. These activities were often correlated with the social studies. Throughout the interwar period, the art deco style influenced the design activities in this journal, replacing the arts-and-crafts style of the era preceding World War I (see Figures 7.2 and 7.3).

Art in Junior and Senior High Schools

After World War I the eight-grade grammar school began to be supplanted by the junior high school, which was organized by subject matter departments. The departmentalization of the curriculum created many op-

Students will enthuse in planning new store front ideas
selecting as subjects home town shops and store fronts

An excellent classroom problem to stimulate interest in
civic beauty is the designing of attractive store fronts.

FIGURE 7.2. Storefront design activity showing the Art Deco influence, from *School Arts* (1938), *37* (10), 319. Reproduced by permission.

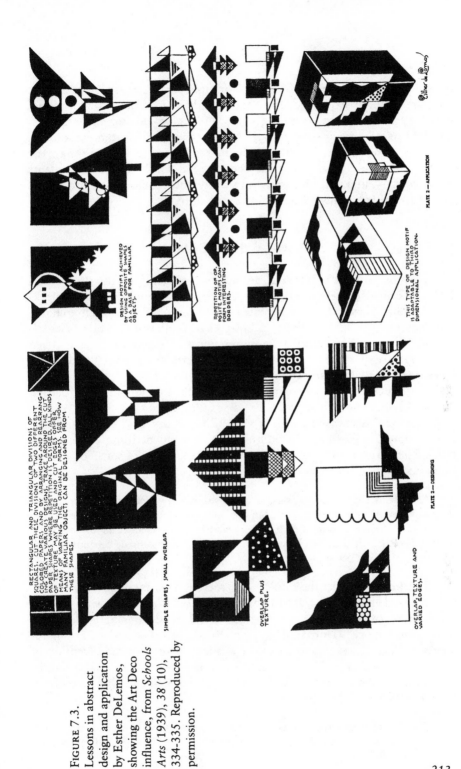

FIGURE 7.3.
Lessons in abstract design and application by Esther DeLemos, showing the Art Deco influence, from *Schools Arts* (1939), 38 (10), 334-335. Reproduced by permission.

213

portunities for art teaching positions. Throughout the 1930s high school art programs actually expanded, since most students remained in high school until they graduated. In previous decades students would quit high school to take jobs in industry as soon as they could legally terminate their schooling, but since there were no jobs they remained in school (Efland, 1983a). For the first time the high school was a secondary school for almost all students in the country, and with this growth in attendance, there were more people taking art courses in high school than ever before.

THE BAUHAUS IN GERMANY

To most American art and architecture students of the 1920s and 1930s, German contemporary art meant the expressionism of Max Beckmann, Franz Marck, Ludwig Kirchner, and Emil Nolde. German architecture was the streamlined Einstein Tower by Mendelsohn, while Wienes's *Cabinet of Dr. Caligari* carried the expressionist style into the cinema. Given the prevalence of expressionist tendencies in German art after World War I, it is surprising that the art school known as the Bauhaus was to become "the one school in the world where modern problems of design were approached realistically in a modern atmosphere" (Barr, 1959, p. 5).

The Bauhaus was founded in 1919 in the city of Weimar. German artistic opinion, like German politics, was then divided into extreme factions. There were those who saw "in every novelty a sign of some ideological program" (p. 9). Dorner noted that:

> As early as 1919 there was talk of "art-Bolshevism, which must be wiped out" and even then there were appeals to the "national German spirit" of artists who were to "rescue mature art." It was a feverish and tormented nation that drew such drastic distinctions between the old and new and made peaceful growth impossible. (1959, p. 9)

The first to protest the founding of the Bauhaus were the adherents of the old academies of art, an art that carried on "the tradition of eclectic architecture, of monuments and portraits in the grand manner, the depiction of historical glory" (Dorner, 1959, pp. 9–10). All the modern art movements in Europe were opposed to the academy, but with the exception of this opposition they had little else in common. Expressionism and dadaism, the two dominant movements in Germany, were described as holdovers from the romanticism of the past century.

> The tide of Romanticism was rising to a new height in this post-war period. Called Expressionism, it was still the same Romanticism which for a century

had been haunting individualism in its struggle against academic traditions. The purpose of that struggle had been to enrich art and extend its horizons. But, because it had taken place isolated from life and its practical demands, the creative geniuses of the 19th century and early 20th had to make their way in solitude. (Dorner, 1959, p. 10)

Dorner's historical sketch tends to create the impression that the Bauhaus was primarily an attempt to put the training of artists, craftspersons, and designers on a rational footing that would free them from the moribund legacy of the academy and, at the same time, would free artists from the excesses of the dadaist and expressionist tendencies of the period. Marcel Franciscono's (1971) history of the early years of the Bauhaus presents us with a different picture. In his view the Bauhaus faculty harbored many conflicting ideological and stylistic tendencies, of which the rational approach to industrial design, for which it is chiefly remembered, was only one.

There were a number of antecedents to the program for which the Bauhaus is known. In 1907 Hermann Muthesius had founded the Deutsche Werkbund. Though inspired by William Morris and England's arts-and-crafts movement, Muthesius sought a synthesis between the "machine style" and the "craftsman's culture" of Morris, but the Werkbund was not successful in assimilating "the spirit of engineering into art" (Dorner, 1959, p. 11), a fusion that successfully took place in the latter years of the Bauhaus.

The Bauhaus sought to combine the theoretical curriculum of an art academy with the practical curriculum of an arts-and-crafts school in its attempt to unify all training in art and design. The ultimate goal was the collective work of art, "the Building—in which no barriers exist between the structural and the decorative arts" (Dorner, 1959, p. 23).

Curriculum and Methods

Its curriculum was divided into two phases. The first involved the crafts (*Werklehere*), which included workshop instruction in such areas as sculpture, carpentry, metal, pottery, stained glass, wall painting, and weaving. The second involved instruction in form problems (*Formlehere*), which involved observation, study of nature, and analysis of materials. A second group of form problems, including descriptive geometry, construction techniques, the drawing of plans, and the building of models, was dedicated to representation. A third group of form problems dealt with the theory of space, color, and design.

By far the most influential course was known as the "foundation course" (*Vorkurs*). Students were initially admitted for a trial period of six

months, during which time they took this course, which was designed to liberate "the student's creative power, to give him an understanding of nature's materials, and to acquaint him with the basic materials which underlie all creative activity in the visual arts" (Dorner, 1959, p. 34). Based on performance in this course, the faculty could decide whether the student had sufficient ability for the program. Students made detailed studies of nature and natural materials by drawing natural forms, followed by exercises in which they made compositions from commonplace materials to develop the sense of touch and a subjective feeling for materials. Other exercises would entail the drawing of contrasting materials.

Upon completion of the preliminary course, the students were tentatively admitted into one of the workshops, where they worked with one material only. After a second six-month trial period the successful student was admitted to the workshop as an apprentice. After serving a three-year apprenticeship, the student was eligible to take the journeyman's examination.

According to Franciscono (1971), the preliminary course was not part of the original program of the Bauhaus but was established to provide students with a common ground of experience. The initial version of the course was designed by Johannes Itten, who was invited by Walter Gropius to come to Weimar in 1919. Recalling his Viennese teaching days, Itten wrote:

> We worked on geometric and rhythmic forms, problems of proportion and expressive pictorial composition. Assignments with textures and subjective forms were something new. Besides the study of polar contrasts, exercises for the relaxation and concentration of students brought amazing successes. I recognized creative automatism as one of the most important factors in art. (1964, p. 8)

Franciscono noted the similarity between Itten's methods and those used by Cizek at the Vienna Kunstgewerbeschule. Like Cizek, Itten had taught art to children. In both cases, their pedagogical approach to adults was to free the creative powers of students by encouraging them to rely on their own experiences and self-discoveries.

> My teaching was designed to guide the student in acquiring the means of artistic expression by appealing to his individual talents and to develop an atmosphere of creativity in which original work became possible. Each student was expected to realize "himself," his original works had to be "genuine." (Itten, 1965, p. 105)

Itten began each instructional period with "exercises in relaxation, breathing, and concentration to achieve a state of spiritual and physical readiness which is conducive to intensive work" (1965, p. 105). He also provided advice on diet and health so that the student would be able to train

"the body as an instrument of the spirit" (p. 105), which he regarded as essential to the creative artist. The exercises concerning the means of artistic expression were presented as a series of visual contrasts.

> Forms and colors were presented in any number of polar contrasts. These contrasts can be presented as intellectual concepts: big-small, long-short, wide-narrow, thick-thin, light-dark, straight-curved, pointed-blunt, much-little, hard-soft, smooth-rough, light-heavy, transparent-opaque, steady-intermittent; there are also the seven color contrasts and the four directions in space. The students had to present these various contrasts, separately and in combinations, in a manner that allowed our senses to perceive them convincingly. I explained three different approaches to form and color: as qualities and quantities that can be recognized by our senses, grasped intellectually, and felt emotionally. (Itten, 1965, p. 105)

This exploration of polar contrasts was for the purpose of heightening the student's awareness of the expressive power of the design elements. This was a radical departure from the teachings of Crane, Dow, and Ross in that they approached design as a search for universal harmony. Itten's was a search for expressive power.

Itten's tenure at the Bauhaus was marked by tension between himself and Gropius. Gropius tended to favor a more rational, technological form of art education, while Itten's approach was expressionistic in character and placed a high premium upon individuality and idiosyncratic production. In 1922 he resigned from the Bauhaus, and the preliminary course was then assumed by Lazlo Moholy-Nagy and Josef Albers. Their approaches were more structured than that of Itten. Albers, for example, began his course with a series of experiments working directly in various materials, starting with a limited number of tools and gradually adding new tools and materials.

Impact of the Bauhaus

The Nazi regime, which came to power in 1932, closed the Bauhaus, resulting in a scattering of its faculty. A significant number of its members settled in the United States. Moholy-Nagy taught at the Illinois Institute of Design, while Albers taught at the Black Mountain College and later became head of the art school at Yale University. Gropius headed the Harvard Department of Architecture, while Kepes joined the faculty at the Massachusetts Institute of Technology. Wherever these teachers resettled, they transformed the teaching of the fine arts, industrial design, architecture, and the crafts along lines established by the Bauhaus.

By the end of World War II the Bauhaus style of architecture had be-

come known as the international style, and the industrial design curriculum of most professional art schools was influenced by Bauhaus courses. The exploratory activities of the Bauhaus foundation course was made available in such textbooks as *Vision in Motion* by Moholy-Nagy (1947) and *Language of Vision* by Gyorgy Kepes (1944). The life drawing course, which had been the traditional core of every professional art school curriculum, was now supplanted by the course in basic design, design fundamentals, or what some schools called their foundation year of study.

One is tempted to contrast these highly systematic, rational approaches to design with those devised earlier in the century by Dow or Ross. What the Bauhaus had in common with these earlier pedagogical schemes was the general conviction that the elements of design were the underlying basis for all of the arts and that therefore design should be the basis for the teaching of art. For Dow the purpose of the study of design was to enable the student of art to understand the basis for beauty. From the Bauhaus perspective, Dow's view of beauty would have been regarded as a sentimentalized version of nineteenth-century romanticism. Instead, they saw design as exploration to discover the basis for vision. The elements of design were fundamental discoveries one made through the investigation of materials. With this as a foundation one could create either functional or expressive forms.

Criticism of the Bauhaus

The Bauhaus instructional program was an attempt to disavow all previous art styles; it was, in a sense, against style per se. The work of art was to be a direct outgrowth of its function and the form given it by the designer. Though its pedagogy attempted to free the student from the legacy of past art, its disavowal of tradition and its functionalist bias imposed an orthodoxy of its own. Though Itten saw design as an intuitive and imaginative response on the part of the artist to a socially defined need, other teachers tended to standardize the approach to problems of design. As a consequence, most industrial design has a sameness about it, so that today's microwave oven looks like a television set. Similarly, the functionalist aesthetic of Bauhaus architecture created an urban environment marked by an impersonal efficiency that denies human feeling and spirit. It has only been in the latter years of the century that architects and industrial designers have moved away from the Spartanlike denial of ornament and decoration in social settings. Though Bauhaus style may now be moving out of favor, its very ubiquity testifies to its success. Moreover, the pedagogical legacy of the Bauhaus lives on in professional art schools and in art classrooms in public schools.

VISUAL ARTS IN HIGHER EDUCATION

In the decade following the First World War, there was a dramatic increase in the teaching of visual art in colleges and universities. In a number of liberal arts colleges the study of art by means of an introductory course in studio studies, or a survey course in the appreciation or history of art, became standard. In 1925 half of the colleges and universities in the country were teaching art. By 1941, the percentage was closer to two-thirds; nearly all women's colleges, half the men's colleges, and two-thirds of the coeducational institutions offered art courses.

Professional Studies

A second major development was the establishment of professionally oriented university art departments. At the turn of the century professional art departments of the quality of Yale's art school were rare. Professional training was available in professional art schools, such as the Pratt Institute or the Rhode Island School of Design, but rarely was this available in the university setting. Larger universities and smaller liberal arts colleges typically had begun to establish small departments of one or two persons to offer courses in appreciation, with some possibility for the pursuit of studio studies. Usually these were courses of a general nature for liberal arts majors or prospective school teachers. After World War I, however, the land-grant universities in the Midwest began to establish larger and more comprehensive departments of art, offering degrees in art, full-fledged programs of professional studies in art, and, in a few instances, art history.

The founding of the School of Art at the Ohio State University is a typical case in point. Central to this university's mission was study and research in such applied fields as agriculture and mechanics. Some liberal arts studies accompanied the applied studies, and in 1890 the university's Greek department offered courses in the appreciation of ancient Greek art. The first drawing courses were designed to serve students in such applied fields as engineering, followed by normal art courses for teachers. The School of Art was established after World War I, offering both undergraduate and graduate degrees in the fine arts.

Art History

Another development was the spread of art history as a scholarly discipline in its own right. In a survey of the teaching of the history of art that was published in 1934, Hiss and Fansler documented the fact that scholarly

study in art history had begun to appear in American universities, with Princeton taking the lead with the founding of the first department devoted to the history of art in 1882. Generally, the teaching of art history began in departments devoted to either classical studies or archeology. Hiss and Fansler reported that in the period between 1876 and 1932 there were some 450 art-related theses written; among these were 79 devoted to Greek art and archeology, 54 to medieval art, 52 to Renaissance art, 49 to American archeology, 32 to Roman art and archeology, 24 to nineteenth- and twentieth-century subjects, 16 to primitive art, and 10 to aesthetics. Most were master's theses, with a few at the doctoral level. Graduates of these programs were usually employed as museum directors and teachers in liberal arts colleges.

Though the history of art had begun to be identified as a scholarly discipline in its own right, its slow but steady progress was greatly accelerated in the 1930s by the immigration of German art historians fleeing the Nazis. Erwin Panofsky (1955) describes this as a "great exodus." Since the German-speaking world had held the leading position in art history, American universities were the beneficiaries of this scholarship. Panofsky, a German emigré himself, notes that many of his fellow scholars found it difficult to obtain recognition in American universities, where the discipline was not fully accepted (1955).

SURVEYS OF THE ARTS IN AMERICA

A Variety of Perspectives

During the interwar period, a number of assessments of the status of the arts in American life were undertaken. Some, such as Hiss and Fansler's (1934) review of postsecondary research, looked at a particular facet; others covered a wider range of topics. *The Arts in American Life* (Keppel & Duffus, 1933), commissioned by President Hoover's Research Committee on Social Trends, dealt with the economic setting for the development of the arts in American life, art education in the schools, architecture, art in advertising, and art in commercial design; it also included chapters on music, dance, theater, and cinema. The chapter on art education documented the growth of art teaching in the colleges and universities in the decade between 1920 and 1930. Much of its statistical data was drawn from the U.S. Office of Education's art education report published in 1931.

Arthur Pope's *Art, Artist and Layman: A Study of the Teaching of the Visual Arts* (1937) surveyed the teaching of the visual arts in the public schools and in colleges, as well as the character of training received by the

professional artist and designer. *The Visual Arts in General Education*, prepared by the Progressive Education Association (1940), looked at the role that art education might play in secondary education. Robert Goldwater (1943) surveyed the teaching of art in 50 colleges and universities. Generally he found that the introductory course in art history was virtually a standard practice at these colleges and that these courses were divided into non-chronological and chronological forms of presentation. He also found that by 1940 the courses in classical art history were largely taught by art history rather than by classics faculties.

The Fortieth Yearbook

The publication of *Art in American Life and Education*, the *Fortieth Yearbook* of the National Society for the Study of Education (NSSE, 1941) was an important milestone for art education: the first time that it was given systematic attention by this educational body. Since this yearbook and the other reports mentioned were written during the Depression years or shortly thereafter, they collectively signified that art education was here to stay, that despite the roadblocks in its path to acceptance, it had become an integral part of the educational scene from the elementary school to the university.

According to Guy Whipple, who served as general editor for National Society for the Study of Education, there was discussion among the Board of Directors of NSSE as to the feasibility of initiating a yearbook on education in the fine arts. The lack of a suitable yearbook editor stalled the project for a number of years. Then, in 1935, Melvin Haggerty, who had become chairman of the NSSE board, distributed the manuscript of *Art, a Way of Life* and urged that a yearbook on art be prepared.

> He was convinced that the point of view of the schools on art was definitely wrong, that the teachers of art were poorly prepared, and that there would be need, within a few years, for a general overhauling and new orientation in the field of art education if the place of art as a social agency affecting the lives of all was to be properly recognized. (NSSE, 1941, p. xii)

In the following year Haggerty submitted a proposal for a yearbook on art education, and the board appropriated a sum of $500 to meet the expenses of a conference to plan the volume. Present at this conference with Haggerty were Alon Bement, Royal Bailey Farnum, and Leon Winslow. They laid out a general plan and identified contributors. In 1937 the Carnegie Foundation for the Advancement of Teaching granted $5,000 with the understanding that the NSSE would add an additional $1,500. When Haggerty died in October of that year, Thomas Munro of the Cleveland Museum was asked to assume the editorial task.

The result was an enormous volume of 819 pages subdivided into the four main sections first indicated by Haggerty in his tentative outline. Section I, "Art in American Life," included articles on the social background of American art, city planning, public architecture, landscape design, flower arrangement, the handicrafts, industrial arts, theater arts, photography, motion pictures, and, surprisingly, television. Section II, "The Nature of Art and Related Types of Experience," dealt with such matters as research in the psychology of art and creativity, analysis of form in art, and art in society. Section III dealt with the institutional settings for art education, while Section IV dealt with the preparation of art teachers. Each of the four sections consisted of short articles written by a cross-section of individuals ranging from museum personnel, to art supervisors in large urban school districts, to persons teaching in colleges and universities.

The yearbook came out in the same year that America entered World War II. The next chapter describes art education during the war years, but suffice it to say that for many students, like myself, who entered art education in the postwar era, the fortieth yearbook was the bedrock of our professional studies in art education.

CONCLUSIONS

After World War I American artists assimilated the styles of modern art. Museums and galleries continued to look to Europe, but during the 1930s, WPA arts projects brought artists into the American mainstream for the first time.

Artistic freedom was the metaphor for the freeing of other social institutions from the weight of tradition, especially the school. The child-centered school was a place of creative self-expression where the child was perceived as an artist. Under the banner of Freudianism, the metaphor of freedom included the freedom from social inhibition and repression. Art education had come to mean creative self-expression and was closely identified with progressive education.

A number of individual artist-teachers originated the practices for which creative self-expression is noted. Though it is often described as a method that avoided the imposition of adult ideas on children, exemplary teachers stimulated children's imagination either by use of word pictures, by helping them recall experiences, or by exposing them to visual or tactile experiences.

From the 1930s to World War II progressive education moved away from an exclusive preoccupation with creative self-expression and began to restructure education around purposes tied to the community and its life.

The Owatonna art education project sponsored by the Carnegie Corporation was the definitive art education experiment in this direction.

The integration of art into other subject matters was related to the attempt to restructure the curriculum around life-centered problems facing the school and the community.

As the storm clouds of the Second World War gathered, American art education was influenced by a great exodus of immigrants from the German-speaking world. Many Bauhaus masters settled in American universities and institutes of technology. Painters brought their modernist styles into American studios and classrooms, and art historians richly infused the intellectual scene.

Though the nation still felt the impact of the Great Depression, and stood on the brink of war, it was evident that art education was an integral part of the educational landscape.

CHAPTER EIGHT

Art Education from World War II to the Present

In a number of histories the end of World War II serves as the dividing point between the recent and distant past, and this date makes sense in discussions of art education as well. The world that existed before the war was no more. The United States and the Soviet Union became the dominant superpowers. The war changed the cultural landscape as well, with New York becoming the center of the art world. The war shattered the belief that humanity is evolving toward higher levels of civilization. The magnitude of the atrocities perpetrated by Hitler's Third Reich and the new horror unleashed by the atom bomb destroyed any belief that the future would necessarily improve on the past and present. Indeed, George Orwell's novel *1984* yielded a vision quite at odds with optimistic future utopias of the past.

W. H. Auden called this "the age of anxiety," while art became "the anxious object" (Rosenberg, 1964/1973). In the visual arts anxiety was made palpable in the paintings of Francis Bacon, in which the faces of humanity were blank and featureless. The sculpture of Giacometti reduced the human form to skeletal leanness, while Armitage's figures are bounded by inflexible limbs unable to control their environment. Art in the postwar era was an existential nightmare.

But postwar malaise was not mirrored in the American economy. The era was one of prosperity that lasted well into the 1970s. With the creature comforts and normal family living previously restricted by depression and war, Americans moved into suburbs and raised large families. A baby boom was under way. Social critics decried conspicuous consumption and the spoiling of the environment. Thomas Griffith (1959) called America "the waist high culture," it had become a culture of consumers. Other voices spoke of society as a "lonely crowd" (Riesman, 1950), composed of "organization men" (Whyte, 1956) whose offspring were "growing up absurd" (Goodman, 1960).

AMERICAN ART DURING THE POSTWAR ERA

The end of the war was also marked by the rise of the New York art world. The community of artists and intellectuals that once gave Paris intellectual supremacy was scattered by the war, never quite to regain its position of influence. A new community of artists converged upon New York, including Piet Mondrian, Max Ernst, Arshile Gorky, Willem de Kooning, Marcel Duchamp, and Hans Hofmann. Though these artists differed in their styles, they began to influence younger Americans, such as Jackson Pollock and Clyfford Still. What emerged was a New York school of painting. At the same time New York became the international gathering place for art critics and dealers and the center of the art press.

The explosion of *Weltangst* after the war that appeared in the paintings of Gorky, Hofmann, and de Kooning went beyond European expressionism. Celebrating action as opposed to contemplation and called "action painting," the new art involved a style based on impulsive intuition. Other art styles, quite opposed to abstract expressionism, soon followed. The cool paintings of Andy Warhol's soup cans and Brillo soap pads, the perceptual abstractions of Bridget Riley, and the minimalism of Ad Reinhardt and Jim Dine were some of its manifestations. By the 1970s conceptual art had succeeded the aforementioned styles, accompanied by a general quickening of the pace of change in art. Finally, in the early 1980s a neoexpressionist trend once again asserted itself.

THE ARTS IN AMERICAN HIGHER EDUCATION

Millions of returning servicemen and -women used their GI benefits to attend colleges and universities. Institutions that before the war were little more than teachers colleges mushroomed into full-fledged universities offering graduate degrees. As a greater percentage of the population entered higher education, there was a concomitant expansion of university art departments. Art departments established during the interwar years turned out graduates for teaching positions in smaller colleges whose enrollments were expanding.

In the first years after the war, the typical art department was made up of individuals trained as artists, art educators, art historians, and industrial designers. Coming from differing specialties and representing different professional commitments, these individuals held different views of art and teaching; thus departmental friction was commonplace. In larger institutions these specialties tended to be organized into separate areas or depart-

ments within schools or colleges of art. Art education faculties were located in either schools of education or departments of art.

Art Teacher Education Programs

There was an acute shortage of art teachers after the war, a situation that lasted well into the middle 1960s. Few persons entered the teaching profession during the Depression and the war years, so that by the late 1940s there were few ready replacements for those retiring. Schools of education usually offered a basic course in the teaching of art for prospective elementary teachers.

Graduate Study in Art Education

At the start of the postwar era, graduate study in art education was limited to the master's degree, which was taken in a department of either art or education. Graduates of these programs usually taught or functioned as art supervisors. A few graduate faculties offered Ed.D. or Ph.D. degrees, such as the New York University, Teachers College of Columbia, the University of Chicago, and Stanford. Most graduates of these programs took positions in university programs, which were beginning to expand with the general increase of college and university students. As art education faculties expanded at the university level, the nature of graduate study changed to reflect a growing interest in research. The Ed.D., which was seen primarily as a teaching degree, began to be supplanted by the research-oriented Ph.D.

Expansion of Art History Programs

By 1942 art history was generally recognized as a scholarly discipline in its own right. Yet by the end of the war few American universities offered a doctorate in art history. These were the programs at Princeton, Yale, Harvard, Columbia, and New York University. With the number of students in higher education, however, there was a growing demand for scholars in art history. Graduate programs thus began to multiply, and by the early 1960s a number of new departments were functioning. By the early 1970s there were some 35 institutions in the United States offering a doctorate in art history.

Graduate Study in the Fine Arts

With some exceptions, most college art teachers possessed an M.A. from a professional art school such as the Pratt Institute or Rhode Island School of Design, although the Master of Fine Arts (M.F.A.) was first

awarded at the University of Iowa in the mid-1930s. After the war the M.F.A. degree replaced the M.A. as the terminal degree for studio faculty members in college art departments. Requirements for this degree varied from one institution to another. In some schools the degree was indistinguishable from the M.A.; but gradually the M.F.A. came to require two years of post-baccalaureate study, with a thesis and show of studio accomplishments, while the M.A. represented one year of post-baccalaureate study. In addition, a number of professional art schools, such as the Cranbrook Academy of Art and the Yale School of Fine Arts, became graduate institutions requiring the B.F.A. degree and a portfolio for admission to the program. Expanding art departments were able to absorb M.A. and M.F.A. graduates until the middle 1960s, when faculty positions reached saturation.

Eisner's (1965a) survey on art and art education in higher education provides a reliable indication of the number and type of graduate programs in the early 1960s. Of the 407 degree granting institutions listed in the 1961 edition of the *American Art Directory*, 357 responded to Eisner's questionnaire, a return of 87.7%. Of these, 120 indicated that they offered a master's program in art and 86 in art education; 14 offered a doctoral program in art and 16 in art education. He also noted that more art education doctorates originated in colleges of education than in departments of art.

TWILIGHT OF THE PROGRESSIVE ERA

Though the progressive education movement gained prominence during the 1930s, it would be wrong to suggest that it was unopposed then, for it was often the subject of heated battles. While the signs of conflict abated during the war, public disaffection with progressivism grew rapidly after the war. Right-wing groups claimed to see a communist plot at work in the permissive teaching methods of the progressivists, especially as the Cold War deepened. Allen Zoll, for example, headed a group called the National Council for American Education, whose pamphlets bore such titles as "The Commies Are After Your Kids" and "Progressive Education Increases Juvenile Delinquency." Some local groups used these to agitate for school boards sympathetic to traditional schooling values.

The criticism of progressivism came not only from the political Right. By the 1950s academic scholars in large numbers were also questioning progressive practices. In 1952 their attack was spearheaded by historian Arthur Bestor in an address before the American Historical Association entitled "Anti-intellectualism in the Schools: A Challenge to Scholars." Bestor's *Educational Wastelands* (1953) expanded his premise that professional educators of the progressive sort had seriously undermined the intellectual

quality of American education. In particular, he reacted to the "life-adjust-ment program" about to be launched by the Vocational Education Division of the United States Office of Education. The literature advocating life-adjustment programs was filled with phraseology expressing concern for "the physical, mental, and emotional health" of students, the need for schools to deal with "the present problems of youth as well as their prepara-tion for future living," the importance of "personal satisfactions and achieve-ments for each individual within the limits of his abilities," and education that "emphasizes active and creative achievements" and "adjustment to exist-ing conditions."

These values and aspirations seemed desirable enough, but Bestor saw this as a disavowal of the school's primary function, which was to provide intellectual training. Such training, he argued, could only be given through the academic disciplines that "have developed historically as systematic methods for solving problems" (quoted in Spring, 1986, p. 292). To say the least, Bestor was not greatly esteemed by the education faculties, but by 1960 the idea of basing educational reform on the disciplines met with wide acceptance.

In spite of vociferous criticism of content there was no call for a return to preprogressive methods; the authoritarian classroom of the 1890s re-ceived no advocacy. Such progressive innovations as moveable classroom furniture became common practice after World War II. Subjects such as social studies continued to be taught by the project method. Field trips continued to be taken. And creative self-expression, once the central preoc-cupation of progressive schools, was now the name for art activities.

A perusal of art education textbooks in use between 1945 and 1960 shows a continued loyalty to the ideals of progressive education and the goals of life adjustment. Lowenfeld's *Creative and Mental Growth* (1947) emphasized physical, mental, social and emotional growth as aims of art education. *Art Today* (Faulkner, Ziegfeld, & Hill, 1941), which was widely adopted as a text at the secondary level, stressed problem-solving skills and preparation for future living. Kainz and Riley's *Exploring Art* (1949) stressed the development of a healthy personality, good taste, and "a spirited and honest production of things suited to daily living" (p. 111).

Evidence of anti-intellectualism in art education abounded at this time. For example, Kainz and Riley (1949) disavowed methods of art teaching that relied on "a preoccupation with past accomplishment" (p. iv). In their view, art education should not look to the history of art for art appreciation; it should occur through the application of art to the tasks of everyday life. Art was described as a "developmental activity and not as a body of knowl-edge" (NAEA, 1949). The art education literature of the day would have provided Bestor with ample evidence of anti-intellectualism.

The Suburbanization of Art Education

In the postwar era, opportunities for newly trained art teachers were expanding. As we saw earlier, older teachers, who received their training in the 1920s and 1930s were retiring, resulting in a shortage of art teachers for the first time since the Depression. In addition, a number of demographic changes in postwar American society strengthened education in the enclaves of the privileged classes while subjecting it to benign neglect in the schools of the poor. One was the mushrooming of the suburbs in the 1950s and 1960s. This resulted from the economic expansion that followed in the wake of the war from such programs as the G.I. Bill of Rights, which enabled World War II veterans to qualify for scholarships and for mortgage loans at modest interest rates. These factors not only created an expansion of the middle class but made suburban migration a middle-class experience.

Moreover, suburban migration was largely limited to the white middle class. Black migration from Southern states to Northern cities had been under way since the end of World War I, but it was in the period following World War II that it greatly accelerated. This was largely the result of the mechanization of agriculture and the resultant elimination of agricultural jobs, one of the few areas of employment available to blacks. As the racial composition of previously white urban neighborhoods in the North changed, racism and fear of declining property values induced large number of whites to move to the suburbs.

As the suburbs became enclaves for middle-class whites, they tended to offer educational programs in accord with middle-class values, and to a large extent these were the subjects favored by progressive educators. We should recall that Counts (1934/1978) had questioned the viability of child-centered progressive education precisely because it was under the influence of middle-class families.

In addition, permissive childrearing practices were encouraged by child psychologists who counseled parents to raise their children to be independent and to express themselves freely. The permissive discipline, freedom, and self-expression practiced in progressive schools were consistent with this advice. The pedagogy of art education, which encouraged personal growth through self-expression, was part and parcel of progressive practices. Curiously, this repeated the situation of the nineteenth century, when art teaching was deemed suitable for the privileged classes, but not the poor.

Programs in art, music, and physical education were part of that middle-class ideal, and in the suburban schools these subjects were usually taught by specialists (in fact, the hiring of such specialists had become common in a number of suburban communities prior to World War II). In using specialists, these schools emulated private day schools and the demon-

stration schools of the colleges of education. Dewey's Laboratory School, for example, had introduced this practice in 1897; others, including the Walden School, Tower Hill School, and the Fieldston School, introduced the practice after World War I. Though progressivism itself was on the decline, such innovations as the hiring of specialist teachers were accepted, especially in communities along the eastern seaboard and in the Midwest.

Decline of Art Supervisors in the Central Cities

Concurrently, art supervisory positions went into decline during the postwar era. Eisner (1979a) notes, for example, that in 1967 there were 408 art supervisors in the state of California, that in 1973 the number had dropped to 115, and that in 1979 there were fewer than 50. The larger central cities were facing severe economic problems as more affluent families moved to the suburbs and were replaced by poorer families. School districts economized by cutting back on central staffs that operated at the district level, placing greater reliance on building principals for curriculum and supervisory functions.

TEACHING ART DURING AND AFTER THE WAR: THE RECONSTRUCTIONIST STREAM

Throughout the Great Depression, social concerns became a priority in art education. Art was seen as a way to strengthen the community and enhance personal living through the use of design in the planning of communities, in interiors, and in clothing design. With U.S. entry into World War II, the social purposes of art education embraced the international issues at stake in the war; with the war's conclusion, child art was used to promote peace and international understanding.

Art as Part of the War Effort

During the war art education was seen as a means of preserving and defending democracy and, indeed, Western civilization itself. In 1942 the annual publication *Art Education Today* (Teachers College, 1942) declared that "the attack upon us is cultural as well as military," that "fascism finds it necessary to 'silence' the creative artists whenever it comes to power" (p. 2). The writers singled out the "enemies of democracy and democratic culture — who will seek to use the present situation to redouble their attacks" (p. 2). The enemies in question were not the Germans and Japanese but the old and familiar enemies of progressive education — the voices advocating curtail-

ment of frills, economy, and retrenchment, but now in the name of sacrifice for the war effort.

The war represented a special challenge to art educators, who had to demonstrate that art was ideologically committed to the struggle to preserve freedom and democracy, the very freedom that permitted artistic self-expression. To do this they had to disavow certain onerous aspects of art—its "escapist" tendencies, for example: "Culture will not be saved by a retreat to Shangri-La, real or imagined"; "Sheltered artists and escape art are neither sound culturally nor valuable as a social force" (Teachers College, 1942, p. 2). This disavowal of escapism is reminiscent of Haggerty's disapproval of art as a "separatist cult" (1935, p. 39).

Though the self-expression of the artist was seen as a form of free speech, these defenders of art education felt that art education would not be worthy of survival unless "escapist art" was excluded. The defense of political freedom required giving up certain forms of artistic expression. This apparent gap in logic was not addressed by the writers, but in all fairness the article was written when the passions of the moment ran high.

The 1943 issue of *Art Education Today* (Teachers College, 1943) provided an array of art activities designed to promote the war effort. There were articles on school art in wartime England, museum programs on war-related themes, postermaking, and the design and construction of booths to sell war bonds. Wartime art activities were also frequent topics. Posters promoting the war effort, such as those shown in Figure 8.1, were reproduced in full color in *School Arts* to inspire the making of posters in art classrooms. In describing the art education literature of the war years, Freedman (1987) notes how American nationalism was cultivated through such activities as postermaking.

> Images of strong, handsome, and determined young men illustrated convictions about the inherent good of the Allied countries. Depictions of Allied women and children were to evoke sympathy for the helpless and innocent. The images of people in nations fighting against the United States, in contrast, took on inhuman characteristics. Germans were represented as eerie, dark, skeletal figures without faces or identities. (p. 19)

The Art-for-Peace Movement

Herbert Read (1943), an Englishman writing at the time when German bombing raids were daily occurrences in that country, equated the universal aspects of the imagery in child art with the archetypal symbols of Jungian psychology, symbols said to exist in a collective unconscious shared by all human beings to provide the ground both for the integration of the personal-

FIGURE 8.1. "Victory Posters" reproduced to promote the war effort, from *School Arts* (1942–1943), 42 (4), color insert between pp. 128 & 129. Reproduced by permission.

ity and social harmony. These images appear in child art "when this integration of the unconscious is allowed or encouraged to take place, which it notably does in all forms of imaginative activity — day-dreaming, spontaneous elaboration of fantasy, creative expression in colour, line, sounds and words" (p. 193). In his view, this natural process of personal integration and communication had become distorted by the sophistication of modern civilization, including modern education. If humanity was to recover the integration that had been lost and that alone makes individual and social harmony possible, it will first have to recover "the total organism's internal feeling behaviour" (1943, p. 197). In Read's view art education dedicated to this aim could be a significant force for social harmony and peace. In a remarkable passage he expressed his deeply felt conviction on the relation between creative expression in art and the prospects of a healthy society:

> The gigantic catastrophes that threaten us are not elemental happenings of a physical or biological kind, but are psychic events. We are threatened in a fearful way by wars and revolutions that are nothing else but psychic epidemics. . . . The secret of all our collective ills is to be traced to the suppression of spontaneous creative ability in the individual. . . . *Destructiveness is the outcome of unlived life!* (Read, 1943, pp. 201–202)

After the war Read worked to establish the peace movement in art education, which also included such individuals as Trever Thomas and Edwin Ziegfeld. According to Rhoades (1985), the prospect of promoting international understanding through art was discussed at the first meeting of the United Nations Educational, Scientific and Cultural Organization (UNESCO), held in 1947 in Mexico City. Resolutions were adopted to begin inquiries into the promotion of international understanding through art education. In the following year a group of experts met in Paris to discuss this idea. Read served as the chairman of the group, while the recorder was Thomas Munro from the United States. This committee recommended establishment of a national committee, made up of representatives from each UNESCO member country, to facilitate cultural exchange in the arts.

At the fifth General Session of UNESCO, held in 1950, approval was given for continued exchange of information on the visual arts, including exchanges of children's art works. To this end, an international seminar on the teaching of art in general education was held in Bristol, England, in 1951. Forty representatives from 19 countries, or about one-third of the countries belonging to UNESCO, attended. It was at this meeting that the International Society for Education through Art was founded. Ziegfeld became the first president and guided it through its first decade of existence (Rhoades, 1985).

TEACHING ART DURING THE POSTWAR ERA:
THE EXPRESSIONIST STREAM

In spite of an atmosphere of continuing crisis throughout the Cold War, art education tended to abandon its reconstructionist stance in favor of expressionism. Why art education veered toward expressionism can probably never be fully explained. It was certainly the case that in the fine arts abstract expressionism had become the dominant American art style, but rarely in the past had schooling practices in art teaching taken their cues from the contemporary art scene. Or perhaps, after two decades of preoccupation with weighty societal issues, it was time to reinstate children and their personal development as a central issue in education. The emphasis upon individuality and uniqueness lived on in art education long after its decline as an objective of general education. Certainly the impact of Read's *Education Through Art* (1943) and Lowenfeld's *Creative and Mental Growth* (1947) have to be cited as contributing causes. One also has to understand and appreciate the impact of Viktor Lowenfeld's ideas on art education in the United States.

The Life and Career of Viktor Lowenfeld

Born in Linz, Austria, in 1903, Lowenfeld as an adolescent was a member of the "Blau und Weis" (Blue and White), a Zionist youth organization. He enrolled in the Vienna Kunstgewerbeschule in 1921 and was a student of Franz Cizek; Saunders (1960) suggests, however, that Lowenfeld was no follower of Cizek, that if Cizek influenced Lowenfeld at all, it was influence of a negative sort. He graduated from the Kunstgewerbeschule in 1925, from the Vienna Academy of Fine Art in 1926, and from Vienna University in 1928. His studies had broadly acquainted him with the arts and the European child study movement (Michael, 1982).

Between 1926 and 1938 he taught at Hohe Warte Institution for the Blind, where he began to develop his ideas about the therapeutic uses of creative activity in the arts, the subject of two books in German and his first English publication, *The Nature of Creative Activity* (1939). With the German invasion in 1938, Lowenfeld and his family fled from Austria to England, later settling in the United States. During the war years he taught psychology at the Hampton Institute in Virginia.

According to Hollingsworth (1988), Lowenfeld was directly responsible for establishing Hampton's art department. At Hampton he encountered racism toward blacks; as an Austrian Jew with first-hand experience of the extremities to which bigotry could lead, he found it deeply offensive. In 1946 he was invited to join the faculty at Penn State, where he established

the art education department. In 1947 *Creative and Mental Growth* was published, and it became the most influential art education textbook of the postwar era.

Lowenfeld's views of child art were grounded in psychoanalytic constructs. He saw free expression as necessary to the healthy growth and development of the child. When this is thwarted either by a loss of self-confidence or by the imposition of adult ideas, the result is emotional or mental disturbance. The stimulation of children's creative abilities minimizes such disturbances. But in Lowenfeld's view the cultivation of mental health also had social consequences. In the second edition of *Creative and Mental Growth* (1950) he injected a personal note:

> Having experienced the devastating effect of rigid dogmatism and disrespect for individual differences, I know that force does not solve problems and that the basis for human relationships is usually created in the homes and kindergartens. I feel strongly that without the imposed discipline common in German family lives and schools the acceptance of totalitarianism would have been impossible. (p. ix)

Lowenfeld had never regarded child art as an end in itself. He was critical of his former teacher Franz Cizek, who tended to emphasize the aesthetic aspects of child art. This "is much against our philosophy, and I believe also against the needs of our time." The goal of art education "is not the art itself, or the aesthetic product, or the aesthetic experience, but rather the child who grows up more creatively and sensitively and applies his experience in the arts to whatever life situations may be applicable" (quoted in Michael, 1982, p. xix).

Lowenfeld's *Creative and Mental Growth* went through seven successive editions, with the last four revisions representing the work of Lowenfeld's student Lambert Brittain. Its success was due to the fact that it provided a developmental basis for understanding children's art. Lowenfeld described these stages in understandable terms, illustrating them with examples of children's drawings and paintings. He also prescribed art activities that were psychologically compatible with these developmental levels.

Thus teachers with a minimal knowledge of art could teach if they learned to motivate children and if they had realistic expectations of what children might accomplish at each stage of development. Lowenfeld probably gave more teachers the confidence to teach art than any other individual in this century. Competing texts, such as Mendelowitz's *Children Are Artists* (1953/1963) were to a great extent modeled after his book. Lowenfeld was the dominant intellectual force in art education until his untimely death in 1960 at the age of 57.

Leadership in Art Education after Lowenfeld

Throughout the postwar era new scholarly traditions were taking shape and new leaders were challenging Lowenfeld's ideas. One was Manuel Barkan who received his doctorate at the Ohio State University in 1952. While he was a graduate student, Ohio State University's College of Education was a center of Deweyan influence. Guided by such interpreters of Dewey as Boyd Bode and Ross Mooney, Barkan regarded the social environment in Deweyan terms, as the place where the child interacts with others and, through such encounters, grows into a social being. This was in marked contrast to Read and Lowenfeld, who saw the environment as a potential source of corrupting influence, and who urged teachers to shelter children from the repressing effects of social influence to allow self-expression to flower. Barkan did not regard self-expression as the aim of art education. Rather, he saw it as a means through which children can be encouraged to interact with other human beings. His *A Foundation for Art Education* (1955) was unique in the annals of art education in that it had no pictures of child art. Instead, it provided a reasoned account of what art education should attempt to accomplish. The book drew heavily on concepts from psychology and social science.

A second person to raise questions about Lowenfeld's views was June K. McFee, whose studies of perception led her to question Lowenfeld's theory of "stages of expression," arguing that they were insufficient to account for human variability. In proposing her "perception delineation" model (McFee, 1961), she raised questions about Lowenfeld's visual-haptic dichotomy. Lowenfeld believed that individuals inherit a disposition to perceive reality through either their vision or their tactile sense. Citing recent experimental evidence, McFee argued that these dispositions could be accounted for by childrearing patterns and that art teaching needs to stimulate both styles of perceiving.

Elliot Eisner represents a third scholarly tradition in drawing upon the advances being made in curriculum theory at the University of Chicago's School of Education by such figures as Joseph Schwab, Ralph Tyler, and Benjamin Bloom. Throughout his career he strenuously challenged the assumption that art should be taught simply by encouraging children to express themselves and to be creative. Eisner was active in promoting the idea of a structured curriculum supported by instructional materials. His book *Educating Artistic Vision* (1972) was largely the result of efforts by himself and his graduate students to prepare a theoretically sound curriculum structure for the teaching of art supported by instructional resources. Eisner, like Barkan, was influential in redirecting the attention of the field from a single-minded preoccupation with children's self-expression to an emphasis on the content to be taught in art teaching.

Teaching Art for Creativity

In October 1957 the Soviets launched the first artificial satellites, Sputnik. American educators entered a period of professional soul-searching that resulted in a major movement for curriculum reform, especially in science and mathematics. Once again subjects such as art had to be defended. The old rationales grounded in self-expression and social reconstruction were swept away with the demise of progressive education.

There were two main reactions within the art education community. The first was to argue that art is important because it enables creative problem-solving skills to develop long before they can develop in other areas of education. This was the path chosen by Lowenfeld. He believed that the purpose of art is to develop creativity and that the promise it could transfer to other spheres of human activity can be seen in the fact that creativity is the same in all areas. He cited the work of the psychologist J. P. Guilford, who speculated that there are specific traits possessed by creative individuals in all fields (Lowenfeld, 1958).

The second reaction in art education was its participation in the curriculum reform movement based on the structure of the disciplines. We will discuss this in the next section.

IMPACT OF THE COLD WAR ON ART EDUCATION

In 1949 the Soviet Union broke America's nuclear monopoly with the explosion of an atom bomb. Nagging questions concerning American defensive capability were raised, which led inevitably to questions about the quality of American education and the ability of the nation to sustain its defensive capability. The uneasiness about educational system led Congress to pass the Cooperative Research Act in 1954 to improve education through basic research. The U.S. Office of Education administered the act, which had as its purpose the development of new knowledge about educational problems and the discovery of new applications of existing knowledge for solving educational problems (Hoffa, 1970). Similarly, the launching of Sputnik served as the catalyst for curriculum reform.

A highlight of the ensuing reform movement was the Woods Hole Conference of 1959. A number of groups, including the National Academy of Sciences, the American Association for the Advancement of Science, the Carnegie Corporation, and the National Science Foundation, had joined forces to sponsor this meeting on the status of the various curriculum projects in science and mathematics. The NSF, the U.S. Office of Education, the U.S. Air Force, and the Rand Corporation provided the funding. The conference reviewed the progress being made by the School Mathematics Study

Group, the Biological Sciences Curriculum Study, the Physical Science Study Committee, and others.

Jerome Bruner's *The Process of Education* (1960) reported on this conference and treated such problems as content selection and sequence with a disarming ease that had eluded the conventional curriculum theorists of the period. The key to the curriculum riddle, according to Bruner, was to be found in "the structure of the disciplines." The problem with the school curriculum, he stated, was that it had become too cluttered with subjects, with facts and techniques organized for instruction. Spelling and arithmetic were subjects that existed in schools and virtually nowhere else. Disciplines, by contrast, were fields of inquiry pursued by professional scientists and scholars in adult life.

Bruner contended that these disciplines could be represented in some intellectually honest form to students at all levels of instruction, and that these early forms of representation would build in the readiness that would enable learners to engage in more complex forms of learning encountered later. It was his belief that these were the heart of the curriculum, for the more fundamental or basic the idea that the student has learned, "the greater will be its breadth, and applicability to new problems" (p. 18). These would come from the best minds in any particular discipline. "Only by the use of our best minds in devising curricula will we bring the fruits of scholarship and wisdom to the student just beginning his studies" (p. 19).

Within two years Bruner's idea of the disciplines began having an impact on art education. In 1962 Manuel Barkan addressed the Western Arts Association at its biennial meeting in Cincinnati. He reviewed the history of the last 35 years of art education and concluded that the field was still living off outdated ideological visions, and then he began to quote from Bruner: "The dominant view among men . . . engaged in preparing and teaching new curricula . . . lies in giving students an understanding of the fundamental structure of whatever subjects we choose to teach" (Bruner, 1960, p. 11). Barkan explained that "Bruner does not deny any developmental values which can be derived from engagement in the study of a subject. All he is saying is that the key educational task is to give students an understanding of the fundamental structure of any subject we see fit to teach, . . . [and that] when applied to the teaching of art this would mean that *there is a subject matter of the field of art*, and it is important to teach it" (1962, p. 13).

The Sixty-Fourth Yearbook

That art education was in transition was a theme reiterated throughout the *Sixty-fourth Yearbook* of the NSSE (1965). The volume was divided into three main sections. The first dealt with the setting for art education in

the second half of the century; the second was devoted to art in the school program and provided a survey of the main philosophies guiding practice in the schools; the third provided guidelines for the future development of art education.

The opening essay by James Schinneller surveyed the recent happenings in the world of art, while Keel's essay detailed the events that had occurred since publication of the *Fortieth Yearbook*, including the "war, uneasy peace, the atom, affluence, television, suburbanization, new concepts of art and of human nature, new ways of teaching, existentialism, American participation in a fast-moving international world of art" — all of which "have transformed aims, aspirations, and much of our sense of what is possible" (p. 36).

The chapters by John A. Michael and Pauline Johnson maintained their allegiance to expressionist art education, while McFee's chapter on art for the economically and socially deprived raised concerns from a reconstructionist perspective in art education. It was in the chapter on future needs that Elliot Eisner raised items for a new agenda for the field. For him a major problem was the status of art curricula in public schools. He decried the lack of published tests in art, which had made it difficult to make intelligent changes in the curriculum, and he described a survey he conducted to determine what adolescents in the eighth grade knew about art. He found that the most basic art terms, such as *value, saturation, hue, contour,* and *symmetry*, were understood by less than half the students tested and that some were understood by less than 10 percent. The art programs taken by these students were ones in which the making of art was the dominant activity, yet fewer than 25 percent understood the meaning of the term *media*.

He also described a new trend, an "interest in enabling students to experience the visual art of significant artists" (p. 322). He referred to this as the "new art appreciation." Though comparable to the "new math," this term was not adopted, but Eisner was correct in his prediction that future trends would be toward art programs in which appreciation of significant artists was important.

Report of the Commission on Art Education

A committee appointed by the National Art Education Association examined the problems faced by the field. To some extent it duplicated the *Sixty-fourth Yearbook*, reiterating many of the same themes. The essay "The Visual World Today" by Irving Kaufman was made up of excerpts from his book *Art Education in Contemporary Culture*. Like the Schinneller essay in the *Sixty-fourth Yearbook*, it dealt with the significance of contemporary art

in the teaching of art. Schinneller concentrated on the stylistic transformations of post-war art, while Kaufman dealt with their significance for the culture, but both argued that the problems posed by the contemporary arts needed to play a greater role in determining what art education teaches. In effect, they illustrated Bruner's contention that curriculum reform begins with the discipline.

Aesthetic Experience in General Education

In the early 1960s terms like *aesthetic experience* or *aesthetic education* appeared with increased regularity. Barkan (1962) referred to "the aesthetic life" as a reality for theorists, teachers, and students alike. Eisner (1965b) spoke of aesthetic education as "the humane education of man in and through the arts" (p. 58), while Lanier (1963) called visual aesthetic experience a value of central importance in the lives of men.

The critical year for aesthetic education was 1966 when a major anthology on aesthetic education made its appearance. This was Ralph Smith's *Aesthetics and Criticism in Art Education*. In 1966 Smith also inaugurated the *Journal of Aesthetic Education*, which he has edited since its inception. Several contributors to this journal have focused on philosophical aesthetics as a source of content and value in general education. According to Smith (1987a), the term *aesthetic education* has at least two meanings. It refers to a tendency within art education to enlarge the scope of content by adding appreciative, critical, and historical activities to activities involving the making of art. It is also used "to encompass more than just the visual arts and to include music, literature, theatre, and dance" (p. 23). This second use is more than an omnibus term for study in the several arts since aesthetic education "generates curiosity about the common properties and functions of the arts as well as interest in the ways in which the arts might be organized for teaching" (p. 24). Harry Broudy (1972; Broudy, Smith, & Barnett, 1964) also discussed *aesthetic education* as a more inclusive term than *art education*; For him, it is a desired outcome of general education and, as such, is not limited to art education.

RIVAL TRENDS IN ART EDUCATION: 1965–1975

Discipline-Oriented Art Education

After 1957 science provided the model of curriculum reform for the whole of general education, including art education. The definition of a

discipline came from the sciences and referred to such attributes as having an organized body of knowledge, specific methods of inquiry, and a community of scholars who generally agree on the fundamental ideas of their field. The method of curriculum reform also came from the sciences, patterned after such projects as the School Mathematics Study Group, where mathematicians first identified the leading ideas of their field and then curriculum experts developed materials for teaching these ideas.

As the disciplines became the focus for curriculum reform, a hierarchy was established, elevating some studies to the status of disciplines and relegating others to the status of mere subjects. As Philip Phenix asserted, *"all* curriculum content should be drawn from the disciplines, or, to put it another way, . . . *only* knowledge contained in the disciplines is appropriate to the curriculum" (1968, p. 2). In this new environment such subjects as the arts had to become disciplines themselves or lose their legitimacy. In 1961 Bruner speculated that structures of knowledge similar to those of science might be found in the social studies and humanities, and then in 1965 he exemplified this very point with the social studies program known as *Man: A Course of Study*. This was a curriculum organized around concepts from such disciplines as linguistics, anthropology, economics, and sociology. The discipline approach to all subjects had by now become canonical (Bruner, 1965).

The political impact of science upon the arts came directly from the president's Science Advisory Committee. In 1961 President Kennedy added a panel on educational research and development, which was chaired by Jerrold Zacharias of M.I.T. (Murphy & Jones, 1978). This panel expressed concern with "the lack of balance in federal assistance to the arts compared to science" and asked whether "curriculum reform as it had developed in science education could be applied to education in the arts" (p. 3).

THE ARTS AND HUMANITIES PROGRAM. In 1962 President Kennedy appointed Francis Keppel as Commissioner of Education. Keppel, in turn, appointed Kathryn Bloom to the position of Arts and Humanities advisor in July of the following year. Bloom headed the Arts and Humanities Branch of the U.S. Office of Education, which, in succeeding years, grew to a staff of seven and was elevated to the status of a program (Hoffa, 1970).

This program funded 17 conferences on the arts between October 1964 and November 1966. The first conference in the visual arts was the 1964 Seminar on Elementary and Secondary School Education in the Visual Arts. Directed by Howard Conant and held at New York University, it focused its recommendations mainly on improving teacher recruitment and training.[1]

THE PENN STATE SEMINAR. A year later a more influential pairing of professional scholars with educators occurred at the Penn State Seminar (Efland, 1984). The most pervasive theme of the seminar was the notion that art is a discipline in its own right, with goals that should be stated in terms of their power to help students engage independently in disciplined inquiry in art. This theme was stated with great force both in Barkan's (1966) paper, "Curriculum Problems in Art Education," and in the structure of the conference itself, which included substantive scholars, such as artist Alan Kaprow, art historian Joshua Taylor, and art critic Harold Rosenberg, as well as prominent art educators like Barkan, Kenneth Beittel, McFee, and Jerome Hausman. Also involved were a number of experts in various research methodologies, such as Asahel Woodruff in curriculum development and evaluation, Dale Harris in the psychology of learning, and Melvin Tumin in sociology (Efland, 1984).

Barkan, in his paper, asked whether the visual arts and the humanities have structures like those in the physical sciences, answering the question in the following way:

> Does the absence of a formal structure of interrelated theorems, couched in the universal symbol system as in science, mean that the branch of the humanities called the arts are not disciplines, and that artistic inquiries are not disciplined? I think the answer is that the disciplines of art are of a different order. Though they are analogical and metaphorical, and they do not grow out of or contribute to a formal structure of knowledge, artistic inquiry is not loose. (Barkan, 1966, pp. 244–245)

Thus the impact of science on Barkan's efforts to conceptualize curriculum problems was more than political; it provided a profound intellectual challenge as well, for though the arts lack the formal structure of the scientific disciplines, its activities are nevertheless disciplined; thus artists can serve as models of inquiry for art education in the same ways that scientists serve as models of inquiry for science education.

To this Barkan added the idea that art historians and art critics are also models of inquiry in art education and that all three should be treated as equivalent candidates for curriculum attention. In time this tripartite conception of curriculum content became the hallmark of discipline-centered art education. Consequently, the overall importance of artistic activity was reduced, for now the artist had to share the stage with two other actors, the art critic and art historian. Indeed, it was Barkan's basic contention that the dominance of studio studies was a problem to be resolved by the strengthening of art criticism and art history within art instruction.[2]

In the decade following the Penn State Seminar there were a series of curriculum development projects, including the Aesthetic Education Pro-

gram prepared by the Central Mid-Western Regional Educational Laboratory, (CEMREL). In a two-phase project Barkan and Chapman were given the task of preparing guidelines for this project, a task which was completed with the help of Evan Kern (Barkan, Chapman, & Kern, 1970). The CEMREL staff, under the direction of Stanley Madeja, prepared a series of instructional packages in the second phase of the project. Other projects included the preparation of *Guidelines for Elementary Art Instruction by Television* (Barkan & Chapman, 1967). A third was a project in elementary art education funded by the Kettering Foundation and directed by Elliot Eisner. In addition, two influential textbook series made their appearance. The first was *Art: Meaning, Method and Media* (Hubbard & Rouse, 1981); more recently a textbook series, *Discover Art* (Chapman, 1987), appeared. The Southwest Regional Educational Laboratory (SWRL) prepared a sequential elementary art curriculum based on four contributing art disciplines: art studio, art history, art criticism, and aesthetics (Efland, 1987).[3]

CRITICISM OF DISCIPLINE-ORIENTED CURRICULA. By the mid 1970s Bruner's grand hypothesis—that any subject can be taught effectively in some intellectually honest form to any child at any stage of development—was questioned, even by Bruner himself. Bruner also tended to describe inquiry within disciplines as something that depended on the mastery of techniques, for example, the hypothetico-deductive process of scientific reasoning. As many scientists and mathematicians report, this is not the means they use for carrying out their inquiries. Their thinking more nearly resembles the imaginative activity of artists, whereby images, analogies, and metaphors enable one intuitively to grasp relationships among phenomena that can then be scrutinized by empirical test. In other words, there was a tendency to confuse the processes by which knowledge is formally admitted into the canon with the inquiry process itself.

Bruner's structures of knowledge tended to exclude aspects of feeling. He assumed that the conceptual organization of instructional materials was sufficient to provide understanding. This problem was identified by Richard Jones, who served as an evaluator for *Man: a Course of Study*. Jones observed that certain understandings pertaining to similarities between Eskimo social structure and our own were missed by fifth- and sixth-grade students, especially when films about Eskimo life aroused strong feelings in the students. It became apparent to teachers that the children needed to be able to deal with their feelings if they were to understand the significance of what they were learning (Jones, 1968).

Third, there was a tendency to impose the methods of curriculum development developed for the sciences upon other subject areas on the assumption that all disciplines had structures analogous to those found in

the sciences. Barkan readily accepted the idea that all subjects, including art, had their characteristic structures, although he greatly underestimated the difficulties entailed in getting scholars in the arts and humanities to agree on what these were.

It should also be said that a great deal of good came from the movement. It shifted the focus of art education from what had become an excessive preoccupation with self-expression. As long as this view prevailed, curriculum problems were not dealt with in any systematic way, since any designation of content was seen as the imposition of "adult standards" that were alien to the child. The discipline focus broke this anti-intellectual stranglehold.

The Arts-in-Education Movement

In 1960, the year Bruner published *The Process of Education*, Paul Goodman published *Growing Up Absurd*. Goodman argued that juvenile delinquency in postwar America had much in common with the "beatniks" of the late 1950s and the "organization man" of William H. Whyte. These social types were responses to an affluent society in which individual effort and work were perceived as lacking purpose and meaning. Though World War II was followed by a decade and a half of increasing conservatism, general protest against the prevailing status quo subsequently broke out on many fronts, including a reaction to the McCarthyism of the 1950s, the civil rights movement, the women's liberation movement, student protests against the seeming irrelevance of academic studies, and opposition to the war in Vietnam.

By the late 1960s a new vocabulary began to appear, with such terms as *counterculture* and the *me generation*. The activism of the civil rights movement, which spoke of political and economic freedoms, was translated into a rhetoric of personal liberation, with individuals demanding freedom from traditional norms, especially in the realm of sexual behavior and in the use of hallucinogenic drugs. Freedom was asserted by living alternative lifestyles that have become one of the legacies of the decade. *Summerhill* became popular reading among parents who wanted natural, nonrepressive educational experiences for their children. Silberman (1970) decried the lockstep regimentation of instruction in American schools and looked to the British infant schools for a humane alternative. Ivan Illich (1970) questioned the basic assumption that schools satisfied social needs and suggested community-based learning networks as a relevant alternative.

THE PHILOSOPHY OF THE MOVEMENT. To advocates of the arts-in-education movement, art was not a discipline. Rather it was "an experience,"

to be had by participating in the artistic process or by witnessing this process in the work of performing artists. They resisted the notion of a "packaged curriculum" (Chapman, 1982, p. 116). It had its origins in the Arts and Humanities Program of the U.S. Office of Education, and it centered around the career of Kathryn Bloom. Bloom was described by a former colleague as "elder statesperson" in the arts-in-education movement (Remer, 1982, p. xvi). Earlier the Arts and Humanities Program had reflected the discipline orientation, as seen by its support of the Penn State Seminar, but with the passage of the Elementary and Secondary Education Act in 1965, federal funding policy began to shift toward programs having a strong social agenda, reflecting President Johnson's war on poverty; but with the escalation of the Vietnam war, this program was dropped.

Bloom then accepted a position as head of the Arts in Education Program of the JDR 3rd Fund, a position she held until the termination of the fund in 1979. This foundation was active in the area of public schooling in the period between 1967 and 1979, granting $5.5 million to school districts, state departments of education, arts councils, and educational laboratories (Fowler, 1980).

UNIVERSITY CITY PROJECT. The first project to be funded was the University City Project, which became the prototype for additional projects supported by the JDR 3rd Fund. Between 1968 and 1971 the University City School District (a suburb on the west side of St. Louis, Missouri) became the site for a project that had as its mission "the possibility that the arts could become a fundamental part of the education of every child at every grade level in the entire school system" (Eddy, 1980, p. 25). This was to be accomplished by a comprehensive curriculum that would integrate the several arts into the teaching of other subjects. This district had a student population of 8,000 and was selected because of its relatively manageable size, as well as its recent history of commitment to change and innovation. An additional reason given for selecting this site was its growing racial complexity. The suburb had recently passed an open-housing resolution and the number of black families had risen from 7 to 15 percent by 1968. The district had resident art and music specialists, but these subjects were taught in the traditional manner as isolated, special subjects. This idea of integrating the arts into the curriculum was the central purpose of the project.

The project began with two in-service workshops for teachers in the summer of 1968, and it ended three years later with a plan called the Comprehensive Arts Program. The Fund had expended about $232,000 to develop and test the idea; the district contributed an additional $215,000. Additional staff members were added to coordinate the use of the arts in

interdisciplinary activities to bring them into general education. Artists, teachers, and arts educators were engaged from time to time to conduct workshops and to take on various assignments. During the first three years of the project a number of instructional units were written that could be utilized by classroom teachers in regular academic teaching. The project's final report listed 14 art-related instructional units (Eddy, 1980).

As the project drew to a close, the Fund supported activities that would enable the district to make the activities of the project into a regular part of the school program. Stanley Madeja reported that new art and music electives were added; that there was an increase in all ninth-grade arts courses, reversing the trend of previous years; that 70 percent of all high school students now took one or more art courses, compared to 30 percent five years earlier; and that there was a proposal for a specialized high school that would have the arts at the core of its curriculum. On the negative side of the ledger, the program lost leadership after 1972 and much of its forward momentum.

CHARACTERISTICS OF THE MOVEMENT. The most prevalent attribute was emphasis upon the arts in the plural. *Arts education* or *arts-in-education* were typical terms in its nomenclature. *Aesthetic education* was sometimes used as an umbrella term for all the arts. The term *interdisciplinary* was often used in descriptions of arts-in-education programs; although this would suggest affinity with the idea of the disciplines, it rather referred to the use of the arts to teach other subjects.

Another attribute was the tendency to seek solutions to educational problems outside of the school, to regard the school itself as *part* of the problem, and to involve community agencies, such as arts councils and museums, as resources for school programs. Networking among arts councils and interested schools was used to promote the teaching of the arts by community resource persons, such as local artists. Publicity and fund raising were used to enable schools to hire artists for service in the schools.

One of the more notable illustrations of the attempt to organize community involvement for the arts was the Arts Education and Americans Panel, headed by David Rockefeller, Jr., which resulted in the publication of a widely distributed book, *Coming to Our Senses* (Arts Education and Americans Panel, 1977). The panel consisted of such prominent personalities as Raye Eames and James Michener, and its object was to use these persons to focus national attention on the importance of the arts in education. Though the effort was well intentioned, it shunned the use of educators as resource persons on the problems affecting the teaching of the arts; as a result, it tended to alienate many of the groups it purported to help.

A third characteristic of this movement might be described as a performance bias. Though it is possible to learn about the arts in a variety of ways—through the study of their history, for example—the movement's prevailing tendency was to involve students in art production or performance. Action was given priority over contemplation, and one sees this especially in the annual reports of the JDR 3rd Fund, which were illustrated with action pictures of dancers or musicians in rehearsal and comparable activities for the other arts.

A final characteristic was the tendency of arts-in-education projects to justify their activities by such rationales as improving the child's self-concept; improving school morale and boosting school attendance figures; furthering interdisciplinary teaching by relating the arts to each other and to other subjects, such as social studies; involving the community in the schools through artist-in-schools programs; accommodating the needs of special populations, such as the gifted or handicapped; and even using the arts as a general strategy to bring about change in the schools (Remer, 1982).

CRITICISM OF THE MOVEMENT. Unlike the discipline-oriented movement, which originated with university educators dissatisfied with the ways their subject was taught, arts-in-education originated in the world of federal agencies and private foundations. Its characteristic rhetoric reminds one of the reconstructionist view of the 1930s, especially in its attempt to integrate the arts into the fabric of school life. One can find striking parallels between the Owatonna Project sponsored by the Carnegie Corporation and the University City Project. Both made use of an outside staff of experts to implement the project, both wrote units of instruction that would integrate the arts into other studies, and both made use of community resources. Nevertheless the arts-in-education program was a child of its time, as can be seen in its strong anti-establishment bias, its rhetoric of social activism, and its tendency to eschew schools and educators in favor of artists and performers in the somewhat naive hope that the very presence of these individuals would induce change in schools.

To its credit, the movement was able to draw attention to the arts as neglected subjects in the curriculum. As a movement toward accountability began to be felt in the early 1970s, arts-in-education programs enjoyed a good press, reminding people that the arts belonged in the school. Finally, it projected an image of the arts as an area of the school program where participatory activity was championed, countering the image of passive engagement with art, which was sometimes characteristic of discipline-oriented curricula.

ACCOUNTABILITY AND QUALITATIVE INQUIRY
AS RIVAL MOVEMENTS: 1972–1980

The previous section described two concurrent but rival movements that arose during the 1960s. The present section does the same for the 1970s. The first of these was a movement demanding greater "accountability" in educational programs. There was a general disenchantment with the discipline-oriented approach to curriculum reform, which is illustrated by the perceived failure of the "new math" program devised by the School Mathematics Study Group. In their pursuit of general mathematical understandings they downplayed computational skills.

This new movement reflected a return to political conservatism. The need for scientific know-how, which seemed so pressing in 1957, seemed less urgent in 1969, after the American space program succeeded in landing men on the moon. Also, by 1973 the Arab oil embargo had precipitated an energy crisis, suggesting to many that American affluence was at an end, that economic opportunities were declining, and that future students would have to compete for the fewer positions at the top of the social ladder.

A major factor that contributed to the demand for accountability was the continued rise of educational costs in spite of a marked decline in the school population as the postwar baby boom came to an end. There was increased resistance on the part of the tax-paying public to support educational programs. Meanwhile, parents were becoming anxious about declining achievement test scores and questioning the effectiveness of the schools. With the decline in scores from 1964 through the mid 1970s, accountability pressures became a social mandate.

As accountability became the new watchword, curricular affairs shifted from consideration of content to identification of effective devices for evaluation and measurement. Popkewitz, Pitman, and Barry (1986) describe this as a shift from "the productive" aspects of knowledge, with emphasis upon inquiry and discovery, to the "reproductive" aspects of knowledge, with an emphasis upon mastery of existing facts. By the late 1960s the rhetoric of instructional objectives was ubiquitous, and by the middle of the 1970s much literature in art education was devoted to instructional objectives, competency-based teacher education, and evaluation.

Behavioral Objectives in Curriculum Development

The emphasis on the writing of behavioral objectives as a basis for curriculum development and evaluation, common in almost all subject fields throughout the 1970s, was also widespread in art education. In *Behavioral*

Emphasis in Art Education, commissioned by the National Art Education Association, D. Jack Davis (1969) argued that "with the emphasis on accountability art educators have come to realize that they must sharpen their skills in stating and assessing the expected outcomes in learning" (p. 7). He blamed the difficulties besetting art education on the fact that art teachers could not offer concrete evidence that their program of instruction resulted in desirable changes in behavior. Davis then prepared a system for classifying various behaviors that are observable in art learning situations. He also provided sample objectives that could be used for teaching art and illustrated how they could function in the planning and evaluation of instruction.

One would have predicted resistance to this new approach to curriculum, with its emphasis upon precisely described objectives, and indeed, such resistance appeared in works like Ralph Smith's anthology, *Regaining Educational Leadership* (1975). Moreover, it had been foreshadowed in Eisner's (1967) formulation of "expressive objectives" as a means of addressing accountability pressures in educational situations where anticipating all the possibilities for instructional outcomes prior to the onset of teaching was not possible. Eisner believed that some of these outcomes can only be discovered after instruction has taken place, and that such outcomes are important and deserve to be included.

In spite of these attempts to restrain the movement, there was a remarkable degree of acceptance of this regimen in the arts. One reason was that many art educators were attracted by a scheme of learning that tended to offset the back-to-basics preoccupation with verbal learning. Another was the fact that a new generation of art educators were ready to distance themselves from the anti-intellectualism associated with creative self-expression. This is seen in their general embrace of empirical research in such areas as psychological creativity and visual perception. Stating objectives in behavioral terms was one way to demonstrate a commitment to rationality and precision. A third factor contributing to the widespread adoption of instructional objectives was the fact that their use was mandated by state legislatures.

National Assessment of Art Learning

In 1963 the idea of developing an educational census was first proposed as a way to determine the status of educational progress in various subject fields. The cost of initial exploratory activity was underwritten by the Carnegie Corporation, and in 1969 the project was assumed by the Education Commission of the States, an organization whose purpose was to dis-

cuss and coordinate educational problems and activities. Ten subject areas were chosen for assessment, including art and music. Five broad objectives were formulated—the ability to (1) perceive and respond to aspects of art, (2) value art as an important realm of human experience, (3) produce works of art, (4) know about art, and (5) make and justify judgments about aesthetic merit and quality of works of art.

These were subdivided into smaller units, and assessment items were devised to determine the degree to which students met these objectives. The items, which were designed with different levels of difficulty, included tasks that usually involved observable behaviors. They were administered to a population of 9- and 13-year-olds from public, parochial, and private schools and from a broad sample of communities from large cities to rural areas. Two art assessments were undertaken, one for the 1974–1975 academic year and the second in the 1978–1979 academic year. Results of these assessments will be discussed later in this chapter.

Criticism of the Accountability Movement

The accountability movement rested on the assumption that management of learning by behavioral objectives was no more than the application of a scientific, value-free technology to the problems of education. This technological approach was seen as an efficient means of providing information on educational effectiveness at the least cost. However, like all technologies, it was better at some tasks than at others. Learning tasks that are standardized are easier to assess than the one-of-a-kind, idiosyncratic, or self-expressive tasks likely to be found in the teaching of art. Thus the technology tends to dictate what is assessed based on what it can best measure.

A second difficulty is created by the demands of the technology itself, which requires an analysis and division of behavior into small specific units. This is made necessary by the requirement that each behavior needs to be precisely identified for the purpose of observation and measurement. This reductionism tends to focus the curriculum task on minutiae, with a resultant loss of larger understandings.

Though behavioral objectives as the means of accountability was mandated in many states, critics of the movement pointed out that these approaches did not necessarily provide more efficiency in instruction and that its latent function was control of the teacher and pupil, but to remain in the schools art educators had to show that art activities were amenable to the same kind of rational, technological manipulation being developed for education as a whole (Duchastel & Merrill, 1973).

Qualitative Inquiry in Art Education

In 1975 William Pinar identified a group of curriculum theorists whom he labeled "reconceptualists." Generally they resisted the use of behavioral objectives as a curriculum-planning device. Among those he named were such individuals as Philip Phenix, Maxine Greene, James Macdonald, Herbert Kliebard, Ross Mooney, and Paul Klohr. Though differing in their particular views of curriculum, they all held holistic or organic views of people and their interdependence with nature, conceived of individuals as agents in the construction of knowledge, valued or relied heavily on personal knowledge, drew upon a broad array of literature from the humanities, valued personal liberty and higher levels of consciousness, and valued diversity and pluralism (Schubert, 1986).

By the mid-1970s a pronounced shift from empirical to qualitative research had occurred. Initially this approach was labeled *participant-observer research*. Later the terms *qualitative research* or *qualitative inquiry* began to be used. Eisner's *The Educational Imagination* (1976b) developed the idea of educational connoisseurship and criticism based on methods of art criticism. Qualitative methods became popular as ways of evaluating educational activities and accomplishments, and as such, the proponents of these methods had a purpose similar to those whose evaluation schemes were based on behavioral objectives. However, they hoped to be able to describe the events of classroom life as a meaningful whole instead of fragments. Other educational researchers went beyond attempts to evaluate teaching and learning. They adopted research methods from anthropology to uncover the social realities in classroom life.

A number of doctoral students in art education have used these qualitative research approaches. Degge (1975) studied the interactions between an art teacher and her students over an extended period of time and concluded that teachers may not always be aware of the actual objectives of their instruction and that the activities they utilize in teaching may not be consistent with the goals they espouse. A study by Sevigny (1977) notes that students and teachers interact with each other on the basis of certain self-fulfilling prophecies they have about each other.

Though qualitative inquiry has been widely adopted as a research method in art education, it has not had the impact on art teaching as has the research on behavioral objectives. However, it has had the effect of reminding evaluators of instruction that classroom life is complex and that the evaluation of art instruction is complicated by the inherently ambiguous nature of its subject matter, where right or wrong answers are not readily forthcoming.

EXCELLENCE AND CRITICAL THEORY
AS RIVAL MOVEMENTS: THE 1980s

As the 1980s opened, a renewed concern for excellence in education began to redirect public attention toward quality in education. A number of reports were issued, such as *A Nation at Risk*, the widely publicized report prepared by the National Commission on Excellence in Education (1983). A second was *High School: A Report on Secondary Education in America* (Boyer, 1983). Both echoed concerns first raised in the post-Sputnik 1950s, though the interest in restoring excellence was triggered this time by rising economic competition in world markets.

These national reports voiced respect for the arts but nevertheless treated them superficially. To remedy this deficiency, the National Art Education Association commissioned a report of its own, *Excellence in Art Education: Ideas and Initiatives* (Smith, 1987a). Smith notes that the idea of excellence enjoyed brief currency in the 1960s and that these earlier discussions centered on improving the teaching of scientific, mathematical, and technological subjects, while current discussions of excellence are at least more balanced, with a number of reports stressing the ideal of "a common, general education that features not only the sciences and mathematics but also the arts, humanities, and foreign languages" (p. 2).

In Smith's view the general goal of art education "is the development of a disposition to appreciate the excellence of art, where the excellence of art implies two things: the capacity of works of art at their best to intensify and enlarge the scope of human awareness and experience and the peculiar qualities of artworks whence such a capacity derives" (p. 16).

In his view, the teaching of art should be approached as one of the liberal arts. He takes issue with the belief that the making of art by children should be at the center of art teaching, and he rejects self-expression and the promotion of creativity as sufficient reasons for teaching art. Further, he suggests that if students are to be involved in the manipulation of the material of art, it should be in order "to help them acquire a feel for artistic design and to grasp ideas that will serve them well in their future commerce with art" (p. 19).

Smith's definition of excellence also denies charges that such an approach contains an element of elitism:

> It is believed that an emphasis on quality represents an unjustifiable imposition of traditional aesthetic values on persons — particularly members of the working class and ethnic groups — to whom such values are purportedly irrelevant. An excellence curriculum for art education is thus forced to defend itself against the charge of elitism. (p. 17)

In his view "there is nothing undemocratic, snobbish, or elitist in want-ing to acquaint young minds with some of the greatest achievements of the human race," and he goes on to argue that excellence is found in all cultures and civilizations, that "so long as the accent is on quality . . . there is no reason to disqualify the art of any group, society, or era" (p. 17).

Smith is comfortable with the idea that professional experts can agree on what these pinnacles of excellence might be, though a perusal of the literature in feminist and African-American art and art history suggests that his confidence is not widely shared. These continue to be controversial topics among art critics and art historians today.

Discipline-Based Art Education

In 1982 the J. Paul Getty Trust held discussions with a group of 17 art educators with a view toward establishing a center for education in the arts. In the following year the center was founded, with LeiLani Lattin-Duke serving as head. It began its work by holding the first of a series of summer institutes in the Los Angeles area to help classroom teachers teach art to elementary school children. The institute staff was headed by W. Dwaine Greer, who originated the term *discipline-based art education* (DBAE), not-ing that it was derived from ideas that first surfaced in the 1960s even though current theory was a departure from these antecedents (Clark, Day, & Greer, 1987). DBAE may be seen as a response to the challenge of excellence, and like the excellence movement itself, it reiterated many of the same themes that were first sounded during the 1960s, when curriculum reforms centered upon the disciplines.

The Getty Center made its publication debut with *Beyond Creating: The Place for Art in America's Schools* (1984). Like the discipline-oriented art curricula proposed during the 1960s, this volume proposed that content was to be drawn from the art studio, art criticism, and art history. To these was added a fourth discipline, the study of aesthetics, but the central idea was the familiar one of basing instruction on the representative ideas of the disciplines comprising art.

Since 1984 interest in DBAE has grown rapidly. For example, the annu-al conferences of the National Art Education Association between 1984 and 1988 reflected an increased attentiveness to this approach, with a large and growing number of conference presentations devoted to this topic. The Get-ty Center commissioned a number of publications to develop the DBAE approach and sponsored conferences advocating DBAE.

Among the more notable of these Getty conferences was one held in Los Angeles in January 1987, which was addressed by Elliot Eisner and Secre-tary of Education William Bennett. Bennett spelled out reasons why it was

important "that disadvantaged children learn about great works and artists that are part of our common culture." The first was the idea that "great works of art form an incomparable record of our past, the evolution of our society," that these are "a principal means of transmitting [the values we cherish] from generation to generation," that art is "a challenge to the intellect" and can inspire us "to worthiness and even greatness," and, finally, that art is among "the best of civilization's products" (Getty Center, 1987, p. 31).

Criticism of the Excellence Movement

When *A Nation at Risk* appeared, many saw it as a way for the Reagan administration to blame the schools for the nation's difficulties in competing in world markets. But because Reagan had promised to reduce the role of the government in education, he was not in a strong position to propose specific remedies for improving education. To many it seemed that the humanities and the Western cultural legacy were being used as a veil to obscure grosser economic objectives to be served by improvements in the teaching of mathematics, the sciences, and computer literacy. Bennett was a strong advocate for the humanities as a way of conserving traditional values. In this respect he was not unlike William Torrey Harris at the turn of the century.

Criticism has been directed both at discipline-based art education as identified with the Getty Trust and at Ralph Smith's *Excellence in Art Education* (1987a) for the conservative tenor of their proposals and for their tendency to see art education as the study of past cultural achievements certified by credentialed experts. Critics (see, e.g., Burton, Lederman, & London, 1988) have claimed that DBAE and the excellence initiative tend to make art learning a passive form of engagement, as symbolized by their reduction in the importance assigned to studio studies. These issues today remain subjects of heated debate.

Critical Theory in Educational Discourse

In the mid-1970s a group of educational historians and philosophers questioned the tendency to take for granted the socioeconomic class structure and the ways in which curricula reproduce and maintain these structures. As a group they attempted to expose social relationships based upon the dominance of one social group over another. Their method of critical analysis tended to be either Marxist or post-Marxist. *Schooling in Capitalist America* (Bowles & Gintis, 1976) was a study of how schools perpetuate inequality. *Ideology and Curriculum* (Apple, 1979) stressed the unacknowledged and often hidden ideological underpinnings of curriculum. "Social

Class and School Knowledge" (Anyon, 1980) examined how the same curriculum was presented differently in schools serving differing social classes in such a way as to maintain class divisions.

Like the qualitative inquiry group, critical theorists have not had a sustained impact upon the field of art education. The Caucus on Social Theory in Art Education, which meets concurrently with the National Art Education Association, has occasionally dealt with topics reflecting the concerns of critical theorists. For example, several have claimed that many educators tend to impose elitist conceptions of art upon students while ignoring multicultural resources for the teaching of art. Nevertheless, there have been no sustained analyses of the structure of ideas in art education as ideological stances bound to dominant or subordinate groups in American society, nor have remedies been proposed to free art curricula from the control of socially dominant groups. In view of the fact that art education has a history of identification with the privileged levels of society, such studies are long overdue.

POSTWAR INNOVATIONS IN ART EDUCATION

Expansion of Art Media

Since the end of World War II there has been a proliferation in the types of art materials used in instruction. Particularly in schools influenced by the progressive educational philosophy, teachers introduced rich, brilliant, and thick tempera colors with large brushes; soft absorbent newsprint in large sizes; and clay for pinching and coiling of animal figures and pots. Activities such as collage, following in the tradition of Braque and Picasso, began to make their appearance.

By the early 1950s it was not uncommon to see such activities as coat-hanger mobiles in imitation of Alexander Calder. Figures 8.2 and 8.3 from *School Arts* show typical projects involving the making of art from scrap materials. These were one of the legacies of the Depression era, when resourceful teachers were forced to rely on discarded materials as potential art media.

Although the Bauhaus preliminary course of instruction first became known in this country during the late 1930s through such teachers as Moholy-Nagy, it was during the postwar era that art schools and departments introduced courses patterned after this course. In this approach, materials were recognized for their unique qualities and different tools were used with these materials to produce an infinite array of visual forms. Art teaching in public schools emulated this teaching at both the elementary and secondary

levels. Such art activities as paper sculpture, the making of collages with
materials of contrasting textures, the rendering of textures in pencil, photo-
grams, and photo collage are examples of studio activities derived from
Bauhaus teachings.

By the early 1960s one also saw evidence that some art history was
being introduced into art classrooms. Examples of such lessons can be
found in *School Arts*. This magazine also featured advertisements for slides
and art reproductions as well as textbooks featuring art appreciation and art
history content.

Uses of Newer Media

In 1966 Vincent Lanier was involved in a study to determine the instructional potential of photographic and electronic media. He argued that traditional art media meant relatively little to the younger generation, that their concepts of reality were based upon the images generated by photography, cinema, and television, and that in many respects contemporary students were more familiar with cameras and electronic gadgetry than either their teachers or parents. He argued that art teachers needed to become more familiar with these newer media.

His advice has become more salient as the list of newer media has expanded to include videocassette recorders and portable cameras for making films. In addition, the microcomputers and software that enable one to create, manipulate, and store images, are likely to revolutionize the ways art teachers think about media (Lanier, 1966).

FIGURE 8.3. Illustrations showing the making of art with scrap materials, from *School Arts* (1964), *64* (9), 37. Reproduced by permission.

New Content as an Issue in Art Education

The availability of new media was one means by which the content of
modern art began to enter art classrooms, but new sources of content also
appeared in response to political and social movements. The civil rights
movements generated a demand for the art forms of ethnic minorities, in-
cluding the study of living African-American and Native American artists,
while the feminist movement generated an interest in the work of women
artists. These movements also led to scholarly study that brought to light
minority and women artists whose work had previously been neglected.
Evidence of this change can be seen by comparing the initial 1962 edition of
Janson's *History of Art* with more recent editions. The early editions fea-
tured no women artists, and non-Western art was relegated to a postscript.
The more recent editions, though firmly rooted in the Western art, deal to a
greater extent with the work of other cultures; they also discuss some con-
temporary women artists. Feldman's *Varieties of Visual Experience* (1972),
in contrast to Janson, is more representative of the diversity of cultures,
religions, geographic regions, genders, and social movements, thus reflect-
ing a greater sensitivity to the political and social climate of the 1970s and
1980s.

THE STATUS OF ART EDUCATION

Founding of National Art Education Association

In 1987 the National Art Education Association celebrated its fortieth
anniversary. The organization was formed by the union of four regional art
teachers associations and the Art Education Department of the National
Education Association. The origins of the Eastern and Western Arts Associ-
ations themselves, we might recall from Chapter 6, went back to the last
century. The Southeastern Art Education Association was formed shortly
after the Eastern Arts Association, while the Pacific Arts Association was
organized during World War II.

An organizational meeting was held in Atlantic City in 1947 comprised
of representatives from the four regional associations and representatives of
the Art Education Department of the National Education Association. Each
of the regional associations voted to form a national association at their
spring meetings, and in July 1947 the leaders of these groups met in Cincin-
nati to establish the NAEA. The first conference was held in 1948 in Atlan-
tic City, and Edwin Ziegfeld served as the first president. The regional
organizations did not lose their identity, and in alternate years they held

regional conferences. The national organization met every two years. In the late 1960s the regional conferences were discontinued and the national conference became an annual event. At its founding the NAEA consisted of 3,500 members, while the 1987 membership approached 11,000, a number that represents about one-fifth of the art teachers, art supervisors, and art teacher educators in the country.

Surveys of Art Education

In 1963 the National Education Association conducted a survey of the teaching of art and music in the United States (NEA, 1963). It revealed that in 75 percent of the elementary schools art is taught by the elementary classroom teacher, that only 25 percent have the services of an art specialist. Chapman (1982) found that in 1979 only about 18 percent of elementary schools had the services of art teachers. With the decline in the number of supervisory positions noted earlier, it is clear that most classroom teachers receive little or no help with the teaching of art. A typical art teacher, she reports, may serve from 500 to 1,500 youngsters, with a teaching schedule that permits little more than a trifle of art instruction for large numbers of pupils. This may help explain why the knowledge and understanding of art possessed by most children is limited.

In the 1974–1975 academic year the National Assessment of Educational Progress (NAEP) conducted the first of two surveys on art achievement. On the drawing and design items in the first assessment, there was no significant difference in overall quality between those youngsters in schools where art was taught and those where it was not taught. This assessment also revealed that of the 9-year-olds surveyed, "27 percent do not think it is important for them to express themselves through art; 34 percent do not create art outside of school; 38 percent have never been to an art museum; [and] 46 percent can offer no answer when asked, 'why is art important?'" (Chapman, 1982, p. 65). Similar results were obtained with the second art assessment, performed in 1979, with declines in scores noted in the area of valuing art.

Chapman notes that the one required art course in the junior high school, given in either the seventh or eighth grade, involves about 90 hours of instruction. Chapman also explains that the NAEP assessment findings for middle school students were similar to those for elementary school students, namely that the one year of exposure to art did little to provide students with a knowledge of art and that few children find value in it.

Chapman's description of high school art programs is equally dismaying, though since her book appeared in 1982, a number of states have mandated a year of study in one of the arts as a requirement for graduation.

In a report prepared for the National Endowment for the Arts, Wilson (1988) found that 19 percent of ninth- and tenth-graders and 16 percent of eleventh- and twelfth-graders were enrolled in art classes. The report also noted that in 1982 only 18 percent of the school districts in the country had specific graduation requirements relating to the fine arts, while 36 percent currently have these requirements. This new trend is a hopeful sign.

This lack of quality art education has been ascribed to a number of causes, including the longstanding myths that art is for the talented few or that it is an easy, soft, nonacademic subject. The lack of intellectual esteem has to some extent been engendered by art educators themselves through their reticence to teach art appreciation for fear of squelching self-expression. But the tendency to regard art as an intellectually inferior subject also has had a long career in the history of ideas, going back to Plato. We can say with some justification that the history of art education is as much a history of reasons for not teaching art as it is a history of movements that succeeded in bringing it into general education.

CONCLUSIONS

This chapter described a series of post–World War II movements in art education, placing them within three streams of influence that are discernible in education generally: the expressionist, reconstructionist, and scientific rationalist streams. All of these streams emerged from influences that were in evidence throughout this century and the last.

By the *expressionist stream* I refer to that set of beliefs, grounded in nineteenth-century romantic idealism, that placed the artist in the vanguard of society. This impulse gave rise to the kindergarten movement; it was expressed in the rebellion against academic rules; it can be seen in the radical art styles of the avant-garde and their manifestos calling for the discard of dead artistic traditions in favor of the free expression of the artist. This stream frequently moved toward a pedagogy with fewer social constraints and expanded possibilities for personal expression. However, romantic idealism also gave rise to conservative initiatives, as we saw in Harris's wish to use art to impose traditional morality in the 1890s.

During the twentieth century "the child as artist" became wedded to the artist's struggle to achieve expressive freedom. The educational counterpart of this was the child-centered school, with creative self-expression as the principal goal. In the nineteenth century the artist was seen as the redeemer of society, the giver of forms that embodied the collective vision of humanity; in the twentieth, it was the child artist who was perceived as expressing universal truths in the unifying symbols of the collective unconscious, an

expression that was to work in the service of peace and civilization. The child artist was given the role of the savior of society.

The expressive stream, best represented by the ideas of Viktor Lowenfeld and Herbert Read, was dominant between 1945 and 1960. Since the mid-1960s the belief in self-expression has declined, though certain aspects of it lived on in the movement for open classrooms and informal alternative schools.

By the *reconstructionist stream* I refer to the general belief that education is a force that can transform society. In the last century it appeared in the common school ideal, which perceived the school, in the words of Horace Mann, as "the balance wheel of the social machinery" (Massachusetts Board of Education, 1849, p. 59). In the last chapter we saw it at work in George Counts's manifesto *Dare the School Build a New Social Order?* and in the Owatonna art education project. Throughout the late 1960s and 1970s this stream surfaced as an arts-in-education movement that saw art as a tool to enliven the school climate by its vitality.

By *scientific rationalism* I refer not to science proper but to ideologies that found their warrant in science, such as the social Darwinism of the end of the nineteenth century. Since World War II this stream has taken the form of a movement to use the disciplines as defined by science as a basis for curriculum reform. The technological side of science also gave rise to the accountability movement.

The social Darwinism of the late nineteenth and early twentieth centuries embraced a conservative ideology that channeled the school curriculum in directions favored by the businessman. This leads us to ask whether these recent manifestations of scientific rationalism are likewise grounded in conservative ideology. Is the scientific influence that nurtured the discipline movement based in a science that is interested in knowledge for its own sake, as the pure scientist would claim, or is it shaped by the economic and military powers that subsidize the sciences? In 1960 few would have regarded the Woods Hole Conference as the partisan expression of what President Eisenhower called "the military-industrial complex, yet the discipline-oriented movement was a direct response to Cold War pressures and to attempts by federal agencies to design educational policies to cope with a national crisis. Do those circumstances allow us to conclude that these were conservative policies?

The answer is not a simple yes or no. The discipline-oriented movement had a conservative impact in narrowing the styles of educational reform and applying that style to subjects for which it may have been inappropriate. Yet in its emphasis upon learning by discovery and in the idea that learners can be their own agent in the production of knowledge the movement was liberal in its educative aspirations. The parallel between science and art can be

found in the writings of Jerome Bruner, who used such words as *serendipity* and *intuition*—words generally associated with artistry—to describe the activities of the scientist. This gave art educators hope that the teaching of art could benefit if the path taken by the science educators was followed. The question remains whether that was the appropriate path for art education.

The accountability movement was also driven by science, but not science in the pure sense. One might better describe it as an application of technologies derived from scientific procedures and preoccupied with objective observation, measurement, and quantification. These features were not taught, rather they were techniques used to evaluate students and the amount of knowledge they had acquired through instruction. The emphasis shifted from the production of knowledge to its reproduction in the minds of pupils.

This shift to preestablished instructional objectives changed the view of knowledge. Knowledge became something already known by the teacher rather than something that can be the result of the student's own intellectual activity. Educational success was defined by how much of the teacher's knowledge was passed on to the student, not by the insights, inventions, or discoveries of the student. Education in this sense is a form of social control, and though control may be used for humane purposes, its exercise is invariably conservative, since the intellectual freedom of the learner is not trusted to achieve socially valued results.

TOWARD A HARMONIOUS CONFLUENCE

Throughout the century art education was strongly influenced by ideas emanating from general education as a whole. The dominance of these streams changed from time to time in response to the prevailing social climate, to social circumstances, and to socially powerful groups. As each stream moved into a position of dominance, its value orientation was heralded as having universal validity. Its goals, methods, and aspirations became canonical—of such obvious worth as to be beyond question. No single stream of influence is likely to be dominant for all seasons and for all persons.

And although these major streams come and go, their historical effects may linger long after the movement itself has become history. Progressivism ceased being the vanguard movement it was in the 1920s, for example, yet many of its initial innovations have become part of the standard practice of schooling.

Often, too, movements do not really die out; instead they assume different guises. The social efficiency movement of 1910 became the scientific

movement of the 1920s and reappeared as the accountability movement of the 1970s. The excellence movement of the 1980s recalls the discipline-oriented movement of the 1960s, while the creative self-expression of the 1920s reappears in the writings of Read and Lowenfeld in the 1940s. Finally, the reconstructionism of the Depression era made a come-back in the arts-in-education movement. This is not to say that each recurrence is identical with its previous incarnations, rather, there are sufficient similarities to enable us to draw comparisons between present circumstances and those of the past and thus to become mindful of past mistakes and missed opportunities.

The current move in art education seems to be toward a pedagogical formalism derived from discipline-oriented curriculum initiatives, with their emphasis on structure and sequence. At other times art education has moved toward freedom from pedagogical constraints, as seen in the self-expression philosophy that arose after World War I and again after World War II. One wonders whether it might be possible to strike a balance between these tendencies, something akin to the balance Plato sought between the music and gymnastics of his day. Today we are apt to talk in terms of balance among the arts, the sciences, and the humanities.

If one aspect such as science becomes dominant, as we have seen in the last generation, the balance might easily elude us. Their differences should be kept in mind. The arts make a virtue of affective engagement and participatory learning, celebrating the life of feeling and imagination. Science, by contrast, makes a virtue of objective detachment and precision, celebrating rational thinking, while the humanities make a virtue of the quest for moral action. Each family of studies requires its own forms of cognition and is essential to fill out the picture of reality. As part of general education the arts have their role to play.

In this century, the conflict in art education has been between those intent upon teaching the content of art and those seeing it as self-expression. In the name of self-expression children were frequently left to their own devices and were denied access to knowledge that could enlighten their personal investigations of art. And yet, in the insistence upon teaching art techniques, or the names and dates of art styles, or the elements and principles of design, one might easily lose touch with art as it enables human beings to realize their spirit and their destiny in the actions and products of the imagination. It remains to be seen how the drama of art education's future will be acted out.

Notes

Chapter 1

1. Kavolis discusses patronage and censorship systems as well as the systems of diffusion that deliver the arts to their various publics. Education is discussed as one of these systems. See also Kavolis (1973).

2. In their second chapter the Wittkowers contrast the changing relationships of artist and patron that occurred during the Middle Ages and the Renaissance. They also discuss effects of competition among patrons for the services of artists. For a similar discussion see also Hauser (1951), vol. 2, chap. 3.

3. Pevsner is the definitive secondary source on the Italian academies of art during the Renaissance and the French Academy. For an analysis of changes in nineteenth-century teaching methods see Boime (1971); see also Brown University (1984).

Chapter 2

1. Castle (1961) provides a lucid overview of Greek and Roman education. Castle makes use of H. I. Marrou's treatment of the same period, which is more detailed but less readable.

2. I do not cite a specific volume of Plato's *Republic* since there are many publications. The references to Plato's writings refer to the specific book and paragraph numbers, which are the same in all translations. For discussions of Plato's educational writings see I. E. Adamson, *The theory of education in Plato's Republic* (London: S. Sonnenschein, 1903); see also R. L. Nettleship, *The theory of education in the* Republic *of Plato* (Chicago: University of Chicago Press, 1906) and R. Barrow, *Plato and education* (London: Routledge & Kegan Paul, 1976). For Plato's aesthetic theory, see I. Murdock, *The fire and the sun* (Oxford: Clarendon Press, 1977) and E. Schaper, *Prelude to Aesthetics* (Oxford: Oxford University Press, 1968).

3. Marrou places great credence in the evidence suggesting that drawing had become an accepted part of Hellenistic education. See also Jaeger (1943–1945), Vol. 2, p. 228.

4. My discussion of Plato's aesthetics is based on Beardsley (1966) and Schaper (1968).

5. Vitruvius' *De Architectura* is cited by both Marrou and Gwynn to illustrate the point that differing views of the liberal arts prevailed among the Romans. The concept of the seven liberal arts apparently was codified not during Roman times but during the early Middle Ages.

6. Perrine (1937) is my chief secondary source on the economic history of Europe. Arnold Hauser (1951) also relies on Perrine. I used Perrine because of its congruence with Hauser, who was my chief source on art teaching in the guilds and academies.

Chapter 3

1. Bell's (1963) and Sutton's (1967) accounts of the English schools of design are based upon two key parliamentary reports. The first is the *Report from the Select Committee on Arts and their Connexion with Manufactures* (British Sessional Paper IX: 1836), while the second is the *Report from the Select Committee on the School of Design* (British Sessional Paper XVIII: 1849).

2. When Henry Barnard printed Ravaisson's report in *Barnard's American Journal of Education*, he added the following headnote on its source without providing the date of the original: "This article was originally translated for the *Dublin Journal of Industrial Progress*, from the *Bulletin de la Societe d' Encouragement pour l' Industrie Nationale* (2d Sec. No. 5). It is part of a report addressed to the Minister of Public Instruction in France, by a commission consisting of Messers Felix Ravaisson (Inspector General of Superior Instruction), Brongiart, Ingres, Picot, Simart, Belloc, Eugene Delacroix, Hippolyte Flandrin, Meissonier, Jouffroy, Duc, and Pillet: The Reporter was M. Ravaisson."

3. Portions of this chapter are based on my paper "School Art and its Social Origins" (1983b).

Chapter 4

1. To compare the introduction of vocal music in 1838 with the introduction of drawing in the 1870s, see also my "The Introduction of Music and Drawing in the Boston Schools: Two Studies of Educational Reform," in B. Wilson & H. Hoffa (Eds.), *History of Art Education: Proceedings of the Penn State Conference* (Reston, VA: National Art Education Association, 1985, pp. 113–124).

2. My account of Fowle is based on Green (1948), who based his account on Clarke (1885), and the biographical article in *Barnard's American Journal of Education* in 1861. Recent work on Fowle based on primary sources is lacking.

3. Spring (1986) cites an entry from Mann's diary dated June 11, 1837, in which he describes a riot between Protestants and Irish Catholics. It was this incident that strengthened his resolve to accept the post of secretary for the Massachusetts Board of Education.

4. Ashwin (1981) provides a detailed account of at least three drawing manuals that were derived from Pestalozzian principles, which makes it quite clear that Mann

and Barnard were mistaken in ascribing Peter Schmid's teaching method to Pestalozzi.

5. A version of Krusi's inventive drawing appeared in Sheldon, E. A. (1869), *A manual of elementary instruction*, New York: Charles Scribner & Co., pp. 424–460.

6. Biographies of Perkins can also be found in the *Dictionary of American biography* (12:464–465), and in Clarke (1892), pp. xxxviii–xli. See also Justin Winsor, *Memorial history of Boston* (Boston: J. R. Osgood & Co., 1880).

7. Biographic information on Smith was amplified by Korzenik's (1985) account of Smith's early life and work in England prior to his immigration to the United States. Green (1948, 1966) provides a detailed account of the controversies Smith was involved in from about 1879 until his dismissals in 1881 and 1882. Green, who tends to dwell on Smith's personality as a contributing source of his difficulties, relied on newspaper accounts from the Boston *Daily Advertiser*. From my perusal of the Boston *Evening Transcript* it would appear that he was subjected to some pointed anti-British feeling. See the February 24, 1881, editorial called "An Unamerican System."

8. I have gone into extensive detail on the matter of Smith's dismissal to correct the accounts in Green (1948) and Clarke (1892), which suggest that he was dismissed due to the absence of his supporters on the school committee. My interpretation of Smith's difficulties was influenced by Katz (1971). Katz describes a reformist group on the school committee headed by Brooks Adams that had rebelled against Philbrick's bureaucratic style of administration. With the dismissal of Philbrick in 1878, Smith was likely to be politically vulnerable. Perkins, as head of the drawing committee, had attempted to placate this faction on the school committee by cutting back on the number of Smith's assistants in 1879, but when Smith began to extend the drawing program with a reduced staff, his troubles were exacerbated by the hostility of the high school teachers.

Chapter 5

1. Robert Saunders's (1961) study of Elizabeth and Mary Peabody and Horace Mann sheds light on the role of the kindergarten movement in the history of art education.

2. Unless otherwise noted, references to Ruskin's works are to the edition of his publications prepared by Edward T. Cook and Alexander Wedderburn (1903–1912).

3. A portion of this section is based on my article "Art and Education for Women in Nineteenth Century Boston" (1985).

Chapter 6

1. Cremin (1964) and Callahan (1962) served as my major secondary sources in this chapter. My discussion of science was guided primarily by Cremin's fourth chapter and my discussions of Parker and Dewey, by his fifth chapter. My under-

standing of Parker's contributions to art education were also influenced by Korzenik (1984, 1985).

2. Grosser stresses the impact of changing technology, while Fleming adds the impact of such social sciences as anthropology and psychology as agents changing the understanding of the artistic process and its role in human affairs.

3. It is not that scientific reductionism is necessarily good or bad, but simply that this is part of the consciousness of the twentieth century and may explain why abstract art rather than some other style developed in this century.

4. The irony of the arts-and-crafts movement was that for all of its socialist propensities, it tended to be an art style for the affluent and not an art for the common people. The connection of the arts-and-crafts movement with political socialism is a theme I do not explore because socialist thought did not take root among American art educators. Purdue (1977) examines the negation of socialist influence in American art education.

5. Throughout its nearly 90 year history, *School Arts* underwent several name changes. It first appeared as the *Applied Arts Book* (Vols. 1 & 2, 1901–June 1903); then it became *School Arts Book* (Vols. 3–11, September 1903–June 1912), and then *School Arts Magazine* (Vols. 12–34, September 1912–June 1935). The title *School Arts* first appeared in September 1935 and continues to the present.

Chapter 7

1. My idea of three streams was based in part on Cremin's (1964) treatment of progressivism.

2. Mimi Fraenkl studied design with Cizek in 1924 as a young adult. In 1981, she gave her grandson (my son) a picture that she made as an adolescent (1918–1919 or 1919–1920). It was made with colored papers that were pasted together. On the reverse side of the picture she wrote about her teacher, Mrs. Seidl, and she described the contents of the picture itself.

3. Peter Smith (1987) looks at some of the English-speaking critics of Cizek and presents some evidence that their stylistic biases may have altered our understanding of Cizek's methods. Yet the illustrations reproduced in Cizek (1927) are among the more problematic ones, since they were selected for reproduction by Cizek himself and bear the obvious marks of his direct instruction.

Chapter 8

1. Hoffa (1970) describes this three-day conference, noting that it had degenerated into a shouting match between professional artists and college art educators. The Yale seminar in music education held in 1963 was also noteworthy in that its organizers tended to exclude music educators from participation and blamed them for the low status of music education in the schools.

2. In my paper (1988) I question this conclusion of Barkan. In stressing the similarities between the activities of artists and scientists one loses sight of what is distinctive about them, and in Barkan's case he conflated the two. Nevertheless

Barkan's paper set the agenda for curriculum work in art education for the next 20 years.

3. My curriculum antecedents paper (1987) looks at curriculum development projects from 1966 to 1980. It may create the impression that the discipline-based art education initiative of the mid-1980s is the logical outcome of a long process of evolution, a view that I do not espouse. In depicting here some of the alternative and somewhat conflicting tendencies of art education in the last 20 to 25 years, I hope that I have managed to create a more balanced account.

References

Abrams, M. (1953). *The mirror and the lamp: Romantic theory and the critical tradition*. New York: Oxford University Press.

Addams, J. (1964). *Democracy and social ethics*. Cambridge, MA: Belknap Press. (Original work published in 1902)

Addison, J. D. (1908). *Arts and crafts of the middle ages*. Boston: Page Co.

Adler, M. J. (1977). *The paideia proposal: An educational manifesto*. New York: Macmillan.

Alcott, A. B. (1836–1837). *Conversations with children on the gospels*. Boston: J. Munroe & Co.

Anyon, J. (1980). Social class and school knowledge. *Curriculum inquiry, 11*(1), 3–42.

Apple, M. (1979). *Ideology and curriculum*. London: Routledge & Kegan Paul.

Aristotle. (1952) *Aristotle's politics and poetics* (B. Jowett & T. Twining, Trans.). Cleveland, OH: Fine Editions Press.

Arts Education and Americans Panel. (1977). *Coming to our senses*. New York: McGraw Hill.

Ashwin, C. (1981). *Drawing and education in German-speaking Europe: 1800–1900*. Ann Arbor, MI: UMI Research Press.

Ayer, F. C. (1919). Present status of instruction in drawing with respect to scientific investigation. *NSSE Eighteenth Yearbook*. Bloomington, IL: Public School Publishing Co.

Bailey, H. T. (1889). Report of Henry T. Bailey, agent of the board for the promotion of industrial drawing. In Massachusetts Board of Education. *Fifty-first annual report of the board of education, 1887–1888*. Boston: Wright and Potter Printing Co.

Bailey, H. T. (1897). Report of Henry T. Bailey, agent of the board for the promotion of industrial drawing. In Massachusetts Board of Education. *Sixtieth annual report of the board of education, 1896–1897*. Boston: Wright and Potter Printing Co.

Bailey, H. T. (1900). Report of Henry T. Bailey, agent of the board for the promotion of industrial drawing. In Massachusetts Board of Education, *Sixty-third annual report of the board of education, 1899–1900*. Boston: Wright and Potter Printing Co.

Bailey, H. T. (1903). Report of Henry T. Bailey, agent of the board for the promotion of industrial drawing. In Massachusetts Board of Education, *Sixty-sixth annual report of the board of education, 1901-1902*. Boston: Wright and Potter Printing Co.

Bailey, H. T. (1905). Schoolroom decoration. *School arts book, 5*, 383-395.

Bailey, H. T. (1908). Picture study: A symposium. *School arts book, 7*, 482-499.

Bailey, H. T. (1910). *The flush of the dawn: Notes on art education*. New York: Davis Press.

Bailey, H. T. (1914). The great transition. *School Arts Magazine, 14*(1), 1.

Bailey, L. H. (1920). *The nature study idea*. New York: Macmillan. (Original work published 1903)

Baker, D. W. (1982). *Rousseau's children: An historical analysis of the romantic paradigm in art education*. Unpublished doctoral dissertation. Pennsylvania State University, University Park.

Barasch, M. (1985). *Theories of art from Plato to Winckelmann*. New York: New York University Press.

Barkan, M. (1955). *A foundation for art education*. New York: Ronald Press.

Barkan, M. (1962). Transition in art education: Changing conceptions of curriculum and theory. *Art Education, 15*(7), 12-18.

Barkan, M. (1966). Curriculum problems in art education. In E. Mattil (Ed.), *A seminar in art education for research and curriculum development* (pp. 240-255). (U.S. Office of Education Cooperative Research Project No. V-002). University Park: Pennsylvania State University.

Barkan, M., & Chapman, L. (1967). *Guidelines for art instruction through television for the elementary schools*. Bloomington, IN: National Center for School and College Television.

Barkan, M., Chapman, L., & Kern, E. (1970). *Guidelines: Curriculum development for aesthetic education*. St. Louis, MO: CEMREL.

Barnard, H. (1839). Royale realschule in Berlin. *Connecticut Common School Journal, 2*, 301.

Barnard, H. (1861). William Bentley Fowle. *Barnard's American Journal of Education, 10*, 597-610.

Barnard, H. (1890). *Kindergarten and child culture*. Syracuse, NY: C. W. Bardeen Co.

Barnard, H. (1906). *Pestalozzi and his educational system*. Syracuse, NY: C. W. Bardeen Co.

Barnes, E. (Ed.). (1896-97). *Studies in education: A series of ten numbers devoted to child study and the history of education*. Palo Alto, CA: Stanford University.

Barnes, E. (Ed.). (1902). *Studies in education: A series of ten numbers devoted to child-study: Volume II*. Philadelphia: n.p.

Barr, A. H. (1959). Preface. In H. Bayer, W. Gropius, & I. Gropius (Eds.), *Bauhaus: 1919-1928* (pp. 5-7). Boston: Charles T. Branford Co. (Original work published 1938)

Beardsley, M. (1966). *Aesthetics from classical Greece to the present*. New York: Macmillan.

Bedell, M. (1980). *The Alcotts: Biography of a family.* New York: Crown.

Bell, Q. (1963). *The English schools of design.* London: Routledge & Kegan Paul.

Bennett, C. A. (1937). *History of manual and industrial education: 1870-1917.* Peoria, IL: Charles A. Bennett Co.

Bestor, A. (1953). *Educational wastelands.* Urbana, IL: University of Illinois Press.

Bigelow, E. B. (1877). *The tariff policy of England and the United States contrasted.* Boston: Little, Brown.

Bleeke-Byrne, G. (1984). The education of the painter in the workshop. In Brown University Department of Art, *Children of Mercury* (pp. 28–39). Providence, RI: D. W. Bell Gallery.

Blunt, A. (1963). *Artistic theory in Italy: 1450-1600.* Oxford: Clarendon Press.

Bobbitt, F. (1924). *How to make a curriculum.* Boston: Houghton Mifflin.

Boime, A. (1971). *The academy and French painting in the nineteenth century.* London: Phaidon Press.

Bolin, P. E. (1986). *Drawing interpretation: An examination of the 1870 Massachusetts "act relating to free instruction in drawing".* Unpublished doctoral dissertation, University of Oregon, Eugene.

Bolin, P. E. (1985). The influence of industrial policy on the enactment of the 1870 Massachusetts free instruction in drawing act. In B. Wilson & H. Hoffa (Eds.), *The history of art education: Proceedings from the Penn State Conference* (pp. 102–107). Reston, VA: National Art Education Association.

Boller, P. (1974). *American transcendentalism: An intellectual inquiry.* New York: G. P. Putnam & Son.

Boston Evening Transcript. (1881, February 24). An un-American system. P. 4.

Boston School Committee. (1871). Report of the committee on drawing. In *Annual report of the school committee of the city of Boston: 1870.* Boston: Rockwell and Churchill City Printers.

Boston School Committee. (1872). Report of the committee on drawing. In *Annual report of the school committee of the city of Boston: 1871.* Boston: Rockwell and Churchill City Printers.

Boston School Committee. (1873a). *Annual report of the school committee of the City of Boston: 1872.* Boston: Rockwell and Churchill City Printers.

Boston School Committee. (1873b). Report of the superintendent. In *Annual report of the school committee of the city of Boston: 1872.* Boston: Rockwell and Churchill City Printers.

Boston School Committee. (1874a). Report of the committee on drawing. In *Annual report of the school committee of the city of Boston: 1873.* Boston: Rockwell and Churchill City Printers.

Boston School Committee. (1874b). Annual report of the superintendent. In *Annual report of the school committee of the city of Boston: 1874.* Boston: Rockwell and Churchill City Printers.

Boston School Committee. (1874c). Report of the committee on drawing. In *Annual report of the school committee of the city of Boston: 1874.* Boston: Rockwell and Churchill City Printers.

Boston School Committee. (1875a). *Annual report of the school committee of the city of Boston: 1875*. Boston: Rockwell and Churchill City Printers.

Boston School Committee. (1875b). Report of the committee on drawing. In *Annual report of the school committee of the city of Boston: 1875*. Boston: Rockwell and Churchill City Printers.

Boston School Committee. (1877). Report of the committee on drawing. In *Annual report of the school committee of the city of Boston*. Boston: Rockwell and Churchill City Printers.

Boston School Committee. (1878). Report of the committee on music and drawing. (School Document #20). In *Annual report of the school committee of the city of Boston: 1878*. Boston: Rockwell and Churchill City Printers.

Boston School Committee. (1879). Report of the committee on music and drawing. (School Document #27). In *Annual report of the school committee of the city of Boston: 1879*. Boston: Rockwell and Churchill City Printers.

Boston School Committee. (1881). *Proceedings of the school committee of the city of Boston*. Rockwell and Churchill City Printers.

Bowles, S., & Gintis, H. (1976). *Schooling in capitalist America*. New York: Basic Books.

Boyer, E. L. (1983). *High school: A report on secondary education in America*. New York: Harper & Row.

British Sessional Papers. (1836). *IX: Report from the select committee on arts and their connexion with manufactures, with the minutes of evidence, appendix and index*. August 16, 1836.

Broudy, H. (1972). *Enlightened cherishing*. Urbana: University of Illinois Press.

Broudy, H. S., Smith, B. O., & Barnett, J. R. (1964). *Democracy and excellence in American secondary education: A study in curriculum theory*. Chicago: Rand McNally.

Brown University, Department of Art staff. (1984). *Children of Mercury: The education of artists in the sixteenth and seventeenth centuries*. Providence, RI: D. W. Bell Gallery.

Bruner, J. (1960). *The process of education*. Cambridge, MA: Harvard University Press.

Bruner, J. (1961). *On knowing: Essays for the left hand*. Cambridge, MA: Harvard University Press.

Bruner, J. (1965). *Toward a theory of instruction*. Cambridge, MA: Belknap Press.

Burton, J., Lederman, A., & London, P. (Eds.) (1988). *Beyond DBAE: The case for multiple visions of art education*. North Dartmouth, MA: University Council on Art Education.

Callahan, R. (1962). *Education and the cult of efficiency*. Chicago: University of Chicago Press.

Callen, A. (1979). *Angel in the studio: Women in the arts and crafts movement: 1870-1914*. London: Astragal Books.

Cane, F. (1932). Art in the life of the child. In G. Hartman & A. Shumaker (Eds.), *Creative expression* (pp. 42-49). New York: John Day & Co.

Cane, F. (1951). *The artist in each of us*. New York: Pantheon Books.

Castiglione, B. (1561). *The book of the courtier* (G. Bull, Ed. & Trans.). Baltimore: Penguin Books. (Original work published 1561)

Castle, E. B. (1961). *Ancient education and today*. Baltimore: Penguin Books.

Cennini, C. (1933). *Il Libro Dell' Arte* (D. V. Thompson, Trans.). New Haven, CT: Yale University Press.

Chapman, J. G. (1858). *The American drawing book*. New York: J. S. Redfield. (Original work published 1847)

Chapman, L. H. (1982). *Instant art, instant culture: The unspoken policy for American schools*. New York: Teachers College Press.

Chapman, L. H. (1987). *Discover art*. Worcester, MA: Davis Publishing Co.

Cizek, F. (1927). *Children's cut paper work*. Vienna: Anton Schroll Co.

Clark, G., Day, M., & Greer, W. D. (1987). Discipline-based art education: Becoming students of art. *Journal of aesthetic education, 21*(2), 129–196.

Clark, J. S. (1894). Art in secondary education: An omission by the committee of ten. *Educational review, 7*, 375–381.

Clark, K. (Ed.). (1964). *Ruskin today*. New York: Penguin Books.

Clarke, I. E. (1875). *The relation of art to education* (Circular of information #2, U.S. Bureau of Education for the year 1874). Washington: U.S. Government Printing Office.

Clarke, I. E. (1885). *Art and industry: Education in the industrial and fine arts in the United States: Part I, Drawing in public schools*. Washington, DC: U.S. Government Printing Office.

Clarke, I. E. (1892). *Art and industry: Education in the industrial and fine arts in the United States: Part II, Industrial and manual training in public schools*. Washington, DC: U.S. Government Printing Office.

Clarke, I. E. (1897). *Art and industry: Education in the industrial and fine arts in the United States: Part III, Industrial and technical training in voluntary associations and endowed institutions*. Washington, DC: U.S. Government Printing Office.

Cleveland Board of Education. (1928). *Report of the superintendent of schools to the board of education of the city school district of the city of Cleveland for the school year 1927–1928*. Cleveland: Board of Education, Division of Publications.

Cleveland Board of Education (1936). *Report of the superintendent of schools to the board of education of the city school district of the city of Cleveland for the school year 1935–1936*. Cleveland: Board of Education, Division of Publications.

Cole, N. (1940). *The arts in the classroom*. New York: John Day Co.

Committee of Ten. (1895). Report of the Committee of Ten. In *Report of the Commissioner of Education for the year 1892–93*, Vol. II. Washington, DC: U.S. Government Printing Office.

Connell, W. F. (1980). *A history of education in the twentieth-century world*. New York: Teachers College Press.

Cook, E. T. (1890). *Studies in Ruskin*. London: George Allen.

Cooke, E. (1912). The basis and beginnings of brushwork. In H. Holman (Ed.),

The book of school handwork (Vol. 1, pp. 92–108). London: Caxton Publishing Co.

Counts, G. S. (1978). *Dare the school build a new social order?* Carbondale: Southern Illinois University Press. (Original work published 1934)

Cowley, M. (1951). *Exiles return.* New York: Viking Press. (Original work published 1934)

Crane, W. (1905). *Ideals in art: Papers, theoretical, practical, critical.* London: George Bell & Sons.

Cremin, L. (1964). *Transformation of the school.* New York: Vintage Books.

D'Amico, V. (1953). *Creative teaching in art.* Scranton, PA: International Textbook Co. (Original work published 1942)

Da Vinci, L. (1958). *Notebooks of Leonardo Da Vinci* (E. MacCurdy, Trans.). New York: George Braziller.

Davis, D. J. (1969). *Behavioral emphasis in art education.* Reston, VA: National Art Education Association.

Dean, M. S. (1924). *History of the Massachusetts Normal Art School: 1873-4 to 1923-4.* Boston: Massachusetts Normal Art School.

Dearborn, N. H. (1925). *The Oswego movement in American education* (Teachers College Contributions to Education No. 183). New York: Teachers College, Columbia University.

Degge, R. (1975). *A case study and theoretical analysis of the teaching practices in one junior high art class.* Unpublished doctoral dissertation, University of Oregon, Eugene.

Dewey, J. (1953). *Democracy and education.* New York: Macmillan. (Original work published 1916)

Dewey, J., & Dewey, E. (1915). *Schools of tomorrow.* New York: Dutton.

Dill, S. (1919). *Roman society from Nero to Marcus Aurelius.* London: Macmillan.

Dorner, A. (1959). The background of the Bauhaus. In H. Bayer, W. Gropius, & I. Gropius (Eds.), *Bauhaus: 1919-1928* (pp. 9–19). Boston: Charles T. Branford Co.

Dow, A. W. (1913). *Composition.* New York: Doubleday Doran. (Original work published 1899)

Duchastel, P., & Merrill, P. (1973). The effects of behavioral objectives on learning: A review of empirical studies. *Review of educational research, 43*(1), 53–59.

Duffus, R. L. (1928). *The American renaissance.* New York: Alfred Knopf.

Dunton, L. (1888). *A memorial of the life and services of John D. Philbrick.* Boston: New England Publishing Co.

Dwight, M. A. (1859). Art, its importance as a branch of education. *Barnard's American Journal of Education, 4,* 191–198.

Eddy, J. (1980). Case study: University City—Ten years of age. In C. Fowler (Ed.), *An arts in education source book: A view from the JDR 3rd fund* (pp. 25–54). New York: JDR 3rd Fund.

Efland, A. (1983a). Art education during the great depression. *Art Education, 36*(6), 38–42.

Efland, A. (1983b). School art and its social origins. *Studies in Art Education, 24,* 49–57.

Efland, A. (1984). Curriculum concepts of the Penn State Seminar: An evaluation in retrospect. *Studies in Art Education, 25*(4), 205–211.

Efland, A. (1985). Art and education for women in nineteenth century Boston. *Studies in Art Education, 26*(3), 133–140.

Efland, A. (1987). Curriculum antecedents of discipline-based art education. *Journal of Aesthetic Education, 21*(2), 57–94.

Efland, A. (1988). How art became a discipline: Looking at our recent history. *Studies in Art Education, 29*(3), 264–274.

Eisner, E. (1965a). Graduate study and the preparation of scholars in art education. In W. R. Hastie (Ed.), *Art education: The sixty-fourth yearbook of the National Society for the Study of Education, Part II* (pp. 274–298). Chicago: University of Chicago Press.

Eisner, E. (1965b). Toward a new era in art education. *Studies in Art Education, 6*(2), 54–62.

Eisner, E. (1967). Instructional and expressive objectives: Their formulation and use in curriculum. In W. J. Popham (Ed.), *AERA: Monograph on curriculum evaluation: Instructional objectives* (pp. 1–18). Chicago: Rand McNally.

Eisner, E. (1972). *Educating artistic vision.* New York: Macmillan.

Eisner, E. (1974). Is the artist-in-the-schools program effective? *Art Education, 27,* 19–23.

Eisner, E. (1979a). Conservative influences on the arts in education. In S. Dobbs (Ed.), *Arts education and back to basics* (pp. 67–82). Reston, VA: National Art Education Association.

Eisner, E. (1979b). *The educational imagination: On the design and evaluation of school programs.* New York: Macmillan.

Ellul, J. (1967). *The technological society.* New York: Vintage Books.

Emerson, R. W. (1950). *The complete essays and other writings of Ralph Waldo Emerson* (B. Atkinson, Ed.). New York: Modern Library.

Encyclopedia of World Art. (1959–1968). (15 vols.). New York: McGraw Hill.

Farnum, R. B. (1932). Art education. *Biennial survey of education: 1928–1930* (Vol. I, pp. 297–322). Washington, DC: U.S. Government Printing Office.

Faulkner, R., Ziegfeld, E., & Hill, G. (1941). *Art today.* New York: Holt, Rinehart, & Winston.

Feldman, E. (1972). *Varieties of visual experience: Art as image and idea.* New York: Prentice Hall.

Fink, L., & Taylor, J. (1975). *Academy: The academic tradition in American art* (Publication No. 6054). Washington, DC: Smithsonian Institution Press.

Fleming, W. (1968). *Arts and ideas* (3rd ed.). New York: Holt, Rinehart, & Winston.

Fowle, W. B. (1825). *Introduction to linear drawing: Translated from the French of M. Francoeur.* Boston: Hilliard, Gray, Little, & Wilkins.

Fowle, W. B. (1866). *Principles of linear and perspective drawing for the training of the eye and hand.* New York: Author.

Fowler, C. (Ed.). (1980). *An arts in education source book: A view from the JDR 3rd Fund.* New York: JDR 3rd Fund.

Franciscono, M. (1971). *Walter Gropius and the creation of the Bauhaus in Weimar.* Champaign: University of Illinois Press.

Franklin, B. (1931). Proposed hints for an academy. In J. Woody (Ed.), *The educational views of Benjamin Franklin.* New York: McGraw Hill. (Original work published 1749)

Frederick, F. F. (1901). The study of fine art in American colleges and universities: Its relation to the study in public schools. In *National Education Association Journal of Proceedings and Addresses of the 40th annual meeting* (pp. 695–704). Chicago: University of Chicago Press.

Freedman, K. (1987). Art education and changing political agendas: An analysis of curriculum concerns of the 1940s and 1950s. *Studies in Art Education, 29*(1), 15–29.

Frieze, J. (1926). *Exploring the manual arts.* New York: Century.

Froebel, F. (1904). *Friedrich Froebel's pedagogics of the kindergarten* (J. Davis, Trans.). New York: D. Appleton.

Gardner, H. (1973). *The arts and human development.* New York: John Wiley.

Getty Center for Education in the Arts. (1984). *Beyond creating: The place for art in American schools.* Los Angeles, CA: Author.

Getty Center for Education in the Arts. (1987). *Discipline-based art education: What forms will it take?* (Proceedings of a national invitational conference sponsored by the Getty Center for Education in the Arts). Los Angeles, CA: Author.

Golden Gate Kindergarten Association. (1884). *Fifth annual report for the year ending October 6, 1884.* San Francisco: George Spaulding Printers.

Goldwater, R. J. (1986). *Primitivism in modern art.* Cambridge, MA: Belknap Press. (Original work published 1938)

Goldwater, R. J. (1943). The teaching of art in the colleges of the United States. *College Art Journal, 2*, suppl.

Gonzales, G. (1982). *Progressive education: A Marxist interpretation.* Minneapolis: Marxist Educational Press.

Goodman, P. (1960). *Growing up absurd: Problems of youth in the organized system.* New York: Random House.

Graves, F. P. (1929). *Great educators of three centuries.* New York: Macmillan.

Green, H. B. (1948). *The introduction of art as a general education subject in American schools.* Unpublished doctoral dissertation, Stanford University, Stanford, CA.

Green, H. B. (1966). Walter Smith, the forgotten man. *Art Education, 11*, 1–9.

Green, M. (1966). *The problem with Boston: Some readings in cultural history.* New York: W. W. Norton.

Griffith, T. (1959). *The waist-high culture.* New York: Harper & Brothers.

Grosser, M. (1956). *The painter's eye.* New York: Mentor Books.

Gutek, G. L. (1978). *Joseph Neef: The Americanization of Pestalozzianism.* University: University of Alabama Press.

Gwynn, A. (1926). *Roman education from Cicero to Quintillian*. Oxford: Clarendon Press.

Haefner, G. F. (1970). *A critical estimate of the educational theories and practices of A. Bronson Alcott*. Westport, CT: Greenwood Press.

Haggerty, M. (1935). *Art, a way of life*. Minneapolis: University of Minnesota Press.

Handlin, O. (1969). *Boston's immigrants: A study in acculturation*. New York: Atheneum. (Original work published 1959)

Haney, J. P. (1908). *Art education in the public schools of the United States*. New York: American Art Annual.

Harris, W. T. (1894). The committee of ten on secondary schools. *Educational Review, 7*, 1–10.

Harris, W. T. (1897). Why art and literature ought to be taught in our schools. *National Education Association Journal of Proceedings and Addresses of the Thirty-sixth Annual Meeting* (pp. 261–268). Chicago: University of Chicago Press.

Hartman, G., & Shumaker, A. (1972). *Creative expression: The development of children in art, music, literature and dramatics*. Salem, NH: Ayer. (Original work published 1932)

Hauser, A. (1951). *The social history of art* (4 Vols.). New York: Vintage Press.

Heckscher, A. (1963). *The arts and national government: Report to the president*. Washington, DC: U.S. Government Printing Office.

Hicks, M. D. (1891). Should instruction in form be based on type solids or upon miscellaneous objects? *National Education Association Journal of Proceedings and Addresses of the Thirtieth Annual Meeting* (pp. 796–806). New York: Published by the Association.

Hiss, P., & Fansler, R. (1934). *Research in the fine arts in the colleges and universities of the United States*. New York: Carnegie Corporation.

Hoffa, H. (1970). *An analysis of recent research conferences in art education*. Washington, DC: U.S. Department of Health, Education, and Welfare, Office of Education, Bureau of Research.

Hollingsworth, C. (1988). *Viktor Lowenfeld and the racial landscape of Hampton Institute during his tenure from 1939 to 1946*. Unpublished doctoral dissertation, Pennsylvania State University, University Park.

Hollis, A. P. (1898). *The contribution of the Oswego Normal School to educational progress in the United States*. Boston: D. C. Heath.

Holloway, J. (1956). *Edward Everett Hale, a biography*. Austin: University of Texas Press.

Holmes, P. (1935). *A tercentenary history of the Boston Public Latin School: 1635–1935*. Cambridge, MA: Harvard University Press.

Hook, D. (1985). The Fenollosa and Dow relationship and its value in art education. In B. Wilson & H. Hoffa (Eds.), *History of art education: Proceedings from the Penn State Conference* (pp. 238–242). Reston, VA: National Art Education Association.

Hubbard, G., & Rouse, M. (1981). *Art: Meaning, method, and media*. Chicago: Benefic Press.

Illich, I. (1970). *Deschooling society*. New York: Harper & Row.

Isherwood, R. (1973). *Music in the service of the king*. Ithaca, NY: Cornell University Press.

Itten, J. (1964). *Design and form: The basic course at the Bauhaus*. New York: Reinhold Publishing Co.

Itten, J. (1965). The foundation course at the Bauhaus. In G. Kepes (Ed.), *Education of vision* (pp. 104–121). New York: George Braziller.

Jaeger, W. (1943–1945). *Paideia: The ideals of Greek culture* (3 vols.). New York: Oxford University Press.

Janson, H. W. (1962). *History of art*. New York: Abrams.

Johnson, P. (1965). Art for the young child. In W. R. Hastie (Ed.), *Art education: Sixty-fourth yearbook of the National Society for the Study of Education, Part II* (pp. 51–85). Chicago: University of Chicago Press.

Jones, O. (1982). *The grammar of ornament*. New York: Van Nostrand Reinhold Co. (Original work published in 1856)

Jones, R. M. (1968). *Fantasy and feeling in education*. New York: New York University Press.

Jones, W. T. (1952). *A history of Western philosophy*, Vol. 2. New York: Harcourt, Brace & Co.

Kaestle, K. (1983). *Pillars of the republic*. New York: Hill & Wang.

Kainz, L. C., & Riley, O. (1949). *Exploring art*. New York: Harcourt, Brace & Co.

Kant, I. (1964). Critique of judgment. In A. Hofstadter & A. Kuhns (Eds.), *Philosophies of art and beauty* (pp. 280–343). New York: Modern Library. (Original work published in 1790)

Katz, M. (1971). *Class, bureaucracy and schools*. New York: Praeger.

Kaufman, I. (1964). *Art education in contemporary culture*. New York: Macmillan.

Kaufman, I. (1965). The visual world today. In J. Hausman (Ed.), *Report of the commission on art education* (pp. 13–34). Washington, DC: National Art Education Association.

Kaufman, E. (1982). Frank Lloyd Wright's mementos of childhood. *Journal of the Society of Architectural Historians, 41*(3), 232–236.

Kavolis, V. (1973). Institutional structure of cultural services. *Journal of Aesthetic Education, 8*, 63–80.

Kavolis, V. (1974). Arts, social and economic aspects. *Encyclopedia Britannica* (pp. 102–122). Chicago: Encyclopedia Britannica.

Kay-Shuttleworth, J. (1862). *Four periods of public education*. London: Longuran, Green & Roberts.

Keel, J. (1965). Art education: 1940–64. In W. R. Hastie (Ed.), *Art education: The sixty-fourth yearbook of the National Society for the Study of Education, Part II* (pp. 35–50). Chicago: University of Chicago Press.

Kelly, C. F. (1915). Art education. In *Report of the commissioner of education for the year ending June 30, 1915* (pp. 371–390). Washington, DC: U.S. Government Printing Office.

Kepes, G. (1944). *Language of vision*. Chicago: Paul Theobald.

Keppel, F., & Duffus, R. (1933). *The arts in American life*. New York: McGraw Hill.

Kershensteiner, G. (1905). *Die entwicklung der ziechnerischen begabung* (Development of the graphic gift). Munich: Carl Gerber.

Kilpatrick, W. (Ed.). (1933). *The educational frontier.* New York: D. Appleton-Century Co.

Korzenik, D. (1984). Francis Wayland Parker's vision of the arts in education. *Theory into Practice, 23*(4), 288-292.

Korzenik, D. (1985). *Drawn to art: A nineteenth century American dream.* Hanover, NH: University Press of New England.

Kristeller, P. O. (1961). *Renaissance thought: The classic, scholastic and humanistic strains.* New York: Harper & Brothers.

Krusi, H. (1872). *Krusi's drawing manual for teachers, inventive course.* New York: D. Appleton & Co.

Krusi, H. (1875). *Life and works of Pestalozzi.* Cincinnati: Wilson & Hinkle.

Krusi, H. (1907). *Recollections of my life.* New York: Grafton Press.

Landgren, M. (1940). *Years of art: The story of the Art Students League of New York.* New York: Robert McBride & Co.

Lanier, V. (1963). Schizmogenesis in art education. *Studies in Art Education, 5*(1), 10-19.

Lanier, V. (1966). *Final report of the uses of newer media in art education project.* Washington, DC: National Art Education Association.

Lazerson, M., & Grubb, W. N. (1974). *American education and vocationalism: A documentary history, 1870-1970.* New York: Teachers College Press.

Locke, J. (1964). *John Locke on education* (P. Gay, Ed.). New York: Bureau of Publications, Teachers College, Columbia. (Original work published in 1693)

Lord, C. (1982). *Education and culture in the political thought of Aristotle.* Ithaca, NY: Cornell University Press.

Lowenfeld, V. (1939). *The nature of creative activity.* New York: Harcourt Brace & Co.

Lowenfeld, V. (1947). *Creative and mental growth.* New York: Macmillan.

Lowenfeld, V. (1950). *Creative and mental growth: Revised edition.* New York: Macmillan.

Lowenfeld, V. (1958). Current research on creativity. *NEA Journal, 47,* 538-540.

Lukacs, J. (1968). *Historical consciousness or the remembered past.* New York: Harper & Row.

Macdonald, S. (1970). *History and philosophy of art education.* New York: American Elsevier Press.

MacVannel, J. A. (1905). *The educational theories of Herbart and Froebel.* (Teachers College Contributions No. 4) New York: Teachers College, Columbia University.

Mangravite, P. (1932). The artist and the child. In G. Hartman & A. Shumaker (Eds.), *Creative expression* (pp. 29-33). New York: John Day Co.

Mann, H. (1841). Moral objects to be aimed at in school. *Common School Journal, 3,* 186.

Mann, H. (1842). Drawing. *Common School Journal, 4,* 209-212.

Mann, H. (1843). Schmidt's [sic] guide to drawing. *Common School Journal, 5,* 241-243.

Mann, H. (1844a). Drawing. *Common School Journal, 6*, 198–200.

Mann, H. (1844b). Drawing: Schmidt to the teacher. *Common School Journal, 6*, 229–232.

Mann, H. (1844c). Excerpt on handwriting from seventh annual report. *Common School Journal, 6*, 132.

Mann, M. P. (1867). *Life and works of Horace Mann* (Vols. 1–4). Boston: Lee & Shepherd.

Marling, K. A. (1974). *Federal art in Cleveland, 1933–1943: An exhibition.* Cleveland: Board of Library Trustees.

Marrou, H. I. (1956). *A history of education in antiquity.* New York: Sheed and Ward.

Marzio, P. C. (1976). *The art crusade: An analysis of American drawing manuals.* Washington, DC: Smithsonian Institution Press.

Massachusetts Board of Education. (1845). Ninth annual report of the secretary. In M. Mann (Ed.), *Life and works of Horace Mann* (Vol. 4, pp. 1–104). Boston: Lee & Shepherd.

Massachusetts Board of Education. (1849). *Twelfth annual report of the secretary of the board* [for 1848]. Boston: Dutton & Wentworth State Printers.

Massachusetts Board of Education. (1871). *Thirty-fourth annual report of the secretary, 1870–1871.* Boston: Wright & Potter Printing Co.

Massachusetts Board of Education. (1874). *Thirty-seventh annual report of the secretary, 1873–1874.* Boston: Wright & Potter Printing Co.

Mather, F. J. (1957). *Charles H. Moore: Landscape painter.* Princeton, NJ: Princeton University Press.

Mayhew, K., & Edwards, A. (1966). *The Dewey school: The Laboratory School of the University of Chicago.* New York: Appleton Century Co. (Original work published 1936)

McClusky, N. G. (1958). *Public schools and moral education.* New York: Columbia University Press.

McFee, J. K. (1961). *Preparation for art.* Belmont, CA: Wadsworth Press.

McFee, J. K. (1965). Art for the economically and socially deprived. In W. R. Hastie (Ed.), *Art education: Sixty-fourth yearbook of the National Society for the Study of Education, Part II* (pp. 153–174). Chicago: University of Chicago Press.

McKeen, P., & McKeen, P. (1880). *A history of Abbot's Academy.* Andover, MA: Warren F. Draper.

McMullen, R. (1973). *Victorian outsider: A biography of J. A. M. Whistler.* New York: E. P. Dutton Co.

McMurry, C. A. (1899). *Special method in natural science.* Bloomington, IL: Public School Publishing Co.

Mendelowitz, D. M. (1963). *Children are artists: An introduction to children's art for teachers and parents* (rev. ed.). Palo Alto, CA: Stanford University Press. (Original edition published 1953)

Michael, J. A. (1965). Art experience during early adolescence. In W. R. Hastie (Ed.), *Art education: Sixty-fourth yearbook of the National Society for the*

Study of Education, Part II (pp. 86–114). Chicago: University of Chicago Press.

Michael, J. A. (Ed.). (1982). *The Lowenfeld lectures*. University Park: Pennsylvania State University Press.

Milton, J. (1911). *Tractate of education* (E. E. Morris, Ed.). London: Macmillan. (Original work published 1622)

Mock-Morgan, M. (1985). The influence of Arthur Wesley Dow on art education. In B. Wilson & H. Hoffa (Eds.), *History of art education: Proceedings from the Penn State Conference* (pp. 234–237). Reston, VA: National Art Education Association.

Moholy-Nagy, L. (1947). *Vision in motion*. Chicago: Paul Theobald.

Mumford, L. (1952). *Art and technics*. New York: Columbia University Press.

Munro, T. (1929). Franz Cizek and the free expression method. In J. Dewey (Ed.), *Art and education*. Merion, PA: Barnes Foundation Press.

Murphy, J., & Jones, L. (1978). *Research in arts education: A federal chapter*. Washington, DC: U.S. Department of Health Education and Welfare.

Music Educators National Conference. (1934). *The present status of school music instruction*. (MENC Bulletin No. 16). Washington, DC: Author.

Nation, The. (1875, December 30). Art instruction in Massachusetts. Vol. 10, pp. 425–426.

Nation, The. (1876, April 13). The Massachusetts system of instruction in drawing. Vol. 11, pp. 252–253.

National Art Education Association. (1949). As an art teacher I believe that. . . . *Art Education, 2(2)*, 1.

National Commission on Excellence in Education. (1983). *A nation at risk: The imperative for educational reform*. Washington, DC: U.S. Government Printing Office.

National Education Association. (1963). *Music and art in the public schools*. Washington, DC: NEA Research Division.

National Endowment for the Arts. (1988). *Toward civilization: A report on arts education*. Washington, DC: U.S. Government Printing Office.

National Society for the Study of Education. (1941). *Fortieth yearbook: Art in American life and education*. Bloomington, IL: Public School Publishing Co.

National Society for the Study of Education. (1965). *Sixty-fourth yearbook: Art education, Part II*. Chicago: University of Chicago Press.

Neef, J. (1969). *Sketch of a plan and method of education*. Salem, NH: Ayer. (Original work published 1808)

New York Department of Public Instruction. (1896). *Drawing for use in teachers institutes and training classes*. Albany, NY: Department of Public Instruction.

Norton, C. E. (1913). *Letters of Charles Eliot Norton*, Vol. 2. (S. H. Norton & A. DeWolfe, Eds.). Boston: Houghton Mifflin.

Neill, A. S. (1970). *Summerhill: A radical approach to childrearing*. New York: Hart Publishing.

O'Connor, F. V. (1972). *The New Deal art projects: An anthology of memoirs*. Washington, DC: Smithsonian Institution Press.

Osgood, James, Co. (1874). *Drawing in the public schools*. Boston: James Osgood Co.

Panofsky, E. (1955). Three decades of art history in the United States. *Meaning in the visual arts*. Garden City, NY: Doubleday.

Panofsky, E. (1957). *Gothic art and scholasticism*. New York: Meridian Books.

Peabody, E. P. (1869). *Plea for Froebel's kindergarten*. Boston: Adams & Co.

Peabody, E. P. (1969). *Record of a school*. New York: Arno Press. (Original work published 1836)

Perkins, D. (1956). *History of education in the ceramic arts*. Unpublished doctoral dissertation, Ohio State University, Columbus.

Perrine, H. (1937). *Economic and social history of medieval Europe*. New York: Harcourt Brace.

Pestalozzi, J. H. (1803). *ABC der Anschauung*. Zurich and Bern: Heinrich Gessner.

Pestalozzi, J. H. (1977). *Leonard and Gertrude* (E. Channing, Trans.). New York: Gordon Press. (Original work published in German 1785)

Pestalozzi, J. H. (1898). *How Gertrude teaches her children* (L. Holland & F. Turner, Trans.). Syracuse: C. W. Bardeen. (Original work published 1801)

Pevsner, N. (1960). *Pioneers of modern design from William Morris to Walter Gropius*. Hammondsworth, Middlesex, England: Penguin Books.

Pevsner, N. (1973). *Academies of art past and present*. New York: Da Capo Press.

Phenix, P. (1968). The use of the disciplines as curriculum content. In F. L. Steeves (Ed.), *The subjects in the curriculum: Selected readings*. New York: Odyssey Press.

Pinar, W. (1975). *Curriculum theorizing: The reconceptualists*. Berkeley, CA: McCutchan.

Plotinus. (1963). Art as beauty. In M. Weitz (Ed.), *Problems in aesthetics* (pp. 25–36). New York: Macmillan.

Plutarch. (1914). Aemillus Paulus. In *Plutarch's lives*, Vol. 6 (B. Perrin, Trans.). Cambridge, MA: Harvard University Press.

Pope, A. (1937). *Art, artist and layman*. Cambridge, MA: Harvard University Press.

Popkewitz, T., Pitman, A., & Barry, A. (1986). Educational reform and its millennial quality: The 1980s. *Journal of Curriculum Studies, 18*(3), 267–283.

Porter, A. (1971). A backward glance. In *The thirties decade: American artists and their European contemporaries* (pp. 13–15). Omaha, NE: Joslyn Art Museum.

Progressive Education Association. Commission on Secondary School Curriculum. (1940). *The visual arts in general education*. New York: D. Appleton-Century Co.

Purdue, P. (1977). *Ideology and art education: The influence of socialist thought on art education in America between the years 1890–1960*. Unpublished doctoral dissertation. University of Oregon, Eugene.

Ravaisson, F. (1857). Instruction in drawing in schools of art and design: Report of a French commission. *Barnard's American Journal of Education, 2*, 419–434.

Read, H. (1943). *Education through art*. New York: Pantheon.

Redgrave, R. (1857). *Manual of design*. London: Chapman & Hall.

Remer, J. (1982). *Changing schools through the arts.* New York: McGraw Hill.

Rhoades, J. (1985). Initial findings on the origin of the International Society for Education through Art. In B. Wilson & H. Hoffa (Eds.), *History of art education: Proceedings from the Penn State Conference* (pp. 334–337). Reston, VA: National Art Education Association.

Rich, A. (1946). *Lowell Mason: The father of singing among the children.* Chapel Hill: University of North Carolina Press.

Richardson, M. (1946). *Art and the child.* Peoria, IL: Charles A. Bennett Co.

Riesman, D. (1950). *The lonely crowd.* New Haven, CT: Yale University Press.

Rogerson, B. (1953). The art of painting the passions. *Journal of the History of Ideas, 14,* 68–94.

Roman, C. (1984). Academic ideals of art education. In Brown University Department of Art, *Children of Mercury* (pp. 81–95). Providence, RI: D. W. Bell Gallery.

Ronda, B. (Ed.). (1984). *Letters of Elizabeth Palmer Peabody.* Middletown, CT: Wesleyan University Press.

Rosenberg, H. (1973). *The anxious object* (2nd ed.). New York: Collier Books. (First edition published 1964)

Ross, D. (1907). *A theory of pure design.* Boston: Houghton Mifflin.

Ross, D. (1912). *On drawing and painting.* Boston: Houghton Mifflin.

Rousseau, J. J. (1976). *Emile.* (B. Foxley, Trans.). London: J. M. Dent & Sons. (Original work published 1761)

Rugg, H., & Shumaker, A. (1928). *The child-centered school.* New York: World Book Co.

Runkle, J. D. (1877). The manual element in education. In Massachusetts Board of Education. *Forty-first annual report of the secretary.* Boston: Wright & Potter Printing Co.

Ruskin, J. (1903–1912). *The works of John Ruskin,* vols. 1–38 (E. T. Cook & A. Wedderburn, Eds.). London: George Allen.

Ruskin, J. (1904). *Letters of John Ruskin to Charles Eliot Norton,* Vol. 2 (C. E. Norton, Ed.). Boston: Houghton Mifflin.

Sargent, W. (1912). *Fine and industrial arts in elementary schools.* Boston: Ginn & Co.

Sargent, W. (1921). Instruction in art in the United States. *Biennial survey of education 1916–1918* (Vol. 1, pp. 227–255). Washington, DC: U.S. Government Printing Office.

Saunders, R. J. (1960). The contributions of Viktor Lowenfeld to art education: Part I: Early influences on his thought. *Studies in Art Education, 2,* 6–15.

Saunders, R. J. (1961). *The contributions of Horace Mann, Mary Peabody Mann, and Elizabeth Peabody to art education in the United States.* Unpublished doctoral dissertation, Pennsylvania State University, University Park.

Schaper, E. (1968). *Prelude to aesthetics.* London: Oxford University Press.

Schiller, F. (1967). *On the aesthetic education of man: In a series of letters* (E. Wilkinson, & L. A. Willoughby, Trans.). Oxford: Clarendon Press. (Original work published 1795)

Schinneller, J. (1965). Art: The present condition. In W. R. Hastie (Ed.), *Art education: Sixty-fourth yearbook of the National Society for the Study of Education, Part II.* Chicago: University of Chicago Press.

Schneider, I. (1965). *The enlightenment: The culture of the eighteenth century.* New York: George Brazillier.

Schubert, W. H. (1986). *Curriculum: Perspective, paradigm and possibility.* New York: Macmillan.

Schwartz, C. (1984). *The shock of modernism in America: The eight and artists of the Armory Show.* Roslyn Harbor, NY: Nassau County Museum of Fine Art.

Sevigny, M. (1977). *A descriptive study of instructional interaction and performance appraisal in a university studio setting: A multiple perspective.* Unpublished doctoral dissertation. Ohio State University, Columbus.

Sigourney, L. H. (1837). *Letters to young ladies.* New York: Harper & Brothers.

Silber, K. (1960). *Pestalozzi, the man and his work.* London: Routledge & Kegan Paul.

Silberman, C. (1970). *Crisis in the classroom.* New York: Random House.

Sizer, T. (1964). *The age of academies.* New York: Teachers College Press.

Smith, P. (1985). Franz Cizek: Problems of interpretation. In B. Wilson & H. Hoffa (Eds.), *History of art education: Proceedings from the Penn State Conference* (pp. 219–224). Reston, VA: National Art Education Association.

Smith, R. A. (1966). *Aesthetics and criticism in art education.* Chicago: Rand McNally.

Smith, R. A. (1975). *Regaining educational leadership.* New York: John Wiley & Sons.

Smith, R. A. (1987a). *Excellence in art education: Ideas and initiatives.* Reston, VA: National Art Education Association.

Smith, R. A. (1987b). The changing image of art education: Theoretical antecedents of discipline-based art education. *Journal of Aesthetic Education, 21*(2), 3–34.

Smith, W. (1872a). *Art education scholastic and industrial.* Boston: James Osgood & Co.

Smith, W. (1872b). *The standard book of graphic reproductions and designs.* Boston: James Osgood & Co.

Snedden, D. (1917). The waning powers of art. *American Journal of Sociology, 23,* 801–821.

Snyder, A. (1972). *Dauntless women in childhood education: 1856–1931.* Washington, DC: Association for Childhood Education International.

Spencer, H. (1966). What knowledge is of most worth? In M. A. Kazamias (Ed.), *Herbert Spencer on education* (pp. 121–159). New York: Teachers College Press. (Original work published 1861)

Spring, J. (1986). *The American school: 1642–1985.* New York: Longman.

Stankiewicz, M. A. (1984). The eye is a nobler organ: Ruskin and American art education. *Journal of Aesthetic Education, 18*(2), 51–64.

Stark, G. K. (1985). Oswego normal's (and art education's) forgotten man. *Art Education, 37,* 40–44.

Stickley, G. (1909). *Craftsman homes.* New York: Craftsman Publishing Co.

Stowe, C. (1838). Instruction in the primary schools of Germany. *Connecticut Common School Journal, 1*, 23–24.

Sully, J. (1890). The child as artist. In *Studies in childhood* (pp. 298–330). London: Longmans & Green Co.

Sutton, G. (1967). *Artisian or artist? A history of the teaching of art and crafts in English schools.* New York: Pergamon Press.

Taylor, H. (1948). *The taste of angels: A history of art collecting from Rameses to Napoleon.* Boston: Little Brown & Co.

Teachers College, Columbia University. Department of Fine and Industrial Art. (1942). Art education, democracy, and the war. In *Art Education Today.* New York: Bureau of Publications, Teachers College, Columbia University.

Teachers College, Columbia University, Department of Fine and Industrial Art. (1943). *Art Education Today: Art and the War.* New York: Bureau of Publications, Teachers College, Columbia University.

Tholfsen, T. (1974). *Sir James Kay-Shuttleworth on popular education.* New York: Teachers College Press.

Thorndike, E. L. (1922). The nature, purposes, and general methods of measurement of educational products. In *The seventeenth yearbook of the National Society for the Study of Education, Part II* (pp. 16–24). Bloomington, IL: Public School Publishing Co.

U.S. Congress, Senate. (1880). Resolution [to the Secretary of the Interior]. *Congressional Record*, 46th Cong., 2nd Sess., p. 647.

U.S. Office of Education. (1933). *Deepening crisis in education* (Leaflet No. 44). Washington, DC: U.S. Government Printing Office.

Vanderbilt, K. (1959). *Charles Eliot Norton: Apostle of culture in a democracy.* Cambridge, MA: Belknap Press.

Vaughn, R. (1980). *German romantic painting.* New Haven, CT: Yale University Press.

Viola, W. (1936). *Child art and Franz Cizek.* Vienna: Austrian Junior Red Cross.

Viola, W. (1946). *Child art.* Peoria, IL: Charles A. Bennett Co.

Vitz, P., & Glimcher, A. (1984). *Modern art and modern science: The parallel analysis of vision.* New York: Praeger.

Ware, C. (1935). *Greenwich Village: 1920–1930.* Boston: Houghton Mifflin.

Webber, A. L. (1911). In memorium: Milton Bradley. *National Education Association Journal of Proceedings and Addresses for the Fiftieth Annual Meeting* (pp. 488–491). Chicago: University of Chicago Press.

Wells, H. G. (1922). *The outline of history: Volume I.* New York: P. F. Collier & Sons.

Werckmeister, O. K. (1977). The issue of childhood in the art of Paul Klee. *Arts Magazine, 52*, 138–151.

Whitaker, W. (1851). *A progressive course in inventive drawing on the principles of Pestalozzi.* Boston: Author.

Whitaker, W. (1853). *A progressive course in inventive drawing on the principles of Pestalozzi.* Boston: Ticknor, Reed, and Fields.

Whitford, W. (1929). *An introduction to art education.* New York: D. Appleton & Co.

Whyte, W. H. (1956). *The organization man*. New York: Simon & Shuster.

Wiebe, E. (1869). *The paradise of childhood: A manual for self-instruction in Friedrich Froebel's educational principles*. Springfield, MA: Milton Bradley Co.

Wightman, J. (1860). *Annals of the Boston primary school committee*. Boston: Rand & Avery City Printers.

Wilds, E., & Lottich, K. (1962). *The foundations of modern education*. New York: Holt, Rinehart & Winston.

Wilson, B. (1988). Art education in the United States: Promises, practices, and problems of reformation. *Canadian Review of Art Education, 15*(1), 1-10.

Winslow, L. (1939). *The integrated school art program*. New York: McGraw-Hill.

Wiseman, N. P. (1869). *The identification of the artisan and the artist*. Boston: Adams & Co.

Wittkower, R., & Wittkower, M. (1963). *Born under Saturn: The character and conduct of artists*. New York: Random House.

Wolfe, T. (1975). *The painted word*. New York: Farrar Straus & Giroux.

Woolworth Ainsworth Co. (1874). *Drawing in the public schools by the use of the Smith books condemned*. New York: Woolworth Ainsworth Co.

Wygant, F. (1983). *Art in American schools of the nineteenth century*. Cincinnati: Interwood Press.

Ziegfeld, E. (1944). *Art for daily living: The story of the Owatonna art education project*. Minneapolis: University of Minnesota Press.

Zimmerman, E. (1985). Art talent and research in the 1920s and 1930s: Norman Charles Meier's and Leta Stetter Hollingsworth's theories about special abilities. In B. Wilson & H. Hoffa (Eds.), *History of art education: Proceedings from the Penn State Conference* (pp. 269-275). Reston, VA: National Art Education Association.

Zueblin, R. F. (1902). The art teachings of the arts and crafts movement. *The Chautauquan, 36*, 282-284.

Index

About the Author

For many years Arthur Efland was a teacher of art in the public schools of Connecticut and California. He received his doctorate in art education from Stanford University in 1965, and is professor of art education at the Ohio State University. He authored the elementary and secondary guidelines in art education for Ohio, the latter of which received an award of excellence from the National Art Education Association in 1982. He has published regularly in the *Journal of Aesthetic Education, Studies in Art Education, Visual Arts Research,* and *Art Education.* In 1984 he received the Barkan Award for the year's best scholarly paper in art education and the McFee Award for distinguished service to the art education profession. In 1987 the editors of *Studies in Art Education* invited him to present the fourth invited lecture at the national art education conference. He is a frequent participant at national and international conferences in art education, and in recent years he has been an invited participant at conferences on the history of art education in São Paulo, Brazil; University Park, Pennsylvania; Halifax, Nova Scotia; and Bournemouth, England.